Rebecca Stuhr
Y0-BRH-245

SWITCHING CODES

SWITCHING CODES

Thinking Through Digital Technology in the Humanities and the Arts

EDITED BY **THOMAS BARTSCHERER AND RODERICK COOVER**

THE UNIVERSITY OF CHICAGO PRESS
CHICAGO + LONDON

Thomas Bartscherer is assistant professor of humanities and director of the Language and Thinking Program at Bard College. He is coeditor of *Erotikon: Essays on Eros Ancient and Modern*, also published by the University of Chicago Press. Roderick Coover is associate professor in the Department of Film and Media Arts at Temple University. He is the author of the digital publications *Cultures in Webs: Working in Hypermedia with the Documentary Image* and *Vérité to Virtual: Conversations on the Frontier of Film and Anthropology*.

"Relating Modes of Thought" by William Clancy is a work of the US Government and is not subject to copyright protection in the United States.

"Figment: The Switching Codes Game," © Eric Zimmerman.

"Electronic Linguistics," © Gary Hill and George Quasha.

"Enquire Within upon Everything," © 2009 by Richard Powers. First published in the *Paris Review*. Reprinted by permission of Melanie Jackson Agency, L.L.C.

The University of Chicago Press, Chicago 60637
The University of Chicago Press, Ltd., London
© 2011 by The University of Chicago
All rights reserved. Published 2011
Printed in the United States of America

20 19 18 17 16 15 14 13 12 11 1 2 3 4 5

ISBN-13: 978-0-226-03830-8 (cloth)
ISBN-13: 978-0-226-03831-5 (paper)
ISBN-10: 0-226-03830-0 (cloth)
ISBN-10: 0-226-03831-9 (paper)

Library of Congress Cataloging-in-Publication Data
 Switching codes : thinking through digital technology in the humanities and the arts / edited by Thomas Bartscherer and Roderick Coover.
 p. cm.
 Includes index.
 ISBN-13: 978-0-226-03830-8 (cloth : alk. paper)
 ISBN-10: 0-226-03830-0 (cloth : alk. paper)
 ISBN-13: 978-0-226-03831-5 (pbk. : alk. paper)
 ISBN-10: 0-226-03831-9 (pbk. : alk. paper)
 1. Communication in learning and scholarship—Technological innovations. 2. Information technology. 3. Humanities—Information technology. 4. Arts—Information technology. I. Bartscherer, Thomas. II. Coover, Roderick.
 AZ195.S95 2011
 303.48'33—dc22
 2010048752

♾ The paper used in this publication meets the minimum requirements of the American National Standard for Information Sciences—Permanence of Paper for Printed Library Materials, ANSI Z39.48-1992.

CONTENTS

III. Panorama, Interactivity, Embodiment

Response

IV. Re/presentations: Language and Facsimile

Responses

SWITCHING CODES

Introduction

1

The aim of this volume can be simply put: to bring together scholars, scientists, and artists to reflect on the impact of digital technology on thought and practice in the humanities and the arts. It may seem improbable that there would be an antihero in a book like this—or a hero, for that matter—but so there is, as one discovers upon reading the epilogue. And while this is not the only improbable feature of *Switching Codes*, it's a good one to flag at the start, for it turns out that the antihero, who is never given a proper name, is in a way a proxy, or perhaps a foil, for you, dear reader.

It will help to know that the novelist Richard Powers, the author of the epilogue, accepted the editors' invitation to read the ten primary essays and to respond in writing, with the genre of the response left entirely to his discretion. And I trust it won't be too much of a spoiler to reveal that he chose to write a piece of fiction, a condensed biographical tale, set mostly in the near future, that begins with an allusion to Charles Dickens's meditation on the French Revolution, *A Tale of Two Cities*. The implication, one imagines, is that the latter days of the digital revolution may be, in some sense, the best of times and the worst of times.

In the case of the humanities, writes the computer scientist Ian Foster in the book's opening essay, "computation . . . has the potential to transform . . . how humans communicate, work, and play, and thus—to some extent—what it means to be human." Foster then envisions the state of scholarly research in the year 2030, shaped by the pervasive influence of digital technology. Powers takes to heart this projection and those of other contributors and responds by placing his protagonist at a time when the technological developments they anticipate have come to fruition. The narrator conjures this future world by recounting the story of one life, thought and written into being for the present volume.

It is precisely this kind of dialogue—the exchange between Powers and the other contributors—that *Switching Codes* aims to facilitate. The impediments to such a dialogue have often been referred to collectively as the "two cultures" problem, a phrase that first gained currency through an influential 1959 lecture by C. P. Snow. Snow, himself both a scientist and a novelist, argued that in the modern world scientific and humanistic discourses were becoming increasingly isolated from one another, to the detriment of both (1961).[1] At the time—thirty years before the birth of the World Wide Web—digital technology was in its infancy and the revolution it would precipitate was but a twinkle in the eye of rare clairvoyants like Vannevar Bush (1945).

With the spectacular expansion of information technology (IT) in the past four decades, the "two cultures" problem has become considerably more complicated. In ways that Snow could hardly have anticipated, the culture of arts and letters is now permeated by science in the form of information technology, from word processing and semantically structured research networks to computer-generated imagery, interactive cinema, and creative machines. The very idea of "information science" indicates how "deeply intertwingled" the two cultures have become (Nelson 1987). Yet mutual incomprehension persists. Generally speaking, scholars and artists understand little about the technologies that are so radically transforming their fields, while IT specialists often have scant or no training in the humanities or traditional arts.

Switching Codes is conceived as a response to this problem, an attempt to bring scholars and artists into more robust dialogue with computer scientists and programmers. There are, to be sure, an increasing number of individuals who have real competence in both domains—indeed, some of them have contributed to this volume. But these cases are still rare. And so, for the most part, we have sought out specialists from each side of this digital divide who are open to and interested in genuine exchange. We have asked them to choose topics that they are actively researching, issues that are vital in their own disciplines. At the same time, however, we have urged them to write for a broader audience, in the hope that all of the contributions might be comprehensible and (at least potentially) useful to experts in a wide range of fields. We have encouraged contributors also to engage with themes that have resonance beyond the discipline or context in which they originate—traveling concepts, as they are sometimes called (Bal 2002). "Ontology," for example, denotes a branch of philosophy, one of the oldest and most fertile, but in recent years it has also become a term of art in computer science. Likewise, "embodiment" has obvious philosophical and even theological valences, but it takes on new

significance when juxtaposed with the concept of the "virtual" as it has come to be understood in digital culture. And, as the title of the volume suggests and as several contributors demonstrate, the notion of "code" has currency in both the human sciences and computer science. These and other traveling concepts are used to establish common ground for cross-disciplinary conversation and to clarify key differences. As they migrate from one field to another, they inspire and provoke new lines of thought and more effective forms of expression.

The book is divided into four sections, with an interlude in the middle and an epilogue at the end. Each section concludes with two responses, and here too the goal has been to promote cross-disciplinary conversation: scholars and artists respond to IT specialists and vice versa. Respondents were asked to regard the essays in their section as a set, with the intention of encouraging them to highlight common themes. Beyond that, however, they were given free rein, and so there is considerable variety in approach, tone, and length. Like the epilogue, the interlude effectively responds to all of the essays. This contribution, by game designer and design theorist Eric Zimmerman, takes the form of an original game, called *Figment*. As Zimmerman notes, *Figment* is not an argument to be analyzed but a game to be played, with all the constraint and freedom that attend such structured play. As the reader—or rather, the player—will discover, this game does not only radicalize the notion of traveling concepts and playfully engage with the ideal of cross-disciplinary dialogue; it also reflects the habits of thought and expression that have developed in an age of electronic cut-and-paste, wikis, and trackback protocols.

Switching Codes is thus designed to exemplify the kind of conversation it seeks to facilitate and promote. To understand how digital technology is transforming thought and practice in the humanities and the arts, it is necessary to cultivate cross-cultural communication, to establish points of reference, and to develop a shared vocabulary. Given the globalized and decentralized nature of digital culture, this cannot be mandated from the top down, as it were, but must be cobbled together from the bottom up and on the fly. The intention here is not to compile an authoritative survey—truly a quixotic endeavor in such a rapidly changing landscape—but to model and catalyze a conversation. Alan Liu's response to the first section of the book is exemplary in this respect, as he calls attention to important and relevant issues left unaddressed by the primary essayists. It also bears emphasizing that the contributors are, for the most part, actively engaged in projects that integrate digital technology and the humanities or the arts. The goal in producing this book has been to fos-

ter an exchange that draws on that concrete, hands-on experience, in all its particularity and diversity, while also addressing matters of common interest and concern. The grouping of the essays, moreover, while drawing attention to certain clusters of issues, does not embody strong claims about the division of the material, and the four-part structure is not meant to obscure the many links between contributions in different sections.

Surveying the volume as a whole, several themes seem particularly salient. To start with, it is evident that in the field of what has been called the "digital humanities," the effort to develop ways of amassing data and making it widely available over the Internet has been terrifically successful. As a result, scholars are, now more than ever, confronted with the challenge of ordering vast quantities of information. How will the information be organized, filtered, and made meaningful? What will count as authoritative and how will authority be established? How much of information processing can be automated, and what is gained or lost in that automation? These and related issues are addressed from both practical and theoretical perspectives in the pages that follow. While the contributors reach no unanimous conclusions, there is a shared sense of the shape and urgency of the questions.

No less profound in its effect has been the shift in recent years toward collaborative and collective modes of working in scholarship, the arts, and culture generally. Many of the authors here address this development in one way or another: we read of scholarship becoming less of an individual, more of a social, activity; of "open scholarly communities on the web"; of the effort to leverage the knowledge of social networks; of interactive cinema and "cumulative creativity." As becomes evident in these essays, this trend has implications as much for the understanding of what constitutes "a work" (of scholarship, of art) as it does for the conception of social organization. One contribution proposes that the task of the contemporary artist is to articulate and give meaning to these "new modalities of 'being' in this world." From the evidence on view in the present volume, this task is shared by theorist and scholar, as they contemplate an intellectual and artistic culture increasingly constituted by networked collaboration.

It is perhaps inevitable that a book focusing on the impact of digital technology will, at some deep level, raise questions about the status of human being in the world. In a traditional conception of human being stretching back to Aristotle, the human is located between the bestial and the divine. In modernity that traditional notion has been challenged from both sides; the line separating human from animal has become ever more difficult to draw, while

at the same time the divine has for many ceased to be a relevant category for philosophical thought. While these two categories, conceived as sub- and supra-human respectively, have certainly not disappeared from the discourse, the present age demands that we add a fourth term to the Aristotelian triad. Now we must also consider the being of humans relative to the being of machines. This concern surfaces in various contexts throughout *Switching Codes*: in Paolo D'Iorio and Michele Barbera's dialogue about the design of a humanities research infrastructure; in Jean-Gabriel Ganascia's inquiry into the possibility of making "creative machines" by simulating "essential unpredictability" on "finite state automatons"; in Albert Borgmann's argument that the human "immersion in reality" cannot ultimately be encoded or simulated; in Bruno Latour and Adam Lowe's reconsideration of the status of originality in the reception of artworks; in the account of Jeffrey Shaw's attempts to engineer interactions between human beings and machines, where machines are said to "determine our spatial formations" and even to behave as "autonomous agents"; and in George Quasha's discussion of Gary Hill's work, where the key question is how "what emerges in the electronic space takes on life and speaks for itself." As noted above, Ian Foster suggests in his piece that the power of automated computation may in certain respects change "what it means to be human." This possibility—both a promise and a threat—is clearly on the minds of many contributors to *Switching Codes*.

The impact of new information technologies has been felt nowhere more acutely than in the world of publishing. While it is no longer in vogue to predict the "end of the book," the future of the traditional codex remains a matter of considerable speculation among those who write on technology and culture. It is yet another peculiarity of the present volume that we have chosen to publish on paper a work dedicated to digital technology, new media, and the virtual world. We have done so in part because we believe that the traditional codex nurtures modes of thought and being that are increasingly rare in our time. *Festina lente*—the proverb that the great Renaissance publisher Aldus Manutius chose for his imprint—is now, more than ever, the most fitting motto for book culture. To make haste slowly means to cultivate the habits of mind and hand that attend the writing, publishing, and reading of books.

Switching Codes, moreover, is designed to prompt reflection on this venerable medium. *Figment*, the game at the center of the book, draws attention to the materiality of the codex, calling for the use of playing cards, ink on paper, that can be snipped out of the pages of this volume. Alan Liu, in his response to Mark Stefik, maintains that the "logical modularity" of the lat-

ter's text, which is the default mode of writing for electronic publication but not for the traditional book, reflects and reinforces a set of convictions about how thought is communicated and meaning established in the digital sphere. Other contributors follow the conventions of traditional essay writing, which is a substantially different kind of discourse. D'Iorio and Barbera deviously subvert this distinction by simulating (or, who knows?, simply reproducing) a Skype chat and putting that forward for print publication. The crowning irony here, as Liu observes in his response, is that their contribution deliberately recalls one of the oldest modes of philosophical writing, the Platonic dialogue, a form that itself marked the transition from oral to written culture. We need only look to the critique of writing in Plato's *Phaedrus* to see why that revolution too may well have been regarded by some as the best of times and the worst of times.

And so we return to our antihero, the protagonist of the epilogue. The book in which he lives is—another irony here—replete with an everyday kind of heroism. Most of the contributors to this volume work daily on conceiving, building, using, and evaluating the complex conglomerations that structure the future world Powers postulates. By and large, these contributors portray their work in terms of opportunities, discoveries, and achievements. The scope of ambition and ability manifest in these pages is nothing short of breathtaking, and the frank enthusiasm buoys the spirit. Yet the novelist sounds a note of caution. Our hope is that *Switching Codes* may stimulate and contribute to a conversation marked equally by caution and enthusiasm.

Thomas Bartscherer

0

Philosophy is not only a form of knowledge; it is also an expression of cultures.
Richard McKeon (1952)

The essays in *Switching Codes* constitute not only an exchange between individuals but also a coming together of cultures—the scholarly and creative cultures of computing, the humanities, and the creative arts. The volume builds a conversation between these cultures, introducing those in information technologies who are conceiving of electronic tools and environments to those in the humanities and arts who use digital technologies, often in ways

not imagined by their inventors. Each of these cultures is characterized by a distinct set of lexicons, methods, theories, and goals; each is embedded in complex webs of knowledge. Even within a given culture, philosophies and methods are diverse and contested. Yet digital technologies are stimulating, and perhaps even necessitating, bridge-building within and between cultures. The questions provoked by thinking and making by way of digital technologies are not only shaping a discourse between information technologies and intellectual/creative fields, they are also provoking questions about conventional borders that separate artistic and scholarly activities.

Many terms now being used to describe the processes of intellectual and creative work are new and derive from the computing industries. In numerous cases, the terms are only beginning to be understood; their meanings grow through the diversity and depth of their applications. Some, such as "semantic web" and "metadata," have gained common usage in the context of computing practices and code; nonetheless, the concepts they invoke may have antecedents in such fields as art history, literary studies, or information management and library sciences.[2] Other terms, for example, "ontology," "compositing," and "facsimile," originated in one field but have, under the influence of computing technology, come to be used in others. The deeper one probes, the more one realizes the need to clarify—and also to enrich—the lingua franca. Shared understanding about terms and the concepts they invoke enables collaboration. *Switching Codes* contributes to this process, as scholars, artists, and computing innovators weigh in on the terms of an emergent discourse and on the implications of new and evolving meanings for future disciplinary and cross-disciplinary praxis. The technologies themselves would seem to be drawing these very differing fields onto a shared terrain. Yet while there have been some substantial works that address such questions within disciplinary contexts,[3] few have successfully bridged the divide that separates the very differing cultures of computing, humanities scholarship, and creative production.

As William Clancey observes in his contribution to this volume, the very act of exchanging ideas aims to establish common ground. The participation of the scholars and artists included here thus evinces a shared interest in conducting this pluralist discourse while maintaining the integrity of the multiple worldviews that are brought together. At the same time, such exchanges may bring to light differences in how concepts derived from computing relate to the questions, methods, and goals of other fields. As Clancey points out, theories may be easily named, but the beliefs underlying them—beliefs that

dictate the need for and determine the structure of whole fields of inquiry—can be more difficult to articulate.

The impact of computer technologies on thinking and representation is manifest in the very specific contexts in which scholarly and artistic practices take place. The broad themes addressed in *Switching Codes*, such as authenticity (Latour and Lowe), learning and creativity (Ganascia), the semantic web (Hendler), and ontologies (Ceusters and Smith), are approached through the lens of specific questions. Latour and Lowe, for example, confront issues of authenticity and the circumstances of reception in the context of how art aficionados respond to facsimiles of Paolo Veronese's *Nozze di Cana* and Hans Holbein's *Ambassadors*. In addition, Lowe's description of the process of making facsimiles demonstrates how technological methods are developed to respond to specific challenges. Other contributors address similar issues in relation to such creative practices as gaming (Zimmerman), immersive environments and panoramas (Shaw, Coover, Sorensen), creative writing (Bernstein, Powers), and video (Hill), and in each case, specific disciplinary concerns take on cross-disciplinary dimensions. The essays in this book thus demonstrate that the relationship of technology to humanities and arts is not a one-way street. The invention of digital tools in computing industries and computer sciences responds to the diverse needs and innovations of users.

This process of seeking common ground is speculative; the essays suggest links and make propositions. In "Electronic Linguistics" for example, George Quasha, in dialogue with Gary Hill, proposes that while we get by with existing terms, other kinds of expressive and abstract linguistics are taking form, ones that bind us all through screen experiences. Quasha points to the ways that language in Hill's artworks is more about communion than communication. What gives meaning to terms and makes them valuable is collective participation itself. Shared dialogues, like those taking place in this volume, redefine a lexicon of living practices, giving shape to an abstract geography. Hill's works attempt to draw out—and perhaps even give form to—ways we process electronic information as it takes form in our consciousness. Time itself is the central paradox in this attempt to articulate the rhetoric of an electronic linguistics. Flux cannot be recorded; it can only be pointed to *in medias res*.

The book you have in hand is the result of collaborations on many fronts. *Switching Codes* draws practitioners of diverse cultures of intellectual and artistic praxis into shared debates about the terms and rhetoric of digi-

tal technologies. The contributors were asked to follow threads of inquiry, not fixed agendas, and these threads are woven through the volume. In numerous ways reflected in the book, new technologies are bridging a gap by making digital scholars and artists out of humanists, and vice versa. Whether writing a simple e-mail or complex code, we are all multimedia makers now. Many of the contributors demonstrate how the integration of diverse media methods adds to an enduring discourse on rhetoric and poetics, on how the ways that questions are posed shape the results (in form and content) one attains.

The contributors of the primary essays were invited to consider the ways in which concepts particular to their fields are gaining new meaning or currency in digital contexts, as well as what those contexts are bringing to their fields. Respondents were asked to extend this dialogic process by exploring connections between ideas in the essays and their own diverse practices. Some respondents find common ground with the essayists, while others offer alternative viewpoints or take the essayists' propositions in new and surprising directions. Their responses offer both reflections on the topographies of ideas that they perceive as being delineated by the primary essays and personal trajectories through and beyond those realms.

It is our belief that digital technologies can illuminate the shifting relationships between form and content that occur within each conversation, project, discipline, and discourse. Switching Codes employs a myriad of forms—exposition, fiction, poetry, game design, critique—to engage questions about the relation between ideas and methods, between the kinds of inquiry that take place in particular disciplinary contexts and the shared issues and organizing principles that link such inquiries at their foundations—their poetics and rhetoric. The uncredited but most vital authors in this process are you the readers, who in traversing the intellectual landscapes within these pages may discover and redefine aspects of these diverse fields within your own cultures, ideas, and methods.

<div align="right">Roderick Coover</div>

Notes

1. One might argue that the ascendancy of modern science and the decline of classical learning are merely contingent exacerbations and that the root problem is a bifurcation in human intellect. The seventeenth-century philosopher Pascal, for example, distinguishes between l'esprit de géométrie (mathematical thinking) and l'esprit de finesse

(intuitive thinking). It could be argued that this distinction is adumbrated already in Plato, but that is an argument for another occasion.

2. See, for example, Bowker (1999); Hayles (1999); Manovich (2001); Rodowick (2001); Wardrip-Fruin and Montfort (2003); Ganascia (2006); Popper (2007); Borgman (2007).

3. Examples in the humanities include Barrett and Redmond (1995); Bolter and Grusin (1999); Hockey (2000); Floridi (2004); Schreibman, Siemens, and Unsworth (2005); Landow (2006); O'Gorman (2006); Morris and Swiss (2006).

References

Bal, Mieke. 2002. *Travelling concepts in the humanities: A rough guide.* Toronto: University of Toronto Press.

Barrett, Edward, and Marie Redmond. 1995. *Contextual media: Multimedia and interpretation.* Cambridge, MA: MIT Press.

Bolter, Jay David, and Richard Grusin. 1999. *Remediation: Understanding new media.* Cambridge, MA: MIT Press.

Borgman, Christine. 2007. *Scholarship in the digital age: Information, infrastructure, and the Internet.* Cambridge, MA: MIT Press.

Borgmann, Albert. 1999. *Holding on to reality: The nature of information at the turn of the millennium.* Chicago: University of Chicago Press.

Bowker, Geoffrey. 1999. *Sorting things out: Classification and its consequences.* Cambridge, MA: MIT Press.

Bush, Vannevar. 1945. As we may think. *Atlantic Monthly* 176 (July): 101–8.

Ceusters, Werner, ed. 1998. *Syntactic-semantic tagging of medical texts: the MULTI-TALE Project.* Studies in health technologies and informatics, vol. 47. Amsterdam: IOS Press.

Floridi, Luciano, ed. 2004. *The Blackwell guide to the philosophy of computing and information.* Malden, MA: Blackwell.

Ganascia, Jean-Gabriel. 2006. *Communication et connaissance: Supports et médiations à l'âge de l'information.* Paris: CNRS éditions.

Hayles, Katherine. 1999. *How we became posthuman: Virtual bodies in cybernetics, literature, and informatics.* Chicago: University Of Chicago Press.

Hockey, Susan M. 2000. *Electronic texts in the humanities: Principles and practice.* New York: Oxford University Press.

Landow, George. 2006. *Hypertext 3.0: Critical theory and new media in an era of globalization.* Baltimore: Johns Hopkins University Press.

Manovich. Lev. 2001. *The language of new media.* Cambridge, MA: MIT Press.

McKeon, Richard. 1952. A philosopher meditates on discovery. In *Moments of personal discovery,* ed. R. M. MacIver. New York: Institute for Religious and Social Studies

Morris, Adalaide, and Thomas Swiss. 2006. *New media poetics: Contexts, technotexts, and theories.* Cambridge, MA: MIT Press.

Morrison, Gunnar, Andrew Morrison, and Terje Rasmussen. 2003. *Digital media revisited: Theoretical and conceptual innovation in digital domains.* Cambridge, MA: MIT Press.

Nelson, Theodore H. 1974. *Computer lib/dream machines.* Self-published. 2nd ed., Redmond, WA: Tempus Books/Microsoft Press, 1987.

O'Gorman, Marcel. 2006. *E-Crit: Digital media, critical theory, and the humanities.* Toronto: University of Toronto Press.

Perloff, Marjorie. 1986. *The futurist moment: Avant-garde, avant guerre, and the language of rupture.* Chicago: University Of Chicago Press.

Popper, Frank. 2007. *From technological to virtual art*. Cambridge, MA: MIT Press.

Rodowick, David N. 2001. *Reading the figural, or, Philosophy after the new media*. Durham: Duke University Press.

Schreibman, Susan, Ray Siemens, and John Unsworth, eds. 2004. *A companion to digital humanities*. Malden, MA: Blackwell.

Snow, C. P. 1961. *The two cultures and the scientific revolution*. Cambridge: Cambridge University Press.

Wardrip-Fruin, Noah, and Nick Montfort. 2003. *The new media reader*. Cambridge, MA: MIT Press.

Research,
Sense, Structure

trust

LIU

allows human
users to access

◄　　FOSTER　　►

multiple
perspectives

STEFIK

How Computation Changes Research

IAN FOSTER

> Civilization advances by extending
> the number of important operations
> which we can perform without
> thinking about them.
> Alfred North Whitehead (1911)

> There was always more in the world
> than men could see, walked they ever
> so slowly. They will see it no better
> for going fast.
> John Ruskin (1857)

Advanced computation has already had a profound impact on the conceptualization and analysis of problems across a broad spectrum of intellectual activity. In the sciences, engineering, medicine, humanities, and arts, we can point to significant intellectual advances enabled by massed data (and its increasingly sophisticated analysis), numerical simulation (as an alternative or adjunct to experimentation in the study of complex processes), and rapid communication (which allows research results to be quickly pooled, potentially generating new insights). A common theme underlying these advances is an increased focus on understanding entire systems rather than individual components.

Disciplines in which computational approaches have already had a profound impact include astrophysics (modeling, for example, mechanisms for supernova explosions), climate (understanding global change), astronomy (digital sky surveys), and genetics (sequencing genomes). In essentially ev-

ery scholarly discipline—including those in which research is currently qualitative rather than quantitative—the future impact seems certain to be yet greater. For example, the scanning of entire libraries seems likely to transform scholarship in the humanities during the next decade.

My goal in this essay is to explore the ways in which computation has changed, and will continue to change, the nature of research. Using examples from many disciplines, I first examine how data, simulation, and communication are being applied in different contexts today. I then extrapolate from current practice to hypothesize the likely situation two decades from now. Clearly, a far greater quantity of data will then be available in digital and online form. Perhaps less obviously, new tools will allow for the large-scale automated analysis of that data and the aggregation and second-level analysis of evidence obtained via that primary analysis. I assert that the ultimate impact will be not just increased productivity for individual researchers, but a profound change in every aspect of the research process, from how data is obtained to how hypotheses are generated and results communicated.

Every field of research may be changed by computation in two distinct ways: first, computation enables broader access to both raw materials and research products, and second, computation enables new research approaches based on computer modeling, data analysis, and massive collaboration. In the case of the humanities, computation also has the potential to transform research in a third way, namely by changing how humans communicate, work, and play, and thus—to some extent—what it means to be human.

The Case of Astronomy

In the sixteenth century, the pioneering astronomer Tycho Brahe and his assistants spent many years—and a small fortune—cataloging the positions of 777 stars and the paths of the then-known planets with unprecedented accuracy (Thoren 1990). The data, initially held privately, took decades to become known to the (still small) community of astronomers. It was these data, obtained with measurement devices of Brahe's own design (but without the use of the telescope), that led his erstwhile assistant Johannes Kepler (who some claim murdered Brahe to get access to his data) to propose his revolutionary heliocentric theory of the solar system, in which all of the planets revolve around the sun.

Some four hundred years later, the Sloan Digital Sky Survey used auto-

mated digital photography to capture images of a hundred million stars in just a few years, producing a total of more than 10 terabytes (10 trillion bytes) of data (Szalay et al. 2000). To "observe" any (or all) of the stars captured by Sloan, one merely needs to access the Internet and request the corresponding data, which include position data, spectra, and raw images. In just a few years, Sloan data have been accessed by over a million people and have resulted in more than a thousand scientific publications, yielding new insights into the large-scale structure of the universe, among many other things.

Underpinning this story is a history of continual improvement in the technologies used to measure, record, compute, and communicate. Brahe was himself an outstanding technological innovator, developing instruments more accurate than any made before him, but his catalog relied on painstaking hands-on observations and complex manual computations. The Sloan and other similar sky surveys, by contrast, depend utterly on the power of silicon to collect data (via CCD cameras), store data, make computations using that data, and communicate that data to people worldwide.

The methods now available to astronomers allow research to be performed differently than in Tycho Brahe's time. They do not render scholars obsolete. Astronomy today is no less intellectually rewarding; it is just that different questions can be asked and different discoveries made. Interestingly, astronomy also remains a field in which amateur observers (albeit amateurs with reasonably sophisticated equipment) still make fundamental discoveries. Some believe that the next generation of digital surveys, such as the Large Synoptic Survey Telescope (which will generate 15 terabytes of data per night [LSST Corporation 2007]), will signal an end to an era. Time will tell.

The Role of Computation in Research Today

While astronomy makes an attractive poster child for computer-aided research, its concerns are arguably quite different from those of the humanist or the social, biological, or physical scientist who studies objects (books, people, ecosystems, matter) that are nearer to hand. Indeed, several factors combine to make astronomy, despite its cosmological scope, a particularly simple science from the perspectives of both information technology and sociology. The "heavenly sphere" forms a single field of study, and data collected from that sphere have no significant commercial value. Nevertheless, as we shall see, astronomy is far from being alone in embracing computational methods in research for a wide variety of purposes.

Access

For many, particularly in the humanities and social sciences, the most important role that computation plays in research is as an enabler of access. The digitization of texts, images, and other data (e.g., survey data, video, data from various sensors), and the delivery of that data via the web, can enable access by many more people than when the physical objects in question are stored in libraries, museums, or other, less accessible locations, or when the data in question can otherwise be obtained only via expensive or time-consuming experiments (or travel).

Yet the seductive power of the web as an enabler of access to enormous quantities of information can blind us to the limitations of current technologies. Vannevar Bush observed in 1945 that "our methods of transmitting and reviewing the results of research are generations old and by now are totally inadequate for their purposes." He was writing then of the scientific publications of his day, but his criticisms can also be applied to how we share information today, given the (considerable) extent to which they are modeled on the same methods.

For data to be truly accessible, it is not sufficient for it to be available in digital form. The data must be discoverable, it must be understandable to potential readers, and it must be accessible via the Internet. The Sloan survey satisfies all three requirements: its data are organized in a searchable database, with well-defined schema describing that organization and well-defined access protocols for searching the data and for retrieving subsets from remote locations. But each requirement can be nontrivial to achieve, particularly as the volume and diversity of data increase.

For example, NASA's EOSDIS system was created to store and enable access to the (then) massive quantities of data obtained by the space agency's earth-observing satellites (Asrar and Dozier 1994). For a long time, however, the only way to obtain data was to order a tape. When the requested data arrived, perhaps several weeks later, there was frequently a need to convert it into another format suitable for analysis. Months could thus be spent answering even relatively simple questions. In a significant sense, EOSDIS data was not accessible to its user community.

Similarly, much social science survey data is now accessible online but often only via parochial and hard-to-use web interfaces. If researchers want to combine data from several surveys, they must interact with multiple websites in turn to identify and download relevant data, then convert that data into

some equivalent format, and finally ask whatever questions they want to ask of the data. These tasks are tedious and not readily automated.

As this example shows, data sharing inevitably leads to a need for standards. In astronomy, for instance, the number of digital sky surveys is growing rapidly. To avoid the obstacles to access that would result from each using a different format and access protocol, the International Virtual Observatory Alliance (www.ivoa.net) was formed to standardize schema and protocols and create international data registries, so that astronomers can first locate data relevant to their research and then access and intercompare that data, regardless of its publisher.

Enhancing Perception

Information technology can also enhance our abilities to make sense of information, for example by allowing exploration via visual metaphors. By harnessing the tremendous information-processing power of the human visual system and brain, remarkable insights can be obtained, particularly when information is collated from different sources.

One technology that has had a major impact on human sensemaking is geographic information systems (GIS), which allow diverse data to be stored, searched, analyzed, and displayed in a geographical context—making it easier, for example, for researchers to detect patterns of disease, as John Snow famously did manually in his map of cholera cases in 1854 London (Johnson 2006). The importance of GIS is growing rapidly in many different disciplines.

Historical and cultural GIS (e.g., the Electronic Cultural Atlas Initiative [Zerneke, Buckland, and Carl 2006]) extend the GIS concept to allow for the exploration of data in time as well as space (Gregory, Kemp, and Mostern 2001; Gregory and Ell 2007) and for the registration of diverse cultural data, such as texts in different languages. Historical texts may, for example, refer to the same geographical locale by different names or to different places by the same name, while dates may be expressed using different calendars or relative to other historical events. By registering data from different sources in terms of a common geographical and temporal context, and providing tools that facilitate browsing and searching, we can facilitate the study of, say, the dissemination of culture over time and space, or relationships between accusations of witchcraft and land ownership in Salem (Ray 2002).

A second example is the social informatics data grid (SIDGrid) (Bertenthal et al. 2007), which aims to reduce barriers to the sharing and collaborative

analysis of experimental data in psychology. SIDGrid enables researchers to amass real-time multimodal behavior data at multiple time scales in a distributed data warehouse that supports storage, access, exploration, annotation, integration, analysis, and mining of individual and combined data sets. A graphical user interface allows human users to access data regardless of their geographic location. Programmatic interfaces allow users to write programs that implement useful functions, such as checking for new data.

As a third example, the Xiangtangshan Caves Project is using laser scanning, digital photography, and computerized image processing methods to create three-dimensional digital reconstructions of unique Buddhist cave temples in China (Carnig 2005). Not only is this work preserving unique cultural locations that are rapidly deteriorating due to air pollution, it is enabling scholars to reconstruct the appearance of the caves before the many statues that they once contained were removed by looters in the early twentieth century. The statues, located in collections around the world, are being scanned separately and will then be (re)placed in the virtual caves.

Automated Analysis

Advances in computing also enable entirely new research methods and tools. For example, once large quantities of digital data are accessible electronically, we can develop automated procedures that compare many data elements to characterize the typical or to identify the unusual, check periodically to see what is new, or search for data "similar" to that which we produce ourselves. Thus, astronomers can write programs that compare data from different sky surveys to identify objects visible in the infrared but not in the optical spectrum; such objects may be "brown dwarves," stars too small to shine via nuclear fission (Tsvetanov et al. 2000). Biologists can build systems that integrate new data from genomic and proteomic databases as it becomes available, accumulating information from many sources to guide their research (Sulakhe et al. 2005).

Such methods can also be applied to text. For example, we can analyze the link structure of the web to infer patterns (Barabási 2001) or to rank search responses according to the number of pages that link to them (Brin and Page 1998; Li 1998). With electronic access to manuscripts, we can analyze the development of genres over time (Moretti 2005) or attempt to identify automatically text genre (Kessler, Numberg, and Schütze 1997) or metaphor (Krishnakumaran and Zhu 2007; Birke and Sarkar 2006; Gedigian et al. 2006). These methods are unlikely to be a substitute for close human reading, but because

they can be applied to vastly more data, they can detect patterns that a human cannot, and because they are implemented as computer algorithms, results obtained by one researcher can be reproduced by another. Over time, we can expect such methods to be more broadly applied.

Similar methods have been applied to extract knowledge from the scientific literature (Rzhetsky et al. 2004), to track the evolution of scientific consensus, and even to estimate how many papers likely contain errors and thus should be retracted (Cokol et al. 2007).

The emergence of automated analysis methods has important implications for how we make data accessible online. In the early days of the web, people published data to make it available to other people. But web pages designed for human browsing may not be navigated easily by computer programs. "Web services" (Booth et al. 2003) seek to overcome this problem by defining conventions for describing the "services" that exist at a particular location to provide access to data or programs, and the messages that should be sent to and from that location to invoke those services. Thus, we can build distributed systems such as the US National Cancer Institute's Cancer Biomedical Informatics Grid (caBIG) (Oster et al. 2007), in which dozens of sites deploy services for locating, serving, and analyzing biomedical data. While data may be stored in different formats at different sites, the fact that all accept the same request formats means that users can easily construct "workflows" that, for example, extract data from two different databases, pass that data to an analysis procedure at a third location, and finally display the results on their screens.

Modeling and Simulation

Computers have long been used in the physical sciences (and, more recently, the biological sciences) to study the implications of theoretical models too complex for manual analysis and to study the behavior of systems for which physical experiments are prohibitively expensive or dangerous or simply impossible. Thanks to tremendous advances in both numerical techniques and computer power over the past six decades, it is now feasible to predict the performance of a new aircraft without building it, to forecast the weather several days into the future, and to estimate the degree of ground movement and structural damage expected in an earthquake (Jordan, Maechling, and SCEC/ CME Collaboration 2003).

Such computer models are tools not just for prediction but for understanding the behavior of complex systems. Researchers increasingly use com-

puter simulations to study the sensitivity of model results to initial conditions or to changes in parameter values, so as to obtain a better understanding of the robustness of their simulation results. Scientists also frequently use simulation to address system-level problems, to study not an individual organism but an entire ecosystem, not just ocean circulation but the behavior of the entire climate system (Foster and Kesselman 2006).

The state of the art with respect to modeling and simulation in the social sciences and humanities is less advanced, but pioneering studies show promise. In economics, computer models are used to study the implications of theoretical models of economic phenomena (Judd 1998). For example, computers have been used to study the behavior of a set of equations relating the production, consumption, and prices of various goods. The equations modeled can not only deal with the flow of goods between different sectors, but also with individual decisions to change employment or consumption patterns, based for example on availability of capital or the price of goods (Giné and Townsend 2004). By solving the equations over time, these models can also capture rational expectations for the future.

Agent-based models (Axelrod 1997; Epstein 2006) have become popular in many areas of the social sciences. In brief, these tools model the behavior of individual participants and their interactions, which occur according to defined rules. The researcher then observes the emergent behavior of a collection of such agents. Such methods have been used to model, for example, the development of the prehistoric Anasazi society in the US southwest (Dean et al. 2000), patterns of development in ancient Mesopotamia (Christiansen and Altaweel 2006), and language evolution (de Boer 2006).

Research in 2030

Let us now turn our eyes to the future and consider how research may evolve over the next twenty years.

Research is a process by which we human beings investigate, and obtain understanding of, our world. In pursuing this goal, we leverage the sophisticated array of sensors and information processing systems that is the human body. We also depend critically on a rich array of technological aids, from writing and pencils to computers and satellites, and on powerful social structures, from libraries and universities to limited liability companies and virtual organizations, to enhance these ultimately limited biological capabilities.

How will research be different in 2030? While our biology will probably

not have changed and society will have changed probably less than we expect, our technology will have developed tremendously and in ways that we cannot foresee.

It is common to describe technological progress in terms of exponentials, such as Moore's Law, which codifies Intel cofounder Gordon Moore's observation (1965) that the number of transistors per integrated circuit was doubling every two years. As a result, computer performance per unit price has improved at a roughly corresponding rate. Similar trends can be observed in computer storage (which by some calculations has advanced even more rapidly, doubling in capacity per fixed price every year) and computer networks (by some calculations, doubling in performance every nine months).

A Chinese proverb tells of a man who, being granted a reward by the emperor, asked to receive a single grain of rice on the first square of a chessboard, double that number on the second, and so on for all sixty-four squares. The amount of grain starts out small, but suddenly becomes significant (a bucketful, around square 18), then enormous (a roomful, around square 25), and eventually exhausts all available rice on the planet. This story illustrates two important properties of exponential growth: the rapid transition from the insignificant to the significant, and the abrupt cessation of growth if external limits are reached.

In computing, there are certainly physical limits to improvement, but they will not be encountered for a while. So it is the first property that concerns us here. Simply put, while the impact of computers, storage, and networks on both human society and the practice of research has already been tremendous, you ain't seen nothing yet. (We may recall the observation, credited to Roy Amara, that people generally "overestimate the short-term impact of change but underestimate the long-term impact.") The next twenty years will see further dramatic increases in performance, and these improvements will result in significant transitions in capability, as I now discuss.

Data

We will produce and store enormous quantities of data. By one estimate, humanity produced 161 exabytes (160 trillion bytes) of data in 2006 and will produce 988 exabytes per year by 2010 (Gantz et al. 2007). By 2030 these already hard-to-imagine quantities will be far higher still, including the vast majority of extant text but dominated by enormous quantities of image and video data. The International Data Corporation (IDC) estimates that in 2010, 500 billion digital images will be produced by more than a billion cameras—a quantity

dwarfed only by the amount of video data generated by camcorders and sensors for every conceivable purpose, from surveillance to scientific studies.

These numbers are not particularly relevant to research, given that much of this data will be inaccessible or unsuitable for scientific purposes. What is more significant is the rapid decline in the cost of data collection, storage, and analysis and the parallel increase in the quality of the instrumentation used for data collection. In essentially every field of science, we will surely see new the emergence of new research methodologies based around novel experimental programs. Environmental scientists will use an array of new instruments to study every cubic millimeter of an ecosystem, art critics will use functional magnetic resonance imaging (fMRI) to quantify responses to art, and physicians will use genomic and physiological data from large populations to understand genetic predisposition to disease.

One consequence of this exploding ability to capture data about anything, anywhere, anytime is that the question of what data to collect will become of vital importance. Sensors will become less passive collectors of data and more intelligent searchers after interesting events.

The ability to acquire massive amounts of data will have significant impacts on the disciplines thus affected. As the volume of data grows, so too does the effort and expertise required to acquire, curate, and analyze it. Not every scientist can or should become expert in each of these areas, and so specialization will become increasingly necessary.

Virtual Worlds

A virtual world is a computer-simulated environment with which a user can interact. It may correspond to some aspect of the real world (what Gelernter [1991] calls a "mirror world") or, more commonly, to an imaginary location. Virtual worlds are almost as old as computers but were long restricted to simple text-based games. Increasing computing and communications power, however, has led to the emergence of many Internet- and image-based systems, including both games (World of Warcraft) and more open-ended virtual worlds (Second Life). These systems have generated tremendous interest but are still limited in image quality, number of participants, and above all, the "intelligence" embedded in the objects with which participants interact.

Improvements in microprocessor performance, graphics rendering algorithms, virtual environment software, and network performance over the next several years will overcome these limitations to allow for the creation of photorealistic virtual worlds—worlds that are in some respects indistinguish-

able from reality. The implications for both society and research are likely to be substantial. Clearly, people find virtual worlds tremendously engaging, so we can assume that we will see increasing participation, not only for game playing but for purposes such as commerce and social interactions. William Gibson's vision of a highly abstracted mirror world used both for traversing vast quantities of data and for controlling the physical systems that sit behind that data may yet be realized:

> Cyberspace. A consensual hallucination experienced daily by billions of legitimate operators. . . . A graphic representation of data abstracted from banks of every computer in the human system. Unthinkable complexity. Lines of light ranged in the nonspace of the mind, clusters and constellations of data. (1984, 51)

For researchers, virtual worlds may indeed prove attractive as a means of interacting rapidly and intuitively with vast quantities of data. However, it remains to be seen whether and how this interaction will occur. Visual metaphors can be powerful but are notoriously hard to get right. Do we prefer to search by roaming virtual libraries or by clicking Google's "I'm feeling lucky" button? The answer to this question depends, presumably, on what we are searching for, but certainly the virtual world is not always the best approach.

Education may also emerge as an important driver for virtual worlds. In principle, virtual worlds can permit learning by doing in situations where actual doing would be too expensive or dangerous to be practical. Flight simulators are already used to train pilots, surgical simulators are used to train surgeons, and the military uses virtual worlds to train troops not just in combat but also in foreign languages and in how to interact with civilians. In addition, "animated pedagogical agents" (Johnson, Rickel, and Lester 2000) capable of interacting automatically with students may be able to deliver the inspirational power of the best teachers to anyone with a network connection.

The increasing use of virtual worlds creates remarkable new opportunities for social sciences research (Castronova 2005). In virtual worlds, all interactions are technologically mediated and thus can be captured and analyzed by a social scientist interested in, for example, the dynamics of group formation or knowledge transmission. A social scientist can even engage in controlled experiments, by establishing virtual personas that interact with human participants in specified ways. Needless to say, both observation and intervention raise challenging ethical issues.

Collaborative Analysis

Scholarly discussion of important data in the sciences and humanities is documented today via articles published in scholarly journals. But while such articles can refer directly to individual pieces of data ("in line 5 on page 26, Jones said . . ." or "data element 42 in the National Social Sciences Survey"), navigating such references is time-consuming.

The rise of the web and of associated technologies such as collaborative tagging allows for a closer form of collective analysis. In collaborative tagging, individuals associate "tags" (e.g., words or phrases) with images; in collaborative bookmarking, the tags are associated with web pages (Hammond et al. 2005). Tags created by an individual are immediately useful to that individual as a means of facilitating subsequent navigation and interpretation of the tagged data. If individuals share their tags with others (as is encouraged by collaborative tagging and bookmarking systems), they contribute to a collective set of tags that can provide yet greater value for the community. Like glosses in an old text, such tags can provide guidance and supplementary information to future readers. We can imagine the emergence of detailed "hyperglosses" that associate analyses, connections, opinions, and computational procedures with both data and other annotations. If created and maintained appropriately, such hyperglosses could be navigated conveniently by both humans and programs.

Computational Assistants

Internet pioneer J. C. R. Licklider advocated in 1960 the construction of computers capable of working symbiotically with humans to address problems not easily addressed by humans working alone. Fifty years later, we certainly have remarkable tools—search engines that can often find the documents we seek, spreadsheets that automatically update thousands of relations when we change a single cell—yet much research remains painstakingly, sometimes mind-numbingly slow. Part of the problem is the increase in the amount of information available to us. Licklider observed that (without computers) it could take him several hours to organize and plot four sets of pyschoacoustical data for purposes of comparison. Nowadays, it might take us several weeks *with computers* to obtain all relevant data, convert that data into compatible formats, and perform the desired analyses. Clearly, far more work is required before we can establish, as Licklider anticipated, a

> symbiotic partnership [in which] men will set the goals, formulate the hypotheses, determine the criteria, and perform the evaluations . . .

[while] computing machines will do the routinizable work that must be done to prepare the way for insights and decisions in technical and scientific thinking. (1960, 1)

The establishment of such a partnership is a worthy goal for computer science research over the next several decades (Foster 2007).

Massively Human Processing

Advances in communications can serve as a powerful democratizing force in research, making it possible, at least in principle, for anyone with a network connection and a hundred-dollar laptop to access any data, computational tool, or person on the planet. The implications for the individual can be remarkable. Yet more remarkable is the aggregate effect of these changes. As the blogosphere shows us, when everyone is an expert, the average quality of information may decline, but both the total amount of information and the aggregate accessible human information processing power increase tremendously.

Google shows us one way of exploiting this vast increase in available information. Its PageRank algorithm (Brin and Page 1998; Li 1998) applies the simple heuristic that web pages linked to by many other web pages are more likely to contain useful information. By taking this statistic into account when processing searches, Google harnesses the massively parallel and distributed effort of many web page authors, construing their links to other pages as tags indicating that those pages are "interesting."

Others seek to harness the efforts of many individuals more explicitly. A century ago, James Murray famously harnessed the efforts of thousands to collect examples of usage for the *Oxford English Dictionary* (Murray 1977). More recently, Wikipedia has harnessed the efforts of thousands to create an enormous encyclopedia. As an example of how human-created information can be used in novel ways, the Koru system uses Wikipedia thesauri to enable more accurate web searches, by relating terms used in a search to semantic categories (Milne, Witten, and Nichols 2007). The ESP game engages users in tagging images (van Ahn 2006), and the Galaxy Zoo project offers enthusiasts the opportunity to contribute to the classification of galaxies in digital sky surveys.

There must surely be yet other ways to harness the energy of the multitudes in new ways and to extract knowledge from the information that the multitude already generates. For example, rather than writing a program to

identify metaphors in Dickens, we might enlist ten thousand Dickens enthusiasts to tag books with suspected metaphors. Would these results be more useful or reliable than those obtained via a program? We need to experiment to find out.

Challenges for Computer Science and the Disciplines

The use of computing in research poses many challenges for both the computer scientist and the disciplinary scientist. I have mentioned some of these in the preceding discussion; here I introduce several more. This brief discussion cannot do justice to the question of how, in effect, *research changes computation*, but I hope at least to communicate why computer science research is so central to the future of disciplinary science.

Data Integrity

As digital data becomes increasingly central to society and research, so do concerns about its integrity. Digital data is particularly susceptible to modification—although data contained in traditional libraries is also not immune to tampering (Booth et al. 2003). Fortunately, there are well-understood methods for maintaining data integrity over extended periods. Digital signatures can be used to detect changes to data, and multiple institutions can cooperate to re-create damaged data (Maniatis et al. 2005). But of course such methods have to be used, and used correctly.

Digital signatures alone are not, however, sufficient to ensure data integrity: if a signature and the file to which it refers match, how can we be sure that they have not both been modified? The answer is that we need to get the signature from a trusted source. Thus, like all problems in computer security, data integrity is a systems problem (Anderson 2001). Much work is required to create systems that can robustly and efficiently deliver credible information concerning the provenance of digital objects.

Witten, Gori, and Numerico (2007) point to another, subtler danger: as the quantity of digital data grows, so does the gateway role of the intermediaries that people use to locate and access that data. For example, when 60 percent or more of all searches are performed via Google, information that is not, for one reason or another, returned by a Google search is not broadly visible. The integrity of the digital universe can be compromised by sins of omission as well as sins of commission. When data is plentiful rather than rare, we must be careful how we select and summarize.

Semantics

Data is only useful to the extent that we can both find it and make sense of it. Both tasks demand methods for assigning semantics to the data that we search for, discover, and access. By semantics, I mean information concerning its meaning, reliability, lifetime, provenance, and so on—whatever information is needed for the data to be useful to the person accessing it.

If a person accesses a single website, then that person will likely be able to obtain, via indirect means (code books, technical articles, personal communications, etc.) the information required to make use of its data. However, as the number of data sources increases, and to a lesser extent as the sheer quantity of data grows, the feasibility of performing these tasks manually decreases. We need other ways of associating semantic information with data: either a manual process performed by (some other) human or an automatic process performed by a program. These needs are especially urgent when it is programs rather than people that are processing data. Berners-Lee and Fischetti note:

> I have a dream for the Web [in which computers] become capable of analyzing all the data on the Web—the content, links, and transactions between people and computers. A 'Semantic Web', which should make this possible, has yet to emerge, but when it does, the day-to-day mechanisms of trade, bureaucracy and our daily lives will be handled by machines talking to machines. The 'intelligent agents' people have touted for ages will finally materialize. (1999, 169–70)

We encounter here a major source of unsolved problems in computer science. How do we represent data in ways that facilitate the association of meaning? How do we reason about such statements? Translate among different statements? Automate the synthesis of statements? Detect inconsistencies and ambiguities?

The grand goal of encoding information as universal and unambiguous semantic statements seems unlikely to be realized any time soon—after all, humans often do not understand each other, even when speaking the same language, and the world has few if any Platonic forms to which we can definitively tie our terms. (Contrary to some wishful thinking, simply adopting a particular syntax does not ensure comprehension.) But it is certainly possible to develop tools, such as ontologies and thesauri, that facilitate communication of meaning within specific domains and communities within which agreement about

semantics exists. The semantic web (Berners-Lee, Hendler, and Lassila 2001; Shadbolt, Hall, and Berners-Lee 2006) represents the latest attempt to provide such tools, but it is by no means clear that it will be successful.

Data Analysis

Rapidly increasing quantities of data mean that we must analyze that data automatically if we are to make sense of it all—or, to put things differently, that those who have access to effective automated analysis procedures will tend to have a competitive advantage over those who do not.

Yet effective automated analysis is not straightforward. The quantity of available data is increasing exponentially, outpacing improvements in the performance of computers. Moreover, most interesting data analyses involve the intercomparison of data elements. Thus, even the simplest analysis will require a length of time at least proportional to the square of the amount of data.

How to overcome this difficulty represents another substantial challenge for computer science. One promising set of approaches is algorithmic: we may, for example, cluster data and compare against representative samples or averages, or apply probabilistic approaches that compare randomly selected data elements. In either case, we have to accept that our results will be approximate, and we need theory to help understand the limits on what we can know. Here the concerns of computer science impinge upon those of philosophy (Shadbolt 2007).

Other relevant work in computer science focuses on the methods required to analyze, filter, and index data as it is produced and on methods that allow enormous quantities of data to be processed efficiently by harnessing the power of many computers (Dean and Ghemawat 2004; Zhao et al. 2007).

Systems Architecture

Other fundamental problems concern the nature of the computer systems that we will build to make sense of vast amounts of data, to enable large-scale collaboration, and to support massive simulation. As data volumes and the complexity of analysis and simulation codes increase, it will often be the case that no single researcher or institution can assemble the data, computational resources, and disciplinary expertise required to address the most challenging problems. Thus, we must be able to integrate large numbers of distributed resources efficiently, reliably, and securely. Grid technologies address these challenges by

defining methods for describing, locating, and accessing remote computing and storage resources (Foster 2003). Using service-oriented architecture principles, grid systems make it feasible to offload computational tasks to remote facilities and to partition computational tasks among many participants, each of which authors or operates services implementing specialized application functions (Foster 2005). These methods have been deployed in such systems as caBIG (Oster et al. 2007; see above), Open Science Grid (Pordes et al. 2007), and TeraGrid (Catlett et al. 2008), but significant research challenges remain. As the number of services increases, issues of service description, discovery, trust, composition, and provenance become increasingly problematic. For example, if different community members author independent services implementing different elements of a complex geophysical simulation, then in principle I should be able to mix and match different services to study a particular problem. But how do I know exactly what assumptions apply in each individual service and whether I can compose them safely? How do I document for others the methods that I used to obtain my results?

Another set of contemporary concerns relate to how we host services efficiently and reliably. Analysis costs can be reduced by sharing among many users. This, in essence, is why Google has data centers estimated to contain more than half a million servers—they share the enormous cost of computing the indexes used to respond to search requests among their tens of millions of users—or rather, among the advertisers who want to reach those users. The creation of such massive data centers introduces further technical challenges. Managing individual data centers containing tens of thousands of computers, and distributing data analysis computations among those computers, is difficult. Doing the same thing across many data centers is yet more difficult. Currently, companies such as Amazon, EMC, Google, IBM, and Microsoft are working to address these challenges, as are members of the academic distributed-computing community.

Data Access

In principle, electronic access to information is a democratizing force, enabling equal access for all to all knowledge. The great libraries of the world may espouse this ideal, but in practice they are accessible only to few. But electronic access may also be limited, and as a result can have the opposite effect, increasing rather than decreasing the gap between the information-rich and the information-poor. The privileged will then have quasi-instantaneous access, while the rest encounter obstacles.

One cause of restricted access is licensing costs. Only the largest libraries can afford subscriptions to all of the electronic publications desired by their staffs. Open access journals are a solution to this problem but introduce the problem of how publishers will pay for their production.

A second potential cause of restricted access is that larger and more sophisticated data sets may require specialized expertise and equipment. For example, while online access to the Sloan Digital Sky Survey has increased the availability of astronomy data, the amount of data produced by the Large Synoptic Survey Telescope may be so enormous that only specialists possessing large computer systems will be able to make effective use of it. Thus, we must create not only databases for public access, but also the computing facilities and software required to process the data they contain efficiently and effectively. The Open Science Grid (Pordes et al. 2007) and TeraGrid (Catlett et al. 2008) have been established with this goal in mind.

Incentives

The creation, curation, maintenance, and delivery of digital information are all expensive and time-consuming activities. We can reduce costs via automation, centralization to achieve economies of scale and the distribution of tasks to many participants, and information technology can help in each case. The associated problems of either compensating those who perform these functions or providing other incentives for them to perform those functions for free are ultimately economic and social. However, computer science and information technology can help, for example, by providing manipulation-resistant recommender systems to maintain reliable reputation measures (Resnick and Sami 2007).

Expertise

A final and particularly challenging consequence of computational methods is that they demand new skills. Unfortunately, education tends to move more slowly than technology: today's undergraduates tend to spend more time learning about nineteenth-century mathematics (algebra, calculus) than about twenty-first-century computing (data analysis, simulation), and graduate school curricula tend to emphasize disciplinary specialization rather than interdisciplinary collaboration. Thus, a key step toward broader use of computation in research will be a greater emphasis on computational methods in undergraduate and graduate curricula.

Summary

I have argued that computation is changing the nature of research in fundamental ways. These changes are driven by the availability of massive amounts of data; our ability to explore, analyze, and visualize that data in increasingly powerful ways; the ability to explore, via numerical simulation, the consequences of increasingly sophisticated models of physical, biological, and social systems; and the ability to link large numbers of people, databases, and computer systems via an increasingly powerful and ubiquitous Internet.

As a computing partisan, I cannot help but emphasize what I see as the positive outcomes that may accrue from an increased use of computing in research. Nonetheless, I have attempted to point out both obstacles that may hinder the realization of the benefits and potential negative outcomes that may result from increasingly digital scholarship.

Computational methods often serve to automate operations that previously required considerable time and thought. Thus, in the terms of Whitehead's epigram quoted at the start of this article, they "advance civilization" by freeing intellectual energy that we can then direct to other questions and problems. In so doing, they can change profoundly how people think about complex problems.

In other contexts, computation can consume rather than liberate intellectual energy, as when superficial questions that just happen to be amenable to computational approaches distract attention from more important problems. Just because we can write a program to analyze a thousand or a million or a billion instances of an object of study does not mean that we should—our time might be better spent in other pursuits. In the terms of the Ruskin epigraph, it may be that we "will see it no better for going fast." (He was speaking of the railroad, but the sentiment seems equally applicable in this setting.)

The impact of computation on research cannot be reduced to a simple formula. Certainly there are disciplines, such as biology and physics, in which computational methods have been transformative. Those studying climate change or the spread of epidemic disease or developing more efficient devices for energy storage and transmission have advanced civilization in ways that would not be possible without computational methods. Yet there are also fields in which computational methods, at least at present, have had little to add. The scholar of Old Norse literature, for example, will never have vast quantities of data. (But perhaps simulation studies of language evolution and cultural dissemination will ultimately help answer open questions even in that field.)

What seems clear is that when computational methods obtain traction, they have a profound impact on research methods and culture. Time previously spent on other activities must then be diverted to writing software, operating apparatus, and curating data. To ensure that these tasks are performed, participants in a discipline must individually and collectively obtain the resources required to employ information technologists or to provide their colleagues with incentives to specialize in such activities. Research typically becomes more collaborative. The nature of a publishable result, the training of graduate students, the criteria for tenure, and the allocation of resources within the discipline can all be affected.

Acknowledgments

This work was supported in part by the US Department of Energy under contract DE AC02-06CH11357.

References

Anderson, Ross. 2001. *Security engineering: A guide to building dependable distributed systems.* New York: Wiley.

Asrar, Ghassem, and Jeff Dozier. 1994. *EOS: Science strategy for the Earth Observing System.* Woodbury, NY: American Institute of Physics.

Axelrod, Robert. 1997. *The complexity of cooperation: Agent-based models of competition and collaboration.* Princeton, NJ: Princeton University Press.

Barabási, A.-L. 2001. The physics of the web. *Physics World* 14 (7): 33–38.

Berners-Lee, Tim, and Mark Fischetti. 1999. *Weaving the web: The original design and ultimate destiny of the World Wide Web by its inventor.* San Francisco: Harper.

Berners-Lee, Tim, James Hendler, and Ora Lassila. 2001. The semantic web. *Scientific American* 284 (May): 34–43.

Bertenthal, Bennett, Robert Grossman, David Hanley, Mark Hereld, Sarah Kenny, Gina-Anne Levow, Michael E. Papka, Stephen W. Porges, Kavithaa Rajavenkateshwaran, Rick Stevens, Thomas D. Uram, and Wenjun Wu. 2007. Social informatics data grid. e-Social Science 2007 conference, Ann Arbor, MI, October 7–9. http://www.ncess.ac.uk/events/conference/2007/papers/paper184.pdf.

Birke, Julia, and Anoop Sarkar. 2006. A clustering approach for the nearly unsupervised recognition of nonliteral language. 11th conference of the European Chapter of the Association for Computational Linguistics, Trento, Italy. http://www.aclweb.org/anthology/E/E06/E06-1042.pdf.

Booth, David, Hugo Haas, Francis McCabe, Eric Newcomer, Michael Champion, Chris Ferris, and David Orchard. 2003. Web services architecture. W3C Working Draft. http://www.w3.org/TR/2003/WD-ws-arch-20030808/.

Brin, Sergey, and Lawrence Page. 1998. The anatomy of a large-scale hypertextual web search engine. 7th International Conference on World Wide Web, Brisbane, Australia, April 14–18.

Bush, Vannevar. 1945. As we may think. *Atlantic Monthly* 176 (July): 101–8.

Carnig, Jennifer. 2005. Digital reconstruction could resurrect original vision of many ancient artists, craftsmen. *University of Chicago Chronicle* 24 (13). http://chronicle.uchicago.edu/050331/shrines.shtml.

Castronova, Edward. 2005. *Synthetic worlds: The business and culture of online games.* Chicago: University of Chicago Press.

Catlett, Charlie, William E. Allcock, Phil Andrews, Ruth Aydt, et al. 2008. Teragrid: Analysis of organization, system architecture, and middleware enabling new types of applications. In *High performance computing and grids in action*, ed. Lucio Grandinetti. Advances in Parallel Computing, vol. 16. Amsterdam: IOS Press.

Christiansen, John H., and Mark R. Altaweel. 2006. Understanding ancient societies: A new approach using agent-based holistic modeling. *Structure and Dynamics* 1 (2). http://www.escholarship.org/uc/item/33w3s07r.

Cokol, Murat, Ivan Iossifov, Raul Rodriguez-Esteban, and Andrey Rzhetsky. 2007. How many scientific papers should be retracted? *EMBO Reports* 8 (5): 422–23.

Dean, Jeffrey, and Sanjay Ghemawat. 2004. MapReduce: Simplified data processing on large clusters. 6th Symposium on Operating System Design and Implementation, San Francisco.

Dean, Jeffrey S., George J. Gumerman, Joshua M. Epstein, Robert Axtell, Alan C. Swedlund, Miles T. Parker, and Steven McCarroll. 2000. Understanding Anasazi culture change through agent-based modeling. In *Dynamics of human and primate societies: Agent-based modeling of social and spatial processes*, ed. Timothy A. Kohler and George J. Gumerman. New York: Oxford University Press.

de Boer, Bart. 2006. Computer modelling as a tool for understanding language evolution. In *Evolutionary epistemology, language, and culture: A non-adaptationist, systems theoretical approach*, ed. Nathalie Gontier, Jean Paul van Bendegem and Diederik Aerts. Netherlands: Springer.

Epstein, Joshua M. 2006. *Generative social science: Studies in agent-based computational modeling.* Princeton, NJ: Princeton University Press.

Foster, Ian. 2003. The grid: Computing without bounds. *Scientific American* 288 (April): 78–85.

———. 2005. Service-oriented science. *Science* 308 (5723): 814–17.

———. 2007. Man-machine symbiosis, 50 years on. In *High performance computing and grids in action*, ed. Lucio Grandinetti. Advances in Parallel Computing, vol. 16. Amsterdam: IOS Press.

Foster, Ian, and Carl Kesselman. 2006. Scaling system-level science: Scientific exploration and IT implications. *IEEE Computer* 39 (11): 31–39.

Gantz, John F., David Reinsel, Christopher Chute, Wolfgang Schlichting, John McArthur, Stephen Minton, Irida Xheneti, Anna Toncheva, and Alex Manfrediz. 2007. The expanding digital universe: A forecast of worldwide information growth through 2010. Framingham, MA: IDC. http://www.emc.com/collateral/analyst-reports/expanding-digital-idc-white-paper.pdf.

Gedigian, Matt, John Bryant, Srini Narayanan, and Branimir Ciric. 2006. Catching metaphors. 3rd Workshop on Scalable Natural Language Understanding, New York City.

Gelernter, David. 1991. *Mirror worlds, or, The day software puts the universe in a shoebox: How it will happen and what it will mean.* New York: Oxford University Press.

Gibson, William. 1984. *Neuromancer.* New York: Ace.

Giné, Xavier, and Robert M. Townsend. 2004. Evaluation of financial liberalization: A gen-

eral equilibrium model with constrained occupation choice. *Journal of Development Economics* 74 (2): 269–304.

Gregory, Ian, and Paul Ell. 2007. *Historical GIS: Technologies, methodologies, and scholarship.* New York: Cambridge University Press.

Gregory, Ian, Karen Kemp, and Ruth Mostern. 2001. Geographical information and historical research: Current progress and future directions. *History and Computing* 13 (1):7–23.

Hammond, Tony, Timo Hannay, Ben Lund, and Joanna Scott. 2005. Social bookmarking tools (I): A general review. *D-Lib Magazine* 11 (4). http://www.dlib.org/dlib/april05/hammond/04hammond.html.

Johnson, Steven Berlin. 2006. *The ghost map: The story of London's most terrifying epidemic—and how it changed science, cities, and the modern world.* New York: Riverhead.

Johnson, W. Lewis, Jeff W. Rickel, and James C. Lester. 2000. Animated pedagogical agents: Face-to-face interaction in interactive learning environments. *International Journal of Artificial Intelligence in Education* 11:47–78.

Jordan, T. H., P. Maechling, and SCEC/CME Collaboration. 2003. The SCEC community modeling environment: An information infrastructure for system-level earthquake science. *Seismological Research Letters* 74 (3): 324–28.

Judd, Kenneth L. 1998. *Numerical methods in economics.* Cambridge, MA: MIT Press.

Kessler, Brett, Geoffrey Numberg, and Hinrich Schütze. 1997. Automatic detection of text genre. *35th annual meeting of Association for Computational Linguistics,* Madrid, Spain. http://www.aclweb.org/anthology/P/P97/P97-1005.pdf.

Krishnakumaran, SaiSuresh, and Xiaojin Zhu. 2007. Hunting elusive metaphors using lexical resources. *Proceedings of the Workshop on Computational Approaches to Figurative Language* (Rochester, NY), 13–20. http://acl.ldc.upenn.edu/W/W07/W07-01.pdf#page=23.

Li, Yanhong. 1998. Toward a qualitative search engine. *IEEE Internet Computing* 2 (4):24–29.

Licklider, J. C. R. 1960. Man-computer symbiosis. *IRE Transactions on Human Factors in Electronics* HFE-1 (March): 4–11.

LSST [Large Synoptic Survey Telescope] Corporation. 2007. The LSST science requirements document. http://www.lsst.org/Science/docs/SRD.pdf.

Maniatis, Petros, Mema Roussopoulos, T. J. Giuli, David S. H. Rosenthal, and Mary Baker. 2005. The LOCKSS peer-to-peer digital preservation system. *ACM Transactions on Computer Systems* 23 (1): 2–50.

Milne, D., I. H. Witten, and D. M. Nichols. 2007. A knowledge-based search engine powered by Wikipedia. *Proceedings of the 16th ACM Conference on Information and Knowledge Management* (Lisbon, Portugal), 445–54.

Moore, Gordon. 1965. Cramming more components onto integrated circuits. *Electronics* 38 (8): 114–17.

Moretti, Franco. 2005. *Graphs, maps, trees: Abstract models for a literary history.* New York: Verso.

Murray, Katherine Maud Elisabeth. 1977. *Caught in the web of words: James A. H. Murray and the Oxford English Dictionary.* New Haven, CT: Yale University Press.

Oster, Scott, Stephen Langella, Shannon L. Hastings, David W. Ervin, Ravi Madduri, Tahsin M. Kurc, Frank Siebenlist, Peter A. Covitz, Krishnakant Shanbhag, Ian Foster, and Joel H. Saltz. 2007. caGrid 1.0: A grid enterprise architecture for cancer research. In *AMIA Annual Symposium Proceedings,* 573–77. http://www.ncbi.nlm.nih.gov/pmc/articles/PMC2655925/.

Pordes, Ruth, Don Petravick, Bill Kramer, Doug Olson, Miron Livny, Alain Roy, Paul Avery, Kent Blackburn, Torre Wenaus, Frank Würthwein, Ian Foster, Rob Gardner, Mike Wilde, Alan Blatecky, John McGee, and Rob Quick. 2007. The open science grid. *Journal of Physics*, conference series (Scientific Discovery through Advanced Computing [SciDAC] Conference). http://iopscience.iop.org/1742-6596/78/1/012057/pdf/jp-conf7_78_012057.pdf.

Ray, Benjamin C. 2002. Teaching the Salem witch trials. In *Past time, past place: GIS for history*, ed. Anne Kelly Knowles. Redlands, CA: ESRI Press.

Resnick, Paul, and Rahul Sami. 2007. The influence-limiter: Provably manipulation-resistant recommender systems. *Proceedings of the 2007 ACM Conference on Recommender Systems* (Minneapolis), 25–32.

Ruskin, John. 1857. *Modern painters*. Boston: Wiley & Halstead.

Rzhetsky, Andrey, Ivan Iossifov, Tomohiro Koike, Michael Krauthammer, Pauline Kra, Mitzi Morris, Hong Yu, Pablo Ariel Duboue, Wubin Weng, W. John Wilbur, Vasileios Hatzivassiloglou, and Carol Friedman. 2004. Geneways: A system for extracting, analyzing, visualizing, and integrating molecular pathway data. *Journal of Biomedical Informatics* 37:43–53.

Shadbolt, Nigel. 2007. Philosophical engineering. In *Words and intelligence II: Essays in honor of Yorick Wilks*, ed. Khurshid Ahmad, Christopher Brewster, and Mark Stevenson. Dordrecht: Springer.

Shadbolt, Nigel, Wendy Hall, and Tim Berners-Lee. 2006. The semantic web revisited. *IEEE Intelligent Systems* 21 (3): 96–101.

Sulakhe, Dinanath, Alex Rodriguez, Mark D'Souza, Michael Wilde, Veronika Nefedova, Ian Foster, and Natalia Maltsev. 2005. GNARE: An environment for grid-based high-throughput genome analysis. *Journal of Clinical Monitoring and Computing* 19 (4–5): 361–69.

Szalay, Alexander S., Peter Z. Kunszt, Ani Thakar, Jim Gray, Don Slutz, and Robert J. Brunner. 2000. Designing and mining multi-terabyte astronomy archives: The Sloan Digital Sky Survey. *SIGMOD Record* 29 (2):451–62.

Thoren, Victor E. 1990. *The lord of Uraniborg: A biography of Tycho Brahe*. Cambridge: Cambridge University Press.

Tsvetanov, Zlatan I., David A. Golimowski, Wei Zheng, T. R. Geballe, S. K. Leggett, Holland C. Ford, Arthur F. Davidsen, Alan Uomoto, Xiaohui Fan, G. R. Knapp, Michael A. Strauss, J. Brinkmann, D. Q. Lamb, Heidi Jo Newberg, Ron Rechenmacher, Donald P. Schneider, Donald G. York, Robert H. Lupton, Jeffrey R. Pier, James Annis, István Csabai, Robert B. Hindsley, Zeljko Ivesic, Jeffrey A. Munn, Aniruddha R. Thakar, and Patrick Waddell. 2000. The discovery of a second field methane brown dwarf from Sloan Digital Sky Survey commissioning data. *Astrophysical Journal* 531 (1): L61–65.

van Ahn, Luis. 2006. Games with a purpose. *IEEE Computer* (June): 96–98.

Whitehead, Alfred North. 1911. *Introduction to mathematics*. New York: H. Holt.

Witten, Ian H., Marco Gori, and Teresa Numerico. 2007. *Web dragons: Inside the myths of search engine technology*. Boston: Morgan Kaufmann.

Zerneke, Jeannette L., Michael K. Buckland, and Kim Carl. 2006. Temporally dynamic maps: The Electronic Cultural Atlas Initiative experience. *HUMAN IT* 8 (3):83–94.

Zhao, Yong, Mihael Hategan, Ben Clifford, Ian Foster, Gregor von Laszewski, Veronika Nefedova, Ioan Raicu, Tiberiu Stef-Praun, and Michael Wilde. 2007. Swift: Fast, reliable, loosely coupled parallel computation. In *1st IEEE International Workshop on Services*, 199–206.

We Digital Sensemakers

MARK STEFIK

> The creative challenge is not so much
> in gathering information as it is in
> asking the right questions.
> Joshua Lederberg

Sensemaking is the process by which we go about understanding the world. It is as natural as breathing and eating. Everyone does it. Sensemaking employs a raft of cognitive activities, including perceiving and interpreting sensory data, formulating and using information, and managing attention. It also employs social activities such as sharing, recommending, critiquing, and discussing. The promise of digital and social sensemaking is to radically improve our ability to make sense of information.

"Digital sensemaking" is sensemaking mediated by a digital information infrastructure, such as today's web and search engines. While the amount of information continues to expand rapidly, our innate human capabilities to make use of it are approximately fixed. Digital sensemaking counters the growth of information by harnessing ever faster computing. Web search engines have greatly improved our ability to find information. However, tools for sensemaking still fall far short of their potential. Sensemaking on the web is often frustrating and onerous, requiring one to wade through off-topic and poorly written pages of questionable authority.

Even professional sensemakers experience failure and frustration with current tools. Intelligence analysts are the jet pilots of sensemaking, addressing the most extreme professional challenges. Their work involves requesting and otherwise collecting an immense amount of information, sorting through it to identify relevant pieces, and constructing and maintaining an

understanding of international dynamics for tactical and strategic purposes. Yet they failed, for example, to anticipate the Yom Kippur War in 1973 or the collapse of the Soviet Union in 1991, and in the months before the 2003 invasion of Iraq reached the apparently false conclusion that that country possessed weapons of mass destruction. Despite much expense and many organizational reforms, the information gathered by the intelligence community extends far beyond its ability to make use of it.

Two themes guide our ongoing pursuit of quality and ease in sensemaking. The first is the challenge of finding not just the right answers but the right questions. The second is the recognition that there is more power in sensemaking when it is cast as a social activity than when it is seen as an individual pursuit.

Although digital sensemaking today is mostly a solitary activity, social-media approaches are now emerging that may radically change the experience of digital sensemaking. Social sensemaking will counter the proliferation of information sources of varying quality with the collective knowledge and judgment of people, helping us to combine our efforts to evaluate the quality and relevance of information, to develop shared understanding, and to put information to use.

1. Information and Attention

"A wealth of information creates a poverty of attention," Herb Simon once observed (1971, 40). Information and attention are the key resources that we manage in sensemaking. Publishers and professional sensemakers are acutely aware that far more information is available than any of us can consume. Our collective consumption of information can be described by a long-tail distribution.[1] How we consume information individually, however, is better understood in terms of "information diets." This term refers to the information that we consume across different categories, including topics in the news, professional interests, hobbies, and entertainment media. The categories are different for each person. An information diet can be represented as a list of subject areas with figures indicating how much of our time or attention is allocated to each. The total allocations add up to 100 percent of our available time.

Although popularity curves summarize our information consumption in the aggregate, they do not describe us as individuals. For example, the day's most widely consumed news stories may constitute only a minor share of my daily information diet. Except for some teenagers, there are relatively few

people who follow the dictates of popular taste so rigorously that their personal top story, favorite piece of music, and so on correspond to the collective favorites.

Information diets are different for each person. What we have in common is the frustration of clumsy sensemaking services. Current search tools and news services are optimized to serve the head of the long tail. Unfortunately, this information infrastructure, optimized to serve us in the aggregate, does not serve us very well as individuals.

2. Three Challenges for Digital Sensemaking

For our ongoing information needs, the challenge is to track new information that is relevant and important to us. New information becomes available from many different sources. Web search engines are not ideal for satisfying an information diet. They do not enable us easily to focus on a subject area or topic, and typing "What's new?" into a web search box does not yield a useful response. Web search engines generally make little note about whether content is fresh or stale. They favor old information. They prioritize search results using interpage linking structures to estimate authoritativeness and aggregate popularity. Consequently, a web page usually will not be ranked high enough to come into popular view until enough links are made to it, which is probably long after it was new. In contrast, mainstream news services focus on fresh and popular information. The information is organized into broad categories such as "business," "national," "international," "entertainment," and "sports." Such broad categories do not serve the specialized interests in our information diets.

Given limited time and an ongoing concern that they will miss something important, many experienced information consumers employ two kinds of tools that cover topical information from much farther down the tail: RSS feed readers, which allow them to subscribe to professional news feeds and blogs, and news alert services, which filter articles from thousands of sources based on search terms. There are now hundreds of thousands of such sites on the web. Both approaches provide levers for managing attention, balancing information overload against the risk of missing important information, yet neither provides enough help in sorting through the tide with an eye to quality and authority. Users of feed readers can control which sources they pay attention to. They scan titles of new articles on a regular basis, but articles on narrow topics still represent a small fraction of the information on broad feeds. Since even two or three feeds deliver more information than most peo-

ple have time to scan, they may miss articles that appear only in other feeds. Alert services have different leverage and different problems. If people use search terms that match a broad range of topics, they again face an overload of incidental matches and stories from dubious sources. If they narrow their terms, they risk missing important, related information. As with RSS feeds, people generally do not subscribe to more than two or three alerts.

This brings us to our first challenge for sensemaking and information foraging: developing better approaches for tracking new information on the core interests of our information diets.

Information just beyond the edges of our interests constitutes our "information frontiers." We may know people who are familiar with it, but it is over the horizon and beyond the reach of our personal radar. The frontiers in professional fields are topics from related and nearby fields. In community news they often include happenings in neighboring communities. Information frontiers in business and technology may reveal new developments that bring change and opportunity. Exploring frontier information helps in spotting new trends.

As a director at the Institute for the Future, Paul Saffo analyzes technology and business futures. In an interview about their forward-looking process he said:

> When you are mapping out technology horizons and making forecasts, you focus on opportunities at the intersections of fields. If you want to innovate, look for the edges. The fastest way to find an innovation is to make a connection across disciplines that everybody else has missed. (Stefik and Stefik 2004, 167–68)

Saffo's interest in the frontiers or edges of a field brings to mind Ronald Burt's ideas about structural holes in social structures (Burt 2004). People attend mainly to ideas circulating within their group. This leaves "holes" in the flow of information between groups. Burt's hypothesis is that new ideas emerge from *synthesis across groups*. People who are connected across groups become familiar with multiple ways of thinking and thus are better positioned to detect opportunities and synthesize ideas. In short, they have an advantage of vision and use it to broker ideas. Frontiers are challenging because the amount of information on our frontiers is larger than the body of information in our main focus and it is less familiar to us.[2] Consequently, we need more help in allocating some of our scarce attention to scan our information frontiers.

Our second challenge, then, is finding better approaches for gleaning information from beyond our information frontiers. We occasionally need to learn about topics that have not previously been of interest. We may, for example, be considering the purchase of a new kind of appliance. Or we may need to substitute for a coworker on leave whose specialty differs from our own. When a family member develops a health problem, learning about treatments and services may become a sudden, urgent priority.

This brings us to a third challenge for information foragers: coming up with better approaches to support *understanding* in an unfamiliar subject area.

In summary, the three challenges for digital sensemaking are information tracking (keeping up with core interests), information discovery (discovering information from our information frontiers), and information understanding (making sense of subject areas that are new to us). The rest of this chapter takes each of these challenges in turn, considering the nature of each challenge and the emerging technologies that can radically improve our experiences as digital sensemakers.

3. Tracking Information in Our Core Interests

In a typical information-tracking scenario, sensemakers have access to materials with information on their core topics. New materials, arriving from multiple sources, are not categorized by subtopic and may include information beyond our information diets. Levels of authoritativeness may vary. The challenge is to classify the new materials at fine grain by subtopic and to quantify one's degree of interest in order to prioritize articles and allocate attention.

An automatic approach for improving information tracking must address three key subproblems: developing a useful topical structure, organizing new information by topic, and presenting articles within each topic in an appropriate order. The following discussion is based on our ongoing experience with three generations of social-indexing systems that we have built.

3.1. Topics in Books

We begin with the familiar example of books—which often include tables of contents and back-of-the-book indexes. A table of contents affords an overview of the information presented in an order useful for reading. An index allows for piecemeal access to information, according to our immediate needs, based on an expert's articulation of the book's important topics. Both embody judgments about how people will use the information in the book.

TABLE 1. DENSITY OF INDEX ENTRIES IN SELECTED BOOKS

Book	# pages indexed	# index entries	Index entries per page	Words per page	Words in book	Words per index entry
Open Innovation (Chesbrough)	195	448	2.29	390	76,050	169
Crossing the Chasm (Moore)	215	560	2.60	429	92,235	165
Problem-Solving Methods in Artificial Intelligence (Nilsson)	240	640	2.67	429	102,960	160
The Tipping Point (Gladwell)	280	630	2.25	310	86,800	137
Biohazard (Alibek)	292	832	2.84	407	118,844	143
The Psychology of Human-Computer Interaction (Card, Moran, and Newell)	431	620	1.43	350	150,850	243
The World is Flat (Friedman)	469	1,400	2.98	420	196,980	140
The Dream Machine (Waldrop)	472	1,440	3.05	559	263,848	183
Peasants into Frenchmen (Weber)	569	1,870	3.28	516	293,604	157
Applied Cryptography (Schneier)	620	2,140	3.45	580	359,600	160
R&D for Industry (Graham and Pruitt)	623	1,890	3.03	369	229,887	122
Readings in Information Visualization (Card, Mackinlay, and Shneiderman)	640	2,448	3.8	700	448,000	183
Introduction to Knowledge Systems (Stefik)	775	1,544	1.99	500	387,500	250
The Notebooks of Leonardo Da Vinci (MacCurdy)	1,186	2,970	2.5	400	474,400	159

Table 1 presents data about index entries from a set of books selected from my work office one afternoon. Some were academic and discursive, some were technical, and others were popular business books. The counts of words and index entries per page were determined by averaging over several sampled pages. The number of words per page (from 400 to 700) varied according to several factors, including the size of the page and of the type and the abundance of figures, tables, code, and headings. Index entries were counted at all levels. The number of entries ranged from about 2 to 3.5 per page or, taking into account variations in the number of words per page, one for roughly every 166 words. Although some index entries cite only a single page, most refer the reader to several pages, the average being about four. These data sug-

gest that indexers tend to tag content for indexing about every 40 words. This is about one or two tags per short paragraph. The data also show that each page in a book is cited in connection with eight to twelve topics. The index thus provides a relatively fine-grain tool for searching a book by "topic."[3]

3.2. Problems with Automatic Indexes

Various approaches to automatic indexing have previously received research attention, especially indexes based on concordances. A concordance is an alphabetized list of the words and phrases in a document together with their immediate contexts. Concordances can be compiled automatically, sometimes using linguistic techniques for phrase selection and normalization.

For purposes of information tracking, however, concordances fall short because their articulation of subtopics is not informed by domain expertise or historical experience. Unable to distinguish between the important and the trivial, they fail to identify and carve material along useful ontological and topical "joints."

3.3. Generating Topic Models

Although a book index is a good starting point, one inherent limitation is that it is static. It is prepared when a book is created and is frozen in time. This is fine for books but insufficient for dynamic information from online sources. What is needed is an automatic approach to extend topical indexing to new material.

We have developed an approach to this problem called *index extrapolation*. Index extrapolation starts with example pages for each topic, provided by human curators. The topics and their example pages are used as training information to bootstrap an evergreen index. Our machine-learning approach develops topic models and extends the index as new material is collected, as explained briefly in the sections that follow.

3.3.1. FINE-GRAINED TOPIC MODELS.

Our approach to index extrapolation uses a hierarchical generate-and-test algorithm (Stefik 1995, 173). For each fine-grained topic, the index-extrapolation program analyzes the corresponding training pages and selects a set of "seed" words whose frequencies in the example pages are substantially higher than in a baseline set of pages sampled from many sources. Other words may be included as seeds when they are part of the topic's label or occur near a label word in the cited text.

The program then begins a systematic, combinatorial process to gener-

ate optimal queries, similar to the queries people use with web-based search engines. In index extrapolation, the optimal query candidates are expressions in a finite-state pattern language. The queries express subtopic recognition constraints in terms of four kinds of predicates: conjunctions, disjunctions, sequences, and ngrams (sequences of consecutive words). For example, a query might require that a particular seed word appear together with a particular three-word ngram or two words in a nonconsecutive sequence. Tens or hundreds of thousands of candidate queries are generated and matched against the training examples.[4] Candidate queries are rated according to whether they match the "on-topic" positive training examples and miss the "off-topic" negative training examples. A candidate query performs perfectly when it matches all of the positive examples and none of the negative examples. To choose a top query candidate when multiple candidates exhibit perfect performance, the evaluator also considers structural complexity and term overlap with the index label.[5]

The result of the machine-learning phase is an optimal query generated for every subtopic in the index. For example, in an early test of the approach using a book by a defector from the Soviet intelligence community, the book's index entry for the subtopic "Black Death" cited three pages among the several hundred pages in the book. Eighteen seed words were automatically selected, including "plague," "pesti," "yersinia," and "pandemic." About a thousand candidate queries were automatically generated and reported using the seed words. One candidate query required that a page include the word "plague," any word identified in a library as meaning "warfare," and either the word "bubonic" or the ngram "black death." Another required that a page include the word "plague," either the word "pandemic" or "rare," and either the word "yersinia" or "bubonic." The top-rated query, which required that a page contain either the word "bubonic" or the ngram "black death," was a perfect predictor on the training set without any false positives or false negatives, had some word overlap with the subtopic's index label, and had low structural complexity. Running over the entire book, the machine-learning program generated sharp patterns for each of the thousand or so subtopics in the index.

A more familiar example is the topic "housing crisis," which figured in an index about the "US Presidential Election 2008." Depending on the training examples, the optimal query computed by the system includes references to mortgages, housing, foreclosures, and bad loans. Our current social-indexing prototype has over two hundred indexes with several thousand topics.

3.3.2. COARSE-GRAINED TOPIC MODELS. Optimal queries are capable of identifying patterns of words that occur in the short paragraphs that cover the fine-grained topics we identified in book indexes. But books present information without much distraction. Web pages, by contrast, also contain words from advertisements, related articles, reader comments, and publisher notices. From the perspective of topic analysis, such additional material amounts to "noise" added to the information signal. The optimal query for finding fine-grained information across many web pages is vulnerable to being misled by this noise.

To cope with noisy information, we have found it useful to incorporate a

FIGURE 1. A social index about sustainable living. A tree of topics is shown on the left.

second, coarse-grained topic model that is less focused on small paragraphs. Again using the positive training examples, we compute a profile of the frequencies of the characteristic words for each topic. This word-population profile characterizes the kinds of words that are typically used in an article on a topic. Methods from information retrieval, such as cosine comparisons, can be used to compute a "distance" between two information sources based on their word usage.

These two topic models have opposite characteristics that make them powerful in combination. The optimal queries are capable of identifying fine-grained topics but are vulnerable to noise on a page. The word-population models are less precise with regard to topic identification, but are much less sensitive to noise. A web page about a sports story that has advertisements or a few story links related to the housing crisis will be reliably rejected by the word-population model for housing crisis.

Figure 1 shows an example of a social index about sustainable living. The topics used to organize the subject matter are shown in an alphabetical tree of topics on the left. The index curator has given a few training examples for each of the topics in the tree, and the system computed an optimal query for each topic. The system automatically organizes collected articles by topic.

3.4. Keeping an Index Evergreen

The index-extrapolation approach keeps an index open to new, arriving information. New pages are classified by subtopic by matching them against the queries. When a new page matches a query, it is registered as containing information on the corresponding subtopic. This approach is similar to information retrieval systems that use standing queries to retrieve new information. Index extrapolation differs from standing query systems in that the queries are generated automatically by machine learning rather than manually and that the topics are organized in a hierarchical topical index.

As a corpus grows, new pages may show up that should be included under a topic but are not matched by the query. When such pages are identified by a human curator or a voting process, they are logged as new, positive training examples.[6] When other new pages that are matched to a subtopic are judged as inappropriate for it, they are logged as new, negative training examples. Given such updates to the training sets, the machine-learning algorithm can be run again to revise the patterns. This tuning automatically improves the quality of the index going forward.

3.5. Determining Degree of Interest

Index-extrapolation technology addresses the first subproblem of the information discovery challenge: maintaining an evergreen index. We now turn to the second subproblem: determining a degree of interest for each information item. The degree of interest is used to rate and rank the articles or pages on a given topic, and to govern the display of the index information in a user interface. Compared to traditional media, social media offer fresh approaches to addressing the rating problem. Social media are distinguished from traditional media in their emphasis on social networks and their use of human feedback as a source of processing power.

3.5.1. RATING INFORMATION SOCIALLY. Digg pioneered a social-media approach to rating and ranking news stories based on the idea that people are the best judges of what news is important. Digg enables people to submit stories from the web or from news services and to vote on them. It also engages a social network of its readers. Members can subscribe to the stories that a friend or thought leader "diggs." The system maintains a list of current stories prioritized by their votes. As a story gets positive votes it rises on the list. If it gets negative votes, it drops down the list. To make the list responsive to recency, votes and article placement are adjusted for age so that older stories automatically drop and disappear. This approach to ranking stories initiates a positive feedback loop. As a story gets more votes, it rises in the list. As it rises in the list, it is more easily noticed. As it is more easily noticed, it can more easily attract votes. If a story gets onto the Digg front page, there is often a spike in the number of people noticing it. If a thought leader diggs a story, followers of the thought leader may also digg it, causing its rating to shoot upward. This kind of unregulated positive feedback has the potential for misuse and manipulation.

A warning about the workings of Digg's simple democratic voting system was sounded in 2006 when blogger Niall Kennedy noticed that many of the articles on Digg's front page were submitted by the same small group of Digg users voting for each other's stories. His analysis triggered a flurry of articles in various technology-oriented publications about the reliability of voting in social media. In 2007 there were multiple reports that cliques among Digg users were gaming the system in order to get articles on to the front page. A Cnet report, "The Big Digg Rig" by Elinor Mills, posted on December 4, 2006, described how some marketers were planting stories and paying people to promote them on Digg and other social-media sites. In response to this report,

Digg has modified the algorithms it uses to report, weigh, and count votes. Before considering methods for coping with voting problems, it is useful to look at some other issues relating to information tracking. Some typical criticisms of Digg are that it is too focused on technology topics and that articles on different topics are incoherently mixed together. There is an inherent challenge in satisfying multiple perspectives when a story is controversial or polarizing. If diverse communities used Digg, there could be a sustained tug-of-war over a controversial article; votes against would cancel the votes for, and the article would not rise in the popularity ranking.[7]

What kinds of articles appear on Digg? The category mix is indeed weighted toward technology. Even as the 2008 US presidential election was approaching, there were no Digg categories for politics or religion. At the time this was written, Digg had forty-nine classifications for articles, sorted under several general categories: Technology, Science, World & Business, Entertainment, Gaming, and Videos. Articles have just one classification, and it is established manually by the person submitting it. On the day I wrote this, the Digg front page had fifteen articles. Eight were about the technology industry, including one about Digg and several about the web. Three were about games. Two were about humorous online videos. Motor sports and international news had one article each. The list of top articles over the previous thirty days was a similar mixture, with mostly technology articles, including two about the iPhone. There was one article about a strange police arrest, and the rest were about videos. Religion and politics were not represented. Certain topics from down the tail are heavily covered (the network, operating systems, video games), presumably because they are important to the Digg community. Even in a specialized topic area such as World & Business, the articles are far from the mainstream, heavy on sensational stories and technology. This coverage suggests that the Digg community consists mainly of people under about twenty-two years of age who are deeply interested in computers, videos, and games. The particular topical focus of the Digg community is not bad, per se. It represents the votes of a self-selected population with similar interests.

In summary, current systems for rating news socially suffer from several problems. The dominance of cliques in promoting articles is a case of the tyranny of the minority. The suppression of controversial topics by vote canceling is a variant of the tyranny of the majority. Neither form of tyranny in voting is optimal for supporting information discovery across a community of diverse interests and values. This suggests that there is a flaw in the design assumption that populations are best served by aggregating all votes into a

single pool. What seems to be needed is an approach where users with different views are organized into multiple interest groups, each having fairly homogenous interests and values.

3.5.2. AUGMENTED INFORMATION COMMUNITIES.

Organizing users into communities would make it possible for small groups and communities to explore their topics of interest and thus address the tyranny of the majority issue.[8] Each community would have its own index, covering topics in its subject area. Within a subject area, communities could pursue their particular segments of the long tail, rating materials according to their own values. In a technical subject area, professional groups might focus on advanced materials and amateur groups on introductory ones.

Most users would belong to multiple communities, corresponding to the core topics in their personal information diets. For example, a user might belong to one or more communities concerned with professional topics, a sports community related to a local team, a news community reflecting his or her political interests, a hobby-related community, and so on. Different communities could cover similar topics. For example, there might be "red," "blue," and "green" political communities, offering news and perspectives with, respectively, Republican, Democratic, and environmental slants. The placement and space allocated to displaying articles can also be governed by the community's voting practices.

While it may be useful to divide a population into communities of interest, it is also worthwhile to provide transparency across communities interested in related topics. Communities isolated from other worldviews risk becoming self-absorbed. A community whose interests or ratings became narrow and self-serving would probably fail to attract new members or much external attention. By enabling members of one community to see the topics and discussions of other communities, a discovery system can have a broadening influence.

3.5.3. STARTING A COMMUNITY INDEX.

Dividing a population into communities introduces several interrelated issues. How do users join communities? How do they gain influence in them? How can a vote-based ranking system support discovery with rapid response to new information without being subject to the tyranny of cliques? How do communities keep from becoming too self-focused and narrow?

An online community may begin when a founding individual decides

to pursue some interest by starting a private index.[9] Acting as curator, the founder defines an initial set of online sources, such as new feeds, websites, or an online corpus. The index is bootstrapped either by starting with an index from another community or by starting from scratch, specifying subtopics and example articles. The index-extrapolation system automatically creates queries for each subtopic and finds further articles on them. At some point, the founder publicizes the index and opens up participation to like-minded individuals. As a community grows, members may be admitted at different levels. For example, an initial set of experts could be identified, with these "expert members" defined as thought leaders in the community. Experts' votes would have more influence in ranking articles than those of regular community members, and they could take on larger roles in maintaining the structure of the index by occasionally creating and editing topics. New members could gain expert status on the basis of social actions—referral, voting, recommendations, and so on.

Another category of users might be "harbingers." A harbinger is a community member who tends to be early, accurate, and prolific in identifying articles that the community ultimately ranks highly. Whereas experts might be appointed or elected, harbingers could be discovered automatically by tracking their submissions and votes over time. As their standing as accurate predictors of a community's interests and values is qualified, their votes could be given more weight than those of regular members. (Nonmember visitors could also use the index and read the recommended information but would have no say in rating articles.) If harbingers or experts were to have a streak of voting that was out of alignment with the community, their influence could automatically be decreased.[10] Having expert or harbinger status in one community would not give one similar status in a separate community.

3.6. The Few, the Many, and the Machines

This approach to the information-tracking challenge relies on three sources of power. The first is the hard work of the few, the experts who use their knowledge to curate and maintain a topical index. The second is the light work of the many, the people who identify and vote on disputed citations, influencing the training sets for tuning the patterns. The third is the tireless work of the machines—the index-extrapolation algorithms that automatically match the optimal queries against new pages to keep the index evergreen, the data-aggregation algorithms that combine the votes of the many to update the training sets, and the machine-learning algorithms that systematically cre-

ate topic models. Tireless by nature, computers can be massively deployed to meet the scale of the information and usage. These three sources of power are synergistic and fundamental to the design of social media.

4. Discovery on Our Information Frontiers

Discovery refers to finding materials on one's information frontiers, that is, in nearby subject areas. It is tempting to ignore the frontier. There is, as I have mentioned, more information there than in one's central field, and it is typically less important than that pertaining to core topics. Furthermore, the level of expertise of a sensemaker is lower at the frontier, with regard both to identifying good sources and to understanding topic structure. But there is a risk in not looking beyond one's core subject. Material that starts out on the frontier may become central as a field evolves, and early awareness of emerging trends can save the major expense of late remedies. Frontiers are resources for people interested in spotting trends arising at a field's edges.

As with information tracking, the value of discovery is better attention management. There are again three subproblems. The first is to identify frontier communities and their information. The second is to determine a degree of interest for ranking articles. The third is to relate frontier information to home topics.

4.1. Identifying Information Frontiers

In addressing information frontiers, we find it useful to focus on augmented communities as a level of structure and analysis for social networks. At the fine-grain level of individuals, a social network expresses relationships among people with common interests. At a coarser granularity, it expresses relationships among augmented communities that are interested in related subject areas.

Returning to Burt's analysis of communities and structural holes, each augmented community is intended to serve a fairly homogenous social group, in which members focus their attention on its core topics. Neighboring communities represent other fields or other groups. The technology for discovering information in a frontier is intended to provide a "vision advantage" that can be used for synthesizing new ideas and spotting trends.

When, in our model, the leaders of one community want to be made aware of relevant articles that another community finds interesting, they can designate it as a frontier neighbor. In a simple approach, candidates for neighbors might be found manually by searching a directory of communities. In

a more sophisticated approach, the multicommunity indexing system could suggest candidate neighbors using similarity measures that detect an overlap of interesting sources and articles between pairs of communities.

As a hypothetical example, a social index for topics related to "Music by Enya" might have as a neighbor a social index for topics related to "Music by Clannad," Clannad being a Celtic musical group that includes Enya's sister and other relatives. These indexes might connect to other social indexes on "Celtic Music" or "Irish Folk Music." For a geographic example,[11] suppose that there is a social index for the city of Palo Alto, California, where I work. Palo Alto's geographic neighbors include the cities of Mountain View, Los Altos, Menlo Park, and East Palo Alto, as well as Stanford University. For a medical example, a community interested in traditional Chinese medicine might focus on acupuncture and herbology. That community would be distinct from the myriad of "New Age" medical approaches in the West, although it might choose to designate such communities or one concerned with Ayurvedic (Indian) medicine as frontier neighbors. Networks of augmented communities could also be formed for sports, scientific studies, medicine and health subjects, religious subjects, and so on.

Reifying connections at the community grain creates a basis for tracking frontier topics and fostering cross-community information flows. Figure 2 portrays how an information community is located in a social network of other augmented communities, defining its information frontier. Overall, the social medium supports a galaxy of constellations of interlinked information communities.

Links to other perspectives can also be identified without requiring a curator to explicitly identify neighbors. By way of example, figure 3 shows a "front news page" that was computed on our prototype social-indexing system. The story about the swine flu was picked up in the "USA" index and organized under "Health and Safety/diseases/flu." Beneath the story are links to related topics that were identified automatically by the system. This calculation makes a second use of the word-population models discussed earlier. As the set of indexes and topics grows, the social-indexing system can compare the models for topics across all of the indexes. This makes it possible to identify cases where topics in different indexes are covering similar kinds of stories, albeit using different sources or with different user commentary. In this example, the system identified an index with a science perspective on the flu and also an index focused on China covering articles on the bird flu.

In summary, each augmented information community has its own index,

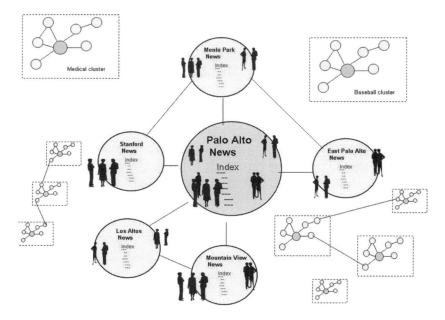

FIGURE 2. Each augmented community has its own information sources and social index and exists in a social network of augmented communities. The neighbors of a community provide a basis for computing its information frontier.

its own members, its own information sources, and its own ratings. Relationships between communities can be explicitly noted or automatically detected. The information resources from neighboring communities then become potential sources for discovering frontier information.

4.2. Rating Frontier Information

This brings us to the second subproblem for information prospecting. Given an information frontier, how can information be selected from the frontier and rated for interest? A useful starting point is the arrival of new information from the frontier communities. We propose using a degree-of-interest function that considers the level of interest an article generates in the frontier community, a distance metric quantifying the separation of the frontier community from the home community (such as the number of degrees of separation within the social network), and an indication of whether the article matches the topics in the home index.[12]

The neighboring community's sources and ranking systems thus provide for a first pass at identifying articles and a preliminary estimate of the degree-

FIGURE 3. A news page in a social-indexing system. The top story is from the USA index, organized under "diseases" and "flu." Related topics below the story show perspectives on similar stories from related indexes.

of-interest. Articles from neighboring communities can be assigned initial ratings (perhaps dependent on topics) reflecting the home community's ratings of earlier articles. These ratings can then be adjusted by voting and viewing response within the home community.

4.3. Relating Frontier Information

The third subproblem is to relate the frontier articles to home topics. Few articles from the frontier will be of universal interest in a home community. One approach is to automatically classify articles by the subtopics that they

match in the home index. In this way, articles can be routed to members of the home community according to their core topics of interest. In one approach, articles from the frontier get ranked and appear in topical indexes along with other articles from the home community's regular sources. As members of the community read articles on their core topics, highly rated frontier articles classified as being on the same topic compete for some of the display space.

In summary, the computational quality of social indexes provides new leverage for tracking frontier information for a community. The home community can rely on the expertise of its frontier communities to source and initially rate articles, and use its native index of topics to organize their presentation.

5. Supporting Understanding in New Subject Areas

Our third sensemaking and information-foraging challenge is understanding and orienting ourselves to information that is outside our usual personal information diets. Orientation refers to a process of getting familiar with a subject area, say, by learning about its topical structure, main results, and best references in order to answer questions important to the sensemaker.[13] The understanding and orientation challenge arises whenever we need to learn about something completely new.

This challenge relates to an old chestnut about struggles with information retrieval systems. How do we get the right answers if we don't know what questions to ask? How do we know what to ask for in retrieving information if we don't know what information is out there? How can we tell the difference between good and bad sources of information?

To explore the nature of this challenge, we consider again the fundamental properties of a good social index. An index provides a layered organization of topics. A good index embodies expert judgments about how people in the community understand the information. Index topics are somewhat like the "important questions" of a subject area. The structure of topics describes how people have found it useful to organize that area. The cited and ranked articles under each subtopic reflect a community's judgments about the best sources and approved answers for each subtopic. An index itself can be designed with some overview subtopics that serve specifically for orientation. Following this line of thought, *the challenge of orientation is largely addressed by providing a sensemaker with a good index.* Figure 1 shows a topical index related to sustainable living. Using it, a person new to the subject area can explore topics on sustainable agriculture, clothing, energy,

FIGURE 4. Finding relevant indexes. A search for "hybrid cars" returns a list of related indexes—ranging from indexes dedicated to the topic to indexes for particular manufacturers (with subtopics on their hybrid models) to indexes focusing on the technology of hybrid cars.

social policies, and so on. In short, the index itself is a guide to questions and answers about sustainable living.

Suppose that a person does not know which index to use to get started. Figure 4 shows how our current prototype helps one identify a suitable index. In this case, the person wants to find out about hybrid cars and enters a search query into the system. The system presents two sets of results—a list of indexes and their matching topics, and a selection of matching articles. The system shows indexes for hybrid cars, Lexus cars, electric cars, and others. For each index, it gives the best matching topics and a sample article. The top

index, "Hybrid Cars," is all about hybrid cars and has topics organized by man-ufacturer and model. The index "Lexus Cars" is about Lexus cars in general; its closest matching topics cover the Lexus hybrid models. The "Electric Cars" index is focused on electric cars. Among five other indexes relevant to hybrid cars are ones that cover their technology. By exploring the topics in indexes, users can identify indexes that most closely match their interests.

6. Sensemaking: Digital and Social

This chapter has introduced social indexing as a new form of social media. Social indexes address three sensemaking challenges: tracking core topics in our information diets, discovering information in frontier topics, and orient-ing ourselves to understand information in new subject areas. Social indexing remakes conventional indexes as *computational, trainable, social, and intercon-nected*. This approach follows the trajectory of emerging technologies for so-cial media. It leverages the activities and knowledge of information commu-nities, helping sensemakers to find both answers and the "right questions."

Acknowledgments

Thanks to my colleagues Eric Bier, Dorrit Billman, Dan Bobrow, Stuart Card, Ed Chi, Jeffrey Cooper, Markus Fromherz, Randy Gobbel, Lichan Hong, Bill Jans-sen, Joshua Lederberg, Lawrence Lee, Peter Pirolli, and Leila Takayama for their very helpful comments on this chapter. Special thanks to the Kiffets social-indexing team—Lance Good, Sanjay Mittal, Priti Mittal, Barbara Stefik, and Ryan Viglizzo—who have joined me in developing the social-indexing vision and making it a vibrant web-based reality. Thanks to PARC management for its support for a new venture during a difficult economic period.

Notes

1. In long-tail distributions the most popular information and media represent the head of the curve; consumption of items in this region dwarfs that of items farther down the tail (Anderson 2006, 1). Most of us, that is, consume the few items at the head, while our selections farther down the tail are more idiosyncratic.

2. Imagine a circle representing a central topic of interest surrounded with other topic circles of equal size. The combined area of these immediate frontier neighbors is six times the area of the central circle.

3. Larger granularities of topic are represented by books' organization into parts, chapters, and sections. My sampling revealed regularities here as well. The number of

chapters varied with the overall length of the book and the complexity of the subject matter. Where there were many chapters, they were often grouped into larger parts. Conversely, chapters were divided into sections and sometimes subsections. The number of hierarchical levels tended to increase with the length of the book, with a transition from two levels to three levels at around 500 pages, or 150,000 words.

4. For efficiency, our query generator employs best-first, anytime algorithms that attempt to visit the most likely parts of the search space first, and manage time and storage-space budgets to focus the search. Branches of the search process are pruned early if it can be determined that they cannot possibly yield candidates that will score better than queries that have already been generated. Because many candidates are eliminated after only a partial generation and partial evaluation, the reported candidates represent only the tip of the iceberg of the queries considered by the generator.

5. The structural complexity of a query is a measure that increases as a query becomes more elaborate, with more predicates, terms, and levels. By favoring low-complexity candidates the program follows the philosophy of Occam's razor, choosing the simplest queries that explain the data. Considerations of structural complexity are also helpful to avoid overfitting in the machine-learning process, especially when the training data are sparse.

6. Topic drift is a phenomenon that arises as news evolves. For example, one of our indexes about golf had a topic about Tiger Woods. It was originally trained on articles written when he was recuperating from a knee injury. Later, when he returned to competition, the query failed to pick up some new stories. Some additional training examples were provided, causing the system to adjust its topic models to accommodate the new stories.

7. In Wikipedia controversial stories are flagged and can be an interesting barometer of active debates. It may be possible to detect controversial articles by their pattern of vote cancellation.

8. Online news sites like Reddit characterize their different topic areas as "communities," but there are no membership requirements. At the time of this writing, the community structure in Reddit was almost identical to the topic structure in Digg. What seem to be needed in the next generation of tools are social indexes created by more specialized and dedicated communities. By comparison, the social processes that are active on Wikipedia for collaborative writing of articles seem more effective.

9. Some online sites (such as http://grou.ps) provide tools for creating social networks to share photos or collaborate. At present, these sites seem to be designed to help people maintain social connections, not to support sensemaking with evergreen indexes. Communities on these sites do not interlink to define information frontiers.

10. Such disagreement may also indicate an impending split of the community, as happens in the life cycles of scientific fields, churches, and political parties. An interesting design challenge arises from the tension between giving experts extra influence to keep the service responsive and limiting expert influence when the field or subject is shifting and the old guard is not keeping up.

11. Geographically organized information is becoming increasingly common on the web, especially for mobile services. Google Maps is one of the best-known examples. Another example is Yelp, an online collection of reviews of restaurants and other retail services organized by city and neighborhood.

12. Degree-of-interest functions are also used in collaborative filtering, where a person's preferences regarding a sample of media are matched against collective prefer-

ences in order to predict additional interests and qualify recommendations. The computation involves estimating a person's closeness to a group. Although a frontier degree-of-interest function can employ an estimate of distance within a social network, the degree of interest is based not on matching preferences but on explicit designations of neighborhood. Furthermore, the degree of interest for an article can be weighted depending on whether it matches one or more of the subtopics in the home index.

13. "Orienting" is not to be confused with a similar-sounding topic in search behavior, "orienteering." As described by Jaime Teevan and others, orienteering involves using prior and contextual information to narrow in on an information target. The searcher generally does not and cannot specify the complete information need at the beginning. The term "orienting" comes instead from the analysis of sensory systems, where there is typically some "alert" that causes an all-hands-on-deck cognitive response. This is the "orienting response." In our use of the term "orienting," we refer both to this point, when attention is drawn to relevant material, and to the providing of additional topical cues for understanding the meaning of the material.

References

Anderson, Chris. 2006. *The long tail: Why the future of business is selling less of more.* New York: Hyperion.

Brin, Sergey, and Lawrence Page. 1998. The anatomy of a large-scale hypertextual web search engine. 7th International Conference on World Wide Web, Brisbane, Australia, April 14–18.

Burt, Ronald D. 2004. Structural holes and good ideas. *American Journal of Sociology* 110, no. 2: 349–99.

Card, Stuart, Jock Mackinlay, and Ben Shneiderman. 1999. *Readings in information visualization: Using vision to think.* San Francisco: Morgan Kaufmann.

Chi, Edward H., Lichan Hong, Julie Heiser, and Stuart K. Card. 2004. eBooks with indexes that reorganize conceptually. Human Factors in Computing Systems Conference, Vienna, Austria, April 24–29.

Pirolli, Peter. 2007. *Information foraging theory: Adaptive interaction with information.* Oxford: Oxford University Press.

Simon, Herbert. 1971. Designing organizations for an information-rich world. In *Communications and the Public Interest,* ed. Martin Greenberger, 37–72. Baltimore: Johns Hopkins University Press.

Stefik, Mark. 1995. *Introduction to knowledge systems.* San Francisco: Morgan Kaufmann.

Stefik, Mark, and Barbara Stefik. 2004. *Breakthrough: Stories and strategies of radical innovation.* Cambridge, MA: MIT Press.

Scholarsource: A Digital Infrastructure for the Humanities

**PAOLO D'IORIO AND
MICHELE BARBERA**

A Skype Dialogue between a Philosopher and a Computer Scientist

P. is a middle-aged Oxford philosopher. He is a proper English gentleman, rather impractical, at times naïve, but erudite and thoughtful. He is fascinated by technology and wants to use it to resolve various problems in his field, while keeping a firm hand on the reins.

M. is a young, self-employed computer engineer of the Google generation. The son of prominent literary scholars, he has an innate affinity for the humanities but finds it all rather comically stuffy and inefficient.

Day One—Conditions of Possibility

P. Hello, are you there?

M. yup.

P. Glad I caught you. I've been meaning to ask you something. Do you think it's possible to use the Internet and particularly the web for humanities scholarship? I mean not only accessing primary and secondary sources, as we scholars usually do in archives, libraries, and bookstores, but also publishing new work in ways that will stand the test of time and win prestige, as we're always trying to do when we submit manuscripts to academic publishers, and educating younger generations, which is the mission of our universities.

M. lol. haven't we been working on that for years? and not just us. remember that book u gave me back in y2k about the nietzsche project?[1]

P. True enough. But occasionally it is prudent to reconsider matters from the beginning, as we philosophers love to do. And I need you to help me understand these new barbarian technologies. I'm just a poor philosopher teetering between nostalgia for the old world I love and the lure of that which is to come. It would be pleasant to discuss it while strolling in the University Park, here at Oxford, but then we would still be in the old Peripatetic style, and in any case, you are in Pisa. I wonder if you have time to discuss it on Skype?

M. not much, but go 4 it. i'll multitask.

P. Good. Then, let's begin: what is your answer to my question?

M. a lot of people r already on this, not just philosophers. the tech is there but u scholars don't know what u want.

P. Perhaps because we all forget to answer a closely related question: What are the *conditions of possibility* of scholarship?

M. conditions of possibility? c.o.p.? what's that?

P. I'm borrowing from Kant, but I use it in a non-Kantian sense. I mean the principles that undergird scholarship. You must have noticed that the digitization projects and digital infrastructures in the humanities have in many cases been driven more by capacity than by exigency, with each advance in technology inspiring a new set of aspirations and plans, many of which never come to fruition or quickly lose relevance. It's true that trial and error is necessary in this field, but we have not paid sufficient attention to how the traditional structuring and practice of humanities scholarship may serve as a guide for the conception, design, and assessment of technological supports.

M. tell me more.

P. Well, if we could identify the general conditions necessary for conducting scholarship, we would have a basis upon which to develop and evaluate digital infrastructures for the support of humanities research, while also considering, of course, whether and how emerging technologies could transform the nature of scholarship and . . .

M. and how to make the web scholarship-friendly?

P. That's right. What is your opinion on the matter?

M. u mean, for ex, i can't make a world cup video game unless i first know the principles of football—2 teams, a ball, no hands except for the goalkeeper, etc., then i make sure the video game has the same elements?

| PAOLO D'IORIO AND MICHELE BARBERA

P. Precisely: conditions of possibility.

M. gotcha: rules of the game. we cmptr geeks call them requirements.

P. Yes, if by "requirements" you mean precisely those rules without which, or by altering which, we would end up playing another game: if everyone picks up the ball, it is not really football. It's more like rugby.

M. ok. so what r the cops of scholarship?

P. I've found three: quoting, consensus, and preservation.

M. just 3?

P. Perhaps I have missed something, but I think that with these three we can play football, or rather, scholarship. Without any one of these we are playing another game.

M. ok. so what's quoting?

P. First you have to understand that scholarship is a conversation based on arguments, demonstrations, and proofs and that facts, in the humanities, are often contained in documents, in texts. When Pinocchio tells lies, his nose gets longer. In literary studies, this is a fact. Remember what the Lovely Maiden with the Azure Hair said?

P. Are you still there?

M. sure. of course i remember. she said, "Lies, my boy, are known in a moment. There are two kinds of lies, lies with short legs and lies with long noses. Yours, just now, happen to have long noses."

P. Excellent! This fact is as certain as the existence of electrons in physics. Maybe more so. But to be sure of this, you must be able to consult the first edition of Collodi's *Le avventure di Pinocchio: Storia di un burattino* (Firenze: Libreria Editrice Felice Paggi, 1883), 83. If you can't quote the original source, you can't really verify the fact, and you can't produce arguments and demonstrations. It's impressive you were able to cite from memory, but you need the sources to do scholarly work.

M. actually i googled it. lol.

P. Well, the citation was right, and the translation wasn't bad; I have just checked it with my original copy.

M. 4 real?

P. Yes. And my point is that a facsimile of such pages needs to be available for scholars to consult. Here, I'll send you a digital reproduction of the page [fig. 5].

M. u r crazy. why do u need the fax if the text is on the web?

P. Well, just imagine if you had found on the web that when Pinocchio told lies his ears and not his nose grew longer. Wouldn't the web in that case

C. COLLODI

LE

AVVENTURE DI PINOCCHIO

STORIA DI UN BURATTINO

ILLUSTRATA DA E. MAZZANTI

FIRENZE

FELICE PAGGI LIBRAIO-EDITORE

VIA DEL PROCONSOLO

1883

— 83 —

così straordinario, che il povero Pinocchio non poteva più girarsi da nessuna parte. Se si voltava di qui batteva il naso nel letto o nei vetri della finestra, se si voltava di là, lo batteva nelle pareti o nella porta di camera, se alzava un po' più il capo, correva il rischio di ficcarlo in un occhio alla Fata.

E la Fata lo guarda e rideva.

— Perchè ridete? — gli domandò il burattino, tutto confuso e impensierito di quel suo naso che cresceva a occhiate.

— Rido della bugia che hai detto.

— Come mai sapete che ho detto una bugia?

— Le bugie, ragazzo mio, si riconoscono subito, perchè ve ne sono di due specie: vi sono le bugie che hanno le gambe corte, e le bugie che hanno il naso lungo: la tua per l'appunto è di quelle che hanno il naso lungo.

Pinocchio, non sapendo più dove nascondersi per la vergogna, si provò a fuggire di camera; ma non gli riuscì. Il suo naso era cresciuto tanto, che non passava più dalla porta.

FIGURE 5. Title page and account of "two kinds of lies," from Carlo Collodi, *Le avventure di Pinocchio: Storia di un burattino* (Firenze: Libreria Editrice Felice Paggi, 1883).

be telling a lie? A lie with short legs in this case, but only if you could verify the correct quote by consulting Collodi. What I mean is that quoting requires the stability of bibliographic references (the author, title, publisher and year of publication, and all the information printed on the recto and verso of the title page) and the stability of texts, and that traditional printing based on scholarship can normally ensure this. But what about the web?

M. quoting is very difficult on the web. the cool thing about the www was that ppl could send a text anywhere and constantly change it. and that's what they do! u get a robust, dynamic, decentralized communication tool where pages change every day, appearing, disappearing, reappearing under other names & addresses. but we can create apps that r like small islands in the web, where addresses and texts r stable.

P. And how could the stability of the addresses be guaranteed, that is, how could it be ensured that when I type in an address I would never receive a 404 error and would always find the same text and not another one?

M. doi (digital object identifiers)[2] give stable addresses. and there r other ways. it's a hot topic among librarians. i think inventing a new naming system is unnecessary because the url (uniform resource locator) or, more accurately, the uri (uniform resource identifier) can already give stable & univocal ids.[3] anyway, a commercial organization handles doi, and so has the same if not more chance of disappearing as does each repository that manages its own uri. anyway it doesn't guarantee stability any more than iana (internet assigned numbers authority), which manages ip addresses & domain names.[4] doi are just "ids of ids" that just shift the problem to a new layer. u know the one about the indian and the tortoise?

P. Of course. "What does the world rest on?" the anthropologist asks the Indian. "The Great World Tortoise." "And what does the Great World Tortoise stand on?" "Another tortoise . . ." If I understand, you're saying that to guarantee the stability of web addresses we don't need special technical measures because the normal web addresses that we type into our browsers, what you call URLs, are sufficient. So what about the integrity and stability of the text?

M. piece of cake from the technological point of view. u just compute a checksum—it's a cryptographic hash, like a digital signature—of the document when it's published for the 1st time. if u compute the checksum again before reading the document and it matches with the original, no modifications took place.

P. Brilliant!

M. but the technical solution alone doesn't guarantee the stability of the web address & text. u need the people in charge of the sites to install the apps and make sure it all works and maintain it; it's not a geek problem, it's a policy problem.

P. But I want the technology to solve all my problems. And instead you talk to me about tortoises and policies. You're as bad as the philosophers!

M. sorry, but there's more policy in IT than is dreamed of in yr philosophy.

P. How poetical of you! But let's come to the second point: Consensus. As in other social activities, to receive support and to be included in the common research enterprises, scholars must produce works recognized as interesting by their colleagues. But more than in other social activities, in scholarship this recognition is understood to be based on evidence and must be as fair and transparent as possible. Of course this is very difficult to realize. Trust, prestige, peer review, and other systems of fair evalua-

tion are continuously contested. Could we do something better on the web?

M. sure. consensus works great on the web: it's easier, more transparent, more efficient. there r plenty of ways to do it: realize a digital environment that mimics traditional peer review; follow social network logic and calculate the impact factor starting from the users' semantic tagging on sites like citeulike or connotea;[5] or use popularity indicators like number of citations or downloads of an article. there's a science blog run by the periodical nature that's called peer-to-peer, where they're talking about different models of peer evaluation on the web. they also have a new type of online journal called nature precedings. and there's postgenomic, also run by nature.[6] it's a feed aggregator that collects posts from scientists' blogs.

P. Very interesting. But I'm not absolutely certain that my colleagues will want to experiment with all these possibilities, so transparent and so democratic.

M. another policy issue. i'm all for openness & democracy in scholarship!

P. Well, that's something we'll have to consider carefully. But let's talk about the third condition: Preservation. We are still working with original documents dating from the Middle Ages or from ancient times. But what will happen to our server, our publications, and our online articles in twenty years, in a hundred years, in a few centuries? How can we be certain that our electronic documents will survive us? It would seem that this question is very much present in the debate about the new communication technologies.[7] What do you think about this?

M. lockss!

P. What? I know what LOL is, but LOCKSS?

M. lots of copies keep stuff safe = lockss. it's the name of an international project for safeguarding the digital info.[8] some librarians at stanford came up with the idea. they say the best way to preserve a text is not to keep one copy in a very safe place, but to let people make 1000s of copies and disseminate.

P. Of course! You are right, they are right, and thirty centuries of our cultural heritage confirm this principle: we have lost only what we didn't copy. Think for a moment: Why did we lose almost all the work of Heraclitus, while we preserved almost all Aristotle's work? Because Heraclitus had a Digital Rights Management System strategy (I believe you call that DRMS, no?): he stored the unique copy of his work in a safe place (the temple at Ephesus), and people couldn't copy it. As a result we lost it, and only the

quotations made by other authors still survive. Aristotle, on the contrary, was what you would call a copyleft guy: he told his students to copy his works whenever they wanted. And copy after copy, Aristotle's works have been passed down us.

M. whatever. i don't know about philosophy. but it's true that copyright, drms, proprietary formats are all enemies of preservation. free sharing and copyleft are friends.

P. And of course, as everybody knows but my colleagues sometimes forget, copyleft does not mean plagiarism. It grants reproduction and access to everyone, while at the same time it protects the integrity of the works and intellectual paternity.

M. and don't 4get the format of the data! open formats have the best chance of being readable in the future. but preservation of e-content is more a legal question than a technical one. it's a matter of the license. that's why copyleft is so important.

P. Do you mean that the fact that everyone can freely copy the content of a website and make use of it increases the probability that in a thousand years, copy after copy, someone, somewhere in the world will still hold part of that content?

M. right, and open formats r the best guarantee that this content will still be legible.

P. Open-source devotees are the monks of the digital era, and vice versa.

M. preservation = dissemination, and vice versa.

P. Good. I was wondering if we should add a fourth condition of possibility: Dissemination. I ask myself if it is possible to imagine science without public diffusion of its results? Probably not. At least not for modern science, which is a public conversation in which the primary sources and the results of research must be easily accessible to all. But if you now say that preservation and dissemination are in fact the same thing, than there are three conditions of possibility, only the third one is twofold: Dissemination/Preservation.

M. ok. but this takes for granted that u remove the legal obstacles that often obstruct access to the sources & the diffusion of the results.

P. I see—another problem of policy, not technology.

M. yup. it seems to me that u humanists really need someone to resolve all these policy problems, without waiting for us cmptr geeks to pull your chestnuts out of the fire. u have to come to an agreement with the universities, the libraries, the publishers.

P. Yes, universities, libraries, publishers . . . but I think that to lead the change into digital scholarship we must first come to an agreement among ourselves: we need Open Scholarly Communities on the Web.

M. say wht?

P. Open Scholarly Communities on the Web. Free supranational associations of specialists who work on a specific author or area of research. They collaborate with libraries, archives, publishers, universities, and foundations, but they themselves fix their own priorities, guarantee scholarly standards, preserve the stability of texts and authorship, and ensure the open dissemination and preservation of content.

M. never heard of 'em.

P. Well, that's because they don't exist yet. They hardly even work within the traditional infrastructure and they don't exist at all on the web. We need to create them.

M. sounds like social networks—facebook, ebay, wikipedia, youtube, del.icio.us, twine . . .

P. Well, perhaps. I was thinking more along the lines of the Accademia dei Lincei, Accademia del Cimento, Académie Française, the Royal Society . . .

M. hang on while i look those up on wikipedia . . .

P. Never mind. These were social networks when modern science was born. In my opinion we need to start again from there. It is necessary to invent organizational models for the future, and we must do this by taking into consideration the effective and time-honored examples of the past. *Reculer pour mieux sauter*—take a step back to jump better, as the French say. I am calling for the founding of Open Scholarly Communities on the Web, to be modeled on the science academies that accompanied the founding of modern science.

M. stakeholders?

P. Yes, stakeholders, but ones who really know what is at stake and are willing to act.

M. ok. I see u r x-cited and i don't want to rain on your parade. let's say your colleagues agree to this crazy scheme. have u thought about the digital infrastructure you'll need? how to organize the knowledge? what your ontology will be? what kind of resources & metadata u need to use?

P. What? This sounds like a big job. I think I had better stroll over to the Bodleian and consult with Aristotle, Lachmann, Dewey, Popper, perhaps also Diderot. You and I can continue our conversation tomorrow.

M. good. i've got an urgent job 4 a client anyway. see u tomorrow & say hi to aristotle.

Day Two—Google, Wiki, Hyper: Knowledge and Information in the Digital Era

M. hey. what did your friends have to say about a digital infrastructure for the humanities?

P. Good morning. I see you are curious. Well, they were quite perplexed and wanted to know more about the question, beginning with the meaning of the word "infrastructure." You know what philosophers and philologists are like . . .

M. what do u think?

P. Well, if you look in a dictionary, you find that an infrastructure, in the real world, is a well-coordinated system of buildings, equipment, services, administrative structures, procedures, conceptual models, etc., that facilitates a certain activity. It can be conceived as an underlying support as well as something that establishes an horizontal network of connections between different elements. In Italian the prefix *infra-* expresses this duality very well because it contains both the sense of "under," coming from Latin, and the sense of "between," as used in the time of Dante.

M. cool. i looked up the technological definitions and it seems the term refers above all to public works, basic physical & organizational structures & facilities such as highways, bridges, airports & airways . . .

P. Airways, that's good. Let's try to use this meaning as a metaphor. Once somebody had invented the aircraft, people constructed a system around the invention. They organized air transport. So given that somebody has invented the web, let's ask ourselves how we can best use the invention to carry out research in the human sciences and disseminate the results.

M. we said yesterday that the 1st step is to analyze the preexisting infrastructure and the needs of its users.

P. Certainly, in this way we could try to anticipate what the scholars will demand from an electronic infrastructure and to create the appropriate tools. Like mobile jetways, for example, that assist passengers in boarding and deplaning.

M. then we have to figure out how many airports and how many flights r needed, to organize the routes so the planes don't collide, to develop the economy of the industry, to regulate safety and overbooking, to coordi-

nate air travel and ground transportation. . . . for example, why aren't there any flights between genova & pisa?

P.　Because the two cities are close by and linked by a motorway. Just as it would be silly to offer detective stories on the web because people like to read them in bed, while traveling, in waiting rooms—all places where a book is more practical than a computer.

M.　ok, let's get back to each other in a few months after you've done some research with your colleagues and can give me a detailed survey with all requirements & specifications.

P.　I think you are overestimating the competence and awareness of scholars in such matters. It's like asking people who ride in a horse-drawn carriage and are afraid of flying how to organize air travel.

M.　so what do we do?

P.　Before asking any questions, I suggest that you and I observe what scholars actually do in the traditional infrastructures, which intellectual operations they perform, and how they organize their research from a social point of view.

M.　maybe you're overestimating *our* competence and awareness :-) but ok, I can see u r not going to let me get any work done today. btw, r u sure that the humanities *has* an infrastructure, i mean, the one for the horse-drawn carriages, to serve as a model for air travel?

P.　There certainly is a research infrastructure for the humanities (just ask the Americans who are talking about building a Cyberinfrastructure[9]). It has been developing over the course of two thousand years, thanks in part to the old friends I visited yesterday. It's a complex whole; let's try to separate it into three logical parts.

M.　cops again?

P.　No, this time let's say Constitutive Elements.

M.　stealing from kant again?

P.　No, it's mere empirical observation.

M.　good, we're coming back to earth.

P.　First comes Physical Structure. This is composed of objects of study and the buildings in which those objects are stored, which serve also as workstations for the people who conduct research and preserve the objects. There are, in addition, distribution systems for the dissemination of knowledge and, last but not least, financial support, which makes the entire system possible.

M.　financial support? now u have my attention ;-)

P. Because you are a businessman, but bear in mind that, unfortunately, in the humanities there are big ideas but little money.

M. it's a niche market—the long tail![10]

P. I see you've been doing your homework! Anyway, the second element of the traditional infrastructure is the Organizational Structure. From a research perspective, the infrastructure has heretofore been organized into disciplines, has used peer review as a filtering mechanism, and has relied on the impact factor to evaluate researchers. From the legal-economic perspective, copyright has served to settle matters of intellectual property since the eighteenth century. Market conditions have also played a role in the traditional model. Finally, from a political standpoint, various institutions have been responsible for the organization and financing of research (universities, research centers, public and private foundations, etc.).

M. i'm beginning to understand what u r getting at. what's next?

P. Well, the third element of the traditional model is what we may call the Logical Structure, which I would in turn divide into authors on the one hand and different types of primary and secondary sources on the other. Primary sources are the documents or objects used by scholars in their research and secondary sources are the publishable results of scholarly research. This division is useful for indicating the various functions that a single object may serve. For example, a text written by Heidegger about Nietzsche would be a secondary source in Nietzsche research but a primary source for Heidegger research.

M. it seems to me that u r drawing an ontology. maybe we could divide it in three: people, resources, and metadata. but tell me: how do u navigate within this logical structure?

P. Using a formidable tool, the citation, which links together the various elements of this logical structure and their parts.

M. i get it. nicely done—your philologist and philosopher friends should be proud.

P. Yes, indeed, the traditional infrastructure is a well-coordinated system that does attain its goal: to engender and disseminate knowledge.

M. then u don't need me :-)

P. Not so fast. The traditional infrastructure is not perfect. There are numerous problems, as in all human activities, but three problems in particular make us think that there is a need for something better.

M. call them the conditions of impossibility . . . lol.

P. Very funny. But seriously, this system is slow and expensive in regard both to access to primary sources and to the dissemination of scholarly publications. If I want to study Rousseau's manuscripts, I have to travel to Paris, Geneva, and New York, and if I want to disseminate the results of my research, I have to print numerous copies of my books and send them hundreds of miles away . . .

M. can't deny it, books r beautiful but heavy, while the bits travel at the speed of light, or almost. wasn't it calvino who said that computer technology is the realm of lightness?

P. Yes, he also said that literature had a vocation for abstracting the weight from things. We could add that computer technology takes the last step toward lightness: it abstracts the weight from texts and brings writing back to what Lucretius called its dusty and combinative nature, bringing it closer to thought.[11]

M. ok, second problem?

P. As the infrastructure grows ever more expansive, research becomes increasingly less collaborative, cumulative, and cost-effective. If a hundred scholars are working on Kant, the traditional infrastructure can establish contact between them fairly effectively. But when one is talking about a thousand scholars, traditional methods cannot easily ensure that, for example, a scholar in Germany will know that a colleague in Brazil or Japan has published an important paper on a particular passage or key concept in the *Critique of Pure Reason*. Admittedly, the apparatus does exist to communicate this information—there are bibliographies, indexes, digests, and so on. But as the field of research grows more complex, this apparatus becomes less and less efficient. As a result, different scholars may undertake the same research, or one scholar may remain ignorant of relevant and valuable investigations conducted by other researchers.

M. but you guys recognized and formulated that problem years ago.

P. True, but we still don't have a good solution to it. And a third problem is the misuse, by publishers, of the otherwise legitimate mechanisms of peer review and copyright for the purposes of financial gain. The fact is that in the hard sciences there is a monopoly market that makes access to scientific information very expensive: at present, the best-funded libraries have to use about 80 percent of their budgets for the purchase of scientific journals and nevertheless will be able to afford only a small part of this literature.

PAOLO D'IORIO AND MICHELE BARBERA

M. is this the "serial price crisis" you've told me about?

P. Yes, it's a perverse consequence of a mechanism for the quantitative evaluation of academic work invented in the 1950s by Eugene Garfield: the Science Citation Index. The SCI included the definition of a collection of "core journals." This list influenced the acquisition practices of libraries, creating the conditions for an inelastic market. At the beginning of the 1970s certain editors became aware of this process and tried to accelerate it, and by the end of the 1980s a new monopolistic market had come into being.[12]

M. and that effects the humanities too?

P. Well, for scholarly publications in the humanities there is no monopoly market—there is no market at all. If libraries spend almost all their budgets on journals in the hard sciences, not much is left for humanities journals and monographs. The only ones that survive are those written by authors who can finance the publication themselves, or those who work on themes that have broad public interest.

M. but now u have the internet. doesn't that solve both problems—the monopoly market and the nonexistent market?

P. Yes and no. Do you know what happened when computers and the Internet were integrated into the traditional infrastructure in the humanities?

M. tell me.

P. At first, computers were used for lexical analysis and the creation of concordances, thesauri, etc., and so a new discipline came into being: computational linguistics.

M. yeah, i've heard that the pisa philologists were pioneers in this kind of thing. didn't they use a punch card system on an ibm mainframe back in '65 to do a dante concordance?

P. That's right. Then, in the 1980s, personal computers and word processing programs came into use and the production of digital texts became common practice. But digital texts, which could be published directly on the Internet, remain on the margins of the traditional scholarly system. Scholars generally have to choose between two alternatives: submit their texts to a traditional publisher for peer review, and thereby surrender their copyright and the option to publish on the Internet, or publish their texts on the Internet, and thereby forego the validation of peer review and forfeit the benefits to their academic careers. This situation results in a charming paradox, symptomatic of a dysfunctional system.

M. crazy. so scholars produce digital texts that could go straight to the in-

ternet but instead r published on paper, then redigitized, for example, by google books. i'm beginning to c the problem.

P. And remember that in Europe we often use public funding—national or European—to digitize monographs. So the public pays once to support the original research (which is good), a second time to publish the results in book form (which is less sensible), and a third time to digitize the books (which is really going too far). Despite a certain number of very important initiatives, the Internet has not yet been adapted for scholarly publishing.[13]

M. has there been any progress?

P. Some. But even in the best cases we witness the gradual creation of a global, Googleized system (which remains quite apart from the traditional infrastructure) composed of a mass of digitized texts of all different kinds with varying degrees of scholarly reliability and, to navigate all this, a simple search engine.

M. but that's still something, isn't it?

P. I do not deny it. But at the same time it is as if we had taken the complex traditional infrastructure (one that did in fact produce knowledge), placed it in a digital blender, and reduced knowledge to mere information. In this model, all notions of structuring information are lost: one searches for words and receives a list of occurrences, and that's it.

M. so it sounds like u need a more a structured model of web-based knowledge organization, like a semantic web of humanities. or maybe a simpler, centralized solution like wikipedia would do. i bet diderot would like wikipedia.

P. I do too. Wikipedia is a wonderful and very successful example of the dissemination of information by means of a common enterprise, in which everyone takes part in the production of articles, proposes improvements, and enjoys sharing. But don't forget about the conditions of possibility we mentioned yesterday. Wikipedia texts have not received any form of consensus from the community of scholars, and they are not stable and can be modified at any time by anyone. I have, for example, just changed the quotation of Pinocchio contained in Wikipedia, writing that when he told lies his finger grew.[14] I know it's not true (at present my nose is growing at a good rate), and I also know that thanks to the strength of the social network my act of vandalism will soon be rectified, but this doesn't seem like we're playing football. It's some other kind of game with much looser rules; anyone can pick up the ball and run.

M. and u want to stick to the old game?

PAOLO D'IORIO AND MICHELE BARBERA

P. Yes, if possible; perhaps switching to virtual to solve some of its problems, but without losing any of its virtues.

M. ok, u've persuaded me. let's try to construct this digital infrastructure for the humanities.

P. What would it look like?

M. we still need a physical structure, but now we're talking not texts but electronic files, not buildings but computers, and the dissemination is not through publishers, distributors, and bookstores but via the internet.

P. Good. Concerning the organizational structure, I think we already talked about Open Scholarly Communities and copyleft yesterday.

M. ok, let's go with that even though, as u said, the scholarly communities don't really exist yet and copyleft will have a hard time making inroads on the human sciences. the logical structure is fine. it's what we tech guys call an ontology; you could call it a scholarship ontology.

P. Scholarship ontology?

M. yeah, or "so" for short. in my lingo, we'd call it a general ontology that expresses the general structure of the topic (humanities scholarship), based on the distinction between research objects (primary sources) and research results (secondary sources) and the general relationships among these sources, such as "related to," "describe," "criticize," "comment."

P. Nice—in Italian "so" means "I know," and it seems as though you know exactly what you are talking about . . .

M. mos def! we'd also want domain source ontologies (dso) to be used by specialized nodes of the infrastructure, for example those dedicated to nietzsche or wittgenstein or ancient philosophy and so on. these ontologies express different types of primary and secondary sources used in the fields, their granularity, and their specific relationships.

P. I don't know exactly what Aristotle or Karl Lachmann would have thought of this. Perhaps they would have laughed at it like good aristocrats, since they defined ontologies in a philosophical sense and articulated the difference between primary and secondary sources in a more complex manner (*recensio, collatio, emendatio* . . .).

M. but along w/ these structural or bibliographical ontologies, dealing with the structure of documents, describing their types, their parts, and their relationships—which can be as articulated and complicated as necessary—we could imagine philosophical ontologies dealing with concepts contained in the documents and their relationships: nature, world, freedom, democracy, truth, evidence, mind, etc.

P. Let's suppose that all this is true and can be realized.

M. this is serious. if our general objective is to publish scholarly content in a web infrastructure that's useful for humanities research, first we have to analyze the structure of scholarship in the real world, then we have to formalize it in a way that can be understood by machines.

P. It is news to me that machines can understand anything. I have always thought of them as fast but stupid.

M. c'mon. in semantic web circles we even talk about *reasoning*, but it would take too long to explain why right now. the point is i think it's better to use a formalization in terms of ontology rather than a data model because it would accommodate multiple points of view, and multiple ontologies on the same domain. of course, once the ontologies were designed, we would have to develop the architecture of our software and make it able to import multiple ontologies to express whatever structures are needed by your scholarly communities.

P. If you say so . . . but I do not quite understand what all this is needed for.

M. u said that if we want to transpose scholarship into an electronic environment we need to understand its general structure clearly. now, if I understand *u* correctly, u think scholarship is based on the distinction between research objects (primary sources) and research results (secondary sources). the primary sources r what u want to speak about and the secondary sources r the product of the different ways in which u can speak about the primary sources. right?

P. Right. And let me add that the distinction between primary and secondary sources has a fundamental epistemic value. According to Karl Popper, what distinguishes science from other human conversation is the capacity to indicate the conditions of its own falsification. In scholarship, normally the conditions of falsification include the verification of hypotheses on the basis of an ensemble of documents recognized by a scholarly community as relevant primary sources. Thus we can affirm that the distinction between primary and secondary sources exhibits the conditions for falsifying a theory in the humanities.

M. interesting. now tell me, how do traditional research environments, like libraries, represent this fundamental distinction between different kinds of sources and help researchers to find appropriate knowledge?

P. Before answering this question I should mention the fact that even if manuscripts, artifacts, and paintings are normally considered primary sources, most printed documents have no fixed status and can be consid-

ered primary or secondary sources according to different research topics. For example, an article written by Nietzsche on Diogenes Laertius is a primary source to Nietzsche scholars, but it is a secondary source to Laertius scholars.

M. yeah, that's what I thought. but do traditional physical libraries reconfigure their bookshelves according to the needs of the scholars?

P. Well, they put in place a certain number of strategies to permit scholars to find their way in the mass of documents preserved. The most successful strategy is to dedicate a library or some part of a library to a single research topic, building what is known as a research library. While a general library allows users to consult numerous collections dealing with a wide variety of subjects, the purpose of a research library is to focus on a single subject and to provide scholars with access to all the primary documents, critical essays, and reference works they need to conduct research on it.[15]

M. makes sense.

P. Yesterday Melvil Dewey told me that open-shelf libraries often arrange the books such that primary sources are placed next to the relevant secondary sources. For example, the critical essays on an author usually follow his collected works.

M. good thinking.

P. And of course, independently from the physical arrangement of the books, catalogs of primary sources and specialized bibliographies of secondary sources help scholars to retrieve relevant publications and to virtually relocate the information according to their research needs.

M. with digital libraries u can do even better. not only can we unite the collections of different libraries, but we can easily reconfigure their holdings according to any scheme, taking into account the different status of a given source in different research contexts.

P. How could that be done?

M. imagine that our infrastructure combines a general scholarship ontology that makes it possible to express the difference between primary & secondary sources and then narrower ontologies—call them domain source ontologies—that express this distinction with regard to research in specific fields (nietzsche, wittgenstein, ancient philosophy, etc.). if a scholar entered our network of semantic digital research libraries through the door of, say, laertius scholars (using the laertius source ontology), knowledge would appear to him in a certain configuration. for example, articles by nietzsche on laertius would be listed as secondary sources, along with

other critical essays on laertius. but if he entered through the nietzsche door (the nietzsche source ontology), the same material would be presented in a different way; nietzsche's articles on laertius would appear as primary sources (in the class "works") and as related to all critical essays and other secondary sources on nietzsche (but not on Laertius), while laertius's lives of the philosophers would be included in another class, say, nietzsche's "library & reading." i think your friend dewey would have liked this.

P. So, in this way we could transpose onto the web the structure of traditional scholarship, preserving the different epistemic values and relationships that scholars attribute to their sources, and improving the way in which documents can be dynamically rearranged according to these relationships?

M. u got it. and more generally, all digital objects would appear as generic resources having the same epistemic status. the user could search them using a minimum set of shared, standard metadata, such as title, author, date of publication, etc. so our infrastructure could be very specialized and targeted to the needs of specialist scholarly communities, and at the same time would be fully interoperable with general digital libraries and part of the semantic web.

P. Now you're the one getting excited! Good. So the general library will serve all kind of readers and ensure interoperability while the specialized research libraries (concerning Laertius, Nietzsche, Wittgenstein, etc.) permit scholars to find their way in an electronic environment structured according to the standard classification used in their communities. That is very useful. And then of course it would presumably be possible to do the same thing with the philosophical ontologies. Great. But how much would this super-technological video game for scholars cost?

M. not much, don't worry.

P. But there is still one element missing.

M. well then it will cost much more ;-)

P. The navigation system is lacking. Why has the traditional infrastructure been so useful? Because with a simple bibliographical reference at the bottom of the page, the author was able to refer to another document in a very precise manner: to a specific page in an article or a book. It is necessary to develop such a system for our digital infrastructure, one that employs all the powers of the Internet.

M. try to explain this "scholarly navigation system" a bit more clearly. i have

a hunch we r switching from knowledge engineering to user interface design here.

P. Well, think how a scholar in predigital times navigated the library. He did not follow a list of "hits" of the kind produced by Google. Scholarly knowledge is not structured like a list or a tree but rather like a graph, a mathematical graph. Understanding this also helps to dispel a common misunderstanding, according to which the difference between printed books and hypertext is that a book ensures a sequential reading whereas hypertext introduces nonsequential reading. Nothing could be more false in the realm of scholarly research. Indeed, a key characteristic of scholarly reading is precisely that it is nonsequential. A classicist at work in the library is likely to have a dozen or more books open on the table and to jump from one to the other: he verifies, he looks for connections, he follows links made explicit through the venerable tradition of scholarly citation.

M. sounds like tbl [Tim Berners-Lee] circa 1999. massive linking is exactly what scientists have tried to do for centuries. "Tables of contents, indexes, bibliographies, and reference sections are hypertext links. . . . Suddenly scientists could escape from the sequential organization of each paper and bibliography, to pick and choose a path of references that served their own interest."[16]

P. He was right.

M. so the question is how to transpose the good old system of scholarly citation into a digital infrastructure for the humanities, right?

P. Yes. So, for example, we want to ensure that when a user selects a critical essay in the digital infrastructure, he will be presented automatically with lists of all primary and secondary sources cited in the essay and, more importantly, a list of all the essays in which other authors cite the essay currently being viewed.

M. if i'm following, then also when a user selects a ms page, the system should immediately present all the transcriptions & editions available for the page, as well as all the relevant critical essays that refer to the page?

P. Precisely! Scholarship, you could say, is the capacity to analyze the same object with different criteria, and different objects with the same criteria. And this is important not only from a methodological but also from an epistemic and cognitive point of view: the oriented graph-data structure produced by such "dynamic contextualization," as I like to call it, is much closer to the way in which knowledge is organized in scholarly practice

and also much closer to the operation of the human mind than the typical data tree structures in the vast majority of information processing systems.

M. i've got an idea. how about if we combine dynamic contextualization with the domain scholarship ontologies we were talking about earlier? so, for example, if nietzsche is cited in an essay published in the wittgenstein research library, the reader could mouse-click to the nietzsche research library and go right to the original source in nietzsche, plus have translations of the passage in different languages & commentaries from nietzsche experts.

P. Yes. This is what the concept of a hypertext, and in general the prefix *hyper-*, should have meant all along. Do you think it would be very difficult to build?

M. blog posts already have "the trackback protocol" to make the links. and we could use semantic-web technologies, like rdf annotations, to tag the passages with structured metadata and citations. the infrastructure would be designed to understand the meaning of the annotations and on that basis establish the bidirectional links.

P. Well that's all Greek to me, but if you say so.

M. there'd still be a little problem of scalability, because there r potentially millions of bidirectional links to be updated on the fly. but there r workarounds.

P. If I have understood correctly, this dynamic contextualization could be the form of scholarly citation in the digital era, more powerful than the old citation system because it is bidirectional (the system can not only point toward a textual passage but also go backward to the origin of all references that quote a certain passage) and because it is dynamic (the list of articles that cite a certain passage is updated automatically without the need to peruse all journals and monographs manually, as in the case of the Science Citation Index).

M. u got it. and then u can develop automatic bibliometric surveys without using core journals arbitrarily chosen and manually perused. if this catches on, it would be the actual give-and-take of real academic discourse across the board, registered automatically on the network through citations, and not a tiny number of core journals, that would determine the reputation of scholars.

P. Adieu monopolistic market for the core journals!

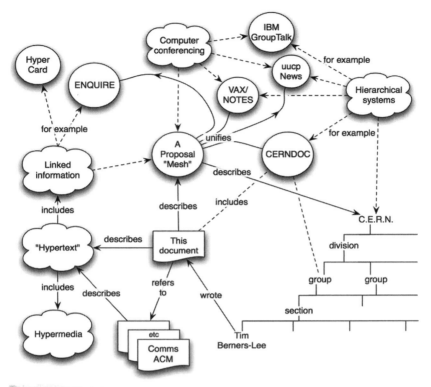

FIGURE 6. Semantic hypertext system, from Berners-Lee (1989).

M. wait, there's more! because with this system we won't be creating mere links but what we call "graphs with labeled arcs."

P. Labeled arcs?

M. yeah. it was something tbl was talking about back in 1989 . wait, i'll send u an image [figure 6].[17]

P. I think I understand Pinocchio better. Do your graphs and arcs lie like he does?

M. no, much better. but listen, here's the exciting part. in our system there are different kinds of links to express the range of relations between pri-mary & secondary sources. so, for example, we could distinguish between positive & negative citations of an article; or between philological, rhe-torical, and philosophical analyses of a text passage; or between archaeo-logical, historical, and stylistic analyses of a painting or artifact. then u

m software agents to exploit these relations, like a bibliometric app
kes account not just of the number of citations of an article, but
ir quality—positive/negative, agree/disagree, etc.—to calculate a
d impact factor. but what really interests me is that if u codify all
this information using a standard language (like rdf), all the computers
connected to the internet could analyze it and everybody could program
apps to use it in ways that we can't even begin to imagine.

P. Imagine indeed—people may say you're a dreamer! But I have to admit,
the whole picture begins to look more like the structuring of knowledge
rather than the mere processing of information.

M. u can ponder that overnight. i'm done for today. haven't even had dinner
yet. ciao!

Day Three—A New Paradigm for a Conservative Project

P. Good morning, have you got time for a chat today?

M. sure. i was just thinking of calling u. as i reread our chat history from the
past couple of days, i had a hard time deciding whether this project we're
talking about is revolutionary or conservative.

P. What do you mean, exactly?

M. well, clearly it's looking to replace the old concept of humanities comput-
ing with a new paradigm that would aim to create online environments
for research and publishing, managed directly by scholars, that aren't fo-
cused on searching textual databanks, as they used to be, but on navigat-
ing structured knowledge.

P. Precisely, and we don't want to add a new discipline (i.e., humanities
computing or digital humanities) to the traditional structure of the hu-
manities, but to transpose the whole structure and the scientific practices
in human sciences onto an electronic environment.

M. let's try to work out the differences from the point of view of the structure
of the knowledge. in the paradigm of humanities computing, the text was
at the center and all the other elements (facsimiles of the original editions
or manuscripts, critical commentaries, etc.) revolved around the text.

P. Right. And the model we are drawing places the primary sources at the
center—that is, the documents in all their materiality—and then all the
other critical contributions, including the texts of the different editions
that have been established, revolve around the primary sources.

M. in the previous paradigm the principal function was always research into and statistical analysis of the text.

P. The new paradigm certainly does not renounce textual research, but it privileges what we have called "dynamic contextualization," in which each document is accompanied by all related scientific contributions.

M. so, from consulting hierarchical trees or lists of occurrences we move to navigation w/in a graph structure, in the mathematical sense of the term, where each element is linked with others according to different criteria of meaning.

P. Precisely. Conceptually, the old paradigm was formed of a undifferentiated mass of texts more or less tagged and a search engine that operates as the tool for textual interrogation.

M. while in the new paradigm, we instead tag the bibliographical references contained in the researchers' articles, which r used as a navigation system within the body of knowledge.

P. So we navigate by following the relationships of meaning that researchers have established between all kinds of documents and textual passages, instead of flicking through lists of occurrences of a word.

M. from the technological pov, the old paradigm, based on computational linguistic, used databases, on cd-rom or on the web—and we're talking web 1.0 (static or dynamic html). the new paradigm is web 2.0–3.0, with all that implies in terms of technology, but also in terms of social networks.

P. Yes, I think so, insofar as I understand what you mean. And don't forget that we are dedicated to open access and use copyleft instead of copyright, that we are inventing new forms of peer review, that we're creating those Open Scholarly Communities on the Web to drive the change . . .

M. ok, ok, i get it. so in this sense it all looks pretty revolutionary, esp for the crusty old humanities. but there's also a desire to reproduce the traditional research structure with all its (old-fashioned?) virtues. u want to have primary & secondary sources, expert opinions, textual stability, citations.

P. All fine principles and they work.

M. but so does wikipedia! 9.5 million articles in 250 different languages w/ about 35,000 new articles per day. it is a source of knowledge for millions of people. and don't forget that institutional repositories, electronic journals, and academic blogs are all developing at full speed. seems like a new way of doing science and transmitting knowledge in a shared manner is growing spontaneously—it's "digital literacy."[18] a more open method,

maybe more ephemeral, but fast, hot, now. yes, it's a somewhat different game, but why not change? why the desire to reproduce the old game in this new medium?

P. Ah, now we get to the nub of the matter. You belong to that emerging, barbarous world that so fascinates old-timers like myself, but I maintain my love for the ways of the past. That's why our discussions are so untimely, as my old friend Nietzsche might say (even if the works to which he gave that title were the most time-bound texts he wrote). To me and my colleagues it's all surprisingly new, while for you and your friends it seems like we're talking about ancient history. We are both on the cusp, on a frontier that moves every day. But perhaps it is not a question of civilization versus barbarianism: I can tell that you are attracted to the old paths of thought just as I am to the slick interfaces and lightning speeds of IT, and we are all immersed in what you might call a grand mutation.

M. are u alluding to baricco? you know I can't stand his work :-)

P. Yes, *The Barbarians*. I do not really like his writing either, but in that book, I see us reflected as if in a mirror.

M. i read a few chapters online—it was published first in *repubblica* and then on the newspaper's website. do you remember the last pages, in which he summarized the nature of mutation?

P. Yes, that's what I'm thinking of.

M. here's the text. i just found it—"a different idea of what experience is . . . the surface rather than the depths, speed rather than consideration, sequences rather than analysis, surfing rather than in-depth study, communication rather than expression, multitasking rather than specialisation, pleasure rather than effort," and this current of mutation, "where what is known to us we call *civilization*, and what still has no name *barbarism*."[19] if you apply all this to the humanities, would you say they are becoming more inhuman???

P. Maybe the humanities are all-too-human at present. But seriously, I don't know if this description can be of any use concerning human sciences. But Baricco did help me to understand what I am trying to do.

M. i think I get it. u r trying to save the rules and the virtues of the old game— the cops, as u call them—but your idea is to save them, not from the mutation, but in the mutation.

P. Let me cite Baricco this time: "I believe that it is a question of being able to decide what part of the old world I want to carry forward into the new world. What we want to maintain intact even in the uncertainty of an obscure

journey. The bonds that we do not want to break, the roots that we do not want to unearth, the words that we would still like to pronounce, and the ideas that we do not want to stop thinking. . . . Because what is saved will never be what we have protected from the changing times, but what we have allowed to mutate, so that it could become itself once again in a new time."

M. so i was right! it's also a conservative project. and maybe this is the only way to preserve the values and the methods that you dear old scholars have adopted and perfected in two thousand years of intellectual history.

P. But if scholars still have a purpose, in these restless times, wouldn't it be to preserve and advance the methods that have been developed since the time of the ancient editors of Homer? And to do that using the most powerful medium that exists, the Internet, endeavoring to create an equally dynamic and useful tool, consulted and augmented like Wikipedia? If traditional scholarship doesn't mutate into digital scholarship, the traditional humanities may continue, but they'll become increasingly insignificant, increasingly distant from the world in which knowledge is produced and shared. Conversely, the information exchanged through the web would gradually degrade without the regulating habits and methods of critical thought.

M. what was it baricco said about erecting useless great walls?

P. Right, we do not want digital scholarship to be protected by a Great Wall that holds back the barbarians. Rather, it should be like an archipelago, as you said at the beginning—accessible and welcoming islands of trusted methods and reliable knowledge in the vast, ever-changing sea of the web.

M. ok, enough with the metaphors. whether it's revolutionary or conservative, together we can figure it out. let's get on with it! btw, u got a name for this project?

P. I would like to call it HYPER: Hypermedia Platform for Electronic Research!

M. great, another acronym :-(even if this one's kind of clever, it's so 20th century, so retro. c'mon, u can do better than that.

P. I was afraid you'd say that. That's also what our American friend said, while I was having coffee with him in Signor Rossi, the Italian café near the University of Munich (we try to be what Nietzsche would call "good Europeans"!). He suggested Scholarsource, which I think might be right. "Source," after all, is an old idea in the humanities but one that is just as relevant as it has always been. More vintage than retro.

M. nice! it works in my world too (think: source code) and has the right po-

litical connotations (open source). but i like that it's rooted in scholarship and philology. maybe your egghead friends won't be allergic.

P. That's my hope. The name suggests the concrete and documented nature of research and also indicates that websites bearing this name will contain essential primary and secondary sources for a given field of study.

M. scholarsource—i just googled it. seems like no one's using it yet. let me buy the domain name.

P. Speaking of buying things, you know we'll have to raise funds for the enterprise.

M. don't you remember that we already got financing from the european commission? first the discovery project and now "agora"?[20]

P. Of course, how could I forget! You know, these big projects involve so much red tape—what with all the endless spreadsheets, workplans, meetings, financial statements, reports, and so forth—after a while you can forget the purpose of it all. It's a good thing you reminded me.

M. well, now that we've clarified the concept, maybe we can streamline the organization.

P. Good idea. But maybe we'd better switch to voice. What do you think?

M. voice

Translated by Thomas Bartscherer and Katherine Margaret Clifton.

Notes

1. D'Iorio 2000, 2007.
2. http://www.doi.org.
3. See Architecture of the World Wide Web, W3C Recommendation, December 15, 2004, http://www.w3.org/TR/webarch/#identification.
4. See http://www.iana.org; http://www.icann.org.
5. See http://www.citeulike.org; http://www.connotea.org.
6. See http://blogs.nature.com/peer-to-peer; http://precedings.nature.com; http://postgenomic.com. For a critical discussion of these ventures see the interesting article by Francesca di Donato (2007).
7. Borghoff et al. 2006.
8. See http://www.lockss.org.
9. Unsworth 2006.
10. Anderson 2008.
11. Calvino 1988.
12. Guédon 2001.
13. Suber 2005.
14. http://it.wikipedia.org/wiki/Le_avventure_di_Pinocchio._Storia_di_un_burattino.
15. See Knoche (1993) and Weber (1997), as well as the websites of various research

libraries: e.g., http://www.cerl.org, http://www.libereurope.eu, http://www.carl-abrc.ca, http://www.crl.edu, http://www.arl.org.

16. Berners-Lee and Fischetti (1999, 38).

17. Berners-Lee 1989.

18. Doueihi 2008.

19. Baricco 2006.

20. Discovery Project: Philosophy in the Digital Era (http://www.discovery-project.eu), supported by the European Commission's eContentplus program.

References

Anderson, Chris. 2006. *The long tail: Why the future of business is selling less of more.* New York: Hyperion.

Baricco, Alessandro. 2006. *I barbari: Saggio sulla mutazione.* Rome: Fandango libri. Originally published at http://www.repubblica.it/rubriche/i-barbari.

Berners-Lee, Tim. 1989. Information management: A proposal. http://www.w3.org/History/1989/proposal.html.

Berners-Lee, Tim, and Mark Fischetti. 1999. *Weaving the web: The original design and ultimate destiny of the World Wide Web by its inventor.* San Francisco: Harper.

Borghoff, U. M., P. Rödig, J. Scheffczyk, and L. Schmitz. 2006. *Long-term preservation of digital documents: Principles and practices.* Berlin: Springer Verlag.

Calvino, Italo. 1988. *Six memos for the next millennium.* Cambridge, MA: Harvard University Press.

D'Iorio, Paolo. 2000. Nietzsche open source. In *HyperNietzsche: Modèle d'un hypertexte savant sur Internet pour la recherche en sciences humaines. Questions philosophiques, problèmes juridiques, outils informatiques,* ed. Paolo D'Iorio. Paris: PUF.

———. 2007. Nietzsche on new paths: The hypernietzsche project and open scholarship on the web. In *Friedrich Nietzsche: Edizioni e interpretazioni,* ed. M. C. Fornari. Pisa: Edizioni ETS.

Di Donato, F. 2007. Come si valuta la qualità nella repubblica della scienza? Una riflessione sul concetto di peer review. *Bollettino telematico di filosofia politica,* http://purl.org/hj/bfp/164.

Doueihi, Milad. 2011. *Digital cultures.* Cambridge, MA: Harvard University Press.

Guédon, J. C. 2001. In Oldenburg's long shadow: Librarians, research scientists, publishers, and the control of scientific publishing. *Creating the Digital Future: Proceedings of the 138th Annual Meeting of the Association of Research Libraries.* http://www.arl.org/resources/pubs/mmproceedings/138guedon.shtml.

Knoche, M. 1993. Die forschungsbibliothek: Umrisse eines in deutschland neuen bibliothekstyps. *Bibliothek* 17 (3): 291–300.

Suber, Peter. 2005. Promoting open access in the humanities. *Syllecta Classica,* http://www.earlham.edu/~peters/writing/apa.htm.

Unsworth, John. 2006. Our cultural commonwealth: The report of the American Council of Learned Societies Commission on Cyberinfrastructure for the Humanities and Social Sciences. http://www.acls.org/programs/Default.aspx?id=644.

Weber, J. 1997. Forschungsbibliotheken im kontext. *Zeitschrift für Bibliothekswesen und Bibliographie* 44 (2): 127–46.

"We Will Really Know"

Alan Liu

The essays in part I of this volume, by Ian Foster, Mark Stefik, and Paolo D'Iorio and Michele Barbera, are quite farseeing, predicting in their different ways that current, leading-edge technologies will bring about sweeping changes in the way we practice knowledge, information, research, or, in Stefik's term, sensemaking. While the essays are not fully convergent, we might put their common prediction roughly as follows: given powerful new computers, client-server networks, metadata protocols (e.g., Semantic Web), and so on, we will soon be able to process ever more data in increasingly flexible mixes of aggregation, analysis, extrapolation, simulation, modeling, communication, and collaboration so as to become smarter both in specific communities of knowledge and in long-tail or network effects. Ultimately, perhaps, we will not just work at knowledge (as when we now say we are "knowledge workers"). We will really *know* (i.e., make sense of it all).

I wish to tease out just one problem that may not be sufficiently addressed in the three essays. Who actually is the *we* in a formulation like "we will really *know*"? Foster writes, "Over time, we can expect such methods to be more broadly applied"; Stefik titles his essay "We Digital Sensemakers"; and in D'Iorio and Barbera's dialogue, P. says to M., "With these three [conditions of possibility] we can play football, or rather, scholarship." What I mean will come into focus if we first observe a few, formal paradoxes in the three essays:

Foster quotes the following well-known passage from William Gibson's *Neuromancer* while discussing virtual worlds:

> Cyberspace. A consensual hallucination experienced daily by billions of legitimate operators. . . . A graphic representation of data abstracted from banks of every computer in the human system. Unthinkable complexity. Lines of light ranged in the nonspace of the mind, clusters and constellations of data.

In Gibson's novel, however, this passage is itself set in quotation marks. It is fed to Gibson's hero, Case, by his Hosaka computer as a "voice-over" from a "kid's show." That is, Gibson on virtual reality as "experienced daily by billions" is like Carl Sagan on PBS discussing cosmic "billions." He is ventriloquizing the voice of expertise, which, however, is precisely what Case has no patience for: "He flipped the channel selector. . . . 'Off,' he said to the Hosaka."

In his later discussion of "massively human processing," Foster observes contrapuntally: "Rather than writing a program to identify metaphors in Dickens, we might enlist ten thousand Dickens enthusiasts to tag books with suspected metaphors." Not the expert voice-over, in other words, but ten thousand enthusiasts. This is subtly different from his paradigm of thousands of astronomers, all accessing the Sloan Digital Sky Survey but still expert enough (billions of Carl Sagans, we might say) to produce "more than a thousand scientific publications."

Thus, a formal paradox: like everyone else asked to contribute an essay to this volume, Foster is an expert. Exactly how does that match up with "ten thousand . . . enthusiasts" whose prevalent form of essaying or assaying anything today is a blog post, a wiki edit, or even a Twitter tweet?

Stefik writes in a "chunked" style of numbered sections, in effect morphing the essay form in the direction of government or legal documents, grant proposals, technical manuals, and similar discourse—all of which are now rapidly migrating online in ways that are modular at the web page or even subpage level (since XHTML tags can assign addressable "id" attributes to individual page elements). Such writing exerts a bias toward logical modularity as well—nowhere better demonstrated than in Stefik's section 3, "Tracking Information in Our Core Interests," with its subsections—3.1, 3.2, 3.3, and so on. The overall section is about automatic topic-modeling methods that can help users track "new materials, arriving from multiple sources, [that] are not categorized by subtopic and may include information beyond our information diets." In effect, the chunked subsections enact this topic. Each is a subtopic whose standalone autonomy is brought into line with the overarching thesis, but without effacing the potential for that autonomy. For example, subsection 3.2, "Problems with Automatic Indexes" begins, "Various approaches to automatic indexing have previously received research attention, especially indexes based on concordances." Stated in the general case without explicit connection to the previous and following subtopics on book indexing, this topic sentence could well be the start of its own encyclopedia article on automatic indexing or concordances.

The formal paradox of Stefik's essay is that such modularity at once supports and contradicts his argument. On the one hand, modularity agrees in principle with Stefik's overarching (metaphorical) thesis that we are pioneering an information wil-

derness that rewards data "tracking," "prospecting," and the scouting of "frontiers." (In this context, an "information diet" is just living off the land.) Seen from the perspective of the Silicon Valley Wild West, then, modular writing isn't just more cubicle experience. Rather, it is part of the cyberlibertarian mythos that inspired the Electronic Frontier Foundation, John Perry Barlow's "A Declaration of the Independence of Cyberspace" (1996), and other old testaments of what Richard Barbrook and Andy Cameron (n.d.) call "the Californian ideology." To be modular is to be self-reliant. As in the case of a prospector staking his individual claim in the wilderness, autonomy and stand-alone knowledge is all there is. Every chunk (or "lexia") in modular writing is another forty-niner with his own shovel, pan, jerky, and map. Put less colorfully, packetization is a principle not just of TCP/IP but of documents.

On the other hand, Stefik's modularity conflicts with the flip side of his argument, which is all about laying down in the wilderness, if not the law, then "expertise" and "judgment." Expert judgment means essentially that some ways of prospecting, mining, and scouting information are *more* self-reliant than others, causing others to rely on them. (Super-self-reliance is commonly referred to in information studies as *authority*, *trust*, *credibility*, *reputation*, *quality*, etc.) A case in point is Stefik's innovative "extrapolated," "evergreen" computer-generated indexes, which must be "bootstrapped" from prior, human-created indexes already seeded with an "expert's articulation," "domain expertise," "judgment," and the ability "to distinguish between the important and the trivial." Moreover, he argues that social computing needs "expert members" and "harbingers" (the latter a kind of expert frontier scout). Mediated by the "tireless work of the machines," the "hard work of the few" can thus guide the "light work of the many." How does modular writing fit in with such a vision of expert judgment? In short, it doesn't. Or, at least, the fit is far from clean. Given the controversy attending such Web 2.0 "collective intelligence" sites as Digg (Stefik's example) or Wikipedia (with its vandalism, revert wars, delete wars, etc.), modular writing is surely one of the greatest single challenges to expert judgment. After all, modular writing is of a piece—which is to say, pieces—with the posting, commenting, tagging, and other particulate writing practices of collective unintelligence that Jaron Lanier (2006), a first-generation digerati, criticizes for creating "the anonymous, faux-authoritative, anti-contextual brew of the Wikipedia," where (some) stupidly aggregate articles lack the overall judgment of the traditional "author."

So, another formal paradox—but in reverse. Whereas Foster's essay form lags behind the progressive side of his argument about "ten thousand enthusiasts," Stefik's modular form is avant-garde in relation to the conservative side of his argument about expert judgment.

D'Iorio and Barbera are a philosopher and computer engineer, respectively,

whose essay deliberately recalls one of the oldest, most canonical forms of Western knowledge: the Socratic dialogue. Unlike master Socrates and his mastered acolytes, however, D'Iorio and Barbera are equal partners in the exchange. This formal observation alone is telling because it reveals a paradox akin to those I observed in Foster and Stefik.

On the one hand, the Scholarsource humanistic research platform that D'Iorio and Barbera confabulate (a vaporware equivalent of Plato's myths of truth and love) will facilitate "quoting, consensus, and preservation" in order to retain the "conditions of possibility" of expert scholarship. The goal is to create "Open Scholarly Communities on the Web," allowing "specialists who work on a specific author or area of research" to extend the model of "the Accademia dei Lincei, l'Accademia del Cimento, Académie Française, the Royal Society," and (I would add) the Socratic academy. The goal, in other words, is "to transpose the whole structure and the scientific practices in human sciences onto an electronic environment," complete with the expert logic of "primary & secondary sources, expert opinions, textual stability, citations," and so on.

On the other hand, no one is more aware of the limitations of established academic expertise than D'Iorio himself, in his role in the dialogue as traditional scholar. Scholarship, he criticizes, has been "slow and expensive" to produce and to access; collaboration has not been scalable; and peer review and copyright have become monopoly franchises for publishers. As a result, D'Iorio and Barbera ultimately tilt their consensus toward the *open*. Indeed, they go Stefik one better in mythologizing the open information wilderness. They give the info-frontier the classical connotation of "barbarian" by concluding on a strong recommendation of Alessandro Baricco's book *The Barbarians*, which seems as antithetical to the older, expert notion of knowledge as it is possible to be. According to Baricco, as quoted by D'Iorio and Barbera, barbaric knowledge is "a different idea of what experience is . . . the surface rather than the depths, speed rather than consideration, sequences rather than analysis, surfing rather than in-depth study, communication rather than expression, multitasking rather than specialisation, pleasure rather than effort." (Compare Jean-François Lyotard on "pagan" knowledge [Lyotard and Thébaud 1985].) D'Iorio and Barbera's Socratic dialogue, we realize, is a trojan horse. While its form seems to respect classical knowledge, it actually contains the pent-up barbarism of Web 2.0 "collective intelligence," "the wisdom of the crowd," "hive mind," "long tail," and similar ways of captioning the new world of many-to-many knowledge. This is the real significance of D'Iorio and Barbera's equal status in their dialogue. "Sounds like social networks—myspace, ebay, wikipedia, youtube, del.icio.us, twine," says Barbera, playing the info-barbarian, in one of several such testaments to many-to-many Web 2.0,

open-source, and Semantic-Web *post*-expertise. D'Iorio and Barbera's dialogue is really the minimalist version of a *multi*-logue.

Thus, another formal paradox: a dialogue that at once nostalgically recalls academic philosophical knowledge but really prophesies a new informational blog-logue.

My formal assessment of Foster, Stefik, and D'Iorio and Barbera has not been complete or systematic. But it is enough to prompt a reflection on what I will call—coopting D'Iorio and Barbera's Kantian phrase—the "conditions of possibility" of the present volume of essays. (For Kant, after all, the forms of experience were constitutive of the epistemological conditions of possibility.)

Who actually is the *we* in a formulation like "we will really *know*"? I believe that the most important and most general problem for the academy in the next one to three intellectual generations—the problem to which all others are subordinate—will be to (re)invent the discourses, practices, and institutions needed to negotiate between *expert knowledge* and globally networked *public knowledge*. Only so can the conditions of possibility be created for a new *we* adequate to the world of new technologies now flourishing in the barbaric wilderness between experts and the public. *We* in the future will need discourses, practices, and institutions that show us how to know in ways that draw, for example, from both *Encyclopaedia Britannica* and Wikipedia.

After the extinction of classical, religious, and Enlightenment beliefs in universal knowledge, we remember, scholarly, analytical, technical, and managerial knowledges arose to span across fields, social sectors, and even nations with their illusion of a *professional* common knowledge called expertise. Bill Readings (1996) ironically called it value-free "excellent knowledge." More recently, we call it such things as the global knowledge economy, neoliberalism, or outsourcing (i.e., *we* in the First World thought we knew, but it turns out that *they* in subcontinental or far eastern Asia and other developing centers of knowledge work also know). Today, how shall *we* live knowledge in common? How can we do so when anything even vaguely smacking of professional, expert knowledge causes our kids—expert at info-tech in their own way, but far more vulnerable to the future global-knowledge economy—to say to their TiVo (as Case said to his Hosaka), "Off"?

This kind of question is not just technological but social, economic, political, psychological, cultural, and ethical. It's a harder puzzle than any addressed by Foster, Stefik, and D'Iorio and Barbera. Their essays are prescient on the techno-epistemological front. But they are just as remarkable for the social, economic, political, psychological, cultural, and ethical issues they do not address. Indeed, except for a few instances where the brute complications of the new raw, barbarian knowledge break

into view, the sheer number and scale of such problems not touched upon in part I of this volume of "essays" is amazing.

I am myself not Enlightenment enough to be confident that "we will know" or "make sense" of it all. I think that the nature of the *we* tragically constrains the possibilities of *know*. Yet I am far from standing against future information technologies, networks, media, and digital scholarship. That way lies the future, or not at all, and I have staked my own intellectual career on it. At a minimum, though, I would like to know how delegating the social, economic, political, psychological, cultural, and ethical issues of the *we* so entirely to technologism is not a gigantic euphemism that avoids the hardest, most intractable problems of *old* information technologies and social networks—the way, for example, that rich nations armed with the latest guns, missiles, satellites, and Internet continue to do a number on those (including their own subcultures) armed only with old ways of numbering themselves, their children, and all their generations as what counts in life.

How, actually, does part I of *Switching Codes* address the who, what, when, where, why, and how of making *we* into civilized people(s) able to know each other and our common, global future better? Or, if *actually* is unattainable in today's era of eternal beta releases, should not such issues at least be addressed ideally—as if experts like ourselves cared about the world that the new public blogs and wikis so passionately digg?

References

Barbrook, Richard, and Andy Cameron. N.d. (shorter versions dated 1995–1996). The Californian ideology: Extended mix version. Hypermedia Research Centre, School of Communication and Creative Industries, Westminster University, United Kingdom. http://www.hrc.wmin.ac.uk/hrc/theory/californianideo/main/t.4.2.html (accessed July 13, 2003).

Barlow, John Perry. 1996. A declaration of the independence of cyberspace. Electronic Frontier Foundation, http://www.eff.org/~barlow/Declaration-Final.html (accessed September 12, 2001).

Gibson, William. 1984. *Neuromancer.* New York: Ace.

Lanier, Jaron. 2006. Digital Maoism: The hazards of the new online collectivism. Edge Foundation, http://www.edge.org/3rd_culture/lanier06/lanier06_index.html (accessed September 9, 2006).

Lyotard, Jean-François, and Jean-Loup Thébaud. 1985. *Just gaming.* Trans. Wlad Godzich. Minneapolis: University of Minnesota Press.

Readings, Bill. 1996. *The university in ruins.* Cambridge, MA: Harvard University Press.

On Scholarship

Graham White

Setting the Scene

I am in a cooking equipment shop: I contemplate the ranks of obscure devices, wondering whether to buy anything. My recurring questions are these: Is this thing necessary, or can I simply use the traditional tools (knives, whisks, bowls) together with the appropriate skills? Is this a gadget—a complex device that can perform only one task—or a tool, a simple object that can be used, fluidly, in the complex pattern of human making? How much control would I have were I to use this thing? In summary: How would this expensive little item fit into the activity of cooking, performed, in a human way, by humans, for humans?

As with cooking, so with scholarship. Scholarship studies humans and human artifacts; but it also studies them in a human way, because our motives, in undertaking such study, are human ones. We study each other because we are concerned about each other and we cannot evade this concern. And I would contend that, despite the undeniable usefulness of some of the tools computers have given us, we still need to think more about *how* we should use computers in the humanities.

Direct Manipulation

D'Iorio and Barbera quite rightly describe the scholarly process as being governed by three norms: quoting, consensus, and preservation. However, underlying these norms is another set of concerns, which are, in their own right, just as important. The situation is this: scholarship in the human sciences is based on imprecise and incomplete evidence, and it advances from that evidence by using inferences which are rarely indefeasible. Consequently, scholars are at some pains to expose both the evidence and the inferential process on which they base their conclusions. Further discoveries can always overturn either evidence or inference, and so one must make clear just how much of one's conclusions such discoveries would invalidate. Rather than transparently present-

ing merely one's results, one cultivates a style of nontransparency, forcing the reader to recapitulate the inferential processes by which one reaches one's goal.

This attitude is somewhat alien to the current mentality of computer science. Most software design is based on a paradigm of direct manipulation (Schneidermann 1983): it is assumed that the purpose of software is to inspect, or to manipulate, the state of some system, and that this system is both finite and immediately accessible. Consequently, software should present this state as transparently as possible: a system of windows will, for example, display the state of a computer's file system visually, exposing it to direct manipulation—moving, creating, and deleting files by way of mouse clicks. This is possible because a file system is both finite and immediately accessible. The objects of the human sciences are not, however, in any effective sense, finite, and neither are they immediately accessible. We may have a goal of finding out, in Ranke's words, "how things really were," but that is, in practical terms, a limit, never to be actually attained, and at any time before the limit we are in the situation of never having immediate access to a finite object.

We do not have user interfaces that can deal adequately with this sort of nonimmediacy: it's not impossible, it is simply that nobody seems to have recognized the problem.

Cognitive Transparency

Here is a story. Google has a subsidiary index called "Google Hell," into which it puts sites that try to artificially inflate their page rank. Sites in Google Hell are very rarely returned in searches; some businesses have been adversely affected by this and are complaining. One of the grounds for their complaint is that "so many of the rules are vague" (Greenberg 2007).

Indeed they are: pages are apparently put into Google Hell as a result of numerical algorithms; what it presumably comes down to is that some numbers (in themselves not very meaningful) are above a certain threshold. What this process lacks is what has been called cognitive penetrability (Heal 1996): although the algorithms are specified, and although they seem to give plausible results, we cannot assign cognitive content either to the workings of the algorithm or to its intermediate results. Many of the algorithms described in Foster's section on "Automated Analysis"—for example, the automatic identification of genre—are susceptible to this sort of criticism. Latent semantic analysis, one of the most common of these algorithms, assigns to each document a sequence of numbers:[1] the first one or two correspond to prominent terms in the document and are usually quite easy to recognize cognitively, but once we go further down the sequence all hope of a cognitive interpretation is lost.

The Long Tail

Stefik remarks, in his essay, that people's interests follow what is called a *long-tailed distribution*: if we rank, for example, songs in order of popularity, sales of the relatively uncommon items decline much more slowly than they would if popularity were described by a *normal distribution* (the standard "bell curve"). A great deal of data in the humanities, from statistics of word use in language (Manning and Schütze 1999) to the lengths of messages in a chat room, is long-tailed. There are two things to remark here. First, long-tailed distributions are generally a sign of long-range correlations between data items: in terms of language, this corresponds to the fact that words can be linked by syntactic structures of arbitrary length (anaphora, for example, can extend across an entire discourse).

Second, despite some very interesting mathematical theory (Abe and Okamoto 2001), we have very few practical statistical tools for dealing with long-tailed distributions. Consequently, we are forced to deny the long-range correlations that clearly exist. For example, Manning and Schütze (1999, 193) speak of making "a *Markov Assumption* that only the prior local context—the last few words—affects the next word," and then remark, apologetically:

> For anyone from a linguistics background, the idea that we would choose to use a model of language structure which predicts the next word simply by examining the previous two words—with no reference to the structure of the sentence—seems almost preposterous. (1999, 194)

Essentially Contested Concepts

Foster talks of "the grand goal of encoding information as universal and unambiguous semantic statements"—something he admits is "unlikely to be realized any time soon." He also hints that automatic tools for "the synthesis of statements" may play a role in this, although he admits that "detect[ing] inconsistencies and ambiguities" may pose difficulties.

But apart from questions of feasibility, there are also problems with the potential success of such an exercise: the idea of *essentially contested concepts* (Gallie 1956) is one such. Essentially contested concepts are those "the proper use of which inevitably involves endless disputes about their proper uses on the part of their users." These concepts are typically evaluative or in some sense politically loaded: for an example, see the discussion of power in Allen (2005). They are *essentially* contested because any attempt to define them would involve attaining, or imposing, consensus on political or evaluative norms on which there is not (and likely cannot be) consensus.

Suppose that we had a machine for extracting meaning from text corpora. Suppose that it was loaded with positive feedback, in the way described by Stefik in his section 3.5.1, "Rating Information Socially," and that, because of these features, it always converged. Then we run it on the corpus of all human knowledge (the "scanning of entire libraries" that Foster promises). As if by magic, there are no more essentially contested concepts. Clearly this would be a radical (and probably not very desirable) transformation of human culture.

Conclusion

The developments described in the articles by Foster, Stefik, and D'Iorio and Barbera are interesting, exciting, and stimulating. Many of them are extremely welcome: they should make it possible for isolated scholars, without access to the great libraries of the world, to do research much more effectively and, in so doing, they could make the humanities more accessible and more egalitarian.

Compare this with the situation of the sixteenth-century humanists, who were faced with a flood of texts of previously forgotten classical sources. This brought problems: Which texts were correct? How could they be read in a way that was faithful to their authors, their languages, the cultures in which they originated? In response to these problems, the humanists developed two disciplines. The first was the technical activity of recovering, as far as possible, an original manuscript from a number of close or remote copies, and of recovering, from historical sources, the language spoken in them. The results of such activity were, even on the grammatical level, always defeasible (Schleiermacher 1977, 101ff.). The second discipline was a way of using this knowledge in such a way as to come to terms with its defeasibility.

We are clearly at the beginning of a qualitative transformation of the methods of scholarship. As with the humanists, we too need both components of scholarly activity. We need the technical machinery, which may be different from the traditional techniques of humanism. And we need to reflect on those new techniques in order to use them in a way that is faithful to their nature and their limitations.

First, we will still have defeasibility (and a good thing too, as the example of essentially contested concepts shows). Defeasibility comes from the statistics of our sources as much as anything else: long-tailed distributions are very often *scale-free* (that is, however large they are, they look the same). Correspondingly, however large a corpus you have, you will always find words in it that are so sparsely represented that you have no idea what they mean. Words like this are, frustratingly often, important words. This was a lesson that the early humanists learned. They had, of course,

much smaller corpora than we do, but because the statistics tend to be scale-free, corpus size probably has less significance than we think it does.

Second, we need some sort of cognitive grasp on methods such as latent semantic analysis. Things are not entirely hopeless here; Widdows (2004) and van Rijsbergen (2004) both address this problem and have interesting results.

Third, we need statistical methods which are well adapted to the sort of corpora that we have; we would like to have statistical tests of validity that do not make Markov assumptions. Abe and Okamoto (2001) is an interesting foundational work, but it is not usable as it stands.

Finally, we need user interface designs that are usable by humanists, that is, interfaces that do not aspire to the immediacy of a video game and are suited to representing essentially incomplete states of knowledge, with all of their limitations and defeasibility. D'Iorio and Barbera suggest that one should start by talking to our customers, the humanists. As with any interface design problem, this is the best way to start.

Note

1. To be technical, the numbers are the components of the vector representing the occurrences of terms in the document in a basis constructed from the singular vectors of the term-by-document matrix of the corpus.

References

Abe, Sumiyoshi, and Yuko Okamoto, eds. 2001. *Nonextensive statistical mechanics and its applications.* Berlin: Springer.

Allen, Amy. 2005. Feminist perspectives on power. In *The Stanford encyclopaedia of philosophy* (winter 2005 edition), ed. Edward N. Zalta. http://plato.stanford.edu/archives/win2005/entries/feminist-power/.

Gallie, W. B. 1956. Essentially contested concepts. *Proceedings of the Aristotelian Society* 56:167–98.

Grafton, Anthony. 1997. *The footnote: A curious history.* London: Faber and Faber.

Greenberg, Andy. 2007. Condemned to Google hell. *Forbes,* http://www.forbes.com/home/technology/2007/04/29/sanar-google-skyfacet-tech-cx_ag_0430googhell.html.

Heal, Jane. 1996. Simulation and cognitive penetrability. *Mind and language* 11:44–67.

Manning, Christopher G., and Hinrich Schütze. 1999. *Foundations of statistical natural language processing.* Cambridge, MA: MIT Press.

Schleiermacher, F. D. E. 1977. *Hermeneutik und Kritik.* Berlin: Suhrkamp.

Schneiderman, B. 1983. Direct manipulation: A step beyond programming languages. *IEEE Computer* 16 (8): 57–69.

van Rijsbergen, Keith. 2004. *The geometry of information retrieval.* Cambridge: Cambridge University Press.

Widdows, D. 2004. *Geometry and meaning.* Stanford, CA: CSLI.

Ontology, Semantic Web, Creativity

algorithms for detecting humans and human behavior

CEUSTERS AND SMITH

are not magical; they are

◄ GANASCIA ►

intelligence

BORGMANN

Switching Partners: Dancing with the Ontological Engineers

**WERNER CEUSTERS
AND BARRY SMITH**

> A certain measured, cadenced step,
> commonly called a "dancing step",
> which keeps time with, and as it
> were beats the measure of, the Music
> which accompanies and directs it,
> is the essential characteristic which
> distinguishes a dance from every
> other sort of motion.
> Adam Smith (1980 [1795])

"Ontology" is a term increasingly used in all areas of computer and informa-
tion science to denote, roughly, a hierarchically organized classification sys-
tem associated with a controlled, structured vocabulary that is designed to
serve the retrieval and integration of data. An ontology under this view is an
artifact whose purpose is to ensure that information about entities in some
domain is communicated successfully from one context to another, and this
despite differences in opinions about what is the case in that domain or dif-
ferences in the terminology used by the authors to describe the entities it
contains.

Ontologies are today being applied in almost every field where research
and administration depend upon the alignment of data of distributed prov-
enance. They are used, for example, by biologists to classify genes, toxins, and

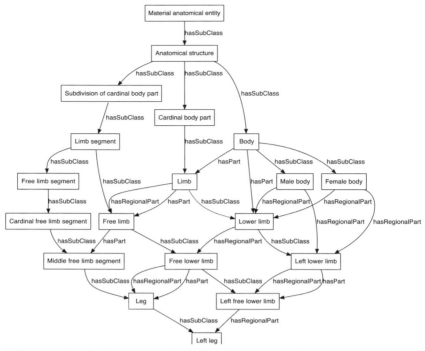

FIGURE 7. Classification of the entity "Left leg" in the Foundational Model of Anatomy.

proteins and by medical scientists to classify diseases, drugs, therapies, and body parts. An example of the latter is the Foundational Model of Anatomy (FMA), which is an ontology of normal adult human and mammalian anatomy. Figure 7 shows the classification of "Left leg" in the FMA, in which it is categorized, among other things, as being a body part that is part of the left lower limb of either a male or female body.

Ontologies are making inroads also in the wider culture. There is an explosion of so-called folksonomies used to tag images on the web. The CIDOC ontology is being used by museum authorities to classify cultural artifacts (Doerr 2003). Ontologies have also been developed to assist lawyers in resolving disputes over the nature of patent and copyright and in determining how different versions of musical or literary works are to be treated for purposes of intellectual property protection (Ceusters and Smith 2007).

Ontologies of the kind just sketched are primarily used directly by humans to perform some classification task, as, for example, to provide appropriate general descriptors for organizing scientific papers in a library collec-

tion. Users of the library, on the other hand, can use this same ontology to find papers on topics they are interested in. An example of this sort of ontology, for web pages rather than scientific papers, is the DMOZ ontology from the Open Directory Project (2007). However, ontologies are increasingly being designed to support computer-based services directly—that is, without human intervention. Among the earliest such applications were ontologies applied to text-mining tasks such as indexing, topic extraction, and summarization of information presented in textual format. Here we will focus on another illustration of the way in which ontologies are being used to help unlock the secrets of human culture, an illustration drawn from the domain of human bodily movements.

The Ontology of Motion

Our movements are being captured on video, and considerable resources are being invested in the development of techniques to extract information about them from the digital outputs of video surveillance cameras. Human movements can be classified, in the first place, from a purely kinematic point of view. But what are kinematically the same movements may still need to be classified in entirely different ways because they occur in different contexts. Consider a short movement of one lower leg crossing the other leg with the foot pointing outward. Such a movement can be part of a mannequin's step on the catwalk, an epileptic jerk, the kicking of a ball by a soccer player, a signal ("Get

out!") issued in heated conversation, or a "half cut" in Irish *Sean-nós* dancing (fig. 8). When we focus on dance movements, image classification is made all the more difficult by the fact that, while the kinematic phenomena which with we are dealing are constrained, in complex ways, by systems of rules, these rules are themselves artifacts of culture that are marked by complex spatial and temporal variations. Like the cultural

FIGURE 8. Irish *Sean-nós* dancer (right) doing a "half cut" with the right leg.

artifacts they govern, they are subject to a continuous process of evolution. A host of additional problems are created for software agents designed to "understand" what is displayed in video images, by the need to translate information about the changes in the pixel configurations that constitute such images into information about movements carried out by the corresponding entities in reality. Can ontological engineering help us to understand what dancing is all about? As a first step toward answering this question we shall explore some of the problems faced when we seek to create software to help the machine recognize what dance is being performed in a particular video.

Pushing the Boundaries of Information Retrieval

Dance has served throughout history as an important force for social cohesion, and public interest in social dancing is once again booming. Western Europe, in particular, is witnessing a huge revival of interest in folk dancing, meaning dance of a sort that is rooted in the culture of some population but has undergone certain characteristic families of changes in the course of time. These dances include especially those that in countries such as France, Belgium, Germany, and the Netherlands are called *bal folk* dances, in reference to the events at which they are performed. They comprise dances such as the polka, mazurka, Scottish, *an dro, hanter dro, bourrée, branle,* (old-time) waltz, *chapelloise* (Aleman's *marsj*), and *cercle circassien* and are becoming increasingly popular among dancers of all age groups, complementing a no less intensively burgeoning interest in modern "ballroom dancing"—the waltz, foxtrot, American tango, and so forth. Social dancing events such as *Le Grand Bal de l'Europe* in France, *Anddanças* in Portugal, *Gran Bal Trad* in Italy, and Dance Flurry in Saratoga Springs, New York, to mention just the most important ones, each attract several thousand dancers every year.[1]

There is clearly a need, supported by a broad and still growing community, to gain a better insight into this complex of dance cultures and associated traditions and also to make sure that it is preserved in its full richness for the future. Growing in tandem with this need is an enormous demand for more and better information about such dances, not only from individual dancers, dance organizations, and dance historians, but also from cultural agencies, libraries, tourist organizations, and dance teachers. Questions relate to the origins of these dances, to the rules governing their performance, to their variations across space and time, and thus also to the question of when a given dance can properly be referred to as "the same" as a dance popular some centuries earlier.

WERNER CEUSTERS AND BARRY SMITH

In answering such questions, traditional dance resources and archives fall short—and this is so even where the relevant information is made available online. If one is not an expert in dance history or choreography, which most social dancers are not, then it is nearly impossible to formulate a search question in such a way that the answers retrieved are relevant and useful to the individual dancer. Search engines that include video resources in their search space may, for example, perform well when it comes to retrieving videos in which a specific dance such as a Viennese waltz is displayed—but only if the user includes the exact term "Viennese waltz" in his query. This, however, supposes that the user already has command of the terminology relevant to the dance he is interested in and in the relevant language, something that is not always the case.

Search Scenarios

Google can readily provide images in response to search inputs such as "Werner Ceusters" or "Barry Smith." A much harder, and more interesting, challenge would be for a search engine to identify a user-submitted image as an image of Werner Ceusters or of Barry Smith. Can we, in similar vein, envisage a search engine able to analyze fragments of video, extracting information that would allow it to tell the user what the video depicts? Here are a few scenarios: A tourist bringing home video fragments of people dancing in a *fest-noz* in Brittany might like to know the name of the particular dance depicted so that he can pursue questions concerning its region of origin or choreography. Or a researcher studying the evolution of specific dances over time might wish to retrieve videos of dances with similar choreographies. More ambitiously, a historian might wish to assemble an entire evolutionary history of dances of a given type, with genealogical trees indicating influences. Or an American country dance choreographer might want to ensure that a commissioned creation is sufficiently different from what already exists in the genre in question; she would find it most helpful to be able to submit a video of her creation to an intelligent library that could match fragments of her choreography against other dances. Here again we address a characteristically ontological question: when do given dance fragments manifest the *same* choreography?

To exhibit useful sorts of behavior in response to such challenges the system would need to bridge the semantic gap between the information that the computer can extract from given multimedia material and the interpretation

that would be useful to a human user in a given situation (Smeulders et al. 2000; Roach et al. 2002). This gap is very large. Imagine a video fragment that shows a person walking in the direction of the camera. Not only does the analysis software need to identify the moving group of pixels as a person, it must also avoid misinterpreting its enlargement as the person moves toward the camera as the result of the person's growing larger. Bridging this gap seems to be achievable, but thus far only in certain very specific application domains, as for example a system that allows users to search for similar fragments in videos of soccer and tennis games (Izquierdo et al. 2004). The similarity of the fragments is computed automatically on the basis of visual features such as color and texture (Xu et al. 2004), a technique also used in the system described by Christmas et al. (2001), which also incorporated search facilities based on auditory clues. (When a goal is scored in a soccer game, at least part of the audience responds by shouting and applauding.) Similar achievements have been reported in relation to tennis videos (Dahyot et al. 2003) and news broadcasts (de Jong, Ordelman, and Huijbregts 2006). But however impressive these results may seem, the problems to be solved before applying the techniques to the domain of dancing remain enormous.

Setting the Research Agenda

These problems fall into at least two categories: one involves representing the domain of dancing in a way that can be understood by software agents; the second involves applying such representations to the semantic analysis of the sort of content provided by video images. The latter entails primarily engineering issues; the former, however, requires the ontological engineer to crack a hard historicosociocultural nut: in order to "represent" dancing in the computer, we must first have a good insight into what dancing is. Before addressing this question, we consider, first, the narrower, engineering-related problems involved in the software analysis of video content.

Challenges in Automatic Video Understanding

Automatic video understanding is a relatively new field for which the research agenda has been set only fairly recently. Cetin (2005) identified two "grand challenges" for video analysis: to develop applications that allow a natural, high-level interaction with multimedia databases, and to find adequate algorithms for detecting and interpreting humans and human behavior in vid-

eos that also contain audio and text information. A number of additional, intermediate-scale challenges relevant to successful human-behavior analysis have also been identified. Some of these, such as problems inherent to face detection, might at first seem irrelevant in the context of dancing. They turn out, however, to be of crucial importance, at least for dances of certain sorts. Facial expressions are in some cultures an intrinsic part of a dance; Argentine tango dancers, for example, tend to look rather serious on the dance floor, while ballroom champions invariably smile, though often in a way that is somewhat strained. Facial expressions might thus provide clues as to the sort of dance on display.

Automatic recognition of the type of dance displayed in a video requires facilities for detecting human bodies, their poses and postures, and their activities, and this in spite of manifold variations in background (including, for example, indoor and outdoor settings). It requires robust techniques to discriminate and track body parts (arms and legs) and to distinguish those belonging to one body from those belonging to another, despite the fact that members of a dancing couple or group often wear similar costumes. In fact, recognizing objects in still images and video remains an unresolved open problem in general and one of the main topics of research in content-based image retrieval (CBIR).

With respect to storage and retrieval, multimedia databases with semi-automatic or automatic natural interaction features do not exist. The ACM Multimedia Special Interest Group (SIG), created over ten years ago, recently identified two further grand challenges that are relevant to the analysis of dancing videos (Rowe and Jain 2005). The first is to make the authoring of complex multimedia publications as easy as using a word processor or drawing program; while high-quality software packages for a number of specific subtasks now exist, there is a conspicuous lack of seamless integration. The second is to make capturing, storing, finding, and using digital media everyday occurrences in our computing environment. The example provided, "*show me the shot in which Jay ordered Lexi to get the ball*," is of the same nature as the kind of services that would be needed with respect to dance. This request requires techniques that push paradigms such as motion-based classification and segmentation much further than those currently realized (IEEE Computer Society 2005). Because digital representations of bodily movement are nothing more than groups of pixels appearing and disappearing in sequence, recognizing such movements in isolation, or recognizing movement-sound complexes such as *tap, stomp, clap, scuff*, requires insight into how such phenom-

ena are captured in digital representations such as videos. Further aspects relevant for video analysis involve the ability to apprehend, classify, and track backgrounds, costumes, multiple couples, camera positions, and so forth. Feature extraction algorithms are as yet insufficiently mature to capture subtle differences between a "ground cut" and a "half cut" in Irish *Sean-nós* dancing, or a *polska* and a *hambo* turn in Swedish traditional dances. This is not only a matter of pixel granularity, which may be insufficient to capture the necessary detail (such as the foot movements of a particular couple dancing in a crowd), but also a problem of knowing what is there to be captured.

A system with the capacity just sketched should, ultimately, be able to recognize not only what dance is being performed but also whether the dancers depicted are experts or beginners. It should be able to identify the various phases of a dance (say, specific figures in a Scottish *ceilidh* or successive moves in a contra dance, or even short meaningful fragments such as a *pas de bourrée* in ballet). It should also be able to detect differences in style, distinguishing, for instance, between the old and the modern Sevillana dancing styles (both still danced socially today), between older *bourrées* (dating back some hundred years and now seen only in dance performances) and their modern counterparts, and between *bourrées* as they are danced in different parts of Europe. Clearly, such differences have to be clarified before video analysis becomes possible at this level at all—which brings us to the second, more properly ontological, challenge to be addressed, namely, what is dance, and how can dances be classified?

Challenges in Understanding Dancing

Dancing has been a subject of research for thousands of years and from a variety of different perspectives. The questions that interest us here concern (1) What is dancing and how can it be distinguished from other complex forms of human behavior (or combined therewith, as in the martial art *capoeira*)? and (2) How have specific dance types evolved culturally over time?

UNESCO classifies dance as belonging to the what it calls "intangible heritage," a term that, with the adoption of the Convention for the Safeguarding of the Intangible Cultural Heritage in 2003, superseded the older term "folklore" (UNESCO 2007).[2] The earlier, folklore model supported scholars and institutions in documenting and preserving a record of disappearing traditions. The intangible heritage model, by contrast, aims to sustain a living tradition by supporting the conditions necessary for cultural reproduction. This means ac-

cording value to the "carriers" and "transmitters" of traditions, as well as to their habitus and habitat.

A further dimension that enters here is that of socioeconomic factors. In the cultural experience of Europe, for example, as contrasted with the North American case, cultural forms were usually generated by and aimed at cultural elites, being transmitted to larger swaths of the population only gradually and after some elapse of time. This pattern constitutes the backbone of the European cultural tradition in domains as various as religion, music, eating habits, dress, manners, and daily life in general (Liehm 2002). And it holds too for dancing, which, although initially a focus of display within elite society, rapidly came to be appreciated across all levels of the social hierarchy. As we can learn from the history of social life and culture in Glasgow, for example, Scottish country dancing began as an elite activity whose refinements were overseen by various dance academies; the latter were, however, unable to keep pace with the "penny reel" gatherings that became increasingly popular at fair time. By the 1830s local householders were cashing in on the crowds attending Glasgow Fair by making their homes available for dances at a penny a time. Dancing was on its way to becoming a marketable commodity with mass appeal (King 1987). But as dances moved further from their cultural roots, there were inevitable clashes between traditionalists and innovators. As Trenner (1998) puts it, "Old-timers are motivated by their loyalty to the history of, the techniques of, and subtle sophistication of their forms. Newcomers are propelled by their enthusiasm, and will provide structure even when they have little information to guide them."

Dance, like culture in general, is always changing, and has to change in order to remain meaningful from one generation to the next. As current historiography teaches us, our past and our heritage are not things preserved for all eternity but processes that must constantly revalidate themselves. The successful, living aspects of culture produce new experiences for its users. Change in the way dances are performed is a matter not just of the passing of time but also of progressive delocalization—they are both a part of the identity of a region and incrementally evolving ingredients in a universal artistic language. They contribute, on the one hand, to the blossoming of cultural diversity and the enrichment of specific cultural identities, while on the other hand, their plasticity renders them capable of nourishing the dialogue between and intermingling of disparate cultures (Rouger and Dutertre 1996). Social dancing therefore forms one of the cultural areas that is best adapted to achieving the cultural objectives set out in the Treaty on European Union,

which include"contribut[ing] to the flowering of the cultures of the Member States, while respecting their national and regional diversity and at the same time bringing the common cultural heritage to the fore," and "encouraging cooperation between Member States and, if necessary, supporting and supplementing their action in the following areas: improvement of the knowledge and dissemination of the culture and history of the European peoples; conservation and safeguarding of cultural heritage of European significance; noncommercial cultural exchanges; artistic and literary creation, including in the audiovisual sector" (Article 151 [ex 128]).

"Ontologies" and "Ontology"

Earlier we presented a view of ontologies as representational artifacts that, when designed in appropriate ways, can help humans and software agents in performing classification tasks. The question here is whether they can also be used in the context of analyzing the content of dancing videos by bridging the semantic gap between pixel sequences and classificatory content. We will now present some reasons to believe that they can. Hakeem and Shah (2004) showed that for the analysis of videos of corporate board and project meetings, the most promising way to bridge the semantic gap is by using an ontology. To support analysis of video content in the domain of dance, we shall need to create two ontologies, the first describing real-world phenomena relevant for the domain of dancing itself, the second covering how these phenomena are exhibited in videos through image and sound. The former would require generic segments covering relevant aspects of human motion, more specific parts focused on the broad domain of dance motions, and still more detailed components relating to the sorts of dances contained in the collection from which information is to be retrieved, including temporal indexing to enable capture of historical aspects of the dances' evolution over time. Building ontologies of this level of complexity poses a challenge in its own right, as witnessed by numerous past mistakes (Ceusters and Smith 2003; Ceusters, Smith, and Goldberg 2005; Ceusters et al. 2004a, 2004b). It is here that "ontology" as a scientific discipline, rather than a computational artifact, comes into its own.

"Ontology" is of course a term having its roots in philosophy, where it means, roughly, the science of being. For a long time ontologists working on information systems ignored the fruits of ontological research in philosophy, and thus they often recommitted errors of a characteristically philosophical sort, above all by confusing the classification of entities in reality with the

├── WERNER CEUSTERS AND BARRY SMITH

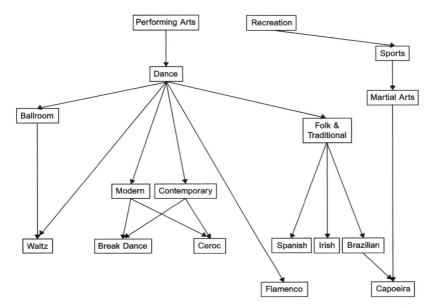

FIGURE 9. Part of the classification of "dance" in the Open Directory Project.

classification of words or data describing such entities. Increasingly, however, it is being recognized in at least certain circles of ontological engineering that data integration of a useful sort cannot be achieved merely by classifying the words or concepts that different groups of experts associate with different types of data. The problems created by the differences in word usage among such groups are indeed precisely what need to be solved with the aid of ontologies.

In addition, ontology builders often fail to take into account the fine details that are needed in order to make their representations conform to what is the case in reality, or they resort to representational languages or systems that are insufficiently expressive to capture such details. An example is the classification of "dance" in the Open Directory Project mentioned above, a small portion of which is shown in figure 9. There are several questions that might be raised here:

- Is a waltz just a ballroom dance? (Apparently not, as it is found in many of what ODP calls "folk and traditional dances" too.)
- Can all dancing activities be considered to be performances, let alone works of (performing) art?

- Why distinguish between *modern* and *contemporary* dance if the subtypes of the former are all and only subtypes of the latter?
- Why are "waltz" and "flamenco" classified twice—once directly and once indirectly, under "dance"?
- Can only *capoeira* be danced for recreational purposes ?
- How can a particular event be at the same time an instance of a dance and of a martial art?

Other, more fundamental questions, not clearly addressed in the ODP documentation: What precisely is being classified here? Actual instances of dancing (datable performances) or general types? As danced within a single culture or community, or across all of human culture? In a single era or throughout human history? To avoid building ontologies that lead to questions of this sort, a mechanism for making clear what the terms in the ontology are actually about—that is, what they represent on the side of reality—is imperative, as also is a clear account of the relation between the ontology and what it describes.

Ontology and Dance

With respect to dance ontology, relevant work has been done by philosophers such as Roman Ingarden, whose *Ontology of the Work of Art* (1989) treats in succession the ontology of musical works, pictorial images, architecture, and film on the basis of a general ontological theory of the structure of the work of art that distinguishes strictly between the work itself as a complex stratified object that is neither physical nor mental, and its various realizations in readings, performances, or physical artifacts. For present purposes it is Ingarden's treatment of the work of music that is of most direct relevance. Here we can distinguish between the work itself, the score, the various performances, and the concretizations of the work in the experiences of listeners. For Ingarden it is important that the work itself, even though it is a bearer of identity from one realization to the next (and a benchmark for the faithfulness or adequacy of such realizations), nonetheless has a history (what Ingarden calls a "life"), encompassing changes, for example, in performance style, instrumentation technology, and interpretations.

Of more direct relevance is the work of movement theorists such as François Delsarte, Frederick Matthias Alexander, Émile Jaques Dalcroze and Rudolph von Laban, all of whom developed influential techniques for thinking about movement. Delsarte was interested in enhancing dance pose and

gesture through an understanding of the natural laws governing bodily move-
ment. To that end, he carefully studied aspects of human gesture in every-
day life and compiled records of thousands of gestures, each identified with
specific descriptions of its time, motion, space and meaning (Shawn 1974).
Alexander was an actor responsible for the educational process that is today
called the Alexander Technique, a method of helping people learn to free up
their habitual motor reactions through improvement of kinesthetic judgment
(1989). Laban was an Austrian-born architect, philosopher, and choreographer
who developed a sophisticated system of movement observation and descrip-
tion (Laban Movement Analysis, or LMA) that enables the observer to identify
and articulate what parts of the body move, and when, where, and how they
move. The body's relation to "space," "shape," and "effort" (or inner impulses)
are some of its primary elements, but in contrast to other methods LMA places
no emphasis on which movement quality or shape is desirable from aesthetic
or other perspectives (Hutchinson 1991).

Such movement analysis and annotation methods can be used to write
out dances, an activity that is called choreology, methodologies for which
were developed not only by Laban but also by Feuillet, Stepanov (Nijinsky),
and Benesh. As an example, Benesh developed a purely kinetic language that
allows positions, steps, and other movements to be directly represented, in-
cluding movements of multiple dancers involved in complex dance produc-
tions. Not only can the reader see the movements that are written in a score,
the mode of recording is sufficiently realistic that they can also be felt motori-
cally. The advantage of using a purely kinetic method for describing dance and
movement is that it is the movement itself that is conveyed, rather than some
analytical, functional, scientific, or poetic verbal description (Benesh and Ben-
esh 1983).

From the scientific perspective, folk or social dancing has generally been
considered to be an incidental part of musicology and thus has attracted little
attention from scholars, who have seen it as lacking the prestige enjoyed by
other aspects of musical life. Thus far, research in dance history has been
primarily focused on dance culture during single epochs, for example, in re-
lation to important political events such as the Congress of Vienna of 1815.
This has made it very difficult to gain a clear understanding of the continuity
or discontinuity in dance culture from one epoch or culture to another. It is
indeed much easier to compile statistics about the numbers of dancers active
at given times and in limited geographical areas than to gauge differences and
similarities between, say, waltz choreography today and at different times in

the past. Even state-of-the-art research such as has been published by Monika Fink (1996), Richard Semmens (2004), or Jean-Michel Guilcher (2004) fall far short of conveying an adequate picture of how dance nomenclature and terminology have evolved and whether or not the changes have adequately reflected the simultaneous evolution of the dance types being studied. In addition, most projects have focused on individual dance practitioners. And because the results have been published mostly in the form of printed collections, such as Valerie Preston-Dunlop's *Dance Words* (1995), they cannot be searched efficiently, nor are they very useful for the analysis of dance practice, as they tend to be colored by historically and culturally specific theories of what dance should be, rather than what it actually is, or was at specific stages in the past.

There is clearly room here for a more objective analysis that can be tested against the real-world needs of large communities of interested persons and in a way that will not only contribute to the quality and quantity of information available online but also yield deeper scientific insights, for example, as concern global patterns in transmission of cultural phenotypes from one generation to the next.

Ontologies for Video Analysis, Indexing, and Retrieval

An important component of future tools for video image understanding will be the ability to make decisions based on a progressively closer approximation to a correct analysis of complex motions based on successively more refined hypotheses as to the activities involved. Recent work has investigated the application of hidden Markov models (HMMs) in a layered approach to the recognition of individual and group actions on the basis of multimodal recordings (McCowan et al. 2005). In this approach, a first layer integrates modalities and recognizes low-level elements such as motion patterns and tempo. A second layer takes likelihoods from the lower layer as input features, integrates them with features coming from audio analysis, and generates hypotheses as to the nature of the actions involved, for instance, the type of dance being performed by a group and the level of expertise of the dancers. Initially, simplifying assumptions are made, which then need to be relaxed in order to address the complexities of real situations. In particular, combinations of activities may change over time, sometimes gradually, sometimes abruptly. The system must recognize and adapt to these changes. Predictive platforms have to learn to respond to such changes efficiently. Also, prediction algorithms need to

be able to infer actions in the presence of multiple persons engaging in the multiple sorts of complex actions that are involved in any given instance of social dancing.

Achieving efficiencies of this sort will involve the use of algorithms that can evolve in light of lessons learned in successive applications. Examples of such approaches include applying high-level learning algorithms like neural networks (Gurney 2002), reinforcement learning (Mozer 2005), semisupervised learning of Bayesian network classifiers, and case-based reasoning in complex environmental settings (Cohen et al. 2004). Though each such approach can form the basis of the resolution of certain tasks that will be required in a powerful dance analysis system, none as yet achieves high-level recognition specifically targeting dancing events. Practical applications thus far are limited to areas such as video surveillance in railway stations (Cupillard et al. 2004), banks (Georis et al. 2004), or combat areas (Kalukin 2005), where the goal is to assess automatically coarse-grained phenomena such as crowding, blocking of entries, vandalism, and so forth. But these applications take advantage of the fact that video-surveillance cameras work with more or less fixed backgrounds and under conditions where it suffices to detect large-scale movements. The requirements for identifying what sorts of dances are being recorded on video are more demanding, though progress toward the necessary fine-grained analysis is being made. Kiranyaz et al. (2003), for example, describe a system that is capable of indexing domain-independent large image databases, and that allows retrieval via search and query techniques based on semantic and visual features. In the professional annotation module of the BUSMAN system, an advanced interface for automatic and manual image annotation has been developed, although the automatic annotation functionality is mainly based on low-level descriptors such as simple shapes, colors, and textures (Waddington 2004). MediaArchive, from Blue Order (2007), is a powerful industrial archiving system allowing storage and retrieval of any media files and is currently used by several major broadcasters across Europe to give users access to their collections. However, much research is still required, the coordination of which is being attempted in Europe by SCHEMA, the Network of Excellence in Content-Based Semantic Scene Analysis and Information Retrieval (Kompatsiaris 2004).

Specifically ontological contributions to video annotation include that of Nevatia, Hobbs, and Bolles (2004), which describes an event ontology framework, a formal representation language, and ontologies for the security and meeting domains. However, the representations of the domains selected are

highly simplified, and each of the developed ontologies contains not more than a dozen entities. Clearly, the framework needs to be refined in such a way as to be applicable to much more complex events, and the ontologies need to be expanded significantly. Also extremely small in design is the TRECVID 2005 "ontology," which works with only ten entities (Over 2006). The same applies to the Large Scale Concept Ontology for Multimedia (LSCOM), a work in progress developed by IBM in concert with Carnegie Mellon University, Columbia University, and the University of California, Santa Barbara. LSCOM envisages an ontology of the order of some one thousand entities, given that this ontology is designed to be used for "understanding" the entirety of news broadcast content (J. Smith et al. 2005).

Moving in the direction of more structurally coherent ontologies, Bremond et al. (2004) developed a video event ontology consisting of representations of entities of two main types: physical objects in an observed scene and states and events occurring in the scene. The former are divided into *static objects* (a desk, a machine) and *mobile objects* detected by a vision routine (a person, a car); the latter, into (static) primitive and composite *states* and (dynamic) primitive and composite *events*. The authors use logical and spatial constraints to specify the physical objects involved in a scene and also temporal constraints, including Allen's interval algebra operators, to describe relations, for example, of temporal order. The result serves as a framework for building two ontologies for visual monitoring of banks and metro stations using ORION's Scenario Description Language.

A comprehensive review of existing content-based retrieval systems and video retrieval literature is provided by Izquierdo (2003), and several such systems are now available for use. For example, Query by Image Content (QBIC) (IBM Corporation 2007), an image-retrieval system developed by IBM, is currently in use at the Hermitage Museum for its online gallery (State Hermitage Museum 2003).

To make an endeavor of this magnitude succeed—that is, to make it possible to extract low-level (e.g., kinetic) features from videos in such a way that they can be combined into constructs of a higher order corresponding to bodily movements and gestures—requires that the varying existing multimedia standards be bridged by ontology standards. Several recommendations issued by the World Wide Web Consortium, above all the Resource Description Framework (RDF) and the Ontology Web Language (OWL), have a role to play from the ontological point of view in realizing this goal, but these languages are not yet sufficiently mature to be usable for the representation of complex

spatial-temporal detail of the sort entailed in the challenges at issue here. They are also not yet easily combinable with the multimedia standards developed by the International Standards Organisation (ISO) and the International Electrotechnical Commission (IEC), such as JPEG 2000, MPEG-4, MPEG-7, and MPEG-21, when dealing with issues such as storage, transmission, and editing of still and video images. Some of these standards are versatile enough to accommodate some of the multimedia access services described above, but much work still needs to be done. Currently, audiovisual content described with MPEG-7 elements (description schemes and descriptors) are expressed solely in the language known as XML Schema. The latter has been ideal for expressing the syntax, structural, cardinality, and data-typing constraints required by MPEG-7. It has also been used to build a preliminary dance ontology based on Labanotation (Hatol 2006). However, in order to make the descriptions accessible, reusable, and interoperable with other domains, the semantics of the MPEG-7 metadata terms need to be expressed in an ontology using a language like OWL. Therefore, new specific data types geared to multimedia content and media-specific data types have to be proposed. A first attempt to build a dance movement ontology called DVSM (Dance Video Semantics Model), is proposed by Ramadoss and Rajkumar (2007); the goal of the authors is to use this ontology in the context of video annotation, but it should be applicable also to some of the other scenarios described above.

Toward a Semantic Web–Based Infrastructure for Experience-Based Search and Retrieval for Multimedia Dance Resources

Delivery of and access to audiovisual content is a business that has accounted for a significant percentage of the world's gross domestic product in recent years and that continues to expand. Current stocks of audiovisual content are growing at an exponential rate, and multimedia services are becoming increasingly sophisticated and heterogeneous. On the consumer side, video on demand, copying, and redistribution, as well as retrieval and browsing through video portals such as those offered by Google, Yahoo, and YouTube, are becoming progressively more popular. Although this development brings increased revenue for the telecommunications and content-provider industry, it also brings a challenging task: to deliver customized functionalities for fast query, retrieval, and access.

Building a digital repository and related analysis, search, and retrieval tools for the domain of video representations of dance is indeed only a small

fragment of the totality of what is required to meet this global challenge. Tackling this narrow fragment will, however, involve addressing many of the same technical problems as need to be addressed on the broader front and will surely bring valuable lessons. It will also improve our knowledge of and access to an important aspect of our cultural heritage and lead to better research and education in this area. As an example: why are culturally educated people not at all shocked when, in the 1954 film version of *Brigadoon,* English contradance choreographies are used to represent and evoke a Scottish dance event, or when a mazurka and non-Regency quadrille are danced in the 1940 film *Pride and Prejudice?* The latter is no less an anachronism than Monet paintings or Rolex watches would be in a film about the life of Mozart. Nevertheless, the former pass unnoticed, while the latter would be considered an insult to our historical consciousness. Stimulating a systematic quest for data and analyses of collected data around dance culture will help to rectify this situation, with broader consequences for our level of sophistication about our own historical past.

The system would be a tremendous help for analyzing both the form (the danced steps) and the ways in which this form becomes meaningful to its users (the meanings found, for example, in ethnic and national dances). As such, it will further contribute to the critical reevaluation of dance, and through dance, of our wider cultural heritage. Dances can be illustrative of the cultural trajectories, influences, fashions, and traditions of an entire continent. Understanding and learning the dances of an alien culture can help us to understand this culture in new ways. A system with the capacities that we described will also foster the development of new traditions by bringing to our attention cultural influences that may be both temporally and spatially distant: looking at pictures of the waltz as danced in the nineteenth century can give us new ideas as to how to dance it today, how it is related to other dances, and so on.

Conclusion

Developments that would allow video search in areas such as dancing cross disciplinary boundaries, particularly those between the arts and humanities, on the one hand, and technology, on the other. Innovative ideas can only derive from a tight integration of professionals from different fields; appropriate state-of-the-art technology cannot simply be put to use by end users but must be designed with them and for them. As research and publication increasingly

move to the Internet, so research materials have to become more accessible via computerized interfaces, and research in the arts and humanities has to become more efficient. Software applications such as the ones envisaged here will enable speedier recovery of data and facilitate its analysis in ways that will assist both archiving of and research on dance. The ontologies that have to be produced as the basis for such software applications should be made openly accessible to researchers. Research questions raised in conjunction with such developments can be adapted to other fields, hopefully also with innovative results. Indeed, the vision algorithms and theories that have to be developed to make such searches possible can be reused for other scientific and practical purposes in all contexts where a video corpus has to be analyzed and queried.

Notes

1. For *Le Grand Bal de l'Europe*, see http://gennetines.org; for *Andanças*, http://www.pedexumbo.com; for *Gran Bal Trad*, http://www.granbaltrad.it/en/indexen.html; and for Dance Flurry, http://www.danceflurry.org (accessed October 30–November 1, 2007).

2. The convention, adopted by the thirty-second session of the UNESCO General Conference, defines intangible heritage as including creations originating in a given community and based on oral traditions, customs, languages, music, rituals, festivities, traditional medicine and pharmacopoeia, the culinary arts, and all kinds of special skills connected with material aspects of culture, such as those involving tools and habitat.

References

Alexander, F. Matthias, ed. 1989. *The Alexander Technique: The essential writings of F. Matthias Alexander*. Ed. E. Maisel. New York: Citadel Press.

Benesh, Rudolf, and Joan Benesh. 1983. *Reading dance: The birth of choreology*. London: Souvenir Press.

Blue Order. 2007. *Media archive*. http://www.blue-order.com/products_media_archive_professional.html (accessed November 1, 2007).

Bremond, François, Nicolas Maillot, Monique Thonnat, and Van-Thinh Vu. 2004. Ontologies for video events. Sophia-Antipolis, France: Unité de recherche INRIA.

Cetin, E. 2005. Interim report on progress with respect to partial solutions, gaps in know-how and intermediate challenges of the NoE MUSCLE. http://www.cs.bilkent.edu.tr/~ismaila/MUSCLEWP11.htm (accessed June 29, 2010).

Ceusters, Werner, and Barry Smith. 2003. Ontology and medical terminology: Why descriptions logics are not enough. Towards an Electronic Patient Record (TEPR 2003) (conference), San Antonio.

———. 2007. Referent tracking for digital rights management. *International Journal of Metadata, Semantics and Ontologies* 2 (1): 45–53.

Ceusters, Werner, Barry Smith, and Louis Goldberg. 2005. A terminological and ontological analysis of the NCI Thesaurus. *Methods of Information in Medicine* 44:498–507.

Ceusters, Werner, Barry Smith, Anand Kumar, and Christoffel Dhaen. 2004a. Mistakes in medical ontologies: Where do they come from and how can they be detected? In *Ontologies in Medicine: Studies in Health Technology and Informatics*, ed. D. M. Pisanelli. Amsterdam: IOS Press.

———. 2004b. Ontology-based error detection in SNOMED-CT®. In *MEDINFO 2004*, ed. M. Fieschi, E. Coiera, and Y.-C. J. Li. Amsterdam: IOS Press.

Christmas, William J., Josef Kittler, Dimitri Koubaroulis, Barbara Levienaise-Obadia, and Kieron Messer. 2001. Generation of semantic cues for sports video annotation. International Workshop on Information Retrieval, Oulu, Finland.

Cohen, I., N. Sebe, F. G. Cozman, M. C. Cirelo, and T. S. Huang. 2004. Semi-supervised learning of classifiers: Theory and algorithm for Bayesian network classifiers and applications to human-computer interaction. *IEEE Transactions on Pattern Analysis and Machine Intelligence* 26 (12):1553–67.

Cupillard, F., A. Avanzi, F. Brémond, and M. Thonnat. 2004. Video understanding for metro surveillance. IEEE ICNSC special session on Intelligent Transportation Systems, Taiwan.

Dahyot, Rozenn, Anil Kokaram, Niall Rea, and Hugh Denman. 2003. Joint audio visual retrieval for tennis broadcasts. *Proceedings of the International Conference on Acoustics, Speech, and Signal Processing (ICASSP '03)*.

de Jong, F. M. G., R. J. F. Ordelman, and M. A. H. Huijbregts. 2006. Automated speech and audio analysis for semantic access to multimedia. *First International Conference on Semantic and Digital Media Technologies, SAMT 2006, Lecture Notes in Computer Science 4306*. Athens: Springer Verlag.

Doerr, Martin. 2003. The CIDOC conceptual reference module: An ontological approach to semantic interoperability of metadata. *AI Magazine Archive* 24 (3):75–92.

Fink, Monika. 1996. *Der Ball: Eine Kulturgeschichte des Gesellschaftstanzes im 18. und 19. Jahrhundert*. Innsbruck: Bibliotheca Musicologica.

Georis, B., M. Mazière, F. Brémond, and M. Thonnat. 2004. A video interpretation platform applied to bank agency monitoring. Intelligent Distributed Surveillance Systems Workshop, London, UK.

Guilcher, Jean-Michel. 2004. *La contredanse: Un tournant dans l'histoire française de la danse, territoires de la danse*. Paris: Complexe.

Gurney, K. 2002. *An introduction to neural networks*. New York: Routledge.

Hakeem, Asaad, and Mubarak Shah. 2004. Ontology and taxonomy collaborated framework for meeting classification. *Proceedings of the 17th International Conference on Pattern Recognition (ICPR'04)*.

Hatol, J. 2006. MovementXML: A representation of semantics of human movement based on Labanotation. School of Interactive Arts and Technology, Simon Fraser University.

Hutchinson, Ann, ed. 1991. *Labanotation: The system of analyzing and recording movement*. 3rd ed. New York: Routledge/Theatre Arts Books.

IBM Corporation. 2007. IBM's Query by Image Content. http://wwwqbic.almaden.ibm.com (accessed October 29, 2007).

IEEE Computer Society. 2005. 7th IEEE Workshop on Applications of Computer Vision/IEEE Workshop on Motion and Video Computing, Breckenridge, CO, January 5–7, 2005.

Ingarden, Roman. 1989. *The ontology of the work of art*. Trans. Raymond Meyer with Jon T. Goldthwait. Athens: Ohio University Press.

Izquierdo, E. 2003. State of the art in content-based analysis, indexing and retrieval. IST-2001-32795 SCHEMA Del 2.1, February 2005.

Izquierdo, Ebroul, Ivan Damnjanovic, Paulo Villegas, Li-Qun Xu, and Stephan Herrmann. 2004. Bringing user satisfaction to media access: The IST BUSMAN Project. *Proceedings of the Information Visualisation, Eighth International Conference on (IV'04)*. IEEE Computer Society.

Kalukin, Andrew. 2005. Automating camera surveillance for social control and military domination. *Online Journal*, http://www.onlinejournal.org/Special_Reports/042905Ka lukin/042905kalukin.html.

King, Elspeth. 1987. Popular culture in Glasgow. In *The working class in Glasgow, 1750–1914*, ed. R. A. Cage. Kent: Croom Helm.

Kiranyaz, S., K. Caglar, E. Guldogan, O. Guldogan, and M. Gabbouj. 2003. MUVIS: A content-based multimedia indexing and retrieval framework. Third International Workshop on Content-Based Multimedia Indexing (CBMI 2003), Rennes, France.

Kompatsiaris, I. 2004. The SCHEMA NoE reference system. Workshop on "Novel Technologies for Digital Preservation, Information Processing and Access to Cultural Heritage Collections," Ormylia, Greece.

Liehm, Anthony J. 2002. The cultural exception: Why? http://www.kinema.uwaterloo.ca/ liehm962.htm (accessed October 29, 2007).

McCowan, Iain, Daniel Gatica-Perez, Samy Bengio, Guillaume Lathoud, M Barnard, and Dong Zhang. 2005. Automatic analysis of multimodal group actions in meetings. *Pattern Analysis and Machine Intelligence* 27 (3): 305–17.

Mozer, M. C. 2005. Lessons from an adaptive house. In *Smart environments: Technologies, protocols, and applications*, ed. D. C. R. Das. Hoboken, NJ: J. Wiley & Sons.

Nevatia, R., J. Hobbs, and B. Bolles. 2004. An ontology for video event representation. Computer Vision and Pattern Recognition Workshop.

Open Directory Project. 2007. http://www.dmoz.org (accessed October 30, 2007).

Over, Paul. 2006. Guidelines for the TRECVID 2005 evaluation, 24 Jan 2006. http://www-nlpir.nist.gov/projects/tv2005/tv2005.html.

Preston-Dunlop, Valerie. 1995. *Dance words*. Newark: Harwood Academic/Gordon & Breach.

Ramadoss, B., and K. Rajkumar. 2007. Modeling and annotating the expressive semantics of dance videos. *International Journal of Information Technologies and Knowledge* 1:137–46.

Roach, M., J. Mason, L.-Q. Xu, and Fred W. M. Stentiford. 2002. Recent trends in video analysis: A taxonomy of video classification problems. 6th IASTED International Conference on Internet and Multimedia Systems and Applications, Hawaii.

Rouger, Jany, and Jean-François Dutertre. 1996. The traditional musics in Europe: The modernity of traditional music. In *Music, culture and society in Europe*, ed. P. Rutten. Brussels: European Music Office.

Rowe, Lawrence A., and Ramesh Jain. 2005. ACM SIGMM retreat report on future directions in multimedia research. *ACM Transactions on Multimedia Computing, Communications, and Applications (TOMCCAP)* 1 (1): 3–13.

Semmens, Richard. 2004. *The "bals publics" at the Paris Opera in the eighteenth century*. Hilsdale, NY: Pendragon Press.

Shawn, Ted. 1974. *Every little movement: A book about François Delsarte*. New York: Dance Horizons.

Smeulders, Arnold W. M., Marcel Worring, Simone Santini, Amarnath Gupta, and Ramesh Jain. 2000. Content-based image retrieval at the end of the early years. *IEEE Transactions on Pattern Analysis and Machine Intelligence* 22 (12): 1349–80.

Smith, Adam. 1980 [1795]. *Essays on philosophical subjects*. Oxford: Oxford University Press.

Smith, John R., Murray Campbell, Milind Naphade, Apostol Natsev, and Jelena Tesic. 2005. Learning and classification of semantic concepts in broadcast video. International Conference on Intelligence Analysis, McLean, VA.

State Hermitage Museum. 2003. Digital collection. http://www.hermitagemuseum.org/fcgi-bin/db2www/qbicSearch.mac/qbic?selLang=English (accessed November 1, 2007).

Trenner, Daniel. 1998. Modern social tango: The changing of the codes. http://www.danieltrenner.com/daniel/ar_codes.html (accessed November 1, 2007).

UNESCO. 2007. Intangible heritage. http://portal.unesco.org/culture/en/ev.php-URL_ID=2225&URL_DO=DO_TOPIC&URL_SECTION=201.html (accessed November 1, 2007).

Waddington, Simon. 2004. The BUSMAN Project. *IEEE Communications Engineer*, August/September, 40–43.

Xu, Li-Qun, Paulo Villegas, M. Diez, Ebroul Izquierdo, Stephan Herrmann, V. Bottreau, Ivan Damnjanovic, and D. Papworth. 2004. A user-centred system for end-to-end secure multimedia content delivery: From content annotation to consumer consumption. Third International Conference, CIVR 2004, Dublin, Ireland, July.

The Semantic Web from the Bottom Up

JAMES HENDLER

I discovered the word "relevate" a few years ago and loved it on sight. According to my *Oxford English Dictionary*, the adjective "relevant" and the verb "relevate" derive from the same source. Thus, "to relevate" is to make something relevant. A modern usage of the term is the claim that the World Wide Web *relevated* hypertext—that is, it took what was a relatively obscure academic discipline and made it extremely *relevant* to modern life, in fact, changing society in many important ways. The relevation of hypertext, with the advent of the web search engine, has in turn relevated the field of information retrieval.

The minute I learned this word, I realized that what the field of knowledge representation (KR) needed was relevation.[1] Since that time, I've argued in a number of papers and talks that research in the Semantic Web could potentially relevate artificial intelligence (AI) in the way that the web did information retrieval, maybe not to the same phenomenal degree, but well beyond what many of us have expected of the field. In this essay, however, I'm going to go beyond that, arguing that many of our assumptions about how we represent knowledge for processing by computers have held us back from really understanding human use of knowledge and have hindered the relevation of artificial intelligence in many ways. (In fact, though I focus on the AI subdiscipline of knowledge representation and reasoning (KR&R), I believe the arguments go way beyond that area, a point I will return to later.)

Knowledge Representation and the World Wide Web

In March 2000 I cochaired a workshop entitled "Semantics for the Web." Bringing together researchers from both the AI and the web communities, this

AI and the Web

- Many characteristics of the Web violate traditional AI assumptions
 - —It's Large and It Grows Fast
 - —Lack of Referential Integrity
 - —High Variety in Quality of Knowledge
 - —Diversity of Content
 - —Unknown/unpredictable Use Scenarios for the Knowledge
 - —Problems of Trust, No Single Authority
 - —Knowledge Acquired, not engineered

FIGURE 10. Slide by Frank van Harmelen, based on a breakout session at the workshop "Semantics for the Web," March 2000.

meeting explored the design of knowledge representation languages for the web, discussed what sort of tools would be required to use them, and defined some of the principles of what we now call the Semantic Web.[2]

During this workshop, I participated in a breakout session, chaired by Frank van Harmelen, that discussed the challenges AI would face in dealing with knowledge on the web. Figure 10 is one of the slides Frank made to summarize the results of our discussion.

Basically, what the group realized was that the use of knowledge on the web, whether encoded in a machine-readable KR language or somehow learned by extraction from the natural language in the documents on the web, was not going to fit neatly into the assumptions typically made about KR&R in the AI community. These assumptions, dating from the early days of AI, are nicely summarized in McCarthy and Hayes's seminal article "Some Philosophical Problems from the Standpoint of Artificial Intelligence," which is often cited as having laid the groundwork for the "logicist" approach to knowledge representation. They wrote:

> We shall say that an entity is intelligent if it has an adequate model of the world (including the intellectual world of mathematics, understanding of its own goals and other mental processes), if it is clever enough to answer a wide variety of questions on the basis of this model, if it can get additional information from the external world when required, and can perform such tasks in the external world as

JAMES HENDLER

its goals demand and its physical abilities permit. . . . The first task is to define even a naive, common-sense view of the world precisely enough to program a computer to act accordingly. (1969, 4)

(They went on to say, extremely presciently, "This is a very difficult task in itself.")

Inherent in this definition, accepted in much of the work that followed, is that intelligence is defined with respect to the world model of a single entity. The goal of building the knowledge for this entity, and thus the representations that support it, was to provide a single, high-quality, reliable model of the world. As Brachman and Schmolze put it in their paper describing KL-ONE, a well-known early KR system, "KL-One is intended to represent general conceptual information and is typically used in the knowledge base of a single reasoning entity" (1985, 173).

On the web, however, where information is created by many different people in many different contexts, it became clear that the knowledge would neither create a neat model nor represent a single point of view. As we observed at that meeting, the web had over a billion pages and was growing at an amazing speed (by an order of magnitude or two in the decade that followed). Anything that tried to represent the knowledge of even a small proportion of the web would need to be able to handle growth and change and would far exceed the scale of the sorts of knowledge being built into traditional AI reasoners.

But worse than the scale of the knowledge were its features. There would be variety in the quality of the knowledge entered, variety in the types of subjects and contents, and no single guiding principle that would make it possible to trust the knowledge. Even worse, if two different documents used the same term, there would be no way to guarantee they referred to the same thing. While this was a well-known issue from the earliest days of knowledge representation, it came out in spades on the web—no subtle issues like "morning star" versus "evening star," but in-your-face issues like the meaning of the phrase "this web page" or a referent like "Bob." In short, the knowledge would need to come not from knowledge engineers, with the connotation of engineering design, but from a wide variety of sources of unknown quality and type.

Figure 11 discusses some of the reasoning challenges that result from these characteristics of KR on the web. It was clear that any reasoning agent that was going to try to function in this environment would face a number of problems. Both the reasoning algorithms used and the infrastructure for pro-

Challenges to AI on the web

- Some of the resulting challenges for AI
 - —Scalability of Individual Reasoners
 - —Scalability of Infrastructure
 - —Local Containment of Inconsistencies
 - —Distribution of Knowledge and servers
 - —Dealing With Unreliability
 - —Knowledge Quality
 - —Pragmatic/context-dependency

FIGURE 11. A second slide based on the March 2000 breakout session.the Web," March 2000.

viding that reasoning would need to be highly scalable—a billion documents hold a lot of facts. More importantly, it was eminently clear that there was no way that this knowledge could be kept consistent. The issue would not be truth-maintenance, but establishing any truth at all. Of course, this wouldn't be the first time AI researchers or logicians had attempted to deal with inconsistency, but the sheer scale would be far beyond anything explored previously. On the web there would be real disagreements (when does "life" begin?), there would be deliberate falsehoods (if asserting a contradiction would get you the money, what an opportunity!), and there would be just plain errors ("Did I say 'Bob'? Phooey, I meant it was Joe who gave me the book"). If inconsistency couldn't be contained, and reasoning couldn't deal with unreliable knowledge, then this web AI stuff would never work.

These characteristics and challenges have led to a lot of different research trends in the Semantic Web, which I won't go into here.[3] Rather, I want to make the point that this approach to exploiting knowledge was held by our group to be a departure from traditional research in knowledge representation and reasoning, one of the key areas of AI research over the past five decades. This web AI was antithetical to the very stuff of which KR&R was made!

Knowledge Representation on the Web

One of the problems with the ubiquity and importance of the web is that it is often hard to tell the marketing from the meat. The trend that has come to be

known as "Web 2.0" (perhaps unfortunately) started from a fairly specific core of technologies (essentially Web Services and Ajax) but became the name by which almost everything new and exciting on the web was called. Wikipedia, Flickr, the "blogosphere," social networking sites, and YouTube, to name just a few, have been associated with this so-called next-generation Web. (It's worth noting that Tim Berners-Lee, as you can read in his book *Weaving the Web*, included such applications in his original web vision, so they might more aptly be considered the realization of the original "Web 1.0" and not a succeeding generation of technology, but such is the marketing needed to make things happen in Silicon Valley.)

From an AI point of view, the most interesting thing about "Web 2.0" applications has been the use of tagging technology as a means of associating keywords with nontextual items. Photo and video sites have taken great advantage of this approach, as have social bookmarking approaches (like del. icio.us) and various players in the wiki and blogging space. "Ahh," cried the critics, "the Semantic Web is overkill. Folksonomies and social processes are all we need to make this work." Perhaps they were right, that is, up to a point.

And that point is being reached now. In retrospect it seems obvious to many (and to many in the KR community it was obvious from the beginning) that this was a technology that can only scale to a certain level. Here's a simple thought experiment. Supposing one was to take every photograph in Flickr and tag it with all the text needed to capture every concept in the photo—the "thousand words" that the picture is worth. Then take the tens of millions of these photo documents and ask how you might search among them based on these keywords. Sounds a lot like what Google was created for, doesn't it? So how, one could ask, would these unstructured, undisambiguated, nonsemantically aligned keywords somehow create, as many of their advocates claimed they would, a naturally occurring semantics that would challenge the rule of the keyword-based search engine. Up to a certain size the statistics look great and work well (clustering was a key to early "Web 2.0" successes), but beyond that size, making statistical retrieval work for language is nontrivial (and a mainstay of many of AI's human-language technology researchers, for whom the claims of the taggers never held water). In short, the taggers are learning one of the recurring themes of AI: that which looks easy in the small is often much harder in the large.

That said, I must admit that those of us pushing AI on the web also had a lot to learn from "Web 2.0." Clay Shirky, for example, who I believe has been wrong in almost every one of his criticisms of the Semantic Web, got one thing

right—he realized that the social aspects of these new applications were critical to their success. The need to organize knowledge in some formal way, such as the expressive ontologies so dear to us in the AI community, is only one way to approach things, especially when there are social processes in place to help one navigate the tangled mess that the Web provides. To use just one specific example, as an information retrieval challenge YouTube is a disaster, but as a way of spreading video in a viral way across the social structures of the World Wide Web, it is an unmatched success.

For many AI researchers, this social part of the web really is like the dark side of the moon. We're so used to thinking that "knowledge is power" that we fall into a slippery slope, "more is better" fallacy. If some expressivity is good, lots must be great, and in some cases this is correct. What we forget, however, is something I've been saying for so long that it's become sort of a catchphrase in Semantic Web circles: "a little semantics goes a long way." In fact, something I'm just now beginning to understand is exactly how little is needed to go a long way on something as mind-boggling huge, broad, and unorganized as the World Wide Web.

A key realization that arose in the the design of the Resource Description Framework, the basis for the Semantic Web, is that having unique names for different terms, with a social convention for precisely differentiating them, could in and of itself be an important addition to the web. If you and I decide that we will use the term "http://www.cs.rpi.edu/~hendler/elephant" to designate some particular entity, then it really doesn't matter what the other blind men think it is; they won't be confused when they use the natural-language term "elephant," which is not even close, lexigraphically, to the longer term you and I are using. And if they choose to use their own URI, "http://www.other.blind.guys.org/elephant" it won't get confused with ours.

The trick comes, of course, as we try to make these things more interoperable. It would be nice if someone from outside could figure out (and, even better, assert in some machine-readable way) that these two URIs really designate the same thing—or different things, or different parts of the same thing, or . . . notice how quickly we reach that slippery slope. If we want to include all the ways we could talk about how these things relate, we're back to rediscovering knowledge representation in all its glory (and the morass of reasoning issues that come with). But what if we stop short of allowing every sort of relation. Suppose we simply go with "same" or "different." Sounds pretty boring, and not at all precise—certainly not something that is going to get you an article in an AI journal.

But now let's move to the web. Whenever a user creates a blog entry in livejournal.com, a small machine-readable description becomes available through a somewhat minimal person ontology called FOAF (for "friend of a friend"). I read recently that livejournal has amassed about twenty million of these FOAF entries. There are other blogging and social networking sites that also create FOAF files, accounting for at least fifty million little machine-readable web documents. And FOAF contains a small little piece of OWL, the Semantic Web ontology language, which says that if two entries have the same e-mail address, they should be assumed to be by the same person. This one little piece of "same" information suddenly allows a lot of interoperability and a jump start for many kinds of data-mining applications. The rule may not be 100 percent correct, but then on the web, what is?

Believe it or not, several startup companies appear to have become quite successful by using this rule, and other, similar assertions about equality (or inequality), to create personal information-management tools for web data or to match advertising to web users (such matching is the biggest moneymaker on the web, starting to outpace even pornography, the early leader). By being able to, even heuristically, equate things found in different web applications, a whole range of mash-ups and other web applications becomes possible. A very little piece of semantics, multiplied by the billions of things it can be applied to on the web, can be a lot of power.

There's more to this "bottom-up" story that gets into technical aspects of web application development. New Semantic Web standards, such as the SPARQL query language or the GRDDL mechanism for adding semantic annotations to XHTML pages, make it much easier to embed these little bits of semantics into other web applications (including those of "Web 2.0"). So while funding from places like DARPA and the NSF in the United States, and from the European Union's IST program, has been looking at what we might call the "high end" of the Semantic Web, the leading edge of the web world has been bumping into the "low end" and finding useful solutions available in the RDF and OWL world.

Expert systems, the attempt to build AI systems that could do complex reasoning in narrow domains, never really made it as a stand-alone technology, but they were far more successful when appropriately embedded in other applications (Pat Winston is frequently quoted as referring to AI as the "raisins in the raisin bread"). Semantic Web developers are beginning to understand that our technology can similarly gain use by being successfully embedded into the somewhat chaotic, but always exciting, world of web applications.

This opens up a brand-new playground for us to explore largely unexamined approaches in which a little AI, coupled with the very "long tail" of the web, opens up new and exciting possibilities for a very different class of (just a little bit) intelligent systems.

But Is It AI?

So what's the problem? If web AI is different than traditional AI, that's no big deal. After all, the web is different from just about anything that came before it. Or is it? After all, where did that stuff on the web come from? It wasn't created *ex nihilo* by some omniscient information giver. It grew from the interaction of human beings sharing information via a new medium; in other words, the medium is new, but the information and the features of the knowledge are not.

Consider the knowledge that is used by humans as they wander this complex world of ours. It is hard to believe that this information is somehow engineered in the vein of the ontologies described elsewhere in this book, with their careful definition of information contexts and logical contexts. It doesn't seem like the essence of human communication is encapsulated in the mathematical bidding systems dear to the distributed multiagent AI researchers. While there are certainly probabilistic aspects, it is hard to believe that our choice of a favorite TV show or whom to marry is based solely on some kind of Bayesian maximization of expected utility. These may all factor into what we are, who we are, and how we think, but they seem to miss the essence of what it is to be an intelligent entity making use of complex information in a difficult and changing world.

In fact, the information space in which we live, and the ways we interact with that vast welter of knowledge, seems more like web KR than like the sanitized version of reasoning in the thousands of papers presented at AI conferences over the years. Human knowledge and interactions are much more like the challenging AI we were identifying in that 2000 workshop. In short, human intelligence violates many of the traditional assumptions of the field of knowledge representation!

The bottom line is that the real world is a complicated place, and human intelligence evolved from dealing with it (and with other humans). Relevating AI will require building systems that can live in that messy space, helping people do what they need help doing. Whether one's specific AI research proclivities revolve around physical tasks, cognitive tasks, societal tasks, or some

But is it _AI_?

- What about **_human intelligence_**
 - It's Large and It Grows Fast
 - Lack of Referential Integrity
 - High Variety in Quality of Knowledge
 - Diversity of Content
 - Unknown/unpredictable Use Scenarios for Knowledge
 - Problems of Trust, No Single Authority
 - Knowledge acquired, not engineered

- Many characteristics of **_human intelligence_** violate traditional AI assumptions
 - It's time for us to face up to the real challenge!!

FIGURE 12. My slide in response to the previous two, from Flairs (2002).

combination thereof, we must all explore whether the simplifying assumptions that allowed us to achieve early progress are now holding us back. It's my contention that in most cases they are.

Relevate!

What can we do about this? If the assumptions that have defined the field to date are wrong, how do we begin to relax them without losing what rigor the field has been able to achieve? Is there an alternative to starting all over again?

Not too long before the field of artificial intelligence was born, there were some who felt the field of mathematics was splintering into too many subareas and that it had lost touch with the real world. One of those whose work has been seen as an important contribution to unifying the field, and to bringing the field of applied mathematics back to the fore, is John von Neumann, one of the fathers of modern computing. Reflecting on this accomplishment, he observed:

> Mathematical ideas originate in empirics. . . . But, once they are so conceived, the subject begins to live a peculiar life of its own and is better compared to a creative one, governed almost entirely by aesthetical motivations. . . . As a mathematical discipline travels, or after much abstract inbreeding, [it] is in danger of degeneration. . . . When-

ever this stage is reached, the only remedy seems to me to be the rejuvenating return to the source; the reinjection of more or less directly empirical ideas. (1947, 195)

I strongly believe that a critical step for the future of knowledge representation is for us to apply von Neumann's approach to mathematics to our field. We need to take his recommendation for the "reinjection of more or less directly empirical ideas" and see where they take us.

How can we do that? I think there are some obvious starting places. First and foremost, we need to revisit the area of cognitive AI, not *ab initio*, but using what we have learned in the pursuit of specialized intelligent tasks. When I first started in AI, discussion of human intelligence and how it could be modeled was an important part of the field. That, however, fell out of favor in the 1980s. The argument was often made that in developing flight technologies, trying to imitate the way birds fly turned out to be a mistake, and that it was non-bird-related experiments that led to sustained motorized flight and thence to the modern field of aerodynamics.[4] AI, the proponents of this argument said, was better off ignoring human capabilities and building specialized systems for particular tasks.

However, ignoring human intelligence comes at a price. Karen Sparck-Jones put it like this:

> Birds still do rather better in multifunctionality than any plane. The particular birds I had in mind were the smaller birds that migrate huge distances, which requires one sort of "keep going" flight capability, and also are superb at small fine-grained "quick change" capabilities. Swallows are an excellent example—they migrate between the UK and Africa (a nontrivial distance) but also have terrific local maneuverability in doing things like catching insects on the fly and, in a different way, in latching onto walls under eaves etc. to build their nests, alight at them to feed their young, etc., etc. . . . Making all due allowance for the necessary constraints imposed by size, there's no plane that can both fly bang-on straight long distance and do smart, small circles or alight on a slow, tiny half turn to clutch a vertical wall.[5]

In fact, the study of bird flight has become in the past decade or so a vigorous field, with many papers presented at aerodynamics conferences and other (non-biology-oriented) technical forums. The flight industry has come to real-

ize that new successes may require a better understanding of the properties of these amazing natural creatures who in many ways outperform the best engineers can build.

I believe that AI is in a similar situation with respect to human intelligence. We have the ability to vastly outperform humans in a number of narrow areas, for example, chess playing, proof generation, statistical reasoning, and information retrieval. But when it comes to applying these capabilities flexibly to new and unexpected problems, AI can't hold a candle to human capabilities. The original quest for "human-level AI" has succeeded, but only in carefully tailored domains, not in the wild.

So what are we looking at in this new empiricism? First and foremost, I think we must pay attention to scale. No one knows the number of concepts involved in human thought, and early estimates of thousands and later millions have now given way to numbers in the billions—but we are all just guessing. On the Semantic Web we're also guessing, but starting from a much higher number—some startups are talking about numbers in the billions, and that's just representing the data instances. When we look at ontologies per se, that is, documents where there is at least some definition of classes (as opposed to just instance data), Google finds over eighteen thousand files with the extension "owl," the great bulk of which appear to be ontology files in the web language OWL. Semantic search engines currently report over two million web files that contain information in RDF, RDF Schema, and OWL. So there is a lot out there.

A second factor is that of quality—or lack thereof. While there is no easy way to truly know what all these documents contain, there have been efforts to explore what kinds of ontologies they use and the expressivity of the knowledge bases involved (see Wang, Parsia, and Hendler 2006). Not surprisingly to those of us who've gotten used to web studies, the result is mixed. A few ontologies, like FOAF, are very heavily used. Many others are used only rarely—the long tail we are accustomed to in web studies. Also not surprising is the lack of correlation between quality and use. It would be hard to find someone who would defend FOAF, a very simple ontology with only a few classes, as a high-quality description of humans and their properties, yet it is the most widely used by a large margin. (I recently heard the estimate that as much as 60 percent of current Semantic Web content on the web is in FOAF or its derivatives.[6]) On the other hand, some very carefully constructed ontologies, such as the National Cancer Institute's Oncology Ontology, also have high usage. The NCI ontology uses more than fifty thousand classes to

describe many terms linked to cancer, its causes, treatments, studies, and so on. While the number of Semantic Web facts relating to NCI is far smaller than that for FOAF (any specialized ontology may be less likely to be used than any general one), the "provenance" of this ontology, coming as it does from a major US government laboratory, has helped to guarantee use. Many other high-quality ontologies, however, have had little or no pickup beyond the single project they were built for. And of course there are very many small, poorly crafted ontologies out there as well. (Why should the world of ontology publication be different from any other?)

The third thing to note is that the information in these ontologies and knowledge bases is often contradictory and even occasionally formally inconsistent. As an example, a crawl of the Semantic Web retrieves several documents that purport to include my age. Since these have originated over a decade, you can find my age to be anything from thirty-nine to "approaching fifty," to "I refuse to answer that question." Obviously these cannot all be true, and any reasoner that is unable to deal with inconsistent knowledge is going to be doomed if it tries to play on the web.

Of course, this latter point applies to me as well. When I go to human-readable web pages I can find pages that claim I am employed at the University of Maryland, Rensselaer Polytechnic Institute, and various other places. If you were trying to find me, you'd have some problem solving to do. These pages would direct you to many dated articles or abstracts that say where I was at a particular time. In this case, you would conclude, the problem is neither an attempt to deceive nor accidental error (both of which also occur on the web and Semantic Web) but an artifact of the way current search engines work (not distinguishing timeliness as a ranking factor).

What can we do about this? To start with, we must acknowledge that the real world is not the world that KR systems were built for. First, many of them have behaviors that don't scale well. In the attempt to provide greater expressivity, they have forfeited performance. When the knowledge base (or A-box, as it is sometimes called) gets very large—though nowhere near the billions of concepts mentioned above—these reasoners could produce great answers, but often not until after the query had become irrelevant (in many cases, long after the querier had died of old age).

Second, most KR systems are built on the assumption that the knowledge is high in quality, and the tools they employ are usually geared only to creating high-quality ontologies. Great care and energy are put into the "knowledge engineering" of these systems. Unfortunately, once they are opened to the real

world that no longer applies. No one can really explain why some ontologies like FOAF (or, by contrast, NCI) are more successful than others, but it is certainly not the case that quality always wins out.

Finally, reiterating an earlier point, most traditional KR systems are based on first-order logics where (P AND NOT P) IMPLIES Q. Again, welcome to the real world. When we have disagreement, error, and deceit (all of which are hallmarks of systems with large numbers of humans pursuing multiple goals), we'd better have a more robust infrastructure. Otherwise, I beg you to visit the web page where I say "my age is 20" and "my age is 50," and see if you can prove that you owe me a lot of money (small, unmarked bills please). The embarrassing conclusion is that in many years of KR we have not really attacked major problems as a whole. Individual solutions have explored scaling, quality, and inconsistency issues, but when these issues arise together, and at huge scale, we really have no clear road map. We need a different approach to the underlying formalisms, and the technologies they enable, that attacks rather than ignores these critical features of human interaction.

Launching the Attack

If we want to build a new generation of KR systems that will explore these issues, what do we need to do? To start with, we must acknowledge that the problems described above mandate a complex and multifaceted approach. Some knowledge-processing tasks require expressive and complete reasoning. However many, and maybe most, don't. Similarly, for almost any KR technique, symbolic or numeric, there are problems for which it is well suited and problems for which it is not. As KR researchers, we all too often try to find problems that fit our solutions, rather than the other way around.

One approach, and that which I am exploring in my own research, is to take a much more "bottom-up" look at the problem. We are generating large knowledge bases of information that can be tied to simple ontologies (like the FOAF data). One way to do this is by finding existing Semantic Web data and building large collections of it. Since there are other groups doing this at the same time, it's becoming easier and easier to find this sort of information—a community effort to share these can be found on the web.[7]

Once one starts contemplating these large and heterogeneous Semantic Web databases, one realizes that different kinds of tools may be needed at different times. For example, data from specific biological experiments are best approached by using expressive ontologies and traditional reasoners, while

the millions of available FOAF files are better attacked with simple reasoners applied broadly. What is needed to process this large and messy mix of data is, for lack of a better term, an "ecosystem" of reasoners that can work together in concert, processing different kind of data in different ways.

From that point of departure arise many interesting problems. How does a more expressive reasoner ask a less expressive one for information? As a not totally apt analogy, think of the way you reformulate your questions if you want to know what happened in your preschooler's life. "What did Bobby do?" you might ask. Then, "What did you do after that?" "What did he do next?" "Why do you think he did that to you?" You're using (expressive) adult knowledge to ask your child to produce (inexpressive) information that you need. Once you have that information, you can react appropriately, calling Bobby's mother or disciplining your little one.

Of course, in other situations the roles are reversed. Your child asks a question, you reply, and the follow-on is, almost inevitably, "Why?" The child is asking you to turn your adult knowledge into a form that can be understood from a less expressive perspective. If your answer assumes things that are as yet unfathomable to the child, then the inevitable happens again.

Another aspect of this work, again mirrored in our everyday lives, is that the quality of the data must be questioned. In many cases, information gleaned from the web is far from perfect. In fact, in most web applications, an accuracy rate of 70 to 80 percent is considered very high. To deal with this sort of data, we need a different kind of reasoner—one that is markedly skeptical about what it is hearing. Do you believe every advertisement you see on television? Of course not—you've learned to compare and contrast evidence, figuring out what fits best into your worldview. There may be numeric aspects to this, but we must be careful; one good counterexample may outweigh a great many consistent observations, and current systems generally can't account for this.

Trying to build an architecture that allows multiple reasoners to cooperatively explore huge data sets containing information of mixed quality and certitude seems a daunting task. And it is. However, ignoring the complex for the sake of neat theories is not the way to learn more. We must change our research paradigms in response to the overwhelming evidence that, while the old way may be useful for some specific tasks, it is diverging further and further from human abilities and current technological needs. Approaching these hard problems head-on will be exactly what leads to the direct injection

of the empirical into our field, analogous to what von Neumann described for mathematics. In fact, I can think of no more fitting end to this essay than the words he used to end his:

> I am convinced that this was a necessary condition to conserve the freshness and the vitality of the subject and that this will remain equally true in the future.

Notes

1. My spelling checker immediately tried to change this word to "revelation"—while that may also be true, it is not the point of this essay.

2. See http://www.dagstuhl.de/00121/. Papers from this workshop were later published by MIT Press as *Spinning the Semantic Web* (Fensel et al. 2003).

3. For more on Semantic Web research from an artificial intelligence perspective see Hendler 2005.

4. This argument is actually somewhat fallacious. Several of the key researchers in the early days of flight, for example Lilienthal, did directly study birds and abstract some of the principles of lift, and others were motivated by work in hydrodynamics, which had indeed drawn some of its inspirations from the shape of fish. However, it is largely true that post–Wright Brothers aerodynamic engineering largely ignored birds until the past couple of decades.

5. E-mail correspondence, July 2006, quoted with the author's permission.

6. Jennifer Golbeck, "Social Networks on the Web," presentation at Rensselaer Polytechnic Institute, February 2006.

7. See http://esw.w3.org/topic/TaskForces/CommunityProjects/LinkingOpenData/DataSets.

References

Brachman, Ronald J., and James G. Schmolze. 1985. An overview of the KL-ONE knowledge representation system. *Cognitive Science* 9 (2): 171–216.

Crevier, Daniel. 1993. *AI: The tumultuous history of the search for artificial intelligence.* London and New York: Basic Books.

Fensel, Dieter, James Hendler, Henry Lieberman, and Wolfgang Wahlster, eds. 2003. *Spinning the Semantic Web.* Cambridge, MA: MIT Press.

Hendler, James. 2005. Knowledge is power: A view from the Semantic Web. *AI Magazine* 26 (4): 76-84.

McCarthy, John, and Patrick J. Hayes. 1969. Some philosophical problems from the standpoint of artificial intelligence. *Machine Intelligence* 4:463–502.

Neumann, John von. 1947. The mathematician. In *Works of the mind*, vol. 1. Ed. Robert B. Heywood. Chicago: University of Chicago Press.

Wang, Taowei David, Bijan Parsia, and James Hendler. 2006. A survey of the web ontology landscape. *Proceedings of the International Semantic Web Conference.*

Logical Induction, Machine Learning, and Human Creativity

JEAN-GABRIEL GANASCIA

Creative Machines

The ability of machines to create new ideas has long been controversial. In the mid-nineteenth century, Ada Byron-Lovelace argued that a computer was definitely not creative. As Lord Byron's daughter she was well placed to speak about creativity, and she is considered to be the first software engineer, as she wrote programs for Charles Babbage's analytical engine, which is considered to be the world's first computer. According to her, "The Analytical Engine has no pretensions whatever to originate any thing. It can do whatever we know how to order it to perform. It can follow analysis; but it has no power of anticipating any analytical relations or truths" (Menabrea 1843). One of the many commentators of this note, Alan Turing (1950), refuted the argument. For him, even Babbage's analytical engine, which was equivalent to a universal Turing machine, could be unpredictable, and therefore creative. Turing mentioned his own experience with the first electronic computers that were built in the 1940s: even a very simple program, written with a few lines of code, could show surprising behaviors when executed on a finite-state deterministic machine. It would have been possible—but tedious—for someone to replicate the machine activity by following step by step the execution of the program. Nevertheless, the general conduct of the machine is surprising. During the last fifty years, various attempts have been made to confirm Turing's argument by producing creative machines. There are, for instance, storytelling

machines (Turner 1992), automatic music composers (Cope 1991), and painting machines (Cohen).

Attempts to build creative machines have varied considerably (Buchanan 2001). The way to build creative machines, their capacity to originate interesting changes and novelties, and what creation means for a machine are still being debated. For instance, the first attempts to build an automatic music composer ranged from a stochastic approach built on probabilistic calculations, like the one developed by Iannis Xenakis, to a rule-based system similar to what Pierre Boulez was familiar with. But none was completely satisfactory, because artistic creation has to be simultaneously unpredictable, harmonious, and familiar. If a machine systematically applies the rules of harmony, we get a totally consistent musical composition, but a musical composition rapidly becomes disappointing if it contains no elements of surprise. On the other hand, a randomly generated piece that obeys no rules would have no real aesthetic value. Does such a thing as a systematic and general method somewhere between totally predetermined generation and purely random behavior exist? That is what I want to consider here.

To be more precise, the questions I will try to answer concern the status of creative processes and the possibility of reconstructing them on finite-state automatons, that is, computers. Does a logic of creation exist? If so, how could it help to build a creative machine? If we refuse to accept the existence of such logic, it would mean that creation is somehow magical, beyond any systematic and rational analysis. I think that this is not the case and that imagination, inventiveness, ingenuity, and original thinking may be broken down into logical steps that can be simulated by mechanical processes on a computer. The aim of some work in artificial intelligence is to provide empirical evidence to support this argument (Buchanan 2001; Boden 2004). This essay constitutes an attempt to justify it from a logical point of view and to analyze and define the logical status of creativity.

It is obvious that the logical inferences involved in creative abilities cannot be reduced to mere deduction (i.e., to inferences from the general to the particular), because deduction is by nature conservative, whereas creation corresponds to an increase in knowledge. The word "create," after all, comes from the Latin verb *crescere*, which means to grow; in other words, the output of a creative process has to contain more than was given as input. Inductive inference—inference from the particular to the general—could play a key role in creative activities. According to many classical views, induction is a process of generalization, a colligation of facts within a general

hypothesis that entails the loss of all of the specificities of the particular. In other words, induction corresponds to a reduction in knowledge. For induction to play a key role in creative activities would therefore be somewhat of a paradox. However, as we shall see, symbolic machine learning brings out the importance of two other mechanisms that are concerned not with the loss of information but with conceptual mapping and structural matching. Even if most classical philosophical theories of induction do not refer to conceptual mapping and structural matching, practical induction, as it was theorized in Aristotelian natural science (Aristotle 1989), made use of those operations. More precisely, in his introduction to biology, Aristotle describes parts of animals as functional parts that can be mapped onto a functional representation of a living entity and matched with respect to this representation. For instance, wings, legs, and fins can be matched with respect to locomotion. Lastly, psychologists have mentioned the role of conceptual mapping in creativity. Among them, Annette Karmiloff-Smith (1990) has shown that young children need an explicit, though not necessarily conscious, underlying structural representation in order to draw imaginary pictures, tell stories, or play music.

This essay investigates the role of conceptual mapping and structural matching in inductive reasoning in machine learning and in creativity and is divided into five parts. The first is an inventory of artificial intelligence theories of creativity, the second an overview of the classical theories of inductive reasoning. The third presents structural induction in symbolic artificial intelligence; the fourth, inductive logic programming, which simulates induction by inverting deduction; and the last, the analogy between structural induction and Aristotelian induction as practiced in Aristotelian biology.

Artificial Creativity

Ever since the origin of artificial intelligence, there have been different attempts to design creative machines, each of which has been grounded on a more or less explicit model of creativity. These models can be classified into four paradigmatic categories:

- *exploratory*: creativity requires abilities to explore and to find a path through a labyrinth;
- *mathematical*: a creative proof makes explicit some elements that were absent—or only implicit—in the initial formulation;
- *entropy-based*: since the goal is to compress information, i.e., to reduce

entropy, interestingness is related to an unusual and surprising way of reducing information; and

- *compositional*: imagination combines chunks of remembering in a way that is relevant.

Each of these models has its own particularities, which are briefly presented below.

The Exploratory Model

One of the pioneers of artificial intelligence, Herbert Simon, pictured problem solving as the exploration of a labyrinth that can be automated on a computer (Simon 1957). In other words, a problem is viewed as an obstacle on our natural path. Note that the word "problem" comes from the Greek root *probléma*, which means obstacle: it is derived from *proballein*, literally *pro*, "forward," and *ballein*, "to throw"—that is, to throw forward. According to Simon, problem solvers have to find a path in an abstract description of the problem universe, called the problem space, from an initial state to a state satisfying the desired goal. As expressed, problem solving is analogous to finding one's way in a maze of intricate passageways and blind alleys. Usually, the problem space is so large that it cannot be described exhaustively, even by a powerful computer. Intelligent behavior, either natural or artificial, eliminates many paths and leads quickly to the goal, without investigating all other possibilities. Artificial intelligence makes use of heuristics—tricks and rules encoding insight—to simulate such intelligent behaviors.

Simon did not restrict problem solving to games, mathematics, or physics. He thought that all creative behaviors were primarily based on problem-solving abilities. One of his first papers, "The Process of Creative Thinking," coauthored with Alan Newell and Clifford Shaw (Simon 1979), was an attempt to assimilate creativity to problem solving. During the rest of his career, Simon tried to develope creative machines with automatic problem solvers; he also encouraged much research in this direction and was the promoter of "scientific discovery." This area of research, whose main figures are Pat Langley (1987), Jan Zytkow, and Douglas Lenat (Davis and Lenat 1982), aims at a rational reconstruction of old scientific discoveries in a way that could be reproduced by a computer.

The Mathematical Model

According to Simon and many other artificial intelligence scientists, creativity is the ability to move efficiently around a huge, intricate labyrinth. Assimi-

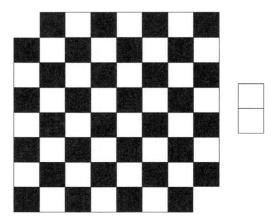

FIGURE 13. The "mutilated checkerboard" and a domino.

lating creativity to the exploration of conceptual space presupposes that the support of the search (that is, the conceptual space) has already been given. In many cases, however, and especially in mathematics, creative behavior consists not only in searching intelligently through a given conceptual space, but also in producing new ideas on which new conceptual spaces are built. Some artificial intelligence researchers, most of whom have been mathematicians and logicians, defined creativity as the capacity to reformulate a problem in a new way that makes the solution appear easy.

To illustrate this, let us take the "mutilated checkerboard" problem, as described by John McCarthy (1999): given an eight-by-eight checkerboard from which the two corner squares of one diagonal have been removed (fig. 13), the problem is to cover the board with exactly thirty-one dominos. To list all the possible combinations of dominos on this checkerboard would take a very long time, even with a computer. The classical solution would be to color in the board and the dominos with alternating black and white squares. It immediately becomes apparent that, due to the mutilation, the number of white squares on the checkerboard differs from the number of black ones, the reason being that the two removed squares lie on the same diagonal and therefore have the same color. But each domino has one black half and one white half, for a total of thirty-one white and thirty-one black squares. Once the color of the squares has been given, then, it can be elegantly demonstrated that it is impossible to cover the checkerboard with dominos.

A creative mathematical demonstration thus shows up a new concept

that was not present in the initial formulation of the problem, like the color in the resolution of the mutilated checkerboard problem. Would a machine be able to reformulate such problems spontaneously and efficiently? That is the question researchers like Saul Amarel (1986), Marvin Minsky, John McCarthy (1999), and Shmuel Winograd have tried to answer. For instance, in the case of the mutilated checkerboard problem, they imagined many solutions that could have been automated without coloring the checkerboard. Each of these, however, depended on a creative reformulation that was not automatically derived from the initial formulation. In a word, even though the best among the artificial intelligence researchers tackled the problem of the automatic generation of new formulations, very few results were obtained.

The Entropy-based (Compression) Model

Over the last few years, some researchers who were originally physicists have been trying to unify artificial intelligence in the same way that physics has been (Hutter 2005), since it would be useful to have a general theory that interprets all the problems with which artificial intelligence deals. In pursuit of this end, they have reduced automated decision making and machine learning to information-compression problems. In both cases, this means summarizing huge amounts of data using a small formula that can regenerate the data and extract their meaning. These researchers conceive truth as an ideal world of optimal and irreducible simplicity. If we have huge sets of data, the natural goal is to simplify it as much as possible, which, since simplicity is the rule, would in turn anticipate new data flow. But if the challenge is to reduce information, once a set of information has been totally simplified it is of no great interest, since there is no more hope of reducing it further. Consider, for instance, a sequence of 97,000 typographic characters. If it is composed of only one character, say, 97,000 occurrences of the letter *a*, it can easily be simplified, but it is not exactly fascinating. If instead those 97,000 characters have been randomly generated, there is no hope of simplifying them, and the result is no more interesting than in the first case. Let us now suppose, however, that this sequence of 97,000 characters corresponds to William Shakespeare's *Macbeth*. It cannot be reduced easily, but the reader continues to pursue a better understanding of the tragedy. More generally, intricate data motivates those who imagine possible reductions. As a result, interestingness can be viewed as the promise of a possible reduction.

According to this view, creativity can be envisaged in two ways: it may be either the ability to generate interesting data, with the hope of further reduc-

tion, or the simplification of existing data in an original and efficient manner that was not previously imagined. In both cases, the key concept on which interestingness (i.e., the hope of reduction) is based is the Kolmogorov complexity of a number or a sequence that is the size of the smallest computer program able to generate it. From a theoretical point of view, Kolmogorov complexity is a perfect heuristic for problem solving and, consequently, for the simulation of creative behavior. However, there is no means to compute it. As a consequence, it remains a theoretical concept that is of no help to anyone wanting to build an effective and efficient creative machine.

The Compositional Model

The last paradigmatic model of creativity is based on what people call imagination, which is a combination of remembered chunks. This model is anchored on memory, identified with a faculty of recollection (and not, in this meaning, reducible to any storage device). To be more precise, memory is understood here in its psychological sense, as the ability to forget and to recall facts or anecdotes by evoking features associated with them, as, for instance, when the taste of the *madeleine* recalls a past episode in the work of Marcel Proust. According to this view, creative activities are not magical; they are, indeed, very common in everyday life, where they help to solve new problems by retrieving old cases and then reusing and enriching past experiences.

The two basic mechanisms on which these memory-based creative activities are grounded are memory retrieval and case adaptation. The first concerns the memory indexes that allow one to retrieve past experiences. The second is a tweaking process that maps remembered episodes onto the present situation, then adapts and combines the cases to help solve a current problem. To illustrate this, let us consider some mythological creatures found in ancient bestiaries that are characteristic of this type of creativity: sphinxes, unicorns, Egyptian gods like Râ or Anubis (fig. 14). All these figures involve combining remembered elements to make strange new figures appear; creativity is viewed here as an ability to reuse remembrances of past experiences in new combinations. This compositional model of creativity would seem to underpin the development of actual creative machines, as can be seen in the following examples. Two of my students, Geber Ramalho and Pierre-Yves Rolland, and I worked a few years ago on an artificial jazz player, which was able to improvise a bass melodic line (Ramalho, Rolland, and Ganascia 1999). The context defined by the audience, the chord grid, and the other players (piano and drums) evoked abstract chunks of music in a memory simulated using

FIGURE 14. The Egyptian gods Râ and Anubis.

knowledge-representation techniques. The chunks were then assembled with respect to constraints defined by both the chord grid and the harmonic rules of music.

In almost all of the systems based on this compositional model, the tweaking mechanism relies on a structural matching between the old cases evoked by the context and the present situation. This structural matching itself makes use of conceptual mapping to find components that play similar roles in the old and present cases. These basic mechanisms have also been identified by psychologists (Boden 1995), who suggest that they play a key role in human creativity. And, as we shall see in the following section, they are involved in inductive reasoning as simulated using symbolic machine-learning techniques. The rest of this essay focuses mainly on these inductive mechanisms.

Induction

In the philosophical sense of the term, induction refers to the shift from the particular to the general. This definition, however, seems rather restrictive with respect to the general meaning of induction, which is reasoning through experience. Philosophers have taken this on board: traditionally they distinguish two types of inductive reasoning, one of which starts from the particular and moves to the general, the other of which moves from the particular to

the particular. Since the aim here is to understand the role that inductive—or, more generally, nondeductive—inference plays in creativity, and since it has been shown that creativity is at least partially related to analogy, that is, to reasoning from particular to particular, it is impossible not to speak about the role of induction understood as reasoning from the particular to the particular when analyzing creative abilities.

However, three questions still need to be discussed. The first concerns the logical status of induction as an inference: Is it certain or just conjectural? Does it correspond to some mechanical inference, like deduction, to a specific kind of syllogism that can be mechanized, or to an inversion of deduction, which would be nondeterministic? The second is related to the informational nature of induction: Is it only a matter of information removal and compression, that is, a reduction in the quantity of information? If so, it is difficult to imagine how induction could lead to the creation of information. The third question is about the evaluation of induction. Many people validate induced knowledge with respect to its predictive power. If, however, an induction is correct only if it anticipates correctly, then good induction would leave no room for surprise, and is that not an essential element of the ability to create?

Logical Status of Induction

Throughout the history of philosophy and logic, the status of induction has remained problematic. Since Aristotle, many philosophers, including Sir Francis Bacon (1561–1626), John Stuart Mill (1806–1873), Jules Lachelier (1832–1918), Rudolf Carnap (1891–1970), Jean Nicod (1893–1931), Carl Gustav Hempel (1905–1997), Nelson Goodman (1906–1998), and Jaakko Hintikka (1929–),have tried to legitimate induction as an inference, that is, a logical operation.

During the 1960s, with E. Gold's "identification to the limit" learning paradigm (Gold 1967), and more recently, with the "probably approximately correct" learning paradigm (Valiant 1984) or statistical learning theory (Vapnik 2000), many researchers have attempted to define the theoretical limitations of learning machines. These formal theories try to clarify the mathematical characteristics of mechanical inductive algorithms in computational terms, that is, in terms of inputs, outputs, and spatial versus temporal algorithmic complexity. In a way, they may be viewed as theories of inductive inference that are complementary to the inductive logics developed by Carnap, Hintikka, and others. Within these inductive inference theories, induction is viewed as an approximate inference the uncertainty of which continuously decreases with the number of observations. The mathematical properties of inductive

machines—the number of required examples, the number of features, the speed of convergence, and so on—are well addressed, but the logical status of induction with respect to deduction is not really determined.

Remember the debates about the relative position of induction compared to other inferences, in particular deduction. To simplify, let us look just at two important positions, the Aristotelian one, which considers induction as an inversion of deduction, and that of John Stuart Mill, for whom induction is a kind of deductive inference.

Although induction probably originated before his time, Aristotle was one of the first to have spoken of it and to have given it philosophical status, even if its place in his work was not that important. Syllogism lies at the heart of Aristotle's approach: the philosopher analyzed specific modes of reasoning such as refutation, abduction, *reductio ad absurdum*, *petitio principii*, in terms of syllogisms. It was in this context, which was the subject of book 2 of the *Prior Analytics*, that induction was considered (Aristotle 1989). Remember that a syllogistic inference contains a *premise* made up of two propositions, the *major* and the *minor*, and a *conclusion* made up of just one proposition. In valid syllogisms the major premises are usually general propositions, while the minor premises and the conclusions are particular propositions. Here is an illustration:

All swans are white Major
A, B, C, etc. are swans Minor
A, B, C, etc. are white Conclusion

Induction, for Aristotle, moves from the conclusion and the minor premise, which have been shown empirically to hold perfectly, to the major premise. To put it another way, starting with two propositions, "A, B, C, etc. are swans" and "A, B, C, etc. are white," induction enables us to infer the major premise of the syllogism—that is, the general proposition—namely "All swans are white," which links the first two, more particular propositions. In other words, for Aristotle, inductive inference is an inversion of deduction: Induction = Deduction[-1].

Note that in some ways Aristotelian induction appears to be reasoning that is certain. In order to be certain, however, Aristotelian induction requires that the extension of the major premise—all the possible instantiations of the induced knowledge—be covered exhaustively by the extension of the minor premise, that is, by the observations, which limits its use to finite cases. What would happen if the set of all the cases covered by a rule were infinite? Because of this, certain induction is an extreme figure of empirical reasoning

that can never be fully realized in practice, since a new case could always appear that would invalidate the existing induction. The number of possible swans exceeds the number of observed swans, and it may also happen that a black swan exists, which would invalidate the induction.

In the nineteenth century, many philosophers were interested in induction: in France we find Pierre-Paul Royer-Collard, Victor Cousin, and Jules Lachelier, and in England, the philosopher who today is considered to be the greatest classical theoretician of induction of them all, John Stuart Mill. In his system of logic Mill presents induction as being the source of all knowledge.

Once induction has been clearly identified and distinguished from the other modes of reasoning, such as abstraction, description, or colligation, with which it is often associated, Mill defines it as a formal operation. To do this he uses Aristotle's definition but twists it so that induction becomes a syllogism in its own right and not a mode of reasoning. Remember that for Aristotle induction consisted in looking for one of the premises of a syllogism by starting from the other premise and the conclusion. Mill transformed this into a syllogism, but of a particular kind:

> Every induction is a syllogism with the major premise suppressed; or (as I prefer expressing it) every induction may be thrown into the form of a syllogism, by supplying a major premise. If this be actually done, the principle which we are now considering, that of the uniformity of the course of nature, will appear as the ultimate major premise of all inductions, and will, therefore, stand to all inductions in the relation in which, as has been shown at so much length, the major proposition of a syllogism always stands to the conclusion, not contributing at all to prove it, but being a necessary condition of its being proved. (Mill 1862)

What Mill does is to transform this syllogism so that the major premise and the conclusion change places. In this way the proposition that is inductively inferred becomes the conclusion and the initial conclusion replaces the original major premise. For the resulting syllogism to remain valid, he adds a new major premise that he derives from the principle of uniformity and which says that what is true for A, B, C, etc. is true for all swans, which gives:

What is true for A, B, C, etc. is true for all swans	Major
A, B, C, etc. are white	Minor
All swans are white	Conclusion

This syllogism thus enabled Mill to reduce induction to a conjectural deduction or, more precisely, to a certain deduction under a conjectural hypothesis, namely here the uniformity hypothesis, which states that "What is true for A, B, C, etc is true for all swans."

Whatever the status of induction, a kind of mechanistic syllogism or an inversion of deduction, machines always have the ability to simulate it. But in each case, induction seems to be viewed as a generalization procedure, which leaves out the specificity of the particular, that is, it leads to removing information.

Information Loss and Prediction

As we have seen, the common view of induction corresponds to a generalization. Either in the Aristotelian view, which assimilates induction to an inversion of deduction, or from the perspective introduced by Mill, induction always leads to a loss of information, since it is the colligation and the discovery of a common property of examples, and as a result reduces or compresses information. In other words, all the specificities of the particular have to be forgotten in the induced knowledge that is a common description of individuals. One of the consequences of this view is that induction is associated with a decrease in information. Though many empirical learning procedures fit this view, it is not at all the case with creativity, which is nothing if not an increase. Therefore, the first point concerns the alternative view of induction: are there any conceptions that do not limit it to a contraction and a reduction? We shall see, below, that artificial intelligence techniques implement inductive generalization procedures that do not reduce to a loss of information.

The other point concerns the evaluation of induced knowledge. Since induction is usually conjectural, the result is not certain and has to be confirmed using some other procedure. The main criterion that validates it is its predictive power. In other words, generalization is supposed to help anticipate the evolution of the world. In the case of natural science, such a view has shown to be very fruitful. However, in the simulation of creative abilities, it appears too restrictive, since one of the criteria of creativity is the capacity to surprise. How would a machine be creative, if it could only anticipate change without introducing any new unexpected elements? One answer would be that the way the machine predicts the change could be quite new and correspond to an original theory. But this means that a criterion of novelty and originality has to be added and that this criterion cannot be reduced to the predictive power.

This last point concerns the new validation procedures that creative machines need, and that cannot be reduced to measuring the percentage of correct expectations derived from the induced knowledge. The so-called Turing test (Turing 1950) was an attempt to evaluate such machines and was built on the machine's ability to deceive men and women in the imitation game. Without going into more detail, it would seem, once again, that artificial intelligence techniques address creativity in an original manner.

Structural Induction

Symbolic versus Numeric Artificial Intelligence

It is common to regard traditional artificial intelligence as being restricted to symbolic, exact, and deterministic approaches, whereas new artificial intelligence takes approximation and uncertainty into account using a numeric approach combining, for instance, neural networks, belief networks, reinforcement learning, and genetic algorithms. However, specialists in artificial intelligence do not all identify with this view. Knowledge representation is a crucial part of their work, and the ontologies to which they sometimes refer are only put forward as hypotheses and models, with nothing definitive or rigid behind them. In fact, in the last few years nothing that has happened in artificial intelligence and machine learning seems to have reduced the opposition between these views, even if it is now common to combine symbolic and numeric approaches.

Moreover, this opposition has persisted throughout the history of philosophy and has still not been resolved. Symbols predated numbers and continued after numbers appeared. Numbers were introduced into theories of induction in the eighteenth century by Buffon and Reid and have remained there, especially in the twentieth century, during which all philosophical theories of induction had recourse to numbers without forgetting symbols. This was true for the probabilistic theories of people like Carnap and Reichenbach and also for those, including Nicod and Hempel, whose work was an attempt to legitimate a logical approach to induction. This is also true in artificial intelligence, where the numeric approaches to machine learning do not signify the definitive rejection of symbols.

This opposition between numeric, subsymbolic artificial intelligence and logic-oriented, symbolic artificial intelligence will not be discussed here; the only point is to determine what exactly is new about the inductive mechanisms used in artificial intelligence. As we shall see, it appears that symbolic

artificial intelligence defines a new approach to induction, whereas numeric machine learning relies on well-known and well-established philosophical principles that have already been clearly described by philosophers. More precisely, classical mechanisms, on which numeric machine-learning techniques are based, do not offer anything new. For instance, the induction of association rules by detecting correlation among descriptors, the discrimination of positive and negative examples by finding the optimal separation, the generalization of propositional depiction by dropping one of the conjuncts, and the introduction of numbers to quantify the degree of confirmation of an induced hypothesis largely predate artificial intelligence and machine learning.

This does not mean that the considerable amount of work that has been done in the last few years in numeric approaches to machine learning has produced nothing new. Today's research is more accurate and precise than ever, yet most of the elementary mechanisms that are commonly used in numeric machine learning are based on well-known preexisting ones. The novelty lies mainly in the way these mechanisms are combined and applied. For instance, the notion of simplicity viewed as controlling the application of generalization operators is nothing other than an instance of Occam's razor.

Features and Structures

Knowledge representation is a key issue in artificial intelligence in general and, more specifically, in both numeric and symbolic machine learning. However, there is a big difference in the way objects are represented in numeric and symbolic machine learning: whereas the representation used in numeric machine learning is restricted to sets of features, symbolic machine learning is able to deal with structured objects containing subparts that are related to each other by logical relationships. In terms of logic, this means that numeric machine-learning algorithms are trained on examples described by conjunctions of propositions, whereas symbolic machine-learning algorithms authorize first-order predicate logic. This increase in knowledge representation has a mathematical counterpart: in the case of propositional logic, the generalization-space algebraic structure is a lattice, while in the case of first-order predicate logic it is far more complex.

To illustrate this point, let us take three examples given in propositional logic. Start with a white rose, $e_1 = white \wedge rose$; a yellow narcissus, $e_2 = yellow \wedge narcissus$; a white narcissus, $e_3 = white \wedge narcissus$. The generalization of two conjunctive descriptions retains all propositional descriptors that are common to both. Therefore, the generalization of e_2 and e_3 is "*narcissus*"; the gen-

eralization of e_1 and e_3 is "*white*"; the generalization of e_1 and e_2 is empty. More generally, there exists one maximal common generalization for each pair of examples, and the lattice structure of the generalization space is based on this property.

Let us now consider two flower baskets represented as structured examples:

$flower_basket_1 = white(a) \land rose(a) \land yellow(b) \land narcissus(b) \land on_top(a, b)$
$flower_basket_2 = white(c) \land narcissus(c) \land yellow(d) \land rose(d) \land on_top(c, d)$

Because these two examples are structured, they refer to predicates, that is, to functions and not to propositions. As a consequence, descriptions are built on terms that are all different: "*white(a)*" is not equal to "*white(c)*" even if they designate a similar property. Therefore, it is not possible to define generalization as an intersection of common conjuncts belonging to descriptions; it is instead necessary to consider the mappings of their subparts. For instance, one may consider that a maps onto c and b onto d, or that a maps onto c and b onto c, and so on. Since there are two objects in $flower_basket_1$ and two in $flower_basket_2$ the total number of map possibilities is $2 \times 2 = 4$. Here are the four maximal generalizations corresponding to the four possible matchings:

$white(X) \land yellow(Y) \land on_top(X, Y)$
$white(X) \land rose(Y)$
$yellow(X) \land narcissus(Y)$
$rose(X) \land narcissus(Y)$

For more than thirty-five years now, researchers have been trying to clearly define the generalization of structured examples so as to be able to establish the logical foundations of inductive machine learning. Different formalisms have been developed by Plotkin, Vere, Michalski, Kodratoff and Ganascia, Muggleton, and others. The next section presents the most wide-spread one today, the inductive logic programming formalism.

Inductive Logic Programming

The inductive logic programming (ILP) formalism is directly related to logic programming and to automatic theorem-proving techniques that use the so-called resolution rule. Therefore, to give an account of ILP, we first need to

remember what the resolution rule, which serves as the basis for deduction procedures, is. It will then be possible to show how, within this framework, induction may be assimilated to an inversion of deduction, as in Aristotelian induction, which naturally leads, since deduction is based on the resolution rule, to an inversion of the resolution rule.

Automatic Deduction Using the Resolution Rule

Many automatic proof procedures are based on the resolution rule. In particular it is the basis for most logic programming languages developed in the 1970s and 1980s, for instance, PROLOG. The key operation that serves as a foundation for the resolution rule is unification. Here are some definitions of the fundamental notions.

Definition: Two terms t_1 and t_2 are said to be *unifiable* if there exists a substitution σ of the variables of t_1 and t_2 such that $t_1\sigma = t_2\sigma$; σ is then called a *unifier* of t_1 and t_2.

Theorem: If terms t_1 and t_2 are unifiable, then there exists a *most general unifier* (mgu) σ such that for all unifiers η there exists a substitution θ with $\eta = \sigma\theta$.

Once unification has been defined, it is possible to define the resolution rule.

Definition: Consider two clauses, C_1 and C_2 (i.e., two disjunctions of literals), and suppose that L_1 belongs to C_1 (i.e., that L_1 is one of the disjuncts of C_1) and that L_2 belongs to C_2.

If L_1 and $\neg L_2$ (or $\neg L_1$ and L_2) are unifiable with the most general unifier σ, then the resolvent C of C_1 and C_2 by L_1 and L_2—noted $\text{res}(C_1, C_2; L_1, L_2)$—is defined thus: $C = \text{res}(C_1, C_2; L_1, L_2) = \{C_1\sigma - L_1\sigma\} \cup \{C_2\sigma - L_2\sigma\}$.

Notation: S being a set of clauses, the derivation of the clause C from the application of the resolution rule to clauses of S is noted $S \vdash_{res} C$.

Theorem: S being a set of clauses, S is unsatisfiable if and only if $S \vdash_{res} \square$, where \square corresponds to the empty clause (i.e., to the falsity).

Corollary: S being a set of clauses and C a clause, $S \vdash_{res} C$ if and only if $S \cup \neg C \vdash_{res} \square$.

Inversion of Resolution

Following the Aristotelian conception in which induction is an inversion of deduction, inductive inference is formally defined as an inversion of deduc-

tive inference. Since the resolution rule plays a key role in deductive infer-
ence, researchers have tried to inverse resolution. The first attempts were
made in the early 1970s by G. Plotkin (1970), who inversed unification. Twenty
years later, S. Muggleton and W. Buntine (1992) proposed inversing resolution.
The induction is formally defined as follows.

Given:

- A set L_o of observations o_i that are supposed to be expressed in the form of
 a set of clauses.
- Background knowledge expressed as a theory θ that does not explain the
 observations, that is, such that $\forall o_i \in L_o \ \neg[\theta \vdash o_i]$.

The induction consists in finding a hypothesis H that explains all the observa-
tions o_i belonging to L_o, that is, such that $\forall o_i \in L_o [\theta \wedge H \vdash o_i]$.

Because the resolution rule is complete, it means that $\forall o \in L_o [\theta \wedge H \vdash_{res} o_i]$.
Since L_o and θ are initially given, this is equivalent to $L_o \wedge \theta \vdash_{res}^{-1} H$, where \vdash_{res}^{-1}
designates the inversion of the resolution rule.

Without going into detail, inverting the resolution rule is a nondetermi-
nate operation that requires inverting substitutions, that is, associating the
same variable to different constants that are supposed to be matched. There-
fore, the number of possible inductions is directly related to the number of
possible matches, which may be huge.

The recent advances in relational learning and inductive logic program-
ming attempt to limit the number of mappings by introducing strong formal
constraints. The notions of determinism, of ij-determinism, of k-locality, of
l-determinacy, and of structured clauses are examples of such restrictions
whenever they are formalized in the inductive logic programming framework.
Other restrictions have been expressed in other frameworks, for instance, the
number of conjuncts in rules, or the notion of "morion."

Some of these constraints that restrict the number of mappings corre-
spond to syntactical limitations of the learned clauses; others refer to out-
side knowledge that authorizes some mappings between objects belonging to
compatible concepts and prohibits others. In other words, these constraints
correspond to a conceptual mapping that guides the structural matching.

As explained above, these two operations, structural matching and con-
ceptual mapping, have been proved by many psychologists to be central to
our creative abilities. This essay has shown that they also play a key role in
the mechanization of inductive inference and, more precisely, of structural
induction, as developed in artificial intelligence. Therefore, structural induc-

tion, relational learning, and inductive logic programming emphasize some aspects of inductive inference that have previously been largely ignored and that correspond to a general operation currently achieved in most practical inductive inferences, and especially in inferences that play a key role in our creative abilities.

Back to Aristotelian Biology

Despite its relative novelty in the theory of induction, the notion of mapping had already been investigated by ancient philosophers. Aristotle, for instance, in the introduction to his *Zoology*, entitled "Parts of Animals" (1968), established a correspondence between organs that are involved in the same biological function.

To take just one example, Aristotle maps birds' wings, fishes' fins, and mammals' legs, all of which are involved in the biological function of locomotion. Aristotle argues that this matching or mapping between functional parts reduces the effort required of zoologists when trying to understand the organization of unknown animals, by allowing them to reuse part of the work that has already been done. Thus, zoologists who know how biological functions such as locomotion, perception, or reproduction are performed for various classes of animals will be able to classify new animals by observing their similarity to known ones, and to understand their organization without having to investigate them fully.

However, even though Aristotle recognized the role of mapping as central to zoology, he never related it to logic. His theory of induction, presented in his logic (Aristotle 1989), is not at all related to matching but to the inversion of a deductive syllogism. In other words, it appears that the inductive inference used in Aristotle's natural science refers to matching among subparts of objects, while the inductive logic does not.

The situation today in artificial intelligence seems curiously similar, since many machine-learning techniques based on an inductive process do not refer to mapping, which is seen as being beyond the scope of the domain. This is the case for neural networks, belief networks, reinforcement learning, and genetic algorithms. On the other hand, both research into structural matching operations and recent advances in inductive logic programming show that matching is a crucial issue and that strong constraints are required to limit the number of possible mappings. It also happens to be true that the solution required to decrease the number of mappings is similar to the Aristotelian solution for zoology,

that is, to provide some prior knowledge about the function of each part or sub-part of a scene and to restrict matching to parts that realize the same function. Lastly, it has been proved that mapping and matching play a key role in many creative activities, since imagination may be viewed as an ability to match and to recombine old memorized structures with respect to some conceptual mapping.

In conclusion, artificial intelligence leads us to revisit classical theories of induction and creativity in a way that has not been theorized before, even if it has long been anticipated in the empirical practice of induction.

Conclusion

This essay refers to many fields in the sciences and the humanities that have been mapped, matched, switched around, and brought together: not only logic, artificial intelligence, philosophy, psychology, and musical composition, but also Aristotelian zoology, which is the core of the notion of structural induction developed here. In a way, we could say that the codes have been switched, but a preliminary condition for such an operation to be viable is conceptual space mapping. I hope that this essay has provided the necessary preliminaries for such a mapping to be possible and acceptable.

References

Amarel, S. 1986. Program synthesis as a theory formation task: Problem representations and solution methods. In *Machine learning: An artificial intelligence approach*, vol. 2. Ed. R. S. Michalski, J. G. Carbonell, and T. M. Mitchell. Los Altos: Morgan-Kaufmann.

Aristotle. 1968. *Parts of animals. Movement of animals. Progression of animals.* Trans. A. L. Peck and E. S. Forster. Cambridge, MA: Harvard University Press.

———. 1989. *Prior analytics.* Trans. R. Smith. Indianapolis: Hackett.

Boden, Margaret A. 1995. Creativity and unpredictability. *Stanford Humanities Review* 4 (2): 123–39. http://www.stanford.edu/group/SHR/4-2/text/boden.html.

———. 2004. *The creative mind: Myths and mechanisms.* London: Routledge.

Buchanan, B. G. 2001. Creativity at the metalevel: AAAI-2000 presidential address. *AI Magazine* 22 (3): 13.

Cohen, Harold. Aaron. http://www.viewingspace.com/genetics_culture/pages_genetics_culture/gc_w05/cohen_h.htm.

Cope, D. 1991. *Computers and musical style.* Oxford: Oxford University Press.

Davis, R., and D. B. Lenat. 1982. AM: An artificial intelligence approach to discovery in mathematics as heuristic search. In *Knowledge-based systems in artificial intelligence*, pt. 1. New York: McGraw-Hill.

Gold, E. M. 1967. Language identification in the limit. *Information and Control* 10 (5): 447–74.

Hutter, M. 2005. *Universal artificial intelligence: Sequential decisions based on algorithmic probability.* Berlin: Springer.

Karmiloff-Smith, A. 1990. From meta-processes to conscious access: Evidence from children's metalinguistic and repair data. *Cognition* 34:57–83.

Langley, P. 1987. *Scientific discovery: Computational explorations of the creative processes.* Cambridge, MA: MIT Press.

McCarthy, J. 1999. Creative solutions to problems. AISB Workshop on AI and Scientific Creativity, http://www-formal.stanford.edu/jmc/creative.html.

Menabrea, L. F. 1843. Sketch of the analytical engine invented by Charles Babbage, by LF Menabrea of Turin, Officer of the Military Engineers. (Bibliothèque Universelle de Genève, no. 82, October 1842). Trans. with notes by Ada Lovelace. In *Scientific memoirs, selections from the transactions of foreign academies and learned societies and from foreign journals* III. London: Richard Taylor.

Mill, J. S. 1862. Of induction. In *System of logic, ratiocinative and inductive*, vol. 1, bk. III. London: Longman, Green, and Co.

Muggleton, S. and Buntine, W. 1992. Machine invention of first-order predicates by inverting resolution. In *Inductive logic programming.* Ed. S. Muggleton. London: Academic Press.

Plotkin, G. D. 1970. A note on inductive generalization. *Machine Intelligence* 5:153–63.

Ramalho, Geber L., Pierre-Yves Rolland, and Jean-Gabriel Ganascia. 1999. An artificially intelligent jazz performer. *Journal of New Music Research* 28 (2):105–29.

Simon, H. A. 1957. *Models of man: Social and rational; mathematical essays on rational human behavior in a social setting.* New York: Wiley.

———. 1979. *Models of thought.* New Haven: Yale University Press.

Turing, Alan M. 1950. Computing machinery and intelligence. *Mind* 59 (236): 433–60.

Turner, S. 1992. Minstrel: A model of story-telling and creativity. Technical note UCLA-AI-17-92. Los Angeles: AI Laboratory, UCLA.

Valiant, L. G. 1984. A theory of the learnable. *Communications of the ACM* 27:1134–42.

Vapnik, V. N. 2000. *The nature of statistical learning theory.* Berlin: Springer.

Relating Modes of Thought

William J. Clancey

Switching Worldviews: Stages of Learning

> There are two kinds of people in the world, those
> who believe there are two kinds of people in the
> world and those who don't.
>
> **Robert Benchley (1889–1945), Benchley's Law
> of Distinction**

When I first read Robert Benchley's Law of Distinction in a grammar school English class, I enjoyed going around saying, "There are two kinds of people in the world, those who agree with Robert Benchley and those who don't." This recursive joke captures the essence of switching codes[1]—there are two kinds of worldviews, those that allow for multiple worldviews and those that don't. Or as Benchley might have put it, there are two kinds of people, those who believe in the integrity of multiple worldviews, the pluralists, and those who don't, the objectivists.

Although theories are thus easily named and distinguished, people's beliefs are not. The three chapters in this section ("Ontology, Semantic Web, Creativity") illustrate quite well that, rather than falling into two obvious camps, people can straddle and blend worldviews. I will gloss the complexities a bit by labeling the three chapters as representing stages of learning, "Get it" (Cuesters and Smith), "Getting it" (Hendler), and "A glimmer of hope" (Ganascia), relative to the perspective that different worldviews are possible, legitimate, and useful for relating technology to the arts and humanities.

A nice positive story would probably end on a happy, triumphant note with Ceusters and Smith, rather than what in my opinion is an early-stage struggle—Ganascia's sincere exploration that just begins to uncover the possibility of a nonlogicist worldview. But an easier and probably more concise analysis would start with Ceusters and Smith, so that what I take to be the standard is clear; then Hendler's progress would be evident,

and the gap over which Ganascia peers more broachable. So I will opt for lucidity over a happy ending and apologize in advance for sounding moralistic.

Cuesters and Smith show us how multiple worldviews—conceptual-representational "codes"—can be related, transforming each other. Hendler tells us the story of transition, of realizing error, and finding another way. Ganascia shows what it's like to begin the journey, the difficulties that loom and why progress requires a transcendent leap—an acceptance that the worldview of the technical rationalist is not sufficient to be useful in human activity, and indeed that some of its tenets must be rejected in the face of new interests, values, and community purposes.

My conclusion is that technologists and artists, as well as different kinds of scientists, are "blending codes," and that in many respects the switching that occurs is from the objectivist worldview to the pluralist. In practice, this means that the logicist-technologists—represented here by the logical induction and semantic web researchers—have the biggest change to accept. Once the technologist believes that there are "two kinds of people in the world," then the dance begins.

Ceusters and Smith: Toolmakers Who Know How to Dance

The work of Ceusters and Smith exemplifies what it means to "get it," to straddle points of view, to live in multiple worlds, blending interests and communities, theories and skills. In contrast with the original intent of AI ontologists—to develop expert systems, programs that would replace human experts—they ask, "Can ontological engineering help us to understand what dancing is all about?" They seek to use modeling technologies as a tool for human learning, not as a substitute for human action (automation). Rather than seeking to codify and bottle knowledge, they seek tools that will facilitate inquiry: "[One] might like to know the name of the particular dance depicted [in a video] so that he can pursue questions concerning its region of origin or choreography." Recognizing the conundrum of the knowledge engineer, they realize that ontologies can provide a framework for developing a new theory: "to 'represent' dancing in the computer, we must first have a good insight in to what dancing *is*."[2]

In Ceusters and Smith's worldview, knowledge is dynamic, adapted, and reproduced: "The earlier, folklore model supported scholars and institutions in documenting and preserving a record of disappearing traditions. The intangible heritage model, by contrast, aims to sustain a living tradition by supporting the conditions necessary for cultural reproduction." They contrast the "traditionalists and innovators," distinguishing preserving from nurturing, like the difference between canning food and promoting gardens: "Our past and our heritage are not things preserved for all eternity but processes that must constantly revalidate themselves."

Ceusters and Smith recognize as well the complexity of communities within communities, the blending of local identity and global assimilation, the dynamic of speciation and ecology: "[Dances] contribute, on the one hand, to the blossoming of cultural diversity and the enrichment of specific cultural identities, while on the other hand, their plasticity renders them capable of nourishing the dialogue between and intermingling of disparate cultures." Another kind of dance develops between the opposing processes of objectification (distinction) and relation (assimilation): "respecting their national and regional diversity and at the same time bringing the common cultural heritage to the fore" (here quoting the Treaty on European Union).

Similarly in their use of ontologies, Ceusters and Smith embrace the discourse between naming/identifying and creating/expressing, the dance between the thing being created and the process of creation. In sketching a tool with many layers of representations, their conception of dance ranges from the dynamics of the individual body to the dynamics of the culture—they speak of "human motion," "dance motions," "sorts of dances," and "dances' evolution over time."

Their understanding of theorizing is sophisticated; they recognize the possible confusion between talk about experience/activities and talk about the map—"confusing the classification of entities in reality with the classification of words or data describing such entities." In their discussion, we see how different systems or domains of action require different languages for articulating, modeling, or guiding action. In advocating the use of a "kinetic language," Ceusters and Smith explain that "it is the movement itself that is conveyed, rather than some analytical, functional, scientific, or poetic verbal description." This awareness reflects experience in switching codes, respecting the difference between action and idea, the territory and the map, and all the many layers of these from deed to concept to remark to theory.

Dance as a domain of inquiry, contrasted, for example, with medical diagnosis, promotes a broad perspective on the nature of data. Hence, Ceusters and Smith use multimodal recordings and integrate layers of representation: motion, tempo, sound, actions. Accordingly, they are engaged in adapting and creating standards that relate complex spatial-temporal details.

And so from the theoretical framework of how a tool would be used (e.g., enhancing experience) follows the nature of the representations and then the formalizations. This turns the technical world on its head, reversing the process of developing standards as ideal pots into which arbitrary applications will fit. Here again, in developing standards, Ceusters and Smith realize that different systems or domains of action lead to different languages for articulating, modeling, and guiding action.

But just as no dance is ever finished or perfected, the dance between ontological theory and practical purposes is for everyone an ongoing project, here and there with

rough edges, some puzzles, and if we are lucky, unexplored territory. For example, Ceusters and Smith cite Ingarden on the work of art as "a complex stratified object that is neither physical nor mental," but rather *both* physical *and* mental. Here I am reminded of Wilden's orders of complexity, which he called a "dependent hierarchy" relating inorganic nature to culture. In this hierarchy, open systems, such as society/ culture, "depend for their existence on the environment of the higher ones," such as inorganic/organic nature (Wilden 1987, 74; Clancey 1997, chap. 10). Like an individual person, a dance event doesn't fit into the hierarchy because it is physically and teleo- logically a complex of multiple orders of complexity, that is, both inorganic/organic and cognitive/social.

One can also quibble about a few other remarks, perhaps just slips. Ceusters and Smith refer to "correct analysis" without qualification about the purposes or con- text that make the analysis useful and hence valid. Their reference to "users" is tech- nology-centric; I'd prefer they stick with "dancers" or "learners." The paper lapses into business-case technology talk at the end—"enable speedier recovery of data and facilitate its analysis"—while everywhere else, the focus is on a tool for creating information, providing a means of seeing, comprehending, and reproducing dance.

Finally, Ceusters and Smith could benefit from a theoretical framework that bet- ter relates data and information. They write about "bridg[ing] the semantic gap be- tween the information that the computer can extract from given multimedia material and the interpretation that would be useful to a human user," when they really mean the gap between the data and the information (interpretation) conceived by the learner. Their inquiry could perhaps benefit from a framework for relating perceiving and conceiving (see Clancey 1997, chap. 4) and Dewey's (1938) notion of inquiry, which might help them better relate learning to see, learning to hear, and learning to move.

Yet overall, Ceusters and Smith masterfully navigate the worldview of dance, as physical, social experience and cultural phenomena, with the worldview of technol- ogy, as a tool for articulating, sharing, and adapting ways of perceiving, conceiving, and acting in the world. It hardly gets better than this.

Hendler: Learning to Switch Partners

Hendler, by comparison, is "getting it"; he is a technologist engaging with another worldview. He tells us about a reluctant switch from pursuing his technological ideal (the semantic web) to dealing with the facts of the world ("from the bottom up"), but he is a bit unrepentant and sometimes indignant about the reality he discovers. This makes Hendler an ideal informant about the journey involved in "switching codes,"

for he still lucidly remembers how he used to talk and think and the tools he built. He remembers what it feels like and is still tugged back by previous ambitions and projects. But he is making progress, finding a new way in new kinds of activities with different groups of people.

Hendler wonderfully lays out the struggle felt deeply among the logicist community when confronting the web, the astonished recognition that something messy, full of discrepant facts and fallacy, could be useful! The scale and nature of interactions on the web is so unprecedented, there is no point in merely arguing that all these people are wrong and building a house of cards. Adopting an "if you can't beat them, join them" approach, Hendler and others have converted to an empirical framework for developing technology. Previously they believed that a logical/formalistic framework for representing knowledge was required: with a set of contradictory propositions, anything could be proven true. Technical rationality (TR) demanded purity: definitions, consistency, completeness. TR demanded a mathematical foundation for validity.

But in studying the web and trying to make a useful contribution, to participate with his tools, Hendler has developed a different rationality, one that motivates making tools that are valued in an activity, what he calls "relevation," making something relevant—in this case, making the semantic web relevant to modern life.

Articulating the human-centered computing perspective, Hendler says, "Many of our assumptions about how we represent knowledge for processing by computers have held us back from really understanding human use of knowledge." In other words, the focus on codifying and preserving knowledge has distorted our understanding of knowledge; developing expert systems and then ontologies as repositories was grounded in an invalid epistemology. Perhaps the AI of the 1980s was logical, but it wasn't relevant, it didn't establish a connection with knowledge as it actually lived in communities. Knowledge engineering wasn't useful.

In studying the nature of the web, Hendler is coming to realize that he is dealing with a conceptual system, a "code," not "knowledge" as he previously understood it, as articulated facts and theories. And possibly he is starting to see that people don't *use* knowledge, but rather knowledge is manifested in action, recognized, adapted, articulated, conveyed (an argument famously presented by Ryle 1949).

Previously, Hendler thought there was only one set of knowledge, one truth, one point of view, that is, one code. The standard of truth in science and professional practice was the notion of accuracy, the relation of diagnosis and prediction to reality. Because there is only one real world, there can only be one true set of theories about the world, and so all ontologies must map onto one another—the economists' ontology onto the physicians' onto the bureaucrats' onto the politicians' onto the

psychologists' and the archaeologists' and so on. The progenitors of the semantic web envisioned one grand dictionary of terms, all the vocabularies properly tied together in definitions that mapped names to meanings and theories. Indeed, the semantic web was to be a veritable Babel of logic, unifying the languages of thought of all peoples, reaching the heavens of true knowledge.

Now Hendler finds that web postings cannot be made consistent and reliable in an effort to "establish truth"—not because they are mistaken or even deceitful (though this still irks him), but because the different points reflect different values, concerns, motives, and activities (Schön 1979). Consider, for example, modeling a computer system in a university: what constitutes "the system" and how it is described in terms of issues, decisions, regulations, and so on, depends on the "code," the systemic perspective, the conceptual system that frames the analysis. A variety of analytic perspectives are possible for talking about (viewing) computer systems, some of which are easily related because the communities work together and others of which are incommensurate: VLSI, software, network communications and services, facilities management, capital investment and inventory, academic infrastructure, ergonomics, energy, instructional design, security, privacy.

Perhaps the first realization about multiple viewpoints arises from seeing one's own ideas and methods applied in unexpected ways. Hendler's reaction is dramatic: "This web AI was antithetical to the very stuff of which KR&R [Knowledge Representation & Reasoning] was made!" Eventually, he realizes that the "AI" technologies of the web originate in activities, social contexts, not in individual expertise or "knowledge." He has the fundamental insight that multiple worldviews are possible and may coexist: "The need to organize knowledge in some formal way . . . is only one way to approach things, especially when there are social processes in place." As Benchley would say, Hendler now believes that there are two kinds of people in the world.

Perhaps most importantly, Hendler recognizes how the essence of the web is to facilitate switching codes: "By being able to, even heuristically, equate things found in different web applications, a whole range of mash-ups and other web applications becomes possible." Because of the combination of contextual information (e.g., topographic maps of California) and scale (e.g., dozens of weather stations posting current data in the San Francisco Bay Area), crossing and intersecting occurs that enables people to notice patterns and relate contexts (e.g., it is warmer on the east-facing spine of the San Francisco peninsula than on the Pacific coast or in Silicon Valley).

But the Pygmalion dream is difficult to forget. Hendler is still driven by creating technology, he is a toolmaker: The web provides "new and exciting possibilities for a very different class of (just a little bit) intelligent systems." Yet what is the purpose of web technology—to charm us with intelligence? Or for people to experience and

find stories, videos, photos, beauty, ideas, and communities? Is the designer of "social networking" centered on the technology or the people? In straddling worldviews, Hendler seems to move back and forth between these intentions, as creator and facilitator, one who controls, making the world tidy and right, and one who nurtures, making the world more lively, dynamic, personally and socially authentic.

The section "But Is It AI?" reveals Hendler's born-again experience. He develops an important insight about people by analyzing the web as a social artifact. The web "grew from the interaction of human beings sharing information." This is a powerful idea: sharing and interaction, building on each other, commenting, collecting, pointing, packaging each other's work.

But people are not just *sharing*, they are declaring, marking, singing their personal expression—the web becomes like the cacophony of the jungle, where birds of a feather can find each other through their postings. The web is emblematic of human intelligence, the very topic of AI, presumably what Hendler had been trying to create for decades. Expressing his amazement at landing in the real world of people, he says, "Human intelligence violates many of the traditional assumptions of the field of knowledge representation." Although he doesn't delve further into the paradigmatic change, these are the very arguments that were so controversial in the 1990s among those proposing "situated cognition," arguments that human knowledge (conceptual memory) does not consist of stored models.[3]

Hendler's understanding of what his observations mean, in terms of both cognitive theory and his own professional practice, was still in flux when he wrote this chapter. From the situated cognition perspective many of his thoughts could have been more developed. He says, for example, "Human intelligence evolved from dealing with [the real world] (and with other humans)." Indeed, human intelligence evolved from dealing with the world *with other humans*, in activity that was inherently joint and transactional (e.g., in a poker game of projected intentions and anticipated projections, actions based on beliefs about the prey's—as well as interpersonal—motives and habits). When Hendler writes about "physical tasks, cognitive tasks, societal tasks," he doesn't admit that being a person sometimes doesn't involve doing a task at all. To take an example close at hand, consider dancing.

Still caught in the formalist notion of inventorying knowledge, Hendler writes, "No one knows the number of concepts involved in human thought." But why should concepts in principle be collectible and countable? Could we count all the dance forms that are possible? All the ways of dancing that people currently practice? In what worldview are conceptualizations—ways of coordinating behavior in different modalities—*things*? The objectification of the observer in naming and classifying looms large in Ceusters and Smith's discussion of pitfalls but does not arise here.

The real leap for Hendler will come not from a better epistemology alone but in recognizing that empiricism, working "from the bottom up," does not mean just learning about human intelligence (particularly to replicate it) but facilitating learning. I kept wanting to ask, are you monks or entrepreneurs?

Here indeed probably lies the crux of the difficulty. As one colleague put it in the early 1990s, "They need to know what to do on Monday." Hendler explains the difficulty of switching codes: if our assumptions have been wrong, how can we change "without losing what rigor the field has been able to achieve?" Rather than throwing out the logicist way of talking, the notations, and the tools—and most fundamentally, the community's values—logicists need to put them to new purposes. Eventually, this will involve reframing, appreciating in a new way, what they have accomplished: the AI discipline created a very general tool (qualitative model representations and operations; Clancey 1989, 1992) that was originally invented for codifying and distributing knowledge but can now be used for creating new understandings and ways of interacting.

The shift required of the technologist is dramatic. As Hendler says, "The real world is not the world that KR systems were built for"—a nice encapsulation of the multiple worldviews. Originally, the metaphor of consultation dominated the AI field of expert systems; that is, the researchers' vision was that people would consult with expert systems, which would give advice or perhaps teach them. This metaphor probably stemmed from the professional settings that inspired building expert systems and the people with whom AI researchers worked—physicians, oil-field geologists, and electronics troubleshooters. In replicating the knowledge of these people, researchers tried to replicate how they worked, or at least how they assumed their work was done: with verbal inputs and verbal outputs in a consultative dialogue. That fit the single-modality verbal view of knowledge very well. The idea that expert systems needed to be actors in complex social interactions was invisible or ignored (e.g., Greenbaum and Kyng 1991; Clancey 2006; Clancey, Sierhuis, and Seah 2009).

What I most like about Hendler's chapter is how he so plainly and honestly articulates his confusion. He is torn by the values of technical rationality. He now lives in a somewhat disturbing world: "It is certainly not the case," he acknowledges, "that quality always wins out." But what is quality? In contrast with the absolute "truth" metric of the logicist's worldview, the quality of a model on the web is contextual, relative to the functionality or usefulness of a model in a community of practice. More than "humans pursuing multiple goals," people have incommensurate goals, multiple points of view, different ways of framing their lives and even their activities within a single community. The web is not just a messy pot of data; it manifests an infinity of pots.

Reading Hendler, I am a bit overwhelmed by how caught one can be in formal

notions of quality. While "expressivity" can be a useful perspective for evaluating notations for some activity, is Hendler right to say that a child is "inexpressive" because he is not verbalizing in the same way as an adult? Might the child be expressive in other modalities, conveying emotional experience through gesture, tone, facial expression? Verbal articulation—modeling the world in fact, causal story, and theory, as the logic formalist requires—is one way of characterizing the child's communication. Compare this adherence to verbal representation with Ceusters and Smith's use of multiple modalities for characterizing dance. One of the most insidious traps of the cognitivist/logicist camp is the representational flatland of verbal models. All knowledge, reasoning, representation, decision making, and so on are viewed as transformations of linguistic expressions: speech, conceptual maps, semantic networks, predicate calculus, and so on. Even interpreting diagrams is reduced to verbal manipulations (Clancey 2000).

Thus Hendler proposes using the model-based point of view to guide people in providing information useful for model-based decision making ("you can react appropriately"). But to exploit the logicist technology, one needs to respect the nature of points of view and the nature of knowledge, plus reframe the nature of knowledge-based (modeling) technology. That's a lot of reconceptualization and juggling of conceptual spaces, inventing new ways of using tools, and finding new partnerships—not so much "switching," unfortunately, as inventing a new life, a new practice.

At the end, it's unclear whether Hendler has accepted the shift to working with the web rather than trying to reform it. Regarding how to handle "scaling, quality, and inconsistency . . . when these issues arise together, and at huge scale," he says, "We need a different approach to the underlying formalisms . . . that attacks rather than ignores these critical features of human interaction." Why not formalisms that embrace, complement, work with, leverage, or expose these aspects, as a tool? But then, in the very next sentence, the "attack" has become an "exploration." So perhaps in saying this, in responding true to formalistic thinking, then equally clearly stating a new resolve for action ("What do we do?"), a conceptual resolution is developing. In my experience this reconceiving occurs naturally in a back-and-forth reworking, like climbing a wall with two ladders, your footing alternating as you grasp and transform different conceptual systems, reorienting your attitudes, attractions, and direction.

Somewhat unexpectedly, Hendler's bottom-up approach shifts from beating logic into the web to joining the enterprise of making contributions. So now groups of semantic web researchers are working in parallel and sharing their work on the web. Engaged in this activity, Hendler recognizes that what counts as correct (factual) or as a good argument depends on the community of practice, and that automated "reasoners" need to evaluate claims by "figuring out what fits best into your worldview."

Notice how the second-person reference ("your") mirrors Hendler's own recognition: a program must respect what he himself has come to realize. The web is an environment where you need to be skeptical, and one way to accomplish this is to work cooperatively. Hence, what is involved is perhaps not just multiple reasoners with different worldviews but reasoners who live in different worlds.

To summarize, Hendler's worldview with regard to knowledge and technology was: be formal or be irrational. His new view is both cultural *and* formalized. Yet he doesn't talk about metaphors, framing, modalities, values. He does mention worldviews but hasn't functionally (productively) factored this into the activity of the web and his own activity. He's trying to figure out *what to do* and that requires figuring out *how to think* about the web.

Hendler doesn't quite articulate how formalism is one game among many, but his interest has plainly shifted from the game board of technical rationality to the empirical, yet in part intangible, world of human action (i.e., culture broadly). In his former world of technical rationality, formalism rules—it enables the world to be rigorously controlled, providing consistency, truth, order. Hendler's journey makes us wonder, what was the motive of the formalist worldview? Bringing truth and order to the world?[4] Providing tools for others to do this? Has evolution provided some special proclivity for this accounting mentality, this verbal orderliness?

The world of the web being discovered by Hendler is divergent, personal, consisting of many communities, involving expression of the self and values, and regulated in many ways (technical, institutional, and informal). The web is dynamic, evolving; it is an instrument for learning on a global scale, comprising a medium and many activities (browsing, blogging, studying, buying, etc.). The effect on humanity is no doubt already profound, and having started in my own work, like Hendler, dominated by the code of technical rationality, I am inclined to say the upheaval is probably most felt among AI researchers. For while others gain new tools, our very livelihood has been called into question. But the rewards of this inquiry are many. At the heart of Hendler's struggle are classic questions, What is quality? What are my motives? How do I find purpose in life? What is my niche?

Hendler's essay ends on a courageous, hopeful note, an unmistakable first step. But he is not yet in the domain of the web creator and browser/reader. He is not fully committed to providing useful tools. In the words of Ceusters and Smith, the real transformation will come through meeting the "real-world needs of large communities of interested persons." The result will fit Hendler's original focus on knowledge. As Ceusters and Smith go on to say, such tools, "not only contribute to the quality and quantity of information available online but also yield deeper scientific insights." Hendler could be headed here, viewing the web as a source of data for theorizing ac-

tivities, for example, for developing better medical care. Doing this requires becoming engaged in a partnership, following the principles of participatory design (e.g., Greenbaum & Kyng 1991).

The next step is to make a commitment to serving others, rather than readjusting the deck chairs on the R.M.S. *Logicist*. Without a meaningful activity, an encounter in partnership, Hendler's community will just be wearing a different garb, not really having been transformed, not really having crossed a disciplinary boundary. That change will not occur until the logicists actually try to dance with people in another community.

Ganascia: Dancing with Logicist Eyeglasses

In comparison with the work on dance and the semantic web, Ganascia's study of human creativity provides only a glimmer of recognition that multiple "codes" can be used to model and organize human activity. He wants to relate human creativity to logic and anchors his argument on certain aspects of creativity: growth, conceptual mapping (prior knowledge), and surprise. But he tries to establish the relation between human creativity and logic in the space of logical formalisms itself, grounding his analysis in certain computational metaphors (e.g., "memorized structures") rather than the real world. His approach is not empirical; rather than studying the creativity of dance or social networks and seeking to relate these phenomena to formalisms, he deals with puzzles, syllogisms, and data sets. There is no mention of Gardner's (1985) dimensions of intelligence, multimodality, practice/norms, instruments/tools, notations/models, and so on. The embodied notion of cognition (see Ceusters and Smith) and its social character (Ceusters and Smith, Hendler) are absent.

In short, Ganascia's notion of knowledge, reasoning, and action adhere to the traditional information-processing perspective, making no distinctions between knowledge and models, conceiving and logical inference, meaning and formalism, experience and computation. This is the very world that Hendler tells us does not fit the reality of human creativity.

Ganascia's article is about a struggle to relate logic to human creativity. But how creativity is defined depends on the worldview within which one characterizes the nature of *change*. Altman and Rogoff (1987) distinguish three worldviews—interactional, organismic, and transactional—that differently frame how scientists formalize "relationships between (a) the reasoning agent, (b) the agent's environment, and (c) the observer of the agent and the environment" (Toth 1995, 345).

Ganascia recognizes at least tacitly the role of the observer in defining creativity ("one of the criteria . . . is the capacity to surprise"), yet seems to view creativity as

an objective property of an act, rather than as a relation among agent, environment, and observer (the transactional view). Somewhere a theory of creativity needs to discuss point of view. Although the observation of creativity may have something to do with "unexpected elements," to the learner creativity is about value, whether it be aesthetic or functional.

Working within the interactional worldview, Ganascia attempts to relate human creativity to logical inference, and notes some puzzles. The glimmer of another perspective arises in his inquiry—a worldview that includes formalism as a tool used by persons, rather than being the substrate and mechanism hidden inside the brain.

Ironically, reading Ganascia tells us something more about the creative process, both through his own work of understanding creativity and the reader's work in understanding his inquiry. "Unpredictable, and therefore creative," he writes at one point, and then, "artistic creation has to be simultaneously unpredictable, harmonious, and familiar." I am jarred; these phrases seem contradictory, lacking in what I take to be common sense about creativity. Apparently this is so for Ganascia too. In making these statements and raising these questions he is expressing the horns of a dilemma, his own bewilderment over the disconnected pieces of his story—our experience of how creativity works, on the one hand, and our definitions and theory of what makes a work creative, on the other.

So we need to jump out of this hyperrational circle and ground our inquiry; we need to find something this inquiry could be *about*. Let us go back to experience for a moment. Consider the mixture of randomness and deliberately patterned coloration in Jackson Pollock's abstract expressionist murals. At first (in the late 1940s) they were not familiar at all, and perhaps this made them interesting. Did dripping paint on canvas qualify as painting? Later the very familiarity made Pollock's paintings valuable, but we might question whether they are still surprising or unpredictable.

Cultural-historic context plays a major role in what is viewed as creative. Genres, as norms, establish boundaries and new opportunities for surprise. Considering the periods of impressionist, cubist, and expressionist painting from the late nineteenth century into the twentieth, we see that a work is not evaluated in isolation but in the context of the period, as an example of a genre or movement, and perhaps as a commentary on another style or work (e.g., the nonrepresentational form of Mondrian), a variation on method (the relation of van Gogh to pointillism), or an exploration of an idea (the series of Monet's lilies and haystacks). The relation among works provides a conceptual space for framing a new work; a work is not just surprising or unpredictable but very often bears a deliberate relation to the context of prior work. A particular work is often reinterpreted as the historical context itself is reconceived (e.g., reinterpreting Picasso's last works as a form of "neo-expressionism").

├──── WILLIAM J. CLANCEY

FIGURE 15. Eight selected drawings from Aaron (Clancey 2005, 5).

How could a computer program that paints be creative if it has no notion of prior work, if it is not part of a community of practice? I have argued (Clancey 1997, chap. 1) that Harold Cohen, an artist, is part of a community and that Aaron, his computer program, is a tool for him to generate works, through his tweaking of parameters and selection of paintings to exhibit (Cohen signs the drawings). Further, by studying drawings generated by Aaron and understanding the program's limitations, we can better understand the difference between a logicist machine and human conceptualization (thus I believe Ganascia's section heading "Creative Machines" is a misnomer).

Several years ago, to better understand Aaron's drawings, I generated thousands of pictures from a version available on the web and studied them, to an extent reverse-engineering the program.[5] It is true that every drawing is different. However, there are distinct categories: drawings with three people (no pots or plants), two people (with one obscuring the other), one person (alone or with a plant), one plant (no people), and one or two pots (no plants or people). Men are always in front of plants; women may be totally obscured by plants (fig. 15). When the pots are empty, there are always two, and they are the same color. There are no drawings of four or

more people, no drawings of two plants or three pots. The rear wall may be mottled in the Tuscan style or appear as a painting itself, somewhat like the abstract expressionist style of the original Aaron of the late 1970s.

Yes, the configurations are often interesting to look at and the colors usually pleasing. Perhaps a street artist might make a living selling them, but after glancing through a portfolio of dozens of these images, I believe you would have a sense of closure, of having seen it all. The program's ontology—people, pots, plants, walls, and a floor—is fixed; in Ganascia words, "the support of the search (that is, the conceptual space) has already been given." Nevertheless, the procedures for creating "plausible representations" from this ontology are quite complex (Cohen 1988; McCorduck 1991, 201–8). The variation we experience in the images comes from the relative size of the people, plants, and pots and their placement in the frame. Postures may vary within bounds: hands on hips, to the mouth, or on the chest. But nobody stands with one foot in the air. Coloring constraints add another layer of variation and hence interest to the drawings.

One might wonder, if van Gogh could have drawn thousands of drawings in a day, whether we would find similar patterns. The point of course is that people learn; they are not bound by today's conceptions. They can generate new categories and, as I emphasized, new ways of using categories and materials to comment on previous works of the self and others. (For example, in the mid-1980s Cohen created a variation of the Aaron program that drew pictures of multiple Statues of Liberty instead of plants and people.)

Does Aaron satisfy Ganascia's quest for a "general method somewhere between totally predetermined generation and purely random behavior"? I believe so, for although the categories are predetermined, the placement and size of elements is random (within set bounds; Cohen 1988, 851). But there is a difference between rules in a program like Aaron and human conceptualizations. Conceptualization, in a manner we do not understand well enough to replicate in a computer program, enables a kind of "run time" generation of patterned behavior that is always potentially new, not restricted to random variation on some fixed number of parameters but meaningfully adapted to multiple overarching conceptual concerns and coordinated in different sensory-motor modalities (sound, image, posture, rhythm) in time (Clancey 1999). That is, human behavior has an improvised, dynamic nature whose patterns are modeled by programs like Aaron, but whose neuropsychological mechanism is not yet understood.

One puzzle presented by Ganascia is that "the output of a creative process has to contain more than was given as input." Yet creative generalization, he says, "entails the loss of all of the specificities of the particular.... Induction corresponds to a reduc-

tion in knowledge." Surely this contradiction between "more than" and "reduction" must be a clue that the theory has gone awry, and I assume this is why he articulates these statements, laying down the troubling implications of the interactional (input-agent-output) worldview for understanding creativity.

But Ganascia's analysis seems not to advance as it might, appearing caught up in a too limited, almost circular notion of information, knowledge, and learning. I would suggest a more scientific approach, starting with observable phenomena, even those generated by a machine. For example, do Aaron's drawings "compress information"? Don't they in fact *increase* entropy by introducing an infinity of colored configurations of people, plants, and pots in a room? Are they interesting because they "reduce information"? It seems I had to look at more than a hundred drawings (a data set) before I *found* information. Indeed, understanding Aaron's drawings was an inductive process, and the rules of operation I have surmised do "compress" the variety of the drawings. But there was no "information" in these drawings, I conceived something informative and conveyed my understanding in rulelike statements about how the drawings are generated.

But notice also how I worked: I didn't merely reason about the images as they were produced. I collected them over many days (having first invented a way of saving them), sorted them, and found ways of describing them (the ontology and rules of configuration). I worked with stuff in the world, not just "chunks of remembering." How I perceived the images changed as I conceived of ways of describing them. My imaginative work involved knowing how to use a computer system to organize thousands of images in folders, to import them into a photography program, and to produce a portfolio (106 drawings on twenty-eight pages with an introduction; Clancey 2005) that I could later study to remember my investigation. I made a product out of the study that I could share and reuse. My portfolio is itself an artistic composition with arrangements of Aaron's drawings, bound by the iPhoto computer tool in pages with one, two, three, four, or eight images (a limitation I also circumvented by including a screen capture with twelve drawings).

Regarding imagination as a "combination of remembered chunks," it is true that in analyzing Aaron's drawings I used my knowledge of how such programs can be designed and the notions of grammars, constraints, and layered sequences of assembly (configure, layout, color). In creating the Aaron portfolio book, I used my knowledge of the photography program. I visualized a product analogous to what I had produced before using my own images, and that conception, a kind of template involving conceptual mapping, drove my project. But were these "memorized structures," or skills and ways of working? I adapted both design ideas and techniques. All that we know about neurological memory suggests that it is a memory of processes,

of ways of behaving, not of stored things (descriptions, maps, and programs; Clancey 1997, chap. 3; Clancey 1999). And remembering is itself an experience, a behavior in time, often guided by representations and tools in the world.

But Ganascia does not mention the instruments or tools that facilitate induction because in his worldview creativity occurs in the timeless, placeless space of the "reasoner," in transformations of inputs and outputs formally codified. In the transactional worldview, a different kind of causal coupling arises between perception, conception, and manipulated physical materials, with simultaneous and sequential relations (Schön 1987; Clancey 1997, chap. 9). Ganascia's references to research into "scientific discoveries" have the same limitation, the vast majority couched only in terms of model manipulation, existing only in the space of the mental, and saying little if anything about exploration as it actually occurs (cf. Clancey 2001).

For Ganascia, the glimmer of another worldview arises when considering the work on conceptual mapping in machine learning—operations involved in "practical induction, as it was theorized in Aristotelian natural science"—and the work on reasoning by analogy. But when he refers to structural representation and matching, Ganascia is thinking in terms of logic expressions, that is, an articulated model constructed entirely of linguistic terms and relations. Such a model would, by conjecture, be the basis for young children's drawing of imaginary pictures. Of course, given the language limitations of children, he states that this knowledge and reasoning must be unconscious—suggesting that the mind has created models that the child cannot create. So the plot thickens, or rather, we get deeper into a mire.

Again, I emphasize that Ganascia is writing about a struggle with the formalist point of view and not simply advocating it. Grounded at least a bit in real experience, he observes that "creative behavior consists . . . also in producing new ideas on which new conceptual spaces are built." The reformulation of the problem in the "mutilated checkerboard" solution accepts the ontology of contiguous squares but adds a category of color. This is creative, but reconceptualization can be broader yet, involving different modes of thought, not restricted to named categories or even articulated meanings.

Notice how a mathematical formalism, a formal puzzle, becomes, without comment, an implicit standard for defining and formalizing the nature of creativity—indeed "problem solving" becomes a metric for characterizing what is creative. Where does this leave dance? Can the quantified mode of thought of logic be used to evaluate the quality (creativity) of the mode of thought of the arts and humanities?

Referring to interpreting large data sets as "reducing information" is already a puzzle chasing its own tail, for the work of understanding is to create (increase) information, to perceive patterns, and to conceive their meaning (e.g., understand-

ing Aaron). Our everyday problem is to grasp complexity or apparent dissonance, to create information about the environment. In science this information might take the form of a generalized model that will allow better predictions—thus increasing information about the future (compare Ganascia: "it leads to removing information"). In human understanding, embracing conceptualizations assimilate, they order and organize experience, and they may do this in different ways across time and sensory-motor modalities (Clancey 1999).

The notion of "reduction" is based on quantification, whereas the cognitive process of comprehending is qualitative, relational, and constructive. In the representational flatland of logic, no distinction is made among the world of stuff, sensation, perceptual and conceptual categorization, feeling, and behavior. Combining a kitchen pantry of flour, fruit, sugar, and butter into a pie doesn't "reduce the ingredients," it creates a qualitatively new kind of entity, a baked good. The illusion that information is reduced by induction is rooted in the failure to distinguish the map and the territory. In the language of logic, baking is simply reducing the complexity of a wheat field to a pie. In the language of logic, creativity is like making a trip by moving on a map.

Ganascia notes the lack of relation between structural mapping and logical induction, which may reflect the attempt to model learning without modeling conceptualization. Explaining creativity in terms of logical induction alone entails viewing all knowing in terms of "knowing that" (Ryle 1949; Chemero 2002)—that is, of tangible and countable expressions. But human learning also involves practical control and know-how and doesn't necessarily require syllogisms and equations. Consider the role of information and reasoning in creating new skateboard gymnastics, a kind of modern dance.

Ganascia is telling us that it is difficult to equate human creativity with logical induction and machine learning, which is not too surprising given the volumes written about the logic of scientific discovery in the last fifty years. I think he is right to conclude that bringing together logic and creativity requires "conceptual space mapping," but the spaces he explores are not sufficient. Another, broader worldview is required, one that admits that different worldviews are possible, that there are indeed two kinds of people in the world. Perhaps switching partners would be helpful here.

Dance of the Systems: Crossing Disciplinary Boundaries

It is tempting to generalize from the three chapters to say something about types of "codes" of the intellect. This ground has been run over before, notoriously in talk about the digital (left brain) and the analog (right brain) (e.g., Hampden-Turner 1981,

TABLE 2. LOGICAL VERSUS ECOLOGICAL MODES OF THOUGHT

Character of Activities

Fixing	Nurturing
Resolution	Transaction
Deciding/having an idea	Doing/embodying an idea
Determinism/mechanization	Inquiry/participation
Pinning down, reification	Activity, dance
Distinction	Assimilation
Knowledge as scientific	Knowledge as instrumental
Law-driven	Interpretive
Automate	Informate
The WORD	Dialog
Top-down	Bottom-up
Preserve	Construct
Idealization	Realization
Optimization	Dynamic
Apply	Relevate
Perfecting	Evolving
Control	Empower
What is the knowledge?	Who's knowledge?
Nemeses: uncertainty, falsehood, disorder, unprincipled action, emotion, surprise	Nemeses: bounds, power/authority, bean counting, impersonal, bureaucratic, pre-determined

Character of Conceptualization

Objectify	Relate
One	Many
Knowing that	Knowing how
Things	Processes
Sequential	Simultaneous
Focal	Contextual
Statements	Melodies
Literal	Metaphorical
Excluding, extracting from context	Including, fitting into context

86–89). Just as consciousness as a topic fell into disrepute within psychology for almost a century, the left-right talk has been viewed as unscientific. However, there is something important to preserve, which I've organized according to types of activities and types of conceptualizations (table 2).

Metaphors and viewpoints are mixed in this table, relating to reification of products and processes, affecting notions of time and causality. Wilden (1987, 231–42) suggests that the distinction here—which he summarizes as "logical" versus "eco-

| WILLIAM J. CLANCEY

logical"—is not an opposition or contradiction but "two complementary forms of coding," which constitute two specialized capacities "constrained by the whole" (233). In other words, whether these are neurological processes (e.g., sequencing versus coupling), human activities (talking about versus doing something), or stages in theorization (refining ideas versus brainstorming), the different aspects depend on and influence each other.

Campbell suggests that the left-side categories correspond to information that is "coded in ways which are more strictly organized, more formal, stable, and free from error. They refer to modes of thought in which structure is of great importance, but structure of the kind in which one component is fitted to another, by a single connection, leaving no room for ambiguity or for multiple relationships" (1982, 243). Perhaps this is like the difference between English gardens and mountain meadows.

Perhaps paradoxically, the process of reifying and theorizing, which dominates the logicist perspective, becomes a deliberate tool for switching codes. But the apparent contradiction between the two perspectives lies in an objectivist worldview. Once multiple worldviews, indeed multiple formalisms and different logics, are admitted, the interplay between the perspectives becomes productive and dynamic (as realized in the work of Ceusters and Smith, as well as my assembling pages of a book from sorted drawings by Aaron). Conceptually, the blending of logical framework and ecology of materials may blend and alternate as perception, meaning, and action arise together (Clancey 1997, chap. 9; Schön 1987).

More broadly, the two perspectives represent different codes of conduct, a combination of values and methods for regulating a community's activities, including access to resources and privileges. Schooling is replete with examples of how to assess proficiency, with debates about the illusory primacy of propositional knowledge over skills. Disciplines evaluate performance according to their own epistemologies, with the arts and humanities emphasizing projects and portfolios and the sciences emphasizing faithful reproduction of accepted theories. Constraints of norms, genres, and settings tacitly and often, on reflection, explicitly regulate the creations of artists, writers, architects, instructional designers, lawmakers, medical providers, and so on (Schön 1979, 1987).

Wilden cautions that we need a "both/and" perspective throughout.[6] The two sides of table 2 are not opposing worldviews but modes of thought that build on each other. Extinguish one half and the activities and conceptualizations on the other half would cease to exist or would have a dramatically different character. As Dewey put one aspect of the relation: "The business of reason is not to extinguish the fires which keep the cauldron of vitality seething, nor yet to supply the ingredients which are in vital stir. Its task is to see that they boil to some purpose" (Dewey 1929, 587). I visual-

ize these modes of thought as two icons: On the right, the many, diversity—a group of people with arms aloft and hands together in a circle (also, the multicolored rings of the Olympics); on the left, the one, purity—the glaring red eye of Hal in the movie *2001: A Space Odyssey*.

The challenge posed for these essays was framed originally as "fostering a dialogue . . . about the impact of digital information technology on thought and practice in the arts and humanities." Yet my reading of the essays in this section suggests that we turn the topic around and consider *the impact of thought and practice in the arts and the humanities on digital technology*. An actor, for example, is well aware of the different mentalities of a performance and a script (Becker 1982, 61); switching codes is part of the actor's everyday experience. But the technologist schooled in the logicist, technical rationality of the twentieth century is taught that scientific thinking is the only kind of truth (at worst, that theories are to be judged by their falsifiability rather than their directive value; Dewey 1938, 519). Learning that technical rationality is just one way of regulating human activity requires the logicist to recognize the dialectic between logic and ecologies of human activity, to appreciate an order, a form of intellectual life, that is not controlled, articulated, or expanded through reason alone, yet still benefits from and often relies on notations, models, and inference.

These essays illustrate how participating to become influential in another community requires scientists and engineers to fit their practices (including the tools they seek to foster) within the practices of that community (Greenbaum and Kyng 1991). Doing this with integrity requires, as Hendler relates so well, understanding that technical rationality is not in control, not a gold standard, and not the savior, but just one (sometimes very important) mode of thought and practice for bringing order to human affairs. So part of "what you do on Monday" is to join a group that lives on the other side and to see how you can be of service. From Hendler and Ganascia's perspective, this is the inverse of Ceusters and Smith's "dancing with the ontological engineers."

Table 2 tells us that there is no transcendent mode of thought but rather a dialectic between "objectifying" and "relating." But is there a transcendent point of view, an epistemology that includes all others? Perhaps, in a metaphysical sense, a transcendent idea is that there exist multiple points of view with validity in different (cultural) systems or for different purposes.

As psychologists who equated concepts with fixed symbols in the brain (Agre 1993; Clancey 1997) came into contact with social scientists, they sometimes felt that science itself was being undermined. Technical rationality, requiring coherent definitions, formal rules, consistency, completeness, and a mathematical foundation for validity, is founded on the notion of models, and by assumption such models must correspond, have a truth relation, to the phenomenon of interest to be of value. Thus,

WILLIAM J. CLANCEY

from the perspective of TR, the notion of multiple worldviews has been regarded at times as cultural relativism that makes impossible a science based on absolute truth (Slezak 1989; Vera and Simon 1993). Yet scientists focusing on ecological problems, such as Lorenz, an ethologist (and even Bohr, a physicist), had long ago adopted a different view of change and complex systems, compatible with a constructivist (as opposed to objectivist) epistemology (Clancey 2008).

We must not, however, simply criticize TR and dismiss it. Rather, the point of table 2 is to provide a transcendent view that puts TR into perspective, making its contributions and indeed its necessity clearer. Thus, in some respect we might argue that it is fine and good for different schools of thought to operate in blissful isolation, as discrete academic societies, departments, and publications. For through this separation, as in the formation of species, different analytic frames, languages, and tools can mature. At some point, though, for some people inclined to "bridge the gaps," an intolerable discrepancy emerges, a tear in the fabric of our common heritage. Perhaps it will be a practical problem that forces a dialogue between communities (as global warming brings together scientists and politicians), or it might be a practical tool that sparks a creative "what if?" (as the Internet has been taken up by journalists, photographers, cooks, genealogists, and so on).[7]

The difference in mentality and practices then provides a potential to cross (cf. Ceusters and Smith), a field of play for intersecting and synthesizing modes of thought—exemplified by the objective of this volume. On the World Wide Web the potential to "relevate" across disciplines is so extensive, the blooming of a thousand flowers so unmistakable, we are thrown up into yet another plane, where we can now see the modes of thought, the speciation of disciplines. We observe from this higher plane, looking down on the river of language, thought, and culture, a continual dance of objectification and relevation, in the self, in society, and in the global community. The unifications have been occurring all along, particularly between the sciences and philosophy. The illusory triumphs of a field (such as the hubris of the AI researchers of the 1960s and 1970s) are but short-lived, mostly harmless eddies, in whose epistemological backwaters an idea can be explored to its limit, matured and admired, and then spit out into the main stream, where it can find its way into a larger activity, and in that flow be transformed into something more alive and uncertain in destination.

Notes

1. In this commentary I use the term "code" informally, in reference to the theme of this book. In the discourse of artificial intelligence research, however, the term conjures up debates about representation and meaning. For this reason, because it suggests a certain "language of thought" that I reject, I would not ordinarily use the term to refer to worldviews (Altman and Rogoff 1987; Agre 1993, 62). By "code" here I

mean broadly a "mode of thought," involving and reflected in a conceptual system, attendant language or notation, and activities of some community of practice (e.g., the code of musical performance and theory; the code of the logicist-technologists who invented the semantic web).

2. Ironically, when Stanford researchers sought funding in the late 1970s to develop an expert system for pneumonia, to collect the best practices for a poorly understood disease, the National Institute of Health rejected the proposal on the grounds that the knowledge did not exist, so attempting to write rules for diagnosing pneumonia was premature.

3. Ryle (1949), Dewey (1938), and many others said this clearly, well before cognitivist psychology dominated the academic scene. For surveys see Clancey (1997) and Wallace et al. (2007).

4. The attitude seems related to the tag line of the 1960s US television show *Superman*: "Truth, justice, and the American way."

5. This version of Aaron has been available online since 2001 at http://www.kurzweilcyberart.com/aaron.

6. For extensive discussion of the nature of communication, particularly the issue of switching codes, see Wilden (1987). Wilden's title, *The Rules Are No Game*, reflects his interest in the relation between coded variety (the rules) and uncoded variety (the game), playing against Korzybski's dictum "The map is not the territory."

7. Although I focus here on technological change since the 1990s, the pattern is also evident in the broad sweep of history in the creation and bridging of political boundaries based on ethnicity, language, and religion.

References

Agre, P. E. 1993. The symbolic worldview: Reply to Vera and Simon. *Cognitive Science* 17 (1): 61–69.

Altman, I., and Rogoff, B. 1987. World views in psychology: Trait, interactional, organismic, and transactional perspectives. In *Handbook of environmental psychology*, ed. D. Stokols and I. Altman, 7–40. New York: John Wiley & Sons.

Becker, H. S. 1982. *Art worlds*. Berkeley: University of California Press.

Campbell, J. 1982. *Grammatical man: Information, entropy, language and life*. New York: Simon & Schuster

Chemero, A. 2002. *Electronic Journal of Analtyic Philosophy* 7. http://ejap.louisiana.edu/EJAP/2002/contents.html.

Clancey, W. J. 1989. Viewing knowledge bases as qualitative models. *IEEE/Expert*, 4 (2); 9-23.

———. 1992. Model construction operators. *Artificial Intelligence* 53 (1): 1–124.

———. 1997. *Situated cognition: On human knowledge and computer representations*. Cambridge: Cambridge University Press.

———. 1999. *Conceptual coordination: How the mind orders experience in time*. Hillsdale, NJ: Lawrence Erlbaum.

———. 2000. Modeling the perceptual component of conceptual learning: A coordination perspective. Reprinted in *Cognition, education and communication technology*, ed. P. Gärdenfors and P. Johansson, 109–46. Lawrence Erlbaum Associates, 2005.

———. 2001. Field science ethnography: Methods for systematic observation on an expedition. *Field Methods* 13 (3): 223–43.

———. 2005. *AARON's Drawings*. Unpublished iPhoto book.

———. 2006. Observation of work practices in natural settings. In *Cambridge handbook on expertise and expert performance*, ed. A. Ericsson, N. Charness, P. Feltovich, and R. Hoffman, 127–45. New York: Cambridge University Press.

———. 2008. Scientific antecedents of situated cognition. In *Cambridge handbook of situated cognition*, ed. P. Robbins and M. Aydede, 11–34. New York: Cambridge University Press.

Clancey, W. J., M. Sierhuis, and C. Seah. 2009. Workflow agents vs. expert systems: Problem solving methods in work systems design. *Artificial Intelligence for Engineering Design, Analysis, and Manufacturing* 23:357–71.

Cohen, H. 1988. How to draw three people in a botanical garden. *Proceedings of the Seventh National Conference on Artificial Intelligence*, Minneapolis–Saint Paul, 846–55.

Dewey, J. 1929. *Character and events.* New York: Henry Holt & Co.

———. 1938. *Logic: The theory of inquiry.* New York: Henry Holt & Co.

Gardner, H. 1985. *Frames of mind: The theory of multiple intelligences.* New York: Basic Books.

Greenbaum, J., and M. Kyng, eds. 1991. *Design at work: Cooperative design of computer systems.* Hillsdale, NJ: Lawrence Erlbaum.

Hampden-Turner, C. 1981. *Maps of the mind: Charts and concepts of the mind and its labyrinths.* New York: Collier Books.

McCorduck, P. 1991. *Aaron's code: Meta-art, artificial intelligence, and the work of Harold Cohen.* New York: W. H. Freeman.

Ryle, G. 1949. *The concept of mind.* New York: Barnes & Noble.

Schön, D. A. 1979. Generative metaphor: A perspective on problem-setting in social policy. In *Metaphor and thought*, ed. A. Ortony, 254–83. Cambridge: Cambridge University Press.

———. 1987. *Educating the reflective practitioner.* San Francisco: Jossey-Bass.

Slezak, P. 1989. Scientific discovery by computer as refutation of the strong programme. *Social Studies of Science* 19 (4): 563–600.

Toth, J. A. 1995. Review of Kenneth M. Ford and Patrick J. Hayes, eds., *Reasoning agents in a dynamic world: The frame problem. Artificial Intelligence* 73: 323–69.

Vera, A. H., and H. A. Simon. 1993. Situated action: Reply to reviewers. *Cognitive Science* 17: 77–86.

Wallace, B., A. Ross, J. B. Davies, and T. Anderson, eds. 2007. *The mind, the body and the world: Psychology after cognitivism.* London: Imprint Academic.

Wilden, A. 1987. *The rules are no game: The strategy of communication.* London: Routledge & Kegan Paul.

Intelligence and the Limits of Codes

Albert Borgmann

If we think of code in a broad sense as a formal language, we can say that reality is ruled by a code. Galileo memorably said of the universe that it is a book "written in the language of mathematics" (Galileo 1960 [1623], 184). Newton was thought to have deciphered the entire code. There was a widespread conviction in the eighteenth century that his laws of motion would provide an explanation of everything. The progress of science has subsequently shown that Newtonian physics gives us but a limited and approximate explanation of the world. The belief that reality can be captured by a code, however, has been vindicated by the discovery of more and more powerful scientific theories.

Scientific laws are formulas that have given us an understanding of the general features of reality. If you want to understand a particular piece of reality, however, you have to plug the values of the particular instance into the variables of the scientific law. As Newton has taught us in his *Principia*, if you want to know the force of gravity between the moon and the earth, you use the formula of universal gravity:

$$f = m_1 \times m_2 \times g/d^2$$

Replace m_1 with the mass of the earth, m_2 with the mass of the moon, d with the distance between (the centers of) the earth and the moon, do the computation (including the gravitational constant g)—and voilà, the particular force of gravity between earth and moon (Newton 1999 [1713], 803–5).

Such a computation is like a snapshot, a record of a particular instance of reality. You can get a series of pictures, depicting, say, the motion of the moon around the earth, if you solve many equations for many different values, as Newton did (832–34, 839–74). With paper and pencil this is a laborious and limited affair, and the result is still an account of only a thin slice of reality. To capture a thicker phenomenon, such as the way air moves around the wing of an airplane, you need more elaborate formulas, more available values, quicker computations, and a more intuitive presentation

of the results than paper and pencil can provide. Computers can produce such an account, and while Newton's work gives us an account that's *about* reality, a computer gives an account that's *like* reality.

Computer science is different from physics, of course. It is a science in its own right, the only essentially new science since the eighteenth and nineteenth centuries, when most of our standard sciences exfoliated from philosophy. But computer scientists share with physicists the conviction that reality is governed by a code and that to articulate the code is to gain insight into reality. What distinguishes computer scientists from other scientists is the belief that the resources of their discipline, the resources of computers, enable them to capture phenomena that are prohibitively complex for other disciplines. Human intelligence is perhaps the most complex and challenging phenomenon, and from the moment there were practicable computers, computers scientists have been concerned to capture and model it. This ambition and its undergirding convictions are reflected in the three papers I'm responding to.

If Werner Ceusters and Barry Smith's project were realized, it would amount to an unfailingly knowledgeable, discerning, and impartial expert on dance, one who had an answer to every query. Jean-Gabriel Ganascia's creative machine would be the equivalent of an artist. Jim Hendler's relevated AI would be an efficient and trustworthy guide to all of the information on the web. These conceptions of human intelligence are reactions to the history of AI as much as they are reflections of it. The full frontal assaults have failed, and efforts are now trained on particular aspects or functions of human intelligence. That leads to the crucial question of AI: How thick a function of human intelligence can be coded? The evidence so far seems mixed. Until May 1997 it looked as though the best human chess intelligence was too thick to be captured by a chess-playing computer. Then again it's been surprising that what we may call Turing intelligence appears to be forbiddingly thick. It's impossible to say a priori exactly how thick a piece of human intelligence can be coded. But I think one can plausibly show that human intelligence is essentially different from any artificial intelligence; and it follows, less plausibly perhaps, that human intelligence will therefore always be able to do things that coded intelligence cannot.

To understand the distinctiveness of human intelligence, we need to understand what the thickness of a function is. To a first approximation the thickness of a function is what a thing and a functionally equivalent device have in common. Take an artificial fireplace. What does it have in common with a traditional fireplace? The artificial version provides warmth, and it looks like a traditional fireplace. There are limits, however, to the thickness of its functional equivalence. It does not crackle, and it does not emit the smells of wood smoke. Obviously its function could be thickened by machineries that would produce the appropriate sounds and smells.

If we think of functional equivalence as a bundle of functions, then how many functions must be replicated for an artificial fireplace to be the functional equivalent of a traditional fireplace? Think of a demanding customer who wants the artificial fireplace not only to heat, look, smell, and sound like its traditional counterpart, but also to show whether it's burning ponderosa pine, Douglas fir, or cottonwood logs— and to show it not only in the appearance of the logs but also in the way they burn and dissolve into ashes. Already we've passed into science fiction, but our demanding customer can demand yet more: that the logs share their dendrochronology with the actual world, that their isotopes be traceable to a particular site in a forest. Let the demanding customer be an analytic philosopher, and when all her demands have been met, the artificial fireplace will be indistinguishable from a traditional one.

Ordinary customers are less resourceful and demanding. They settle for something that heats and more or less looks like a fireplace. We can call an object that performs a function by means of some machinery a device and an object that has no functional equivalent a thing. Just to clarify and extend the terminology, I'll note that what I call the machinery is called the structure in theories of functionalism, and what such theories call functions I will also call commodities. What's remarkable, then, is the common readiness in contemporary culture to let devices take the place of things. People do not insist that music come from a live band; what comes from an iPod is unreservedly taken to be music. What's just as remarkable is that the three papers to which I'm responding refuse to take available functions or commodities as substitutes for what they propose to encode. They could have settled for Google as a guide to dance or information and for "an artificially intelligent jazz performer" as the model of an artist.

Why this dissatisfaction with devices? Why might someone, expecting to find a fireplace in the living room, be disappointed on finding the fireplace to be artificial? Perhaps the house borders on a forest and he was looking forward to cutting his own firewood, making a fire with his own logs, watching them burn late at night. He likes the warmth and the dance of flames in a fireplace, and if this were all he required the artificial fireplace would oblige him and perhaps even fool him. But as soon as he tried to rearrange the logs, he'd be disappointed.

Let's call the whole of the properties that are characteristic of a traditional fireplace and distinguish it from an artificial one the aura of the fireplace. Is human intelligence like the aura or like the heat of the fireplace? Like heat, intelligence is, in a sense, a necessary and distinctive feature. We would not accept an object that could not produce heat as a real fireplace, nor would we consider someone who lacks intelligence a fully human being, even though we should unconditionally respect and support such persons.

In another and more important sense, the distinction between heat and aura is without a difference. The heat that the man expects and cherishes is the heat that comes from logs he has cut, fire he has made, and flames that flicker and later will die. The heat from the artificial fireplace will leave him disappointed. That's what the intelligence of Julia did to Barry, who was briefly charmed until he discovered that she, or rather it, was the housekeeping bot of a MUD (Turkle 1995, 88). The same thing had happened to the people who at first found Joseph Weizenbaum's Eliza to be a gentle and helpful counselor (Weizenbaum 1976, 188–91).

One might think that an artificial intelligence, unlike the function of an artificial fireplace, could be thickened to a level where a conversation would not end in disappointment. One way of following up on that conjecture is to imagine an intelligence that passes the Turing test and to notice what remains concealed and ambiguous in Turing's original setting—the age, the gender, and the intonation of the respondent (Borgmann 1994, 271–83). If these ambiguities remain, the responses become disappointing. If they're resolved, more ambiguities emerge. The last and crucial one is this: Is what this person represents actual or feigned? If feigned, the representation will ultimately be disappointing. If actual, there was in fact that accident on that mountain at that time that tested the respondent and now warrants her professions of fortitude. Such resolutions of ambiguities would be impossible if she were not a mindful and embodied person, engaging and disclosing actual reality (Borgmann 1976, 68–86). This takes us round to the point Hubert Dreyfus made in his classic article "Why Computers Must Have Bodies to Be Intelligent" (1967).

The depth of a person and her immersion in reality are coded in one way but escape coding in another. They are coded at the level of physics and chemistry, but tracing the entirety of the codes of atoms and molecules to the levels of cells, organs, and organisms or of crystals and rocks is impossible. To be sure, what looks like an impenetrable thicket of codes at the micro level assumes an intelligible order at the macro level of the ordinary world. Roughly put, there is an ontology of things and an ontology of devices. The two overlap where the aspect or sense of a thing corresponds to the function or commodity of a device. But from there the two ontologies diverge. The ontology of things is ordered by eloquence, the ontology of functions by definition. The aspect or sense of a thing that speaks to us has the resonance of a context of things. The function or commodity of a device is defined by the design of machinery. Machineries have their own context—the infrastructure. It's possible to deepen or clarify the sense of a thing. But if you probe and press a commodity, you come upon its machinery and then have lost touch with the commodity.

The depth and eloquence of a human being is consonant with the context of things, and it follows perhaps that humans are therefore able to respond to things in

ways that devices can't. Aspects of that ability can be captured as functions or com-
modities. I suspect that beyond a certain thickness of an aspect it's all or nothing,
an actual human being or the failure of a project. The projects of each of the three
papers, I fear, are too thick to be feasible. But that's an empirical issue.

In any event, work at the leading edge of the most advanced technological de-
vices is evidently compatible with a sense for the depth of things. The moral of these
convictions, I'd like to suggest, is to put devices in the service of things.

References

Borgmann, Albert. 1976. Mind, body, and world. *Philosophical forum* 8:68–86.
———. 1994. Artificial intelligence and human personality. *Research in philosophy and technology* 14:271–83.
Dreyfus, Hubert. 1967. Why computers must have bodies to be intelligent. *Review of metaphysics* 21:13–32.
Galileo Galilei. 1960 [1623]. The assayer. In *The controversy on the comets of 1618,* trans. Stillman Drake and
 C. D. O'Malley. Philadelphia: University of Pennsylvania Press.
Newton, Isaac. 1999 [1713]. *The principia.* Trans. I. Bernhard Cohen and Anne Whitman. Berkeley: Univer-
 sity of California Press.
Turkle, Sherry. 1995. *Life on the screen.* New York: Simon & Schuster.
Weizenbaum, Joseph. 1976. *Computer power and human reason.* San Francisco: Freeman.

INTERLUDE

Figment:
The Switching
Codes Game

ERIC ZIMMERMAN

I am a game designer. Figment, my contribution to this volume, reflects my disciplinary activity: it is a game for you to play.

The rules, instructions, and cards for Figment appear on the following pages. It is a real game, not a conceptual exercise that flirts with the form of a game or a playful gesture toward something gamelike. The proper way to experience it is to cut the cards out of this book or download them from http://www.press.uchicago.edu/books/switchingcodes, read the rules, and sit down with a handful of friends to play. (For those of you suffering from a temporary lack of playmates, there is a solitaire version as well.)

Each of the cards in Figment contains a fragment of text taken verbatim from one of the essays in this book. In playing the game, players combine and recombine these fragments, making statements and declarations that are sometimes profound and sometimes comical. But in each case, a move in the game makes use of raw textual materials from this book, remixing them into novel statements. Playing Figment is thus necessarily an exercise in the playful creation of meaning.

Starting a Game

Shuffle all of the cards and deal each player seven cards, which should be kept hidden from the other players. Place the rest of the cards face-down in a deck.

The goal of the game is to make and modify statements using two or three cards, and to be the first player to get rid of all of the cards in your hand. The youngest player goes first by making a statement, and play continues clockwise around the table.

If the youngest player can't make a valid statement to start the game, that player draws a card and the player to the left has a chance to start the game, and so on.

Making Statements

You make a statement by placing two or three cards next to each other in the order that they are to be read. There are two kinds of cards: CONCEPT cards, with no arrows on them, and LINKING cards, with one or two arrows. The arrows on the linking cards show how they connect to concept cards. When you make a statement, *every arrow on a linking card must point to a concept card.* In starting the game, you can make two kinds of statements:

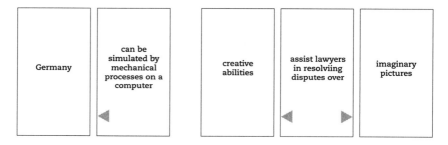

If you use a linking card with two arrows to make a statement, you *must* use three cards.

Every statement must make grammatical sense; subjects and verbs must agree in number. In addition, a statement must bring some kind of insight to its subject matter. Nonsensical statements (even if grammatically correct) are not permitted.

After you play a statement, you must explain to the other players why the statement is insightful, by reading the new statement and then saying, "Because . . ." Other players can challenge the statements you make. (More on explanations, insight, and challenges below.)

Play

Play continues clockwise around the table. On your turn, you can do one of three things:

- **Create a new statement** by playing cards from your hand on the table in front of you. Each player can create only one statement per game.
- **Modify a statement** by playing cards from your hand onto any existing statement.
- **Draw a card** if there is nothing else you can do.

To CREATE a statement, play two or three cards from your hand to make a completely new statement. This new statement can be modified by other players on subsequent turns. When you make a statement, place the cards on the table in front of you. Each player can create only one statement per game.

To MODIFY a statement, play a card from your hand on top of a previously played card, replacing it in the existing statement. All of the rules for making valid statements hold true when you modify a statement: the modified statement must be grammatically correct, it must be insightful, and you must explain it to the other players.

If you play a linking card to modify and the new card has a different number of arrows than the card you are replacing, you must change the number of concept cards in the statement accordingly:

- If you replace a two-arrow linking card with a one-arrow linking card, you must remove the concept card to the right and put it in a discard pile.
- If you replace a one-arrow linking card with a two-arrow linking card, you must also play a concept card from your hand to complete the statement.

If you DRAW, take the top card from the deck and add it to your hand. You do not get to play any cards if you draw.

Challenges

In addition to being grammatically correct, any created or modified statement must bring insight to its subject matter. Each time a player makes or modifies a statement, the player must read the new or modified statement to the group and then explain, "Because . . ." The explanation should make clear how the statement brings insight to its subject matter. The standard for what is considered insightful will, of course, vary from group to group and context to context.

After the explanation is complete, a player who feels that the statement does

not bring insight to its subject matter—because, for example, it is nonsensical, patently false, or simply too conventional—can CHALLENGE the statement. The player who challenges presents an argument as to why the statement should not be permitted to be played, and then the remaining players vote. Challenges should be used sparingly.

If the challenger convinces a majority of the other players (not including the player who made the statement) that the statement is not insightful, the challenge succeeds. Otherwise, the challenge fails.

- **If the challenge succeeds,** the player who played the challenged statement takes all of the cards played that turn back into his or her hand and restores the modified statement to its previous state. The player also draws one card from the deck, and his or her turn ends.
- **If the challenge fails,** then the statement stands on the table. The challenger draws one card from the deck and play continues as usual.

The End

The first player to successfully play the last card in his or her hand wins the game.

Figment Solitaire

Because we so often lack playmates, rules are provided for a solitaire version of Figment. It lacks the disputation and social negotiation of the full game, but the core mechanism of remixing the meanings of the essays in this volume remains.

To prepare, deal five cards across in a row, face-up. Deal four cards on top of the first row, starting with the second card from the left, then three cards, starting from the middle card, and so on, so that the cards are arranged as shown:

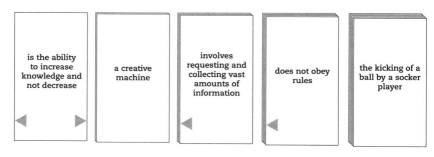

If you can create a two-card or three-card statement using the five visible cards, take the cards off the piles and arrange them to one side to make the statement. If you can't make a statement from the visible cards, deal another card on each pile until you have cards that *can* be made into a statement. Criteria for statements are the same as in the regular game, including grammatical correctness and insight.

Set the rest of the cards aside (you won't be using them). The goal of Figment Solitaire is to get rid of all of the cards in the piles you dealt by modifying the statement and creating new ones. In the solitaire version of the game, unlike the full version, there is always only one statement visible for you to modify.

To play the game, you can take one of two actions:
- **Create** a new statement
- Play a single card from the piles to **modify** the current statement

When you **create** a new statement, take the cards for the new statement off the dealt piles and play them right on top of the current statement, covering up the old cards.

When you play a card and **modify** a statement, you can rearrange any of the currently visible cards in the statement. For example, if the current statement is

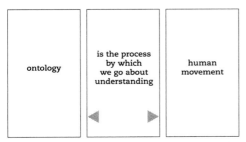

and you want to modify the statement by playing the concept card "dance steps" from a pile, you could rearrange the visible statement cards like so:

One last clarification: Sometimes, you will be turning a three-card statement into a two-card statement. This happens when you create a two-card statement on top of a three-card statement, or when you replace the two-arrow linking card in a three-card statement with a one-arrow linking card. In these cases, you will be left with a visible card that isn't part of the current statement. That's OK. You can decide whether the unused card is the concept card on the left or the right. And on subsequent modifications, you can use any of the three visible cards, not just the two that are being used in the statement.

To win, play the last card from the piles of cards. If you get stuck in a position where you can't play, you lose. As with other solitaire games, there is some luck involved. However, by playing strategically, using cards from your deeper piles first, keeping an eye on which kinds of cards are visible, and thinking two or three moves ahead, you will greatly increase your chances of winning.

the skyscraper

COOVER

play

ZIMMERMAN

the muscleman in
gay culture

COOVER

a Möbius strip

COOVER

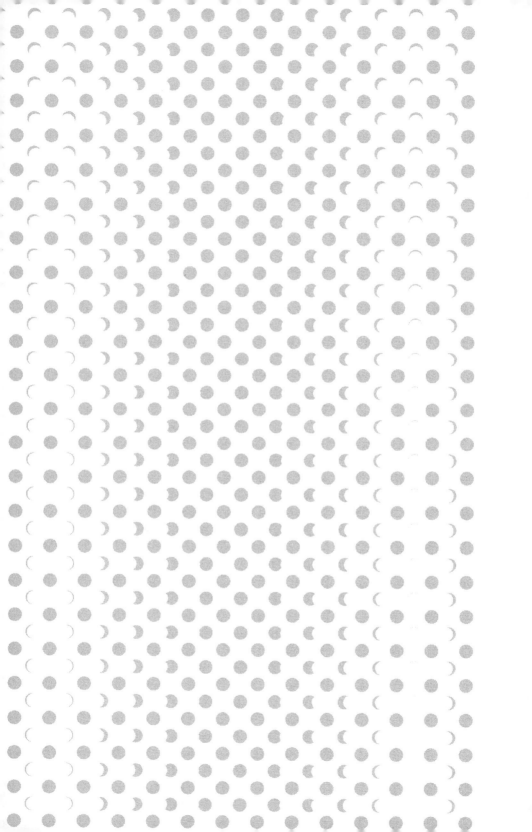

game design

COOVER

Pinocchio

D'IORIO AND BARBERA

trust

LIU

democracy

D'IORIO AND BARBERA

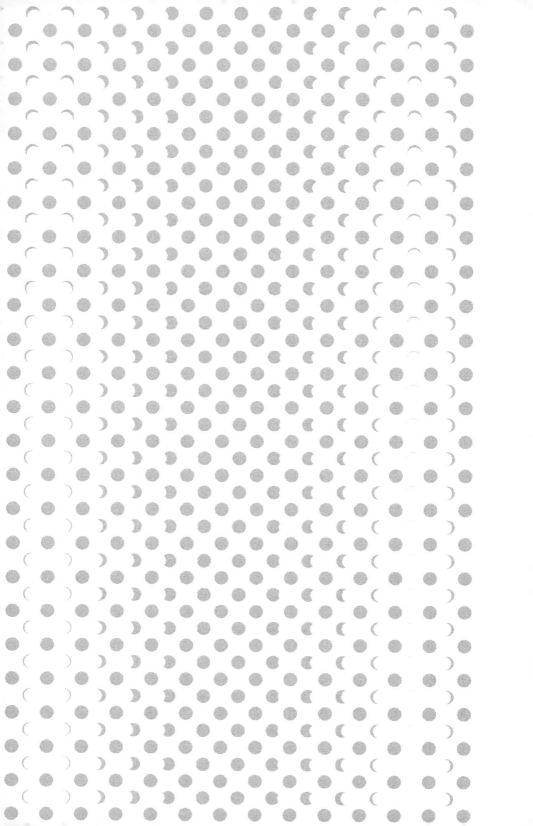

Wikipedia

LIU

nature

WHITE

an out of the blue e-mail

POWERS

truth

BERNSTEIN

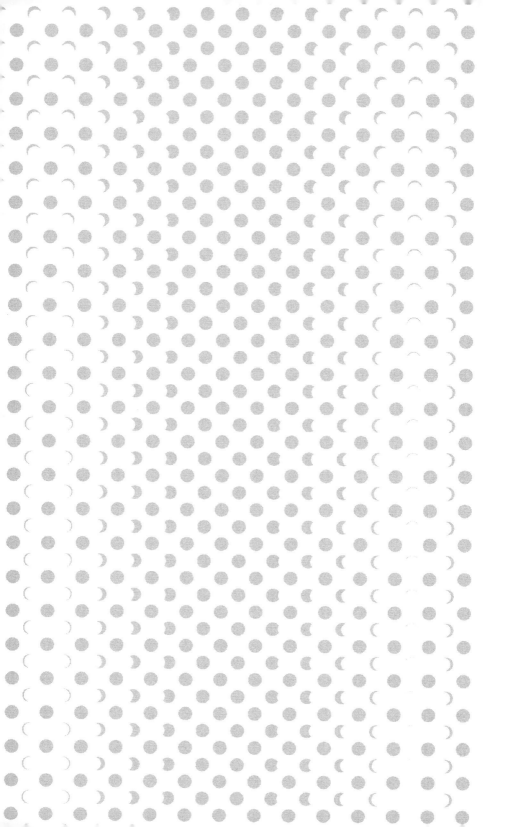

childhood

POWERS

Mozart

CEUSTERS AND SMITH

the seductive power
of the web

FOSTER

witchcraft

FOSTER

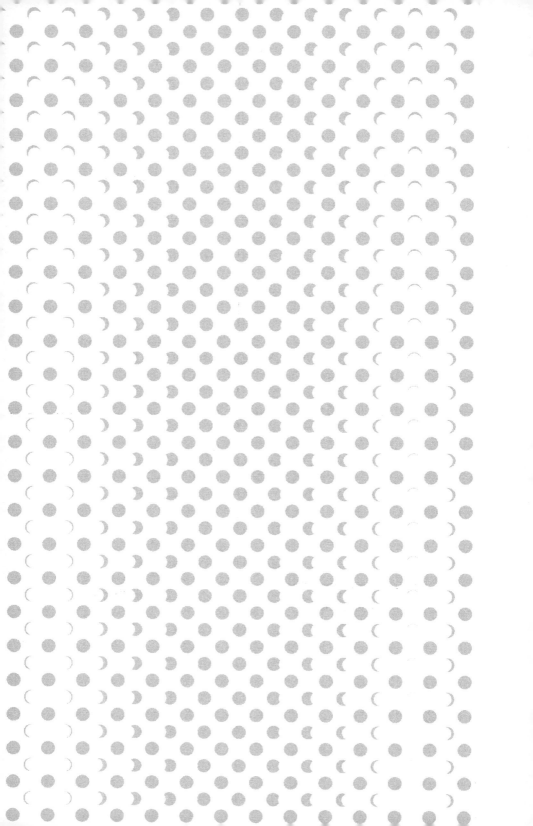

the behavior of the entire
climate system

a chessboard

World of Warcraft

Ada Byron-Lovelace

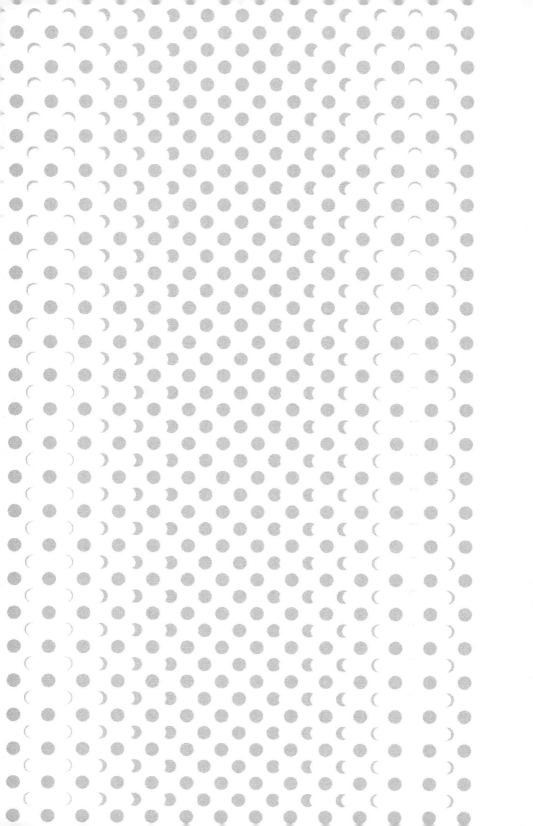

Aristotle

GANASCIA

artificial intelligence

BORGMANN

mathematics

BORGMANN

an artificial jazz player

GANASCIA

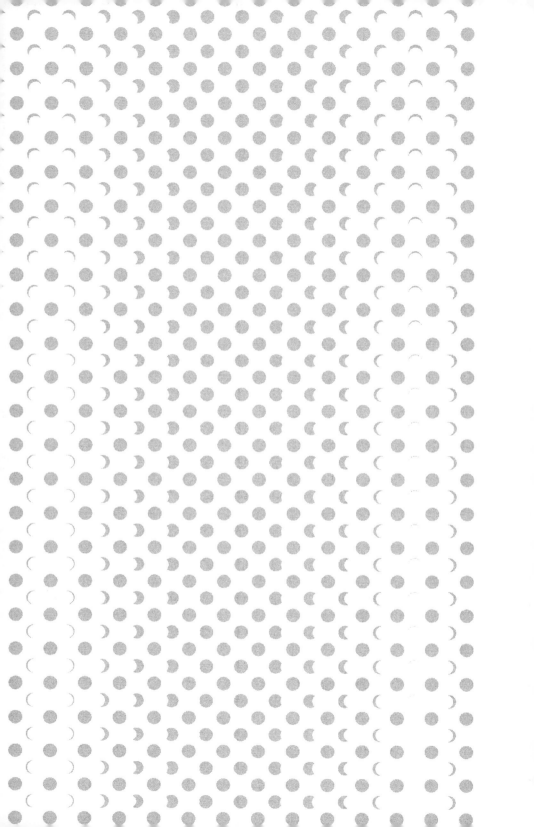

intelligence

BORGMANN

a blog entry in
livejournal.com

HENDLER

the essence of
human communication

HENDLER

the real world

CLANCEY

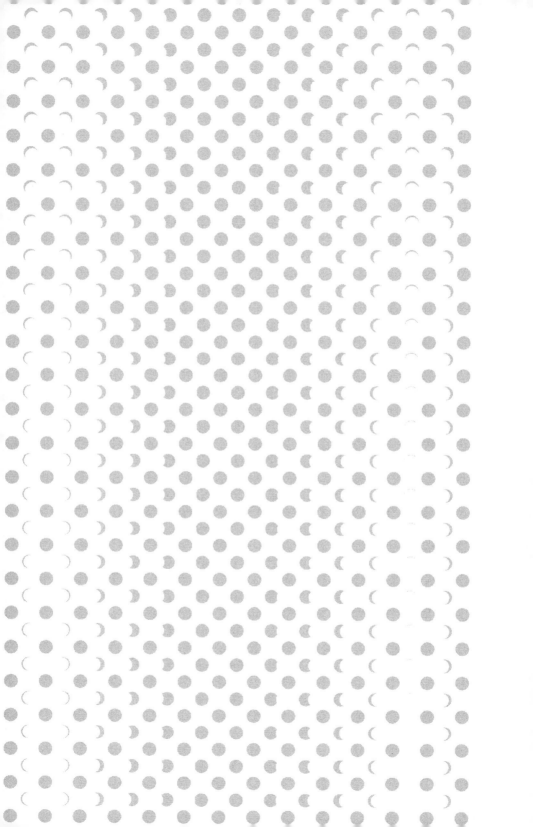

a lot of money

HENDLER

Frankenstein

QUASHA AND HILL

composer/writer
John Cage

QUASHA AND HILL

the body

COOVER

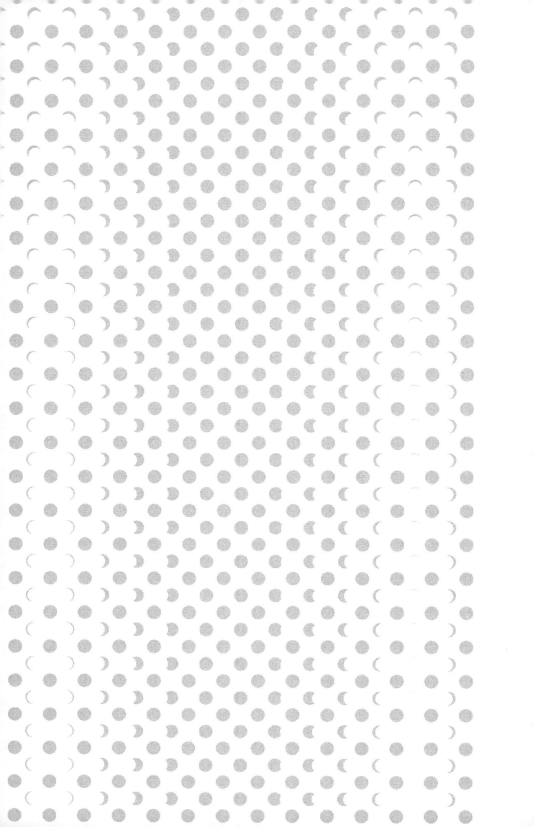

the art of origami

QUASHA AND HILL

the primal urge

QUASHA AND HILL

a glockenspiel

QUASHA AND HILL

a tear

CLANCEY

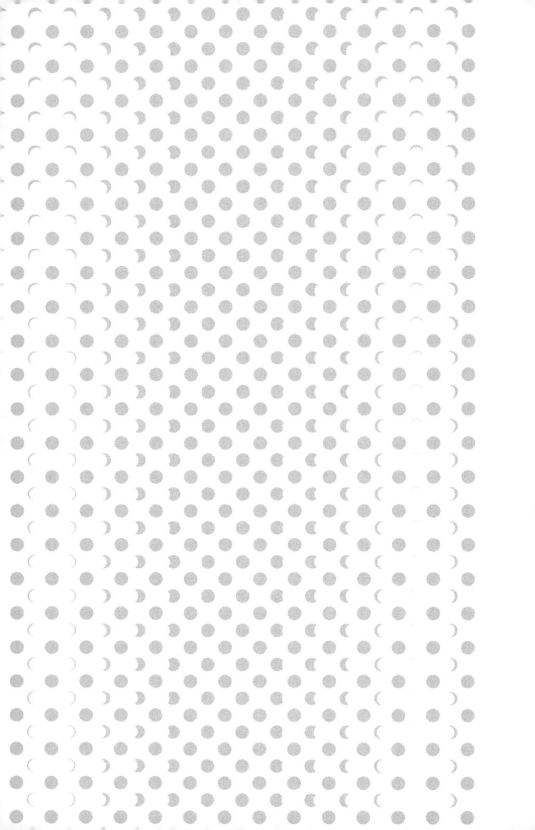

Hollywood

LATOUR AND LOWE

the absolute Platonic ideal

LATOUR AND LOWE

Shakespeare

LATOUR AND LOWE

that worldwide cut-and-paste scriptorium called the web

LATOUR AND LOWE

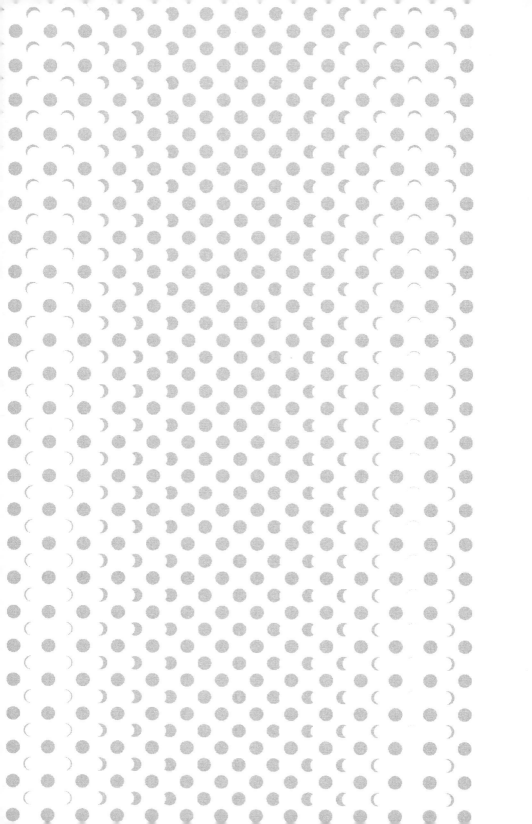

the road to hell

LATOUR AND LOWE

bicycling

SHAW, KENDERDINE,
AND COOVER

the structure
of scholarship in the
real world

D'IORIO AND BARBERA

a self-organizing system

SHAW, KENDERDINE,
AND COOVER

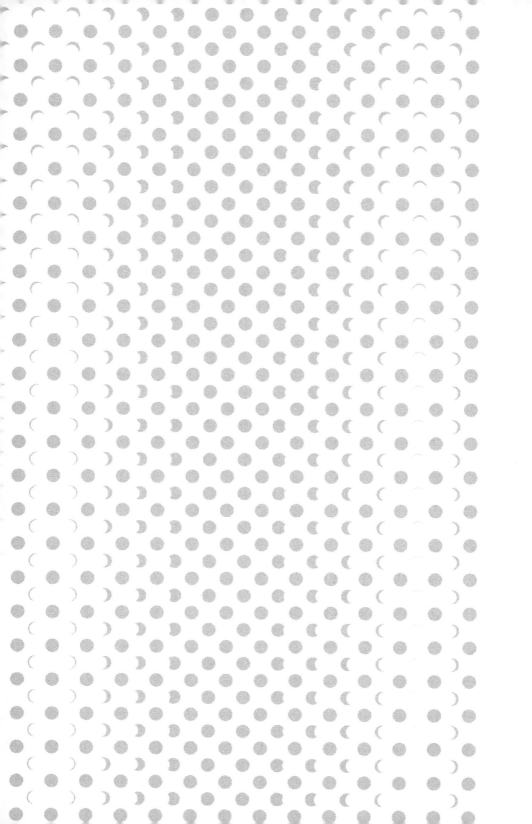

a totally immersive
environment

SHAW, KENDERDINE,
AND COOVER

the recent massive
popularity of social-media
sites on the Internet

SHAW, KENDERDINE,
AND COOVER

the success of the
Nintendo Wii

SHAW, KENDERDINE,
AND COOVER

data

DONATH

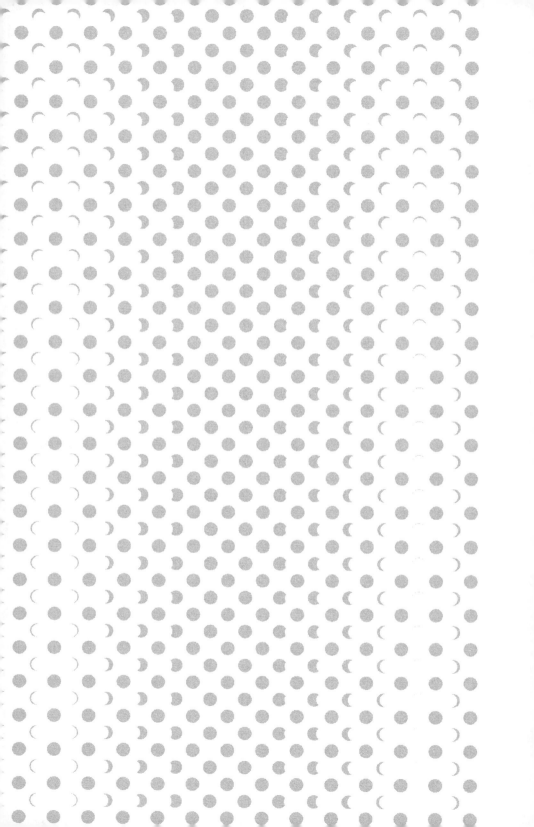

an epileptic jerk

CEUSTERS AND SMITH

Germany

SORENSEN

a martial art

CEUSTERS AND SMITH

all of human culture

CEUSTERS AND SMITH

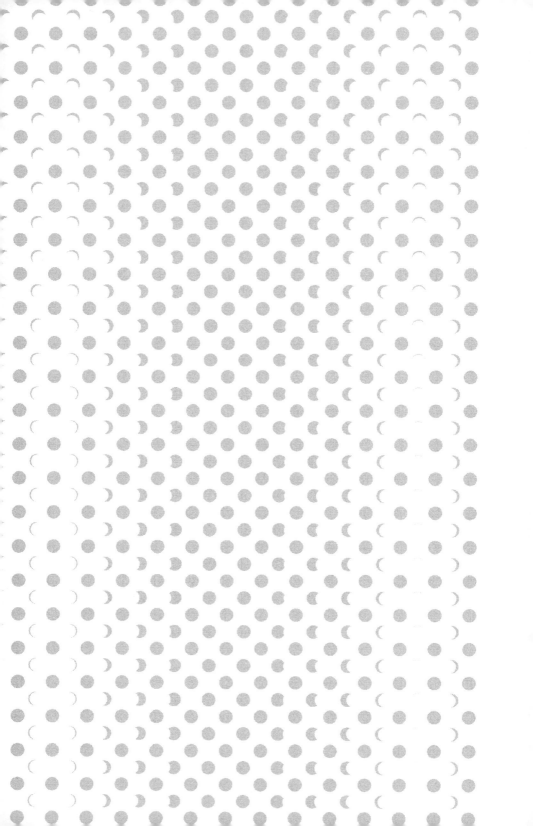

weapons of
mass destruction

STEFIK

the tireless work
of the machines

STEFIK

California

CLANCEY

reality

DONATH

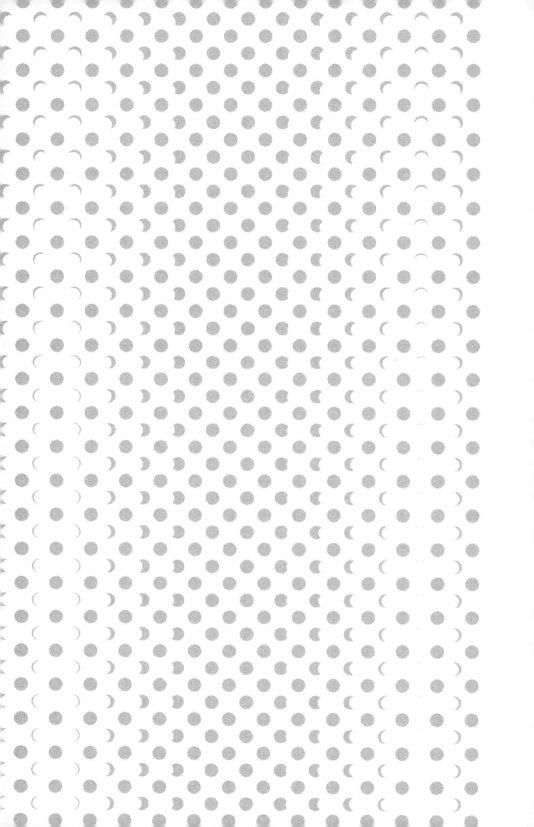

digital environments

SORENSEN

wax statues

COOVER

athleticism, power, and
sexual desire

COOVER

body parts

COOVER

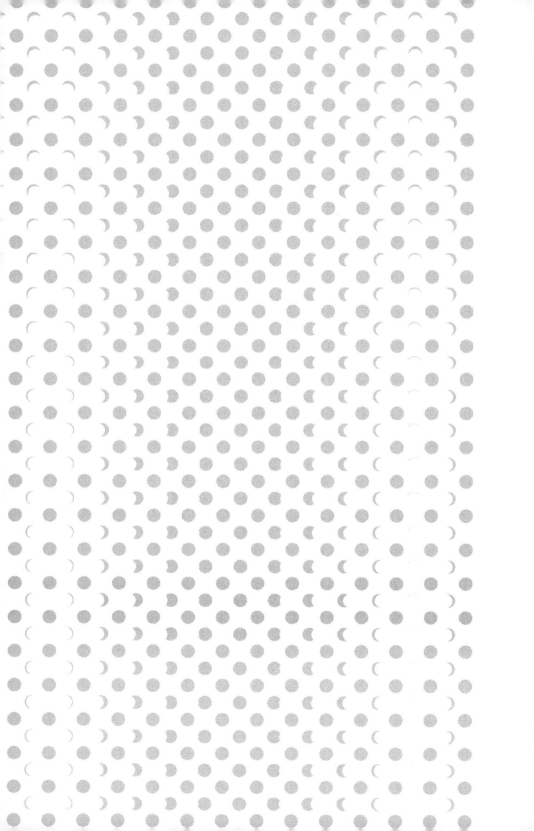

train stations, pubs,
cafes, bridges,
apartments,
and other everyday
London settings

COOVER

archives, libraries, and
bookstores

D'IORIO AND BARBERA

the principles that
undergird scholarship

D'IORIO AND BARBERA

normal web addresses
that we type into our
browsers

D'IORIO AND BARBERA

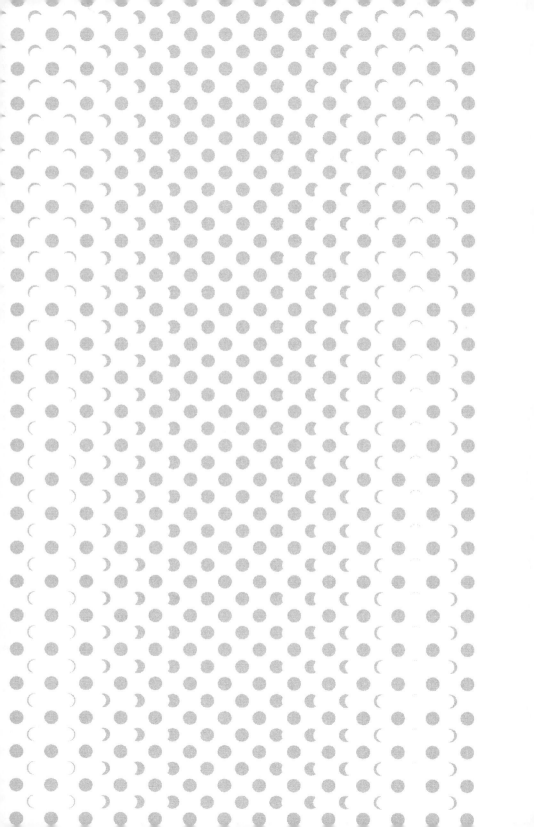

all digital objects

D'IORIO AND BARBERA

Sunny Afternoons

POWERS

pets

POWERS

friends and friends of
networked friends

POWERS

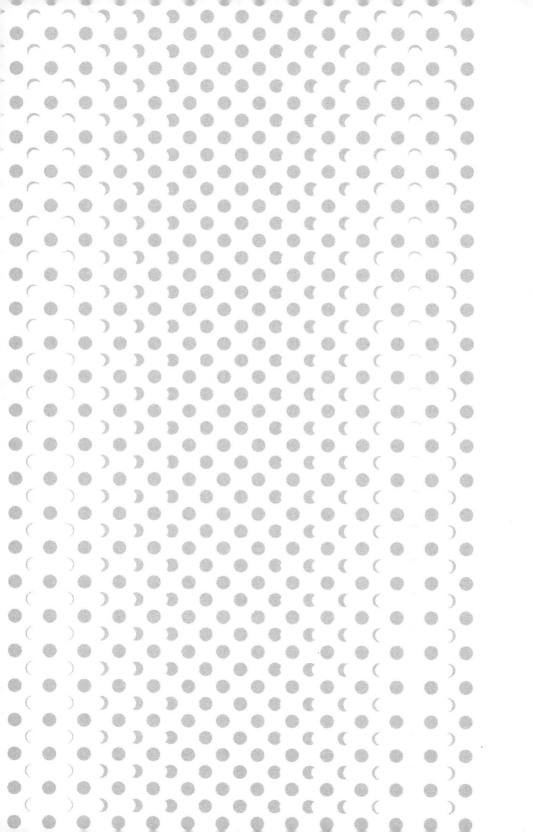

all the pictures in creation

POWERS

images of a hundred million stars

FOSTER

massive quantities of data

FOSTER

time and space

FOSTER

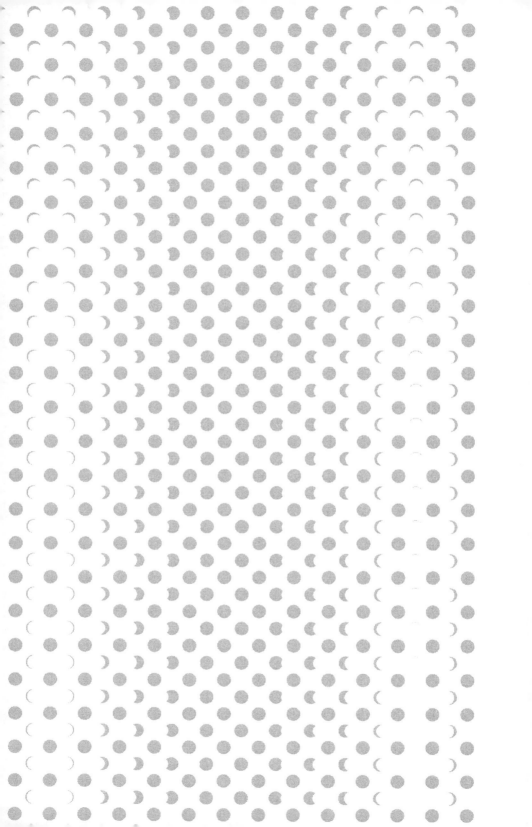

art critics

FOSTER

the first electronic
computers

GANASCIA

games

ZIMMERMAN

mathematicians and
logicians

GANASCIA

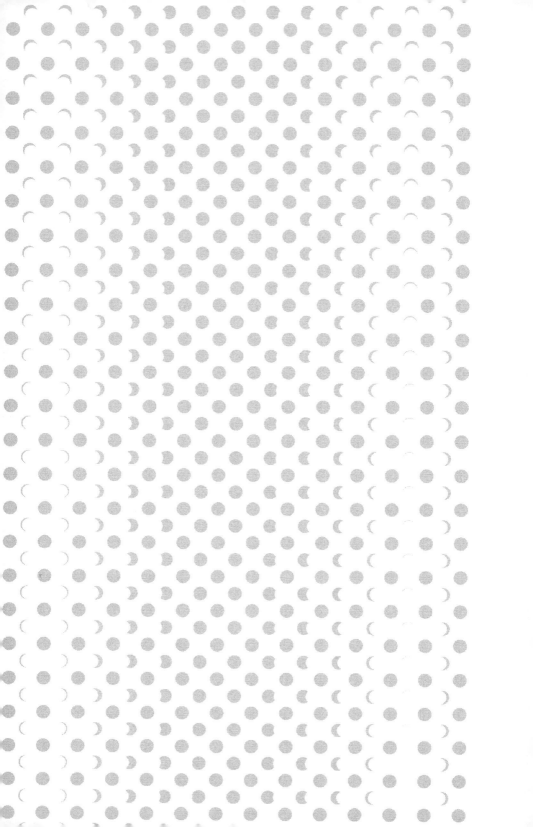

unicorns

GANASCIA

a billion documents

HENDLER

every photograph in Flickr

HENDLER

smaller birds that migrate
huge distances

HENDLER

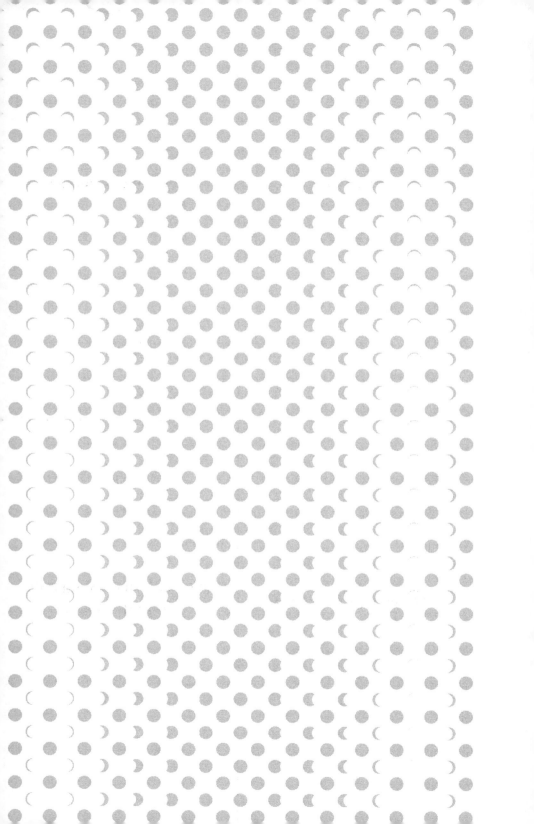

biological experiments

HENDLER

existence and
nonexistence in
electronic timespace

SORENSEN

poets

QUASHA AND HILL

geometric forms (square,
circle, triangle, point, line)

QUASHA AND HILL

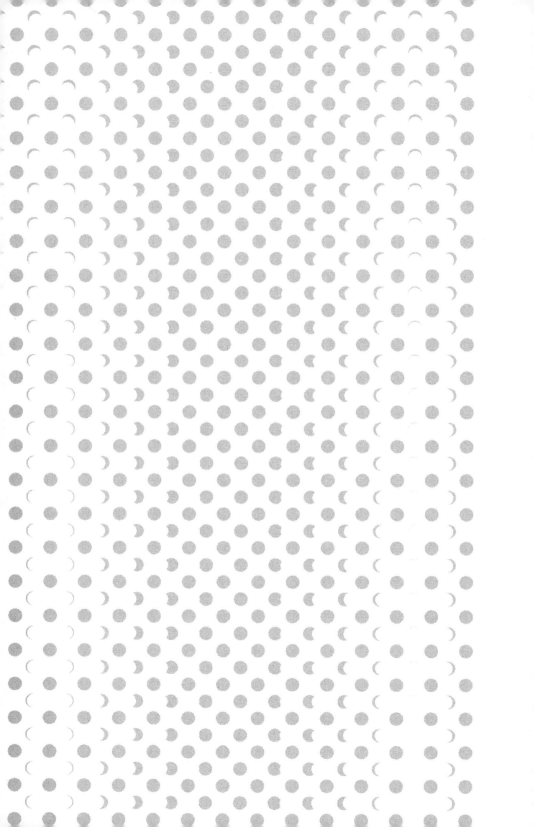

spoken and
written text

QUASHA AND HILL

art teachers

LATOUR AND LOWE

dance music, theater—the
performing arts—

LATOUR AND LOWE

intellectual
oversimplifications

LATOUR AND LOWE

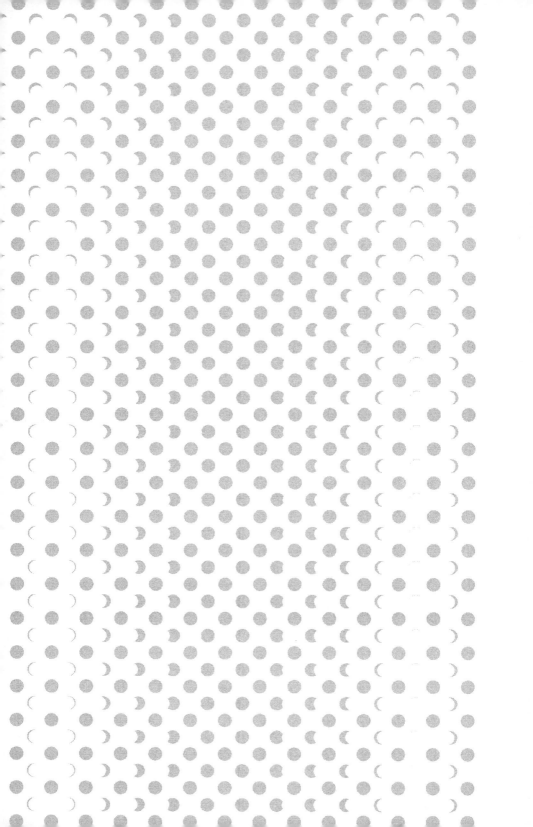

tiny painted dots

LATOUR AND LOWE

abstracted avatar
representations

SHAW, KENDERDINE,
AND COOVER

virtual worlds

SORENSEN

YouTube, MySpace,
and Second Life

SHAW, KENDERDINE,
AND COOVER

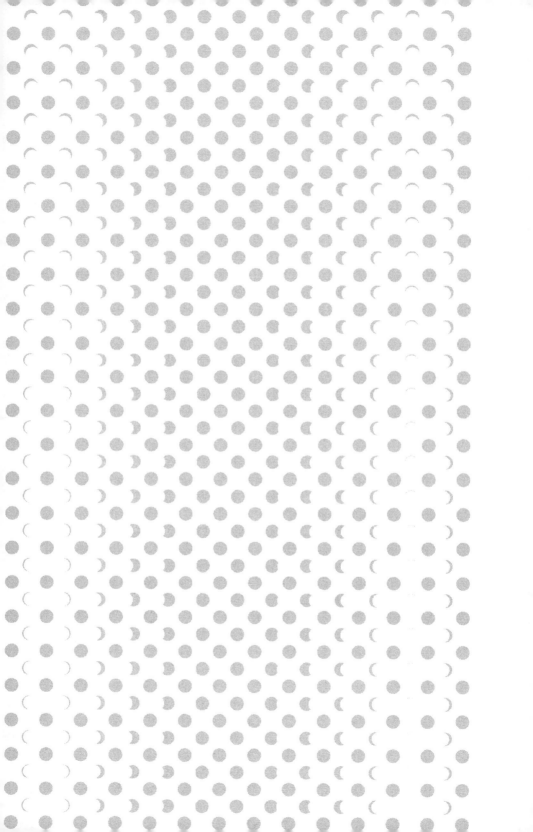

the millions of rhythms
and cycles in our body

SHAW, KENDERDINE,
AND COOVER

bodily movements

CEUSTERS AND SMITH

opinions

LIU

dances such as
the polka

CEUSTERS AND SMITH

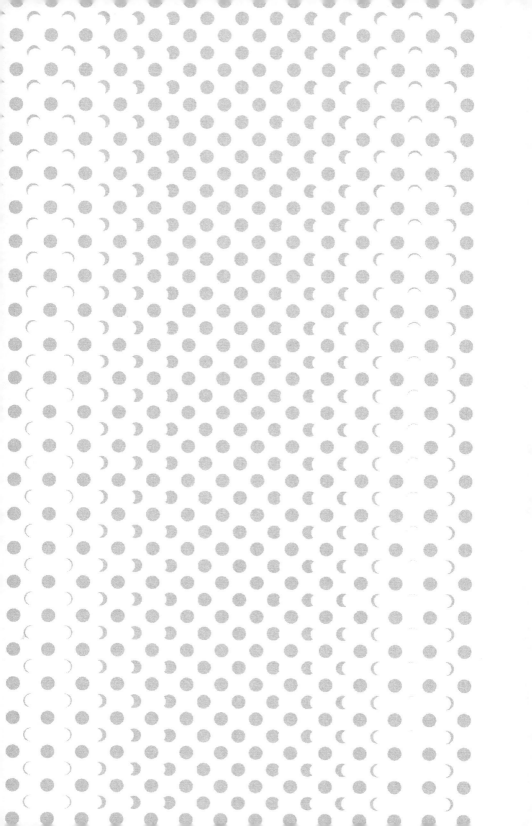

space and time

COOVER

algorithms for detecting
and interpreting humans
and human behavior

CEUSTERS AND SMITH

mistakes

LATOUR AND LOWE

today's web
and search engines

STEFIK

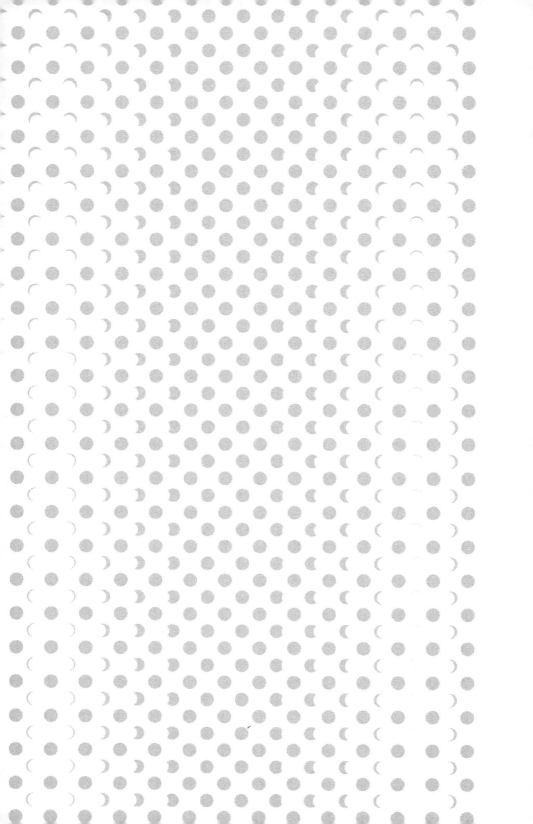

teenagers

STEFIK

multiple perspectives

STEFIK

religion and politics

STEFIK

machine-learning algorithms

GANASCIA

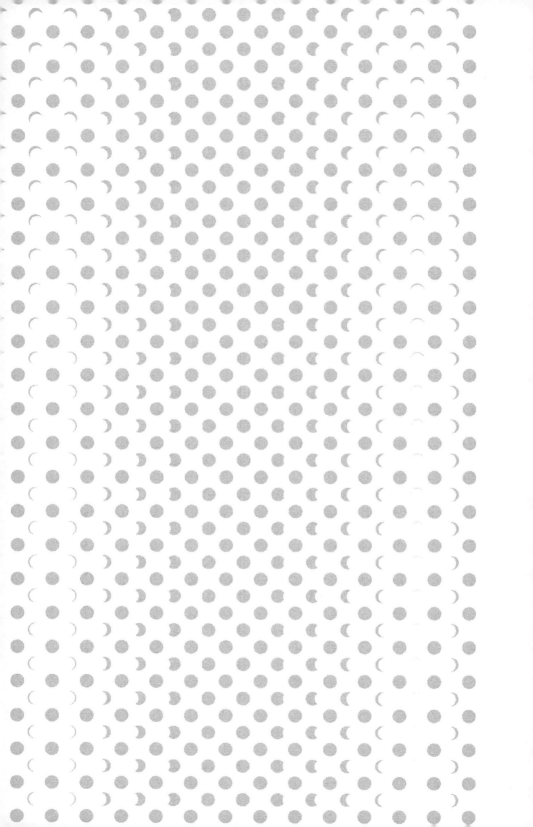

expresses an absence
of time

————————————
COOVER

is artificial and misleading

————————————
COOVER

is unnecessary

————————————
D'IORIO AND BARBERA

is more a legal question
than a technical one

————————————
D'IORIO AND BARBERA

is not structured
like a list or a tree but
rather like a graph

D'IORIO AND BARBERA

has hundreds of members

POWERS

can determine the
percentage of factual
accuracy of any web page

POWERS

may be so enormous
that only specialists
possessing large
computer systems
will be able to make
effective use of it

FOSTER

is a process by which we human beings investigate, and obtain understanding of, our world

FOSTER

remains painstakingly, sometimes mind-numbingly slow

FOSTER

is analogous to finding one's way in a maze of intricate passageways and blind alleys

GANASCIA

remains a theoretical concept that is of no help to anyone

GANASCIA

is like the dark side
of the moon

HENDLER

seems a daunting task.
And it is.

HENDLER

brings the artist near
to a primal truth

QUASHA AND HILL

is in theory inexhaustible

QUASHA AND HILL

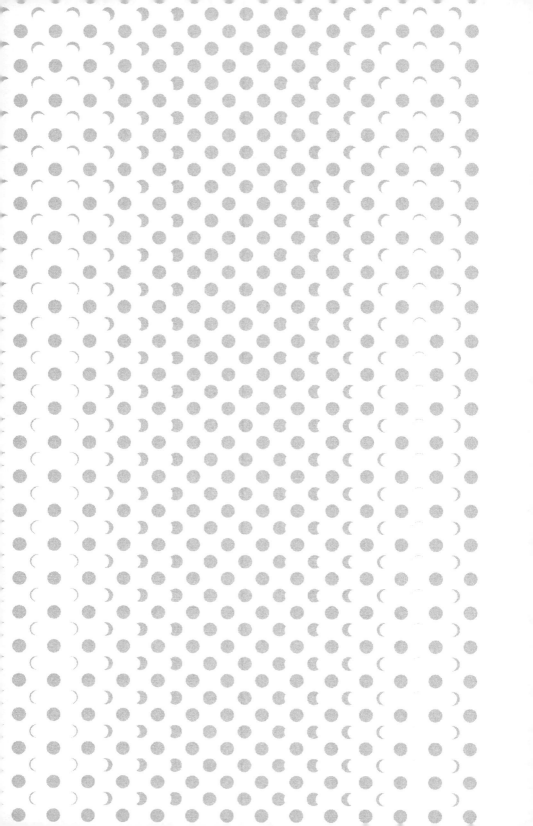

is alive and has a mind
of its own

QUASHA AND HILL

has been irreversibly lost

LATOUR AND LOWE

has been turned into a
copy of itself that looks
like a cheap copy, and no
one seems to complain

LATOUR AND LOWE

is paved with good
intentions

LATOUR AND LOWE

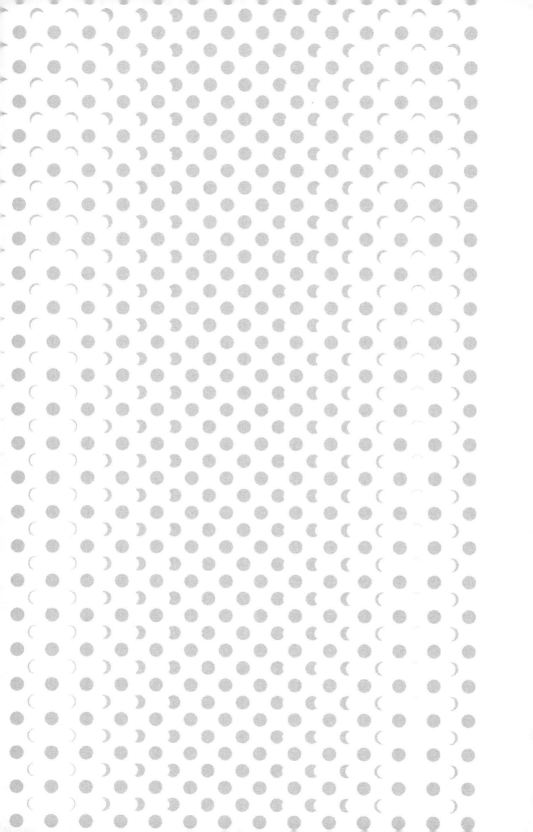

creates technological topographies in which the spectators construct meaning

SHAW, KENDERDINE, AND COOVER

has always been the interpretation and recreation of reality

SHAW, KENDERDINE, AND COOVER

shifts the creative practice of art very much away from being a manual craft into one of conceptual engineering

SHAW, KENDERDINE, AND COOVER

has served throughout history as an important force for social cohesion

CEUSTERS AND SMITH

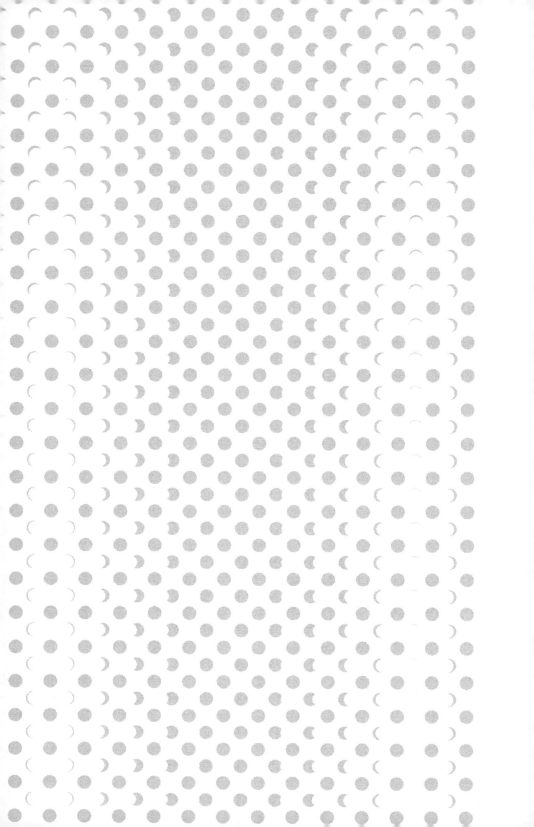

constitutes the
backbone of the
European cultural
tradition

CEUSTERS AND SMITH

is the process by
which we go about
understanding the world

STEFIK

is mostly
a solitary activity

STEFIK

does not serve us very
well as individuals

STEFIK

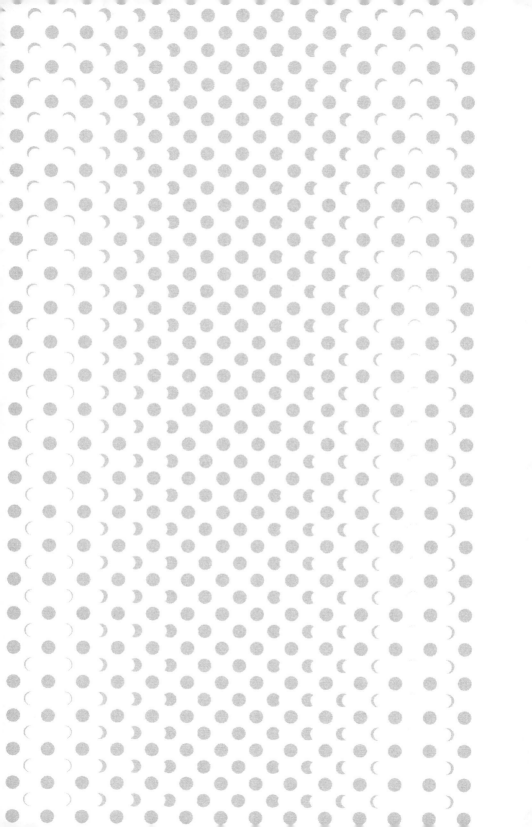

can serve as a powerful
democratizing force

◀ _____
FOSTER

may be broken down into
logical steps that can be
simulated by mechanical
processes on a computer

◀ _____
GANASCIA

opened a quite new
path for art

◀ _____
QUASHA AND HILL

cannot be searched
efficiently

◀ _____
CEUSTERS AND SMITH

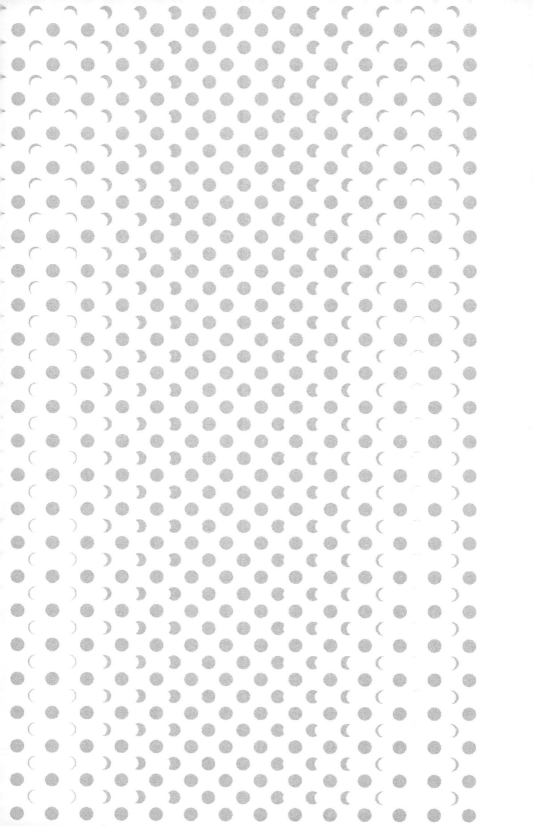

passes the Turing test

BORGMANN

become a kind of language

COOVER

never come to fruition

D'IORIO AND BARBERA

are often contained in
documents

D'IORIO AND BARBERA

involve bathroom fixtures
and treadmills

POWERS

allow diverse data to be
stored, searched, analyzed,
and displayed

FOSTER

results in a charming
paradox

D'IORIO AND BARBERA

advance civilization

FOSTER

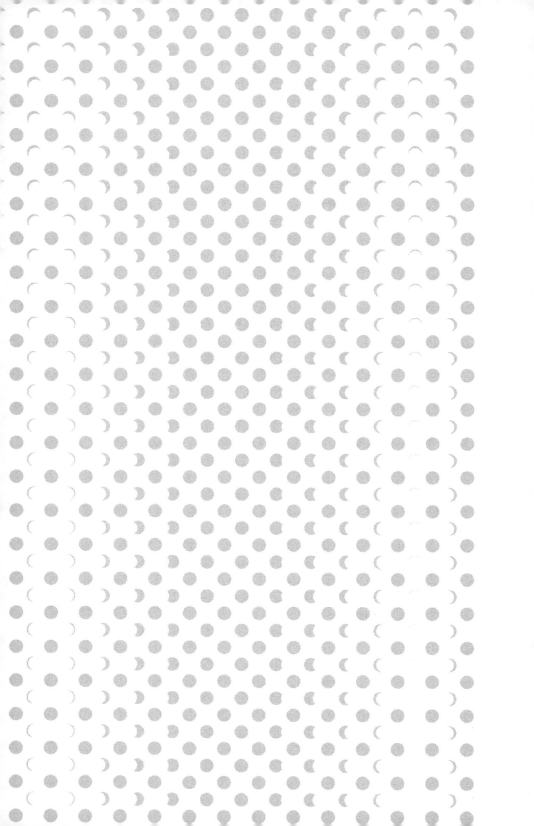

address creativity in an
original manner

GANASCIA

play a key role in
creative activities

GANASCIA

are now holding us back

HENDLER

provide a single, high-
quality, reliable model of
the world

HENDLER

sit like deer in a field

QUASHA AND HILL

speak of nothing
but themselves

QUASHA AND HILL

are looking for trouble

LATOUR AND LOWE

has long been
rendered invisible

SORENSEN

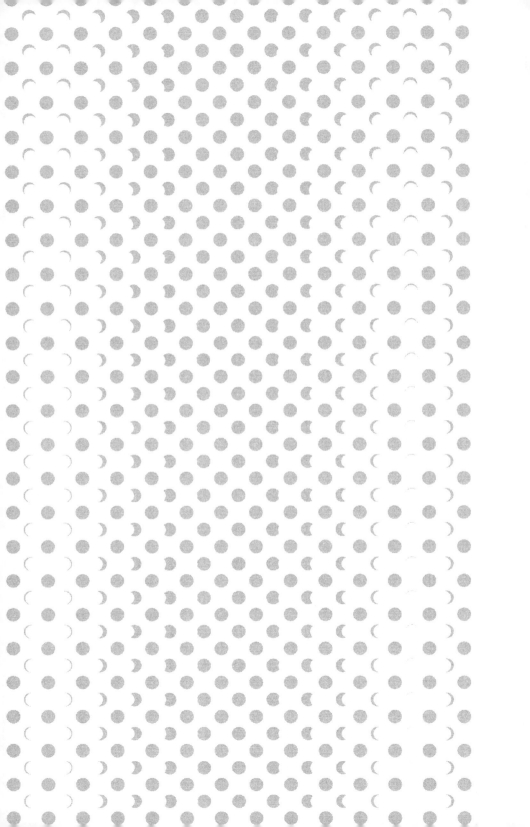

exemplify the peak of
human creativity

◄ _____
SHAW, KENDERDINE,
AND COOVER

cause one to rethink
the artist's role and the
relationship of the artist
to audience

◄ _____
SHAW, KENDERDINE,
AND COOVER

prefigure the shape of
things to come

◄ _____
SHAW, KENDERDINE,
AND COOVER

are nothing more than
groups of pixels

◄ _____
CEUSTERS AND SMITH

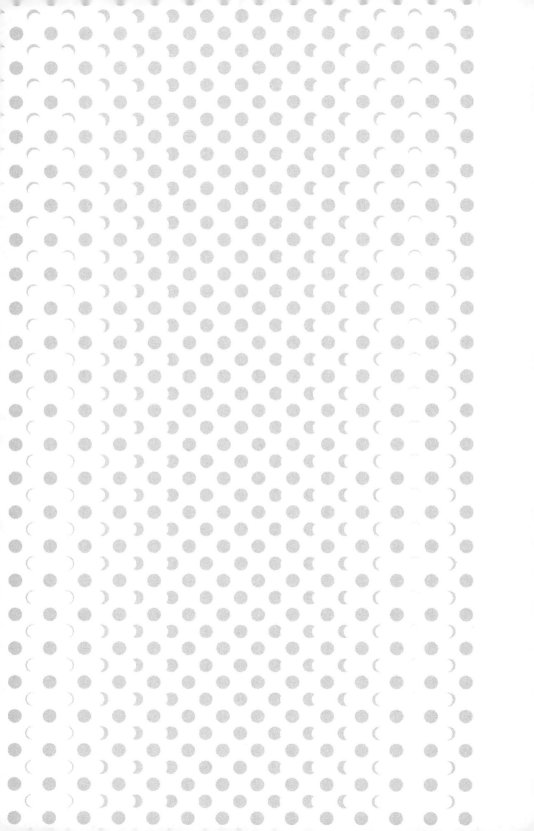

need to be relaxed
in order to address
the complexities
of real situations

CEUSTERS AND SMITH

tend to look rather serious

CEUSTERS AND SMITH

tell the difference
between good and
bad sources
of information

STEFIK

still fall far short
of their potential

STEFIK

promotes a broad
perspective on

is a wonderful and very
successful example of

CLANCEY

D'IORIO AND BARBERA

is more practical than

is missing in

D'IORIO AND BARBERA

POWERS

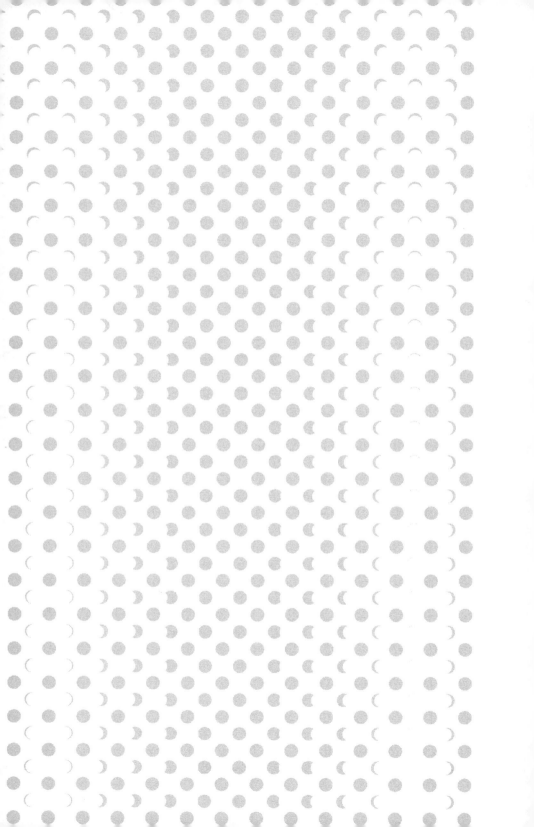

tends to move more
slowly than

does not explain

FOSTER

GANASCIA

have held us back from

has played a critically
important role in the
composition of

CLANCEY

QUASHA AND HILL

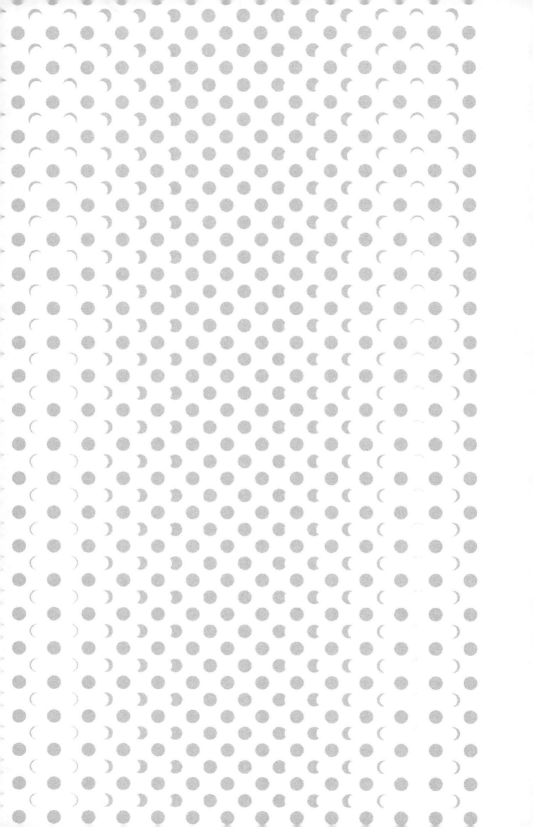

remains concealed and
ambiguous in

is at the furthest pole from

BORGMANN

QUASHA AND HILL

resembles almost exactly

is now just an expensive
copy of

LATOUR AND LOWE

LATOUR AND LOWE

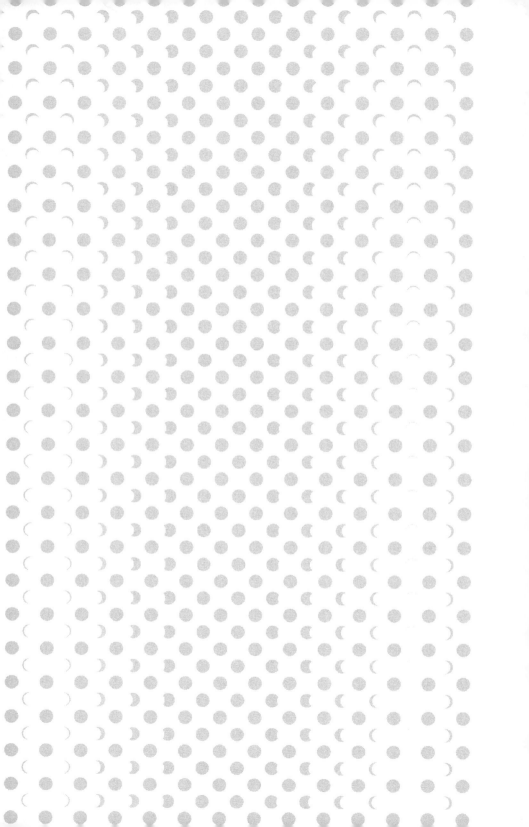

remains in the
background of

continuously redefines
itself in response to

LATOUR AND LOWE

SHAW, KENDERDINE,
AND COOVER

presents the viewer with

has accounted for a
significant percentage of

SHAW, KENDERDINE,
AND COOVER

CEUSTERS AND SMITH

has generally been
considered to be an
incidental part of

CEUSTERS AND SMITH

automatically improves
the quality of

STEFIK

is typically less
important than

STEFIK

involves a spontaneous
emergence affecting the
very meaning of

QUASHA AND HILL

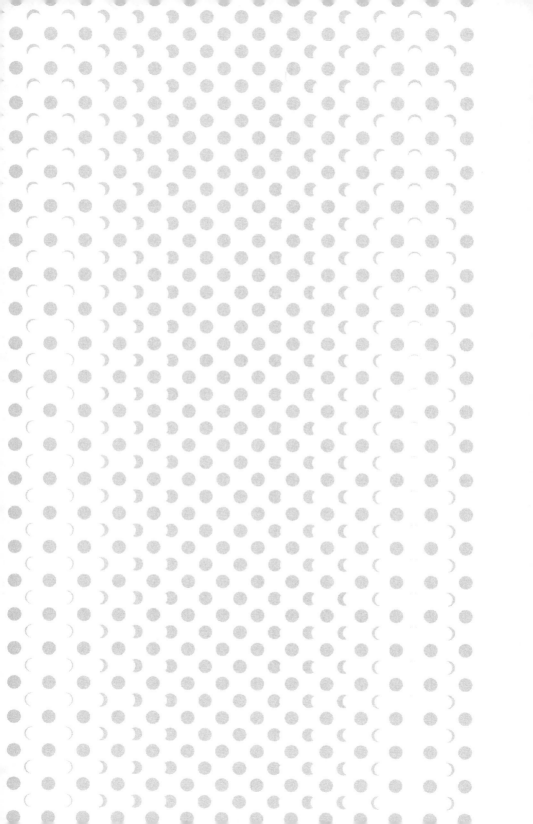

can be dynamically
rearranged according to

D'IORIO AND BARBERA

can blind us to the
limitations of

FOSTER

can help us to understand

CEUSTERS AND SMITH

is never defined by

QUASHA AND HILL

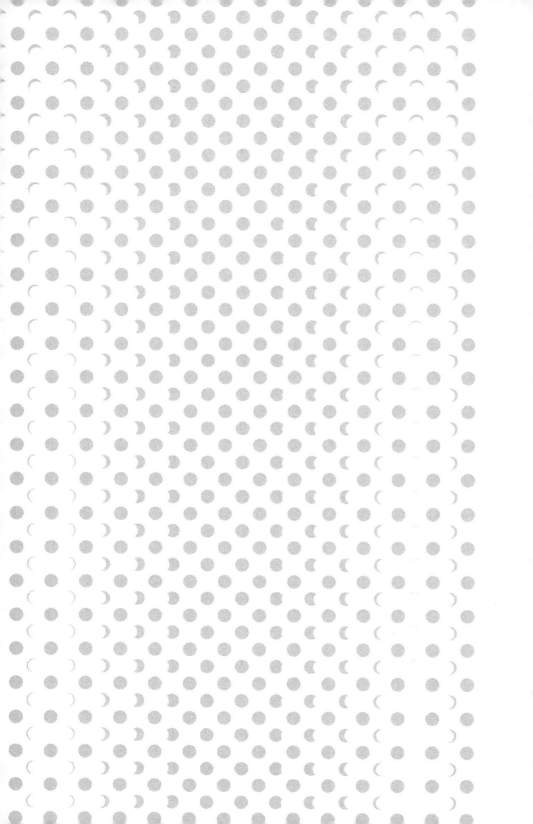

is defined with respect to

help scholars to retrieve

HENDLER

D'IORIO AND BARBERA

may serve as a guide for

can see, analyze, and
interpret nineteenth-
century paintings
better than

D'IORIO AND BARBERA

POWERS

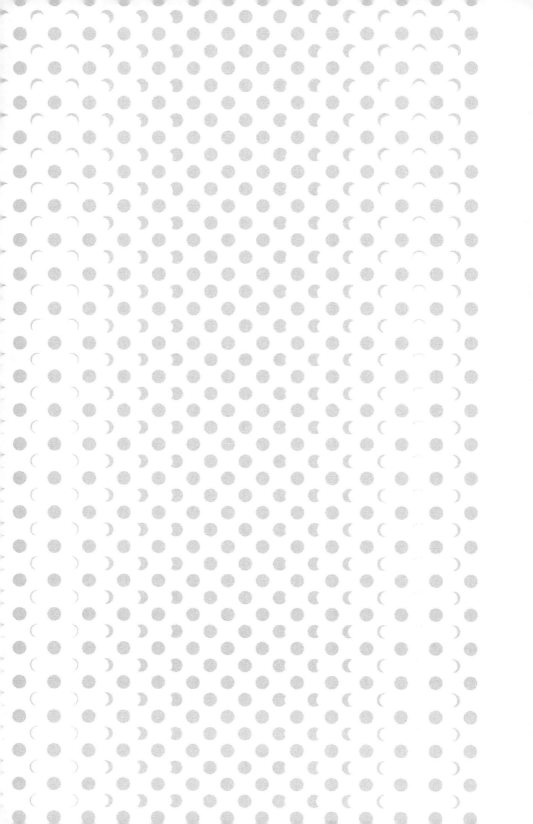

allows human users
to access

FOSTER

are used to study the
implications of

FOSTER

are not magical; they are

GANASCIA

in many ways outperform

HENDLER

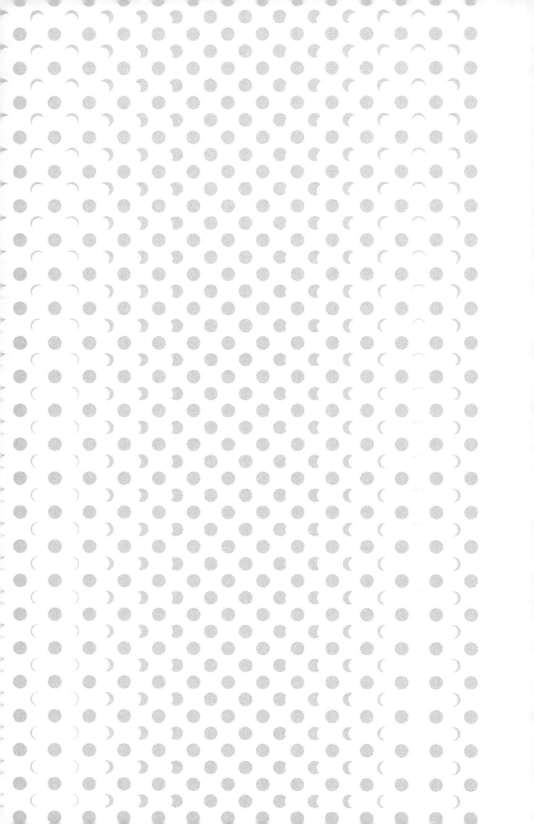

"exist" only by virtue of

have dramatically altered the surface and appearance of

◄ ――――― QUASHA AND HILL ―――――

►◄ ――――― LATOUR AND LOWE ―――――

engender specific forms of artistic expression and

react in real time to

◄ ――――― SHAW, KENDERDINE, AND COOVER

►◄ ――――― SHAW, KENDERDINE, AND COOVER

are being used to help
unlock the secrets of

foster the development of

CEUSTERS AND SMITH

CEUSTERS AND SMITH

recalls one of the oldest,
most canonical forms of

compete for

LIU

STEFIK

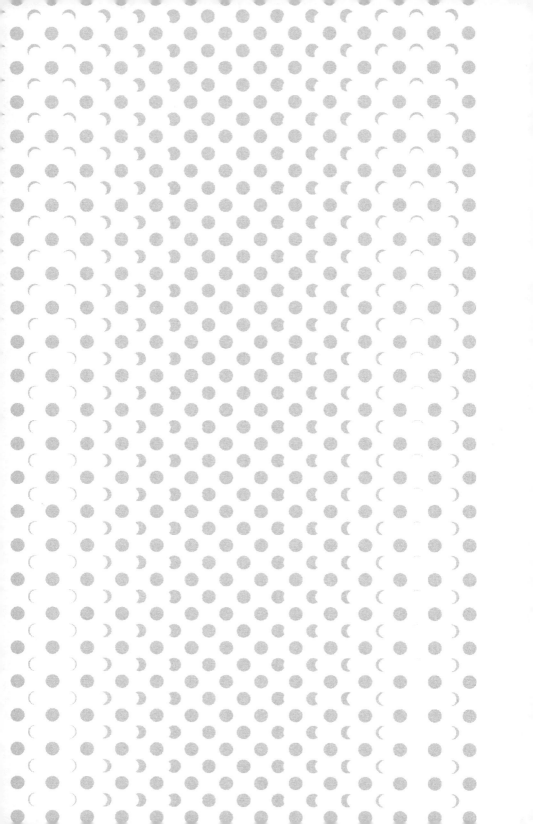

PART III

Panorama, Interactivity, Embodiment

digital
environments

SORENSEN

prefigure the
shape of things
to come

◀ SHAW, KENDERDINE,
AND COOVER

The Digital Panorama and Cinemascapes

RODERICK COOVER

Among the new kinds of media works that are being created with the invention of digital arts software are interactive panoramas and cinemascapes. In these works, users navigate environments that appear visually contiguous (like painted and photographic panoramas) or both spatially and temporally continuous (like moving long takes and cinematic pans). What is different is that these digital environments include layered and composited elements which often disrupt the authoritative stance of objectivity that contiguous and continuous representation is commonly used to represent.

For example, the expression of verisimilitude that is established through fixed and naturalistic relations of scale and position in many documentary photographic panoramas is disrupted when elements from outside the temporal-spatial frame of the photographic moment are layered upon the image. In a naturalistic work, elements in the mise-en-scène will conform to expectations (largely shaped by cultural and aesthetic conventions) that the depicted elements are of common origin (they might actually have been seen together in a particular place and time) and that they are painted in a way that maintains certain formal and spatial relations, such as those of painterly style and perspective. Similar conventions apply in nonfiction work, the primary difference being the degree of legitimacy given to technological mediation (and this degree varies). A documentary photograph may constitute an authoritative record of how elements were arranged as seen from a certain perspective at a certain moment, but people who were there and saw the scene from other positions may remember the scene differently. Works, such as John Rechy's *Mysteries and Desire*, discussed later in this essay, use digital panoramic environments to challenge naturalistic conventions and the relationships (e.g.,

part-to-whole, observer-to-object) that they frequently reinforce. Once dialectically opposed characteristics, such as continuity/contiguity and montage or exposition and narrative, now coexist. They are no longer mutually exclusive; the compositing and layering of materials on a continuous or contiguous environment enables the simultaneous presentation of both syntagmatic and paradigmatic elements. Multimedia is also multimodal.

The impact is significant. As is true with web interactivity in general, scrolling digital environments like those discussed in this essay bridge critical and creative modes of representation. Exposition, poetry, and narrative coexist and share the screen environment with other expressive forms, like music, video, graphics, and games. Cinematic and photographic viewing experiences are equally readerly ones. Passive "viewers" become active "users." The differences between researcher, artist, and user may also dissolve. The researcher and artist may use the same or similar programs to gather and compose their materials. The intended audience may likewise view such works with the same programs, and may even respond to or reconfigure what the artist or researcher has produced.

In a number of new works users may follow—or participate in—the process of building propositions, arguments, or expression. This encourages a critical and methodological shift from product to praxis: theory and practice merge in (the potentially ongoing) process of creative activity. By following what choices the researcher-artist makes, the user is actively drawn to consider alternatives. In some cases these alternatives may even be represented through alternate routes through the same materials.

Pans and Panoramas

Robert Baker patented the concept of panoramic paintings in 1787. His groundbreaking works include *The Panorama of Edinburgh* (1788), which he presented in his home, *London from the Roof of Albion Mills* (1792), which was shown in a rented space, *View of the Fleet at Spithead* (1796), which is shown in a small split level rotunda that Baker built for the purpose in Leicester Square, London, and the highly successful *Battle of Abonlair* (1798), which also was shown there. The success of these works led to his receiving international invitations and also spurred a flurry of copycat projects initiated by other artists and entrepreneurs. The popularity of panoramas endured, in waves, for a century, until the rise of cinema in the 1890s (Oettermann 1997, 6). Many of these nineteenth-century painted panoramas depicted exotic sites and battle scenes, and the

majority were created for display in rotundas. Viewers stood on platforms in the center of a circular environment, from which point they enjoyed unobstructed 360-degree views of the work surrounding them. It is frequently suggested that this panoptic point of view corresponds with a desire for control—a control characterized by omniscience, sight, and separation from the object of one's gaze. Art historian Bernard Comment writes:

> The invention of the panorama was a response to a particularly strong nineteenth-century need—for absolute dominance. It gave individuals the happy feeling that the world was organized around them and by them, yet this was a world from which they were also separated and protected, for they were seeing it from a distance. (Comment 1999, 19)

However, one might ask whether the desire for control does not simultaneously belie a certain loss of control, ceded to the technological apparatus of the rapidly industrializing societies where the form gained popularity. With a panorama, the viewer remains merely a passive spectator to a world of attractions that encompasses her (and extracts her labor and money).

The term *panorama* is derived from the Greek *pan*, "all," and *horama,* "view"; a 360-degree view offers spectators an impression of wholeness. Just as in viewing an actual landscape, in looking at a panorama the spectator sees how each element is connected to the next. The viewer has the impression of seeing everything—of being able to grasp the image as a whole. Paradoxically, the inverse may be more accurate. The panorama offers the viewers an illusion of commanding a total view of a moment; actually, it is the image that encompasses the viewer in the exotic locales of its form (the panoramic rotunda) and of its content (foreign lands, ancients worlds, battlefields). It is impossible for a spectator to grasp a panorama in its entirety; it offers more than a person with two eyes can see at a single glance. As one turns, a viewer must remember what can no longer be seen while looking in some other direction. Both in actuality and in this medium, the impression of unity is provided by a spatial and temporal seamlessness in which each element is both defined and confined in its relationship to the next element in the image and in its relationship to the view as a whole. The illusion is maintained if one does not see a break in the contiguity of the image or in the temporal continuity of the viewing experience. This illusion of seamlessness is one of the characteristics of panoramas that new media artists have been exploring, as, for example, by showing how even the

same scrolling scenes can lead in differing directions or by including layered materials that evoke differing temporal modes.

In his essay "Walking in the City," Michel de Certeau contrasts the experience of admiring a 360-degree view of New York from the top of a skyscraper with the experience of walking in the streets. His description of the view from the skyscraper is much like that of looking at a painted panorama. The viewer exalts in the opportunity to grasp a sense of the whole while also being separated from it:

> To be lifted to the summit of the World Trade Center is to be lifted out of the city's grasp. One's body is no longer . . . possessed, whether as a player or played, by the rumble of so many differences and by the nervousness of New York traffic. . . . When one goes up there, he leaves behind the mass that carries off and mixes up in itself any identity of authors or spectators. . . . It transforms the bewitching world by which one was "possessed" into a text that lies before one's eyes. It allows one to read it, to be a solar Eye, looking down like a god. The exaltation of a scopic and gnostic drive: the fiction of knowledge is related to this lust to be a viewpoint and nothing more. (1984, 91–92)

In the 360-degree painted panorama, the viewer is similarly protected and contained by the remote viewpoint. Standing at the axis of a circular view, the spectator is omniscient and also invisible; the spectator looks out into a world that does not look back.

What both the panorama and the view from the skyscraper share is contiguity—the seamlessness that provides an illusion of wholeness. The unifying elements of a panorama are spatial and provide a structure for interpreting the elements that comprise the scene. The same is true of the overview of the city from a skyscraper: the flow of events is contained within a spatial order. According to Certeau, the cityscape is itself a text. This kind of text is only deciphered from afar, not unlike the way a panorama is deciphered. However, unlike a conventional panorama, with the city view, one then descends the tower and enters the city at street level. There, up close, walking in the streets, experience is fragmented. In walking along streets, turning this way or that, one selects routes that one cannot simultaneously see from above. The viewer becomes a user. Her experience is shaped by unfolding events, unpredictable occurrences, interruptions, and spontaneous acts as well as by choices she makes. The experience of walking in the streets is an active kind of montage.

Like the panorama, the illusion of cinematic long takes and pans are based on continuity and contiguity; the integrity of the image is not interrupted. Early naturalistic recordings, such as the films of the Lumière brothers, presented single takes, constructing an experience of verisimilitude though this expression of temporal continuity—a forever reviewable slice of time—and contiguity, although the experience of the integrity of contiguous elements becomes limited by the frame. Like panoramas, cinematic long takes create a sense of omniscience; the chance to monitor what is going on is never interrupted, as is also the case, for example, with security cameras. The paradox of seeing and not seeing the whole is exaggerated all the more in the cinematic pan. While the seamlessness of space and time suggests that the world beyond the frame remains fully intact, verification is frustrated by the limits of the frame line; the spectator must wait for the technology to deliver the confirmation of wholeness that is established by a rhetorical convention. Technology determines how the image goes around and not the viewer.

It is through its representation of time that film in general, and long takes and pans in particular, augment the qualities of verisimilitude. The evocation of verisimilitude was something that panorama artists struggled with during the latter part of the nineteenth century. They added lighting effects, smells, wax statues, platforms that rocked to simulate boat rides, and reenactments (particularly in battleground panoramas) (Schwartz 1998). But the more artists tried to replicate actuality, the more they also accentuated the differences between the natural world and their constructed ones.[1] In a response in *La Nature* (June 15, 1889) to a Transatlantic Company panorama about an ocean voyage, one critic characteristically wrote, "What the illusion lacks is a light breeze, floating pavilions, the sound of the lapping of waves" (Comment 1999, 105). The disinterested, omniscient viewpoint of the panorama also imposes a separation of time between the viewer, turning and choosing what to look at, and the scene on view. In this regard, the painted panorama expresses an absence of time. It is this absence that is magnified by the awkward attempts to include elements like wind and waves that exist in, mark, and measure time. Film, which draws viewers into its own time conditions, satisfies some of these limits of verisimilitude but introduces others (e.g., linearity).

Film technology imposes an authoritative organizational structure; the time-base of the technology imposes a constant (the frame-rate) by which the content (the images) is mediated. This is very much like the authority that is constructed through other technological institutions of time, such as the universal time system, train schedules, mechanized assembly lines, and

workplace timecards. With film, the rate of the flicker of images is essentially fixed. Through montage, ideas in one shot are connected to those of another. Each cut is a rhetorical device; it proposes an idea through an editing strategy (continuity, association, dialectics, etc.). The compositional and montage choices have much in common with the poetic and rhetorical choices of writing; in digital media these parallel systems begin to come into contact with each other.[2]

In his discussion of walking in the city, Certeau suggests that the skyscraper overview offers a rhetorical proposition: the city as a text. The singular and unified view of actuality from above contrasts with the fragmented one in the streets. Certeau continues his linguistic analogy: the view is structured and unchanging, like a fixed text, whereas walking, which is fluid, fragmented, and can go in any direction at any moment, is like speech. The former (viewing the city, reading the text) is abstract and objective, the latter (walking, speaking) immediate and subjective. In the former, the expression of actuality is visual and static; it is an image that is singular in form and more or less constant. In the latter it is temporal and grows out of a web of experiences and their significations, the meanings of which are continually being reevaluated. In comparing these dialectics of overview/walking and grammar/speech, Certeau argues that the viewpoint from on top of the highrise provides an abstract concept that is unable to account for the diverse forms of expression and time encountered in walking. Walking is a kind of active montage by which one gathers experiences. In walking and talking, movement is fluid:

> If it is true that forests of gestures are manifest in the streets, their movement cannot be captured in a picture, nor can the meaning of their moments be circumscribed in a text. . . . Their rhetorical transplantation . . . constitutes a "wandering of the semantic" produced by masses that make some parts of the city disappear and exaggerate others, distorting it, fragmenting it, and diverting it from its immobile order. (1984, 102–3)

To extend Certeau's analogy, readers and walkers are *users*, navigating texts that require actions, choice making, and perhaps responses. Perhaps, like the city, the screen space is an environment to be navigated, a landscape in which to walk. Digital panoramas maximize this spatial metaphor by extending the parameters of the screen environment and offer visual

platforms in which continuous or contiguous elements may coexist with materials that are fragmented or montaged. Thus, as the borders between reading and viewing break down, so do those between navigated and linearly cinematic forms of reception. In my own work, panoramic methods of production have led to the creation of what I term *cinemascapes*: navigable visual environments of cinematic materials. Panoramas and cinemascapes present users with seemingly contiguous (and perhaps continuous) representations, and in many cases users interact with fragments contained in those environments.

These elements—temporally continuous long takes, spatially contiguous pans or panoramas, montages, text, photos, and so forth—need not be exclusive. Through compositing, layering, and interactivity, new forms of cinematic panoramas are integrating panoramic and cinematic form, problematizing their conventional divisions and forcing a redefinition of their compositional languages. These interactive panoramic environments provide the opportunity for the kind of "wandering semantic" that Certeau describes, while at the same time they undermine his claims of representational boundaries. While no form may lay claim to being able to map and make visual the infinite and symbolic fields of subjective experience, these new forms for media do provide ways to draw multiple expressions of time and expression into a common space, disrupting boundaries of contiguity without destroying them.

Mysteries and Desire: Searching the Worlds of John Rechy

A number of works employ interactivity in panoramic environments to explore what is hidden in the details of the contiguous image—details that users must tease out through navigation, play, and deduction. One such work is *Mysteries and Desire: Searching the Worlds of John Rechy*. Designed in Macromedia Director using Quicktime Virtual Reality (QTVR) panoramas, the CD-ROM work is the result of a collaboration between Rechy and the artists of the Labyrinth Project at the Annenberg Center of Communication at the University of Southern California.

Mysteries and Desire is a kind of autobiography that makes use of interactive panoramic environments to present a series of interpretations of the author's life experiences, with particular attention to the symbols and conditions of being a gay writer in mid- to late-twentieth-century Los Angeles. A short introductory video loop links users to one of three sections, the themes

FIGURE 16. Excerpt from *Mysteries and Desire: Searching the Worlds of John Rechy,* a CD-ROM produced by Rechy and the Labyrinth Project at the Annenberg Center of Communication, University of Southern California (2002).

of which are "Memories," "Bodies," and "Cruising." In these sections, viewers navigate QTVR environments, choosing links that lead down interactive paths or into collections of materials. The participation required of the user to discover links in the panoramic environments is thematically important in a work about the concealed methods of expression in gay cultural life in an era of cultural oppression. Forms of expression represented in the project include exposition, interviews, audio of Rechy reading excerpts from his books, photographs, graffiti, stained glass, a comic strip, and dance, while locations include lonely paths in the woods, urban barrooms, back alleys, and church confessionals. In interacting with the work, users draw the activities into

light, employing mouse actions to trigger aesthetically compelling responses. Panoramic media provide the structural framework for each section.

The first section is a kind of scrapbook made up of photos that, when clicked, lead to narrated passages from Rechy's essays and fiction, interviews with people who have known the writer, and other biographic materials.

In the second section, users find themselves on a street corner in front of a church. One portal from this panoramic image leads into the church, where users discover interactive elements in the stained-glass windows and in the confessional; provocative graffiti blending gay and religious imagery is found in the alley behind the church, presumably a secret meeting place. A series of links leads users to a comic strip based on an advertisement for a body-building device. The comic shows a scrawny boy who has sand kicked in his face on the beach by a tough guy. The boy responds by purchasing weights and becoming a muscleman. Rechy offers viewers two ways of exploring the materials. One is an essay on the role of the muscleman in gay culture; the other is an animated photo sequence evocative of the visual iconography of the muscleman in the contexts of athleticism, power, and sexual desire. The choice of which route to follow is in the hands of the viewer, literally: the computer mouse is represented on the screen by a small iconic barbell. If the reader-viewer starts to lift the barbell and "work out," the reward is a kaleidoscope of evocative and sensual body transformations. If not, the reader-viewer listens to the exposition. In this way, a user learns how simple actions become a kind of language; using specific gestures at specific moments will yield special, surprising responses.

Thus, from within a panorama, viewers enter into layers of materials that evoke, as much as explain, Rechy's views of gay cultural conceptualizations of the body. The panoramic structure allows the author to bring diverse methods of interpretation together on a common platform. Among the resulting messages offered by Rechy's work are that no single form of representation is good for all seasons, and that meaning is as much to be found in the movement between modes, costumes, performances, and personas as in any particular content-event.

The panoramic device also solves some presentational problems of working with fragmented, linked materials. It provides a common framework in which elements of a theme or a moment may reside. The elements play to, and revolve about, the invisible axis at the center of any panorama—the user. But in contrast to the painted panorama, in this kind of work the user is invited to participate in the scenes and travel through their portals.

What we will have of what we are: something past . . .

What we will have of what we are: something past . . . is a multi-panorama online work written and developed by John Cayley in collaboration with Giles Perring and Douglas Cape.[3] At the top of the screen is a twenty-four-hour clock whose hour numbers are laid over day and night images of London taken from the top of Saint Paul's Cathedral. The user clicks on the clock to enter the work. The clock slowly turns, suggesting a chronological structure, and the user is dropped into a naturalistic scene—a panoramic photograph presented using QTVR—that is indeed determined by the time selected. Small pop-up windows announce each location and provide clues as to how to navigate the scene. For example, a user entering at 8 a.m. finds herself in Richard's Flat. Richard sits on his bed in a T-shirt and underwear, his hand on the telephone message machine. Clothes are scattered on the sofa. The explanatory text reads, "Richard has been missing Helen's calls, messages of mixed media will have been left, handwritten, beside him." The letter on the bed contains a link.

There is no beginning or end to the story; navigating in this manner, the user can drop into scenes in any order. Moreover, the structures of time as given by the clock and the location as established by the naturalistic panoramic photos are deceptive; users are trapped within circular narratives interlinked like magician's rings that connect, disconnect, and reconnect in time frames that differ depending on which character one is following. Parallel to the naturalistic, technologically determined structure is another subjective, achronological one, and the choice of using the cathedral to represent this is apt.

One of the unique features of Saint Paul's Cathedral is the Whispering Gallery, which runs around the interior of the dome. A whisper at any point along its wall is audible to a listener with her ear held to the wall at any other point in the gallery; due to the peculiar acoustics of the dome, however, words spoken normally do not carry in the same way. In the dome, time is mirrored across the circle; at any given point, one hears whispers from the opposite point.

In *What we will have of what we are: something past* . . ., such whispers are linked to dreamy, black-and-white imagery. The methods suggests that for each naturalistic and temporally specific color image there are corresponding and seemingly timeless memory fragments—whispers that echo across a divide between inner mind and the outer worlds. The links that trigger these whispers and imagery are often media objects such as letters and phone mes-

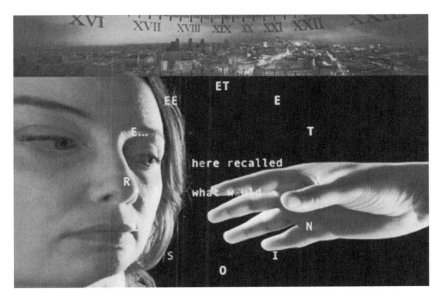

FIGURE 17. Excerpt from *What we will have of what we are: something past...*, produced by John Cayley with Giles Perring and Douglas Cape (2003), http://www.z360.com/what.

sages that call attention to the absence of the sender. In these dreamlike sequences, body parts are severed, collaged, or superimposed over strange settings; faces meld or are stretched and squeezed into bizarre forms; eyes blink open and shut. The whispers evoke an ethereal subtext of the dreams and desires of the three characters who, in the naturalistic photos, are depicted performing mostly mundane activities in train stations, pubs, cafes, bridges, apartments, and other everyday London settings.

The naturalistic panoramas seem to promise temporal and narrative continuity, and at first the narrative seems tied to a simple linear chronology. Soon, however, one realizes that the chronological structure is artificial and misleading. Without disrupting the ongoing structure of technological time—as established by the ticking clock—Cayley is able also to represent aspects of subjective temporal experience. This is different from cinematic expressions of technological and subjective time in several ways. Users experience individual panoramas in their own time and not at a pace dictated by frame-rate; users determine the narrative order of the work and may or may not trigger particular elements. While the audiovisual layering is adapted from film, movement between parallel modes is more fluid in this work, if perhaps at the expense of the rhetorical power gained in film through dialectical, associative,

FIGURE 18. Excerpt from Tirtza Even and Brian Karl, *Counterface.*

and continuity editing—devices by which a filmmaker drives home ideas in the flow of action. Cayley's works demonstrate how layering and linking in panoramic form can allow the mediamaker to interconnect parallel temporal structures, at least within the design limitations of the finite cycles of the work itself.

Another example of using layered motion imagery to destabilize temporal continuity is Tirtza Even and Brian Karl's *Counterface,* in which a dark glass plane in a metal frame is mounted on a gyroscope-like double axis so that it can be rotated up and down as well as sideways. The primary (or outdoors) stream is a video pan that can be viewed right-to-left or left-to-right. While multiple exposures have been used in linear film since its earliest days, digital tools offer many more options for manipulating the time-image as a composite element; the resulting works have more in common with the layered (still) photographic montage popular in the 1910s and 1920s than with cinematic montage. Window slats provide mysterious points of entry and exit. Long takes recorded in the same place at different times are composited using masking techniques so that differing events are compressed into a single image causing individuals to seem to appear and disappear in midaction in seemingly continuous environments. The effect is haunting.

As with Cayley's work, the project uses new media tools to expand the experience of individual scenes and to present materials that are connected by topic but vary by mode. Here, users may rotate the glass to halt the pan and view action unfolding in the depth of the image, along the virtual z-axis. By turning the frame up or down on its x-axis, users trigger a parallel (indoor) sequence of interviews that can then be navigated by turning the

frame left or right. The gaps created by presenting concurrently accessible materials also evoke a sense of absence, in terms of what seems to be erased from the documented surface, and the potential for concealed elements to reemerge.

From *Something That Happened Only Once* to *The Unknown Territories*

Something That Happened Only Once is an animated photographic panorama for projection on one or two walls, and *The Unknown Territories* is a series of spatially organized interactive cinemascapes combining video clips, pop-up interactive panoramic photographs, and other materials over contiguous, scrolling environments.[4] Both explore questions of contiguity and montage. Playing on the conventions of the cinematic pan and long take, the time-based structure in a work like *Something That Happened Only Once* emphasizes questions of expectation and temporal unity, whereas the interactive scrolling environments of *The Unknown Territories* draw attention to questions of praxis and choice making.

Something That Happened Only Once slowly revolves, like a cinematic pan. Each cycle takes about ten minutes, and in most presentations two different cycles are shown. Some installations present these loops using dual projectors that connect along a single edge. The seamless panorama may at first appear to be a naturalistic or documentary representation of a busy plaza in Mexico City. The project was recorded around lunchtime in Coyocan Plaza, where about a dozen actors—provocateurs of a sort—were scattered among the crowd, some performing roles for the camera and others provoking responses from the public. The actions are photographed. These photographs are then layered and composited so as to create what at first seems to be a seamless panorama, and elements are animated so that some characters may appear to move. The audio is also layered; found sounds mix with fragments of text that are spoken and sung. The audio may play in stereo or surround-sound.

A conventional panorama is not one moment but a collection of moments seamlessly combined. The layered elements in *Something That Happened Only Once* float freely at rates shaped by their own narrative trajectories. This layering separates individual actions (and the characters who perform them) from the singular, authoritative order of time implied by the technological apparatus of the pan. As the image turns, the user will recognize that the second time around is *not* the same as the first. The structure

FIGURE 19. Excerpt from *Something That Happened Only Once,* a multimedia installation by Roderick Coover (2007).

of the cycles resembles a Möbius strip. Events that begin in the first cycle may be shown to develop in a second one, while those that would seem to begin in the latter cycle may conclude in the former, such that there is no beginning. Or, rather, there are many beginnings, and each is determined by the actions of individuals rather than by the seamless backdrop. The effect of this is that users cannot rely on the temporal apparatus of the recording device as a means of making the elements of the space conform to a single narrative. Instead users must identify characters and follow their narrative trajectories through a temporally destabilized space.

Although contrary to many conventions of panoramic representation, these strategies may be truer to natural processes of cognition than those of the conventional long take or pan. In looking at the world, attention jumps from one

action to another, glossing over areas that are bland. If the goals of the viewer change such that the details matter, otherwise ignored aspects of experience are then looked at closely (Goodman 1978). The slow pans used in works like *Something That Happened Only Once* accentuate this tension between sight and apparatus, because they draw attention to how the frame line becomes a marker of time; this experience is magnified when the work is played on two adjoining walls, spiraling in opposite directions from a common border.

To explore how interactivity may enhance understanding of these questions of representation and authority, I developed a series titled *Unknown Territories*, which includes the sections "Voyage into the Unknown" and "Canyonlands: Edward Abbey in the Great American Desert." Edited video sequences, interviews, archival images, uncut video long takes, photographs, and original text documents are layered and composited upon seamless illustrated scrolling environments. In scrolling through these panoramic environments, viewers build their own documentaries based on the unique paths they construct. The format is particularly well suited to documentary projects in that it allows makers to include supporting materials that, although exciting and valuable, might be cut from a linear work because they depart from the primary thread or are simply not cinematic.

An interactive documentary humanities project about how perceptions of place are shaped through writing and the arts, the series takes its name from the label applied to unmapped areas on early-nineteenth-century maps of the American Southwest. This project weaves together text, sound, and image from the works of explorers and geographers, developers, environmentalists, artists, and writers to ask how we come to know and imagine an "unknown territory." The format allows for the inclusion of maps, diaries, photos, draw-

FIGURE 20. Excerpt, with select video clips illuminated, from *Unknown Territories,* an online project by Roderick Coover (2010), http://www.unknownterritories.org.

ings, and other materials from such diverse fields as geography, cartography, ethnography, and history.

In one of the series' cinemascapes, a primary path is constructed through a series of seven long-take video sequences about the author Edward Abbey. Between these are clusters of video clips that include edited overviews of historical, cultural, and environmental issues of the period, as well as extensive interviews and archival recordings concerning topics such as western migration in the 1950s, the Cold War–era boom in uranium mining, the impact of large dam projects on development and growth, and the changing nature of the environmentalist movement in the 1960s and 1970s.

Users may follow a primary path that presents selections of materials in ways one might experience in watching a documentary film. However, the cinemascapes offer viewers something that a linear documentary cannot: choices. The spatial structure allows users to follow Abbey's texts as he responds to events unfolding around him. And it allows them to follow the mediamaker's choices and to create their own judgments through the paths they weave. The format has a loose analogy with film editing; laying clips along a terrain is not unlike the process of creating a *timeline*, only here the timeline is visible to viewers. Further, the clusters of materials that are collected en route are not unlike those one might have collected in *bins*, only now the bins contain more than just footage. While supporting materials are commonly included as separate tracks on DVDs, the alternative routes through these materials are fully integrated into the viewing experience, allowing users the flexibility to expand or limit the narrative, to choose among expository and poetic approaches to the documentary's primary topic and its offshoots. The footage that went into the video clips is also included in its original form, and long takes of interviews supplement the edited sound bites.

The spatial structure of this and other cinemascapes, by letting users select a particular set of clips and supporting materials, offers them the means to follow how arguments are built out of experiences and may be constructed with poetry and visual imagery as well as through exposition. If they select to follow alternative paths through the data, then they will find themselves working through many of the same issues the mediamaker did. This shifts the user from being a critic of a fixed product to a participant-analyst in a process. Now implicated as a choice maker, the user engages both in an analysis of the mediamaker's path-making decisions and in self-analysis: what has she learned in actively navigating this environment, and toward what new questions do her chosen paths lead?

Conclusions and Discussions

The digital theorist Lev Manovich has been a proponent of the idea that uses of new media tools are giving rise to a new, hybrid language—a way of communicating that includes both prior methods of expression and new ones (Manovich 2002). In writing about the impact of design software like Adobe After Effects on how images are edited and how they are used to communicate ideas, he writes:

> The working method is neither animation nor graphic design nor cine-matography, even though it draws from all these areas. It is a new way of making image media. Similarly, the visual language is also different from earlier languages of moving images. (Manovich 2006, 5)

Whether or not it fully constitutes a language, digital media have unique argumentative and expressive characteristics: a digital rhetoric and poetics. Layers, links, paths, and multimodal juxtapositions impact how one idea, word, or image might lead to another, and these are only a few of the mechanisms that shape invention and expression.

The examples in this essay explore representations that are spatially and visually cohesive but temporally multivalent. Questions of subjectivity and narrative choice raised by these panoramic works are also explored in game design and in works for immersive environments, such as CAVEs (Cave Automatic Virtual Environments).

The rhetoric and poetics of the new media reposition old media—holding their characteristics in a new light. What had seemed to be fundamental characteristics of old media, such as the spatial contiguity of panoramas or the temporal constant of film projection, are pulled apart, juxtaposed, and recomposed in new and hybrid forms.

Works like those discussed in this essay could not have been imagined using other media. All explore characteristics unique to computing. The tools used in these works are still evolving, and new applications for these tools are being developed in other fields and disciplines.[5] Works like these are imagined by adapting digital tools to advance goals that might not have been anticipated by the hardware and software developers, and this in turn frequently, although often indirectly, impacts how the tools are further developed or how new tools come to be invented.

The emerging rhetoric and poetics of digital media are a result of this kind

of adoption (across fields), adaptation, and reinvention, which cycles between independent innovators, information technology professionals, researchers, scholars, artists, and almost all other users as well. This level of exchange was less common or even nonexistent in the growth of most nondigital media tools, from the printing press to the film camera; and when it did occur, it was mostly between specialists.

In computing, all works are multimedia and we are all multimodal; makers and users move fluidly among concepts, cultures, and forms of expression. Once positioned by media as relatively passive readers and viewers, the individuals who now navigate digital works are computer users. While few might watch a movie in the cinema and immediately find themselves loading a film camera, most who view digital works like those in this essay will soon—or even simultaneously—do other things on a computer as well. The flow between engaging works like these and doing other personal work is seamless, as is the cycle by which the poetics and rhetoric of works are interpreted, adopted, and adapted. In this sense, there is a new kind of contiguity defined by our networks and exchanges, by the extensions of ourselves in the digital environment. And this contiguity is also a montage.

Notes

1. There is a corollary in gaming: it is often the case that the more figures resemble humans the more they evoke a sense of the uncanny border between the living and the mechanically reproduced, what animation and gaming designer Glenn Entis (2007) describes as the "the zombie effect."

2. For further discussion on the relation between the long take and montage see Coover (2001, 2003).

3. "What we will have of what we are: something past . . ." (2003), http://www.z360.com/what.

4. My multimedia installation *Something That Happened Only Once* had its premiere at the Esther Klein Gallery, Philadelphia, January 2007. *Unknown Territories* (2008) can be accessed at http://www.unknownterritories.org.

5. For example, social scientists like Eric Margolis, president of the International Society of Visual Sociology, are adapting digital techniques like these to help students develop interpretative historical and ethnographic models.

References

Certeau, Michel de. 1984. *The practice of everyday life.* Berkeley: University of California Press.

Comment, Bernard. 1999. *The painted panorama.* New York: Harry Abrams.

Coover, Roderick. 2001. "Worldmaking, metaphors, and montage in the representation

of cultures: Cross-cultural filmmaking and the poetics of Robert Gardner's *Forest of Bliss.*" *Visual Anthropology* 14 (4).

———. 2003. *Cultures in webs: Working in hypermedia with the documentary image.* Watertown: Eastgate Systems.

Entis, Glenn. 2007. Keynote address. SIGGRAPH, San Diego, CA, August 5–9.

Goodman, Nelson. 1978. *Ways of worldmaking.* Indianapolis: Hackett.

Manovich, Lev. 2002. *The language of new media.* Cambridge, MA: MIT Press.

———. 2006. After effects, or the velvet revolution. *Millennium Journal,* nos. 45/46, 5–20.

Oettermann, Stephan. 1997. *The panorama: History of a mass medium.* New York: Zone Books.

Schwartz, Vanessa R. 1998. *Spectacular realities.* Berkeley: University of California Press.

Re-place:
The Embodiment
of Virtual Space

JEFFREY SHAW,
SARAH KENDERDINE,
AND RODERICK COOVER

Jeffrey Shaw is one of the pioneers of interactive cinema and haptic digital arts. He creates technological topographies in which the spectators construct meaning by engaging both physically and intellectually with the environment. The space of these works is literary, cinematic, and geographic, with a focus on *presence*—confronting the challenge of how to understand "being" in spaces that are technologically mediated and virtual.

In the following pages, Jeffrey Shaw and the artist and curator Sarah Kenderdine of Museum Victoria (Australia) describe a series of projects by Shaw and one, *PLACE-Hampi*, that Shaw and Kenderdine coauthored. These descriptions are grouped into three sections; after each, Shaw responds to questions posed by Roderick Coover.

Embodied Interfaces: *Legible City* and *Distributed Legible City; conFiguring the CAVE; Web of Life*

In *Legible City*, created with Dirk Groeneveld (1989–1991), the viewer bicycles through a virtual city constituted by an urban architecture of computer-generated three-dimensional letters that form words and sentences along the sides of the streets. The layout is based on the ground plans of Manhattan, Amsterdam, and Karlsruhe, and traveling in these cities of words becomes a literal journey on many levels. While peddling an exercise bike, the viewer can freely explore over fifteen square kilometers of content. This may be compared with conventional interfaces—keyboard, mouse, joystick—that trans-

pose minimal displacements of the body into media coordinates. The *Legible City* embodies single-user interactivity through a purely individual and personal control of all navigation parameters; this lone bicyclist moves about in a city deserted by its inhabitants, now inhabited only by visitors. *Distributed Legible City* (Shaw and Groeneveld 1998) introduces multiuser functionality whereby two or more bicyclists at remote locations can be simultaneously present in the virtual environment. They can meet each other (by accident or intentionally), see abstracted avatar representations of each other, and (when they come close to each other) communicate with each other via headphones and microphones. While *Distributed Legible City* presents the same urban textual landscape as the original *Legible City*, this database now takes on a new meaning. The texts are no longer the sole focus of the user's experience. Instead, they become the con/text (in terms of both scenery and content) for possible meetings and resulting conversations between the bicyclists. A rich new space of commingled spoken and readable texts is generated, and the artwork changes from a wholly kinesthetic visual experience to the visual ambience for a disembodied social exchange.

The interface design of *conFiguring the CAVE* (Hegedus et al. 1996) presents the viewer with a surrogate body that both iconically inhabits and physically animates its virtual worlds. This work utilizes an innovative virtual-reality environment with contiguous 3-D projections on three walls and the floor, fully immersing the viewer in its space of representation. The user interface is a nearly life-size wooden puppet that is formed like the prosaic artists' mannequin; it can be manipulated by viewers to dynamically modulate, in real time, various parameters in the image and sound generating software, and particular postures cause specific visual events to occur. Most significantly, the action of moving the puppet's hands to cover and then uncover its eyes trigger transitions from one pictorial domain to the next.

Web of Life (Gleich et al. 2002), a networked installation, allows users to interactively influence the performance of an audiovisual environment by imparting to it the unique patterns of their individual hand lines. The environment is formed by an immersive conjunction of projected three-dimensional computer graphics and video sequences, together with a fully spatialized acoustic experience and a specially conceived architectural surrounding. This artwork is configured as a distributed network of installations—one large-scale environment situated permanently at the ZKM Karlsruhe and four others designed to travel to various locations around the world during the period of the project. User interaction at any location com-

municates with and affects the audiovisual behavior of all the installations. The artwork's algorithmic emergent tapestry of audiovisual and thematic correspondences is activated and modulated by patterns derived from the palms of visitors' hands, which are scanned and entered into the system from the local and remote input terminals. The varied and always uniquely individual palm lines appear on the installation's screen, then merge into and activate a singular sequence of transformations on the screen and the musical score that accompanies the imagery. The visual network is programmed as a self-organizing system, utilizing biology-derived metaphors such as neuronal growth. The topic of networking logic is at the core of the *Web of Life* project. As in the Net, where we move from single-user cause-and-effect models to multiuser emergent-behavior models, *Web of Life* sets out to create a paradigmatic and aesthetically formed exposition that both describes and evokes the core experience of emergence, thereby inviting and revealing the inexhaustible vernacular of shared individuated connectivity via the crafting of strategies that can reembody the disembodied spaces of digital fragmentation.

Roderick Coover. I would like to begin with the question of what is the same and what is different about creating art with digital media—in particular how a cinematic activity is transformed, on the one hand, into a haptic experience and, on the other hand, into a readerly one of prewritten paths and passages. In *The Cinematic Imaginary after Film*, a book you coedited with Peter Weibel, you draw attention to works of artists like Friedrich Kiesler, who made media-mixing works in the 1920s, and Stan VanDerBeek, who developed the 1963 Movie Drome. Are there ways in which these works are still relevant today, or has something changed that renders them distant, historical reflections of their own age, an age that we are leaving or have already left?

Jeffrey Shaw. Early on I wrote:

> The activity of both art and science has always been the interpretation and recreation of reality. It is an exercise of the human imagination, creating concepts, forms and images that imbue our lives with meaning. Art continuously redefines itself in response to cultural transformations. Nowadays these transformations are very closely linked to the pace of technological developments, and therefore it is appropriate that art addresses itself to technology on the most fundamental level of its aesthetic and conceptual discourses. (Shaw 1999)

And recently, Terry Smith wrote:

> We are starting to see that in the years around 1989, shifts from mod-
> ern to contemporary art occurred in every cultural milieu throughout
> the world, and did so distinctively in each. Just what happened is only
> now becoming clear, even to those who most directly participated in
> the events of those days. We can also see that, even as they were oc-
> curring in the conflict zones, these events inspired a critique of spec-
> tacle capitalism and globalization on the part of a number of artists
> working in the advanced economies. They developed practices—usu-
> ally entailing research over time, widespread public involvement, and
> lengthy, didactic presentations—that critically trace and strikingly dis-
> play the global movements of the new world disorder between the ad-
> vanced economies and those connected in multiple ways with them.
> Working from similar perspectives, other artists were inspired to base
> their practice around exploring sustainable relationships with specific
> environments, both social and natural, within the framework of eco-
> logical values. Still others work with electronic communicative media,
> examining its conceptual, social, and material structures: in the con-
> text of struggles between free, constrained, and commercial access to
> this media and its massive colonization by the entertainment indus-
> try, artists' responses have developed from net.art towards immersive
> environments and explorations of avatar-*viuser* (visual information
> user) interactivity. (Smith 2009, 7–8)

Every gesture in art is a historical moment, a momentary embrace of,
or revulsion against, the exigencies of current conditions. Works endure ei-
ther because those conditions (in whatever permutation) also endure, or (as
in Kiesler) because they prefigure the shape of *things to come* or because they
themselves are the progenitors of condition change. A comprehensive read-
ing of art history would say that it is a process of creative inquiry into the
infinite complexity of the world via ever-changing strategies of representa-
tion and embodiment, and its works remain relevant as long as they continue
to inform/inspire this inquiry. On a perceptual (and sensual) level this world
presents itself as a totally immersive environment, and an artform that wants
to represent and elucidate its psychogeography is driven toward the form of
a *gesammtkunstwerk* whose inclusive strategies transform the viewer into a
protagonist. Thus we have, for example, the trompe-l'oeil entireties of the Ba-

FIGURE 21. Interior view of the installation *conFiguring the CAVE* (Hegedus et al. 1996), showing the CAVE 3-D projection and wooden mannequin interface. Collection of the ICC Intercommunication Centre, Tokyo.

roque imaginary, the amalgamated reality of Panorama Mesdag's beachscape, the myriad permutations of Raymond Queneau's "Hundred Thousand Billion Poems," and the suffusing spectacle of Stan VanDerBeek's Movie Drome. Because of the world's wholehearted obscurity, literal representation borders on idolatry or kitsch, and other methods (esoteric and otherwise) are invented to "reveal" its multivarious nature. One such "technique" has been the mirror—literally, as in the traditional painted anamorphoses that describe a deformed (hidden) world whose shape is only detected through its reconfigured reflection, and immaterially (but in a similar spirit perhaps) as afforded by the optico-digital technologies of virtual, augmented, mixed, and hybrid reality. This new-media art of technologically informed "reflection" offers a productive field of investigative inquiry, testing blurred boundaries of perception and participation, often in paradoxical parenthesis, to expose our operations of being in the world and our means of imagining (in moments of aspiration and/or delusion) new ways of being.

RC. One of the ways you draw attention to how we perceive and imagine

├── JEFFREY SHAW, SARAH KENDERDINE, AND RODERICK COOVER

worlds through digital media is through your exploration of "interface"—the point of exchange between humans and computers. How do you define the concept of interface in a context of works that are physical and haptic? The term coincides with an apparent shift in which "viewers" become "users." What does this mean for embodied works?

JS. An understanding of the new role of the user interface in the context of the manufacture of interactive artworks must firstly recognize its operational requisites. To quote Wikipedia:

> The user interface (or Human Machine Interface) is the aggregate of means by which people—the users—interact with the system—a particular machine, device, computer program or other complex tool. The user interface provides means of input, allowing the users to manipulate a system, and output, allowing the system to produce the effects of the users' manipulation.

But the "complex system" that constitutes an interactive artwork embodies aesthetic and conceptual formulations that articulate these input/output processes as artistically defined components of the total experience. The "creativity" that traditionally expressed itself in the invention of new modalities of representation here extends itself into the search for new modalities of communication between the human and the computer, such as vision or touch.

The major achievements in interactive art over the last thirty years show a profusion of idiosyncratic and often eccentric approaches in the design of their user interfaces, as each artist seeks to mold the uniqueness of each work's user experience. Fundamental to all of these experiments is the creative engagement of the user—his or her input is integral to the work's possible paths of self-revelation, and at the same time this input modifies those paths to create a unique moment that constitutes the ever-unfolding "liveness" of an interactive work. This constitutes a new relationship between the producer and the consumer of artifacts, one where the builder of the interactive system and its users participate in a situation of cocreative formulation, discovery, and experience. Another major significance of this development is the fact that such artworks are never conclusive—they are *always* in a state of continuous reformulation and refreshment at the hands of their users—and their cultural longevity will be measured by the extent to which they continue to offer inspiration for such user engagement.

RC. Simultaneous with evolving interface design is a reconceptualization of

the "frame" or film "shot". The analog frame directs viewer attention and fixes a set of relations in memory (one thinks here of Bergson and Deleuze); in digital environments, however, the elements that constitute an image are in flux and its dimensions may be boundless. Works like *Legible City*, *conFiguring the CAVE*, and *Web of Life* seem to make use of new interfaces to take aim at the notion of the frame—is that right?

JS. My expanded cinema installations of the 1960s (which I usually titled "Disillusionary Situations") marked the beginning of a long-term research effort to expose and "explode" established cinematic, proscenium, televisual, and painterly framing conventions and to create a fluid indeterminate arena of shared experience that would constitute a co-space of artistic expression and user (inter)action. My commitment to and enthusiasm for new media (inflatable structures in the 1960s and 1970s, computer-aided visualization systems since then) is based on the appreciation of how these media are able to offer unprecedented opportunities to articulate such an open space of artistic experience, and each of my works researches/articulates one or another nuance of this capability. Of course the liberation of the image from the frame is as fraught as is the struggle for existential liberation defined by mortality. Magritte perfectly pictured this paradox, while the Renaissance invention of perspective was a heroic achievement of pictorial liberation that the Mannerists quickly realized had to be disfigured to be more "true." Ultimately one can only talk about artistic freedom by acknowledging and subverting constraints, like the Oulipo writer George Perec's novel *A Void* (1994), where he manages to avoid that most basic prop of traditional syntax: the letter *e*. Works like *conFiguring the CAVE*, *Place—a user's manual*, and *Web of Life* go about transcending the traditional framing of artistic representation by creating expanded and virtual frames: the stereoscopy of *conFiguring the CAVE* offering an immersive set of nested spheres that extend into optical infinity, the modular architecture of *Place—a user's manual* simply multiplying itself forever in every direction, the networked intercommunicative space of the *Web of Life* allowing the work to be virtually connected and copresent at multiple locations worldwide. Simply put, I am fascinated by the space outside the frame, whose ubiquitous absence entails utter potentiality. That is why my recent work has been so engaged with strategies of panoramic visualization, where the viewers can let their attention wander into the periphery to discover something that might reframe everything.

RC. You draw several analogies to writing traditions—to the use of constraints by writers like Perec and to the conceptualization of the city as a text. What

├── JEFFREY SHAW, SARAH KENDERDINE, AND RODERICK COOVER

FIGURE 22. Installation view of *The Legible City* (Shaw and Groeneveld 1989-1991), showing a bicyclist in front of the projection screen. Collection of the ZKM Karlsruhe. Photo: Jeffrey Shaw.

shapes this relationship between language and image in *Legible City* and in your works in general?

JS. A city is simultaneously a tangible arrangement of forms and an immaterial pattern of experiences. Its architecture is a linguistic morphology, its ground plan a psychogeographic network, and its streets a labyrinth of narrative pathways. In *Legible City* the viewer rides through a virtual city whose architecture is made up of letters and texts. The bicycle trip through these cities of words is consequently a journey of reading. Choosing the path one will take is a choice of certain texts and their spontaneous juxtapositions. The identity of these new cities thus becomes the conjunction of the meanings these words generate as one travels freely around in this virtual urban space.

The Manhattan version of the work (1989) follows distinct, fictional story lines created through monologues by ex-mayor Ed Koch, Frank Lloyd Wright, Donald Trump, a tour guide, a confidence trickster, an ambassador, and a taxi driver. Each story line has a specific lettering color. The bicyclist can choose one or another to follow the path of a particular narration. In the Amsterdam (1990) and Karlsruhe (1991) versions, all the letters are scaled to have the same

proportion and location as the actual buildings they replace, resulting in a transformed representation of the actual architectural appearance of these cities. The texts for these two places are largely derived from archival documents that describe somewhat mundane historical events that took place there.

When first conceptualizing *Legible City* in 1989, I was referencing a number of avant-garde tendencies that strongly interested me including Lettrism, concrete poetry, haptic poetry, and the Situationist notions of urban psychogeography and the *dérive*. I was also very struck by the seventeenth-century author Madeleine de Scudéry's *Carte de Tendre* (1654) when I came across it in the 1980 Centre Pompidou Paris exhibition catalogue *Cartes et Figures de la Terre*. This map of the fictional country where Scudéry's novel *Clélie* (1979) takes place, is a topographic allegory representing the stations of love as if they were real paths and places. Recently I found the relation I had envisaged between the *Carte de Tendre* and *Legible City* reiterated in Guy Debord's publication *Internationale Situationniste 3* (1959, 14–15), where he puts the map of Tendre side by side with an aerial map of Amsterdam; he too was articulating the notion of a shared emotional topography between these two places. And in this context we must also think of the psychogeographic conjunction of the two Venices in Italo Calvino's *Invisible Cities* (1974).

With *Legible City* I was also responding to the iconographic nature of computer graphics (CG) in the late 1980s. In the nonscientific and commercial sector, this often manifested itself in the form of "flying logos," simply because CG technology at the time was limited in its capacity to display more complex objects. In other words, the early manifestations of CG occupied a space of concrete poetry by default, albeit in the banal guise of advertising. Most importantly, CG was able to give text a spectacular new three-dimensional tangibility—suddenly letters could fly and twist and join in space, an apotheosis of which is the opening title sequence to George Lucas's first *Star Wars* film.

Legible City, being a real-time interactive CG artwork, was similarly constrained by the technology available in the late 1980s—a finite number of flat, shaded polygons was the scope of current CG performance. But at the same time, this capability was perfectly suited to the aesthetic and conceptual formulation of *Legible City*—so one could say it is a work that is both technologically and artistically symptomatic of its time. This is an important aspect of the full appreciation of any technologically assisted artwork, because temporal technological conditions (both technical and cultural) strongly influence the artistic formulation—in the best cases, such conditions inspire and en-

JEFFREY SHAW, SARAH KENDERDINE, AND RODERICK COOVER

hance the artistic production, but they can also cripple it (which is one cause of a simplistically negative attitude to media art in general).

The use of text (and hieroglyphs and symbols) has been a recurrent feature of my practice. Following *Legible City*, for example, I became interested in the possibility of users actually creating their own texts in the virtual world—a sort of graffiti capability. This led me to develop voice-activated texts in *Place—a user's manual* that each user could release. These textually construed virtual domains are quite distinct from other works of mine such as *The Narrative Landscape*, *Heavens Gate*, and *Web of Life*, which luxuriate in their layered density of images. Yet, I see both attitudes as being facets of the psychogeography of contemporary machine culture. On the one hand, there is an almost obscene proliferation of images and of the visual manipulation, combination, and transformation that is afforded by digitization. This offers reason enough for one to recoil and seek hope in an iconoclastic embrace of the word—language as a refuge of "truth" in a world being saturated (made speechless) by "untruthful" images—reason to feel an affinity with those artistic traditions that have belied the image and elevated the word to the greatest heights of visual expression. On the other hand, it is exactly that power of digitization that is freeing the image from its traditional analog constraints—enabling one to conjure a cultural imaginary with such virtuosity and vitality that it is difficult to resist its expressive possibilities, and this despite its almost simultaneous commercial depreciation. So in my work, I find myself oscillating between these two positions, and now and then attempting a merger. An interesting possibility for the latter emerges when one considers an image that is determined by its algorithmic description, that is, by language.

RC. Does this correspond to the perpetual tensions in digital-media works between reading and viewing and between unconstrained "browsing" and the framed, focused, or delineated trajectories of many of our expository and narrative traditions?

JS. That tension between unconstrained movement and narrative focus is actually one of the primary dramatic and aesthetic properties and qualities of interactive new media. It is the place where an artistic construct is modulated (deformed/reformed/informed) by the action of the user, and it is the place where the user takes personal possession of (and responsibility for) the work. To be wholly successful such an artwork will endeavor to give aesthetic and conceptual "shape" to this process of indeterminate unfolding by "crafting" the design of its operative algorithms in such a way that the work can maintain and extend its expository/revelatory coherence under all circum-

stances, and thus continue to express its integrity (value) as a singular artistic proposition. In this context it should be said that the social media currently in vogue—such as YouTube, MySpace, and Second Life—operate so exclusively as user-articulated frameworks that one should distinguish that phenomena from what I am describing here.

Cinematic Narrative and Immersion:
Points of View III; T_Visionarium, EVE

Points of View III (Shaw 1984) is an early interactive narrative installation in which each "user" makes a personal audiovisual journey through the work and in so doing generates a unique real-time performance for the rest of the public. This work is a theater of signs where both the stage and protagonists are represented by 3-D computer graphics and where the interactivity of a flight simulator lets the user shift his or her virtual point of view with respect to the visual setting. The representation of each of the figures on the stage is done with a character derived from Egyptian hieroglyphics, and the resulting constellation of signs is used to articulate a world model with a particular set of aesthetic and conceptual relationships. For its sound tracks, sixteen people were invited to write short narratives that reference all of the characters in the work. Using a single joystick to explore both the sound and image landscape, the viewer generates an extemporary transcriptive conjunction of spoken narratives that is openly linked to the shifting configurations of the hieroglyphic imagery.

T_Visionarium (Brown et al. 2008) utilizes AVIE (Shaw and Del Favero 2004), the world's first 360-degree stereoscopic projection theater. Its 120-square-meter circular screen surrounds the audience and provides the conditions for a completely immersive three-dimensional cinematic experience. For the T_Visionarium project, researchers at the iCinema Centre in Sydney captured twenty-eight hours of digital free-to-air Australian television over a period of one week. This footage was automatically segmented and converted into a large database containing over twenty thousand video clips. Each clip was then manually tagged with descriptors known as metadata, which defined its properties. The information encoded included the gender of the actors, the dominant emotions being expressed, the pace of the scene, and such actions as standing up or lying down. Having the video data segmented in this way deconstructs the original linear narrative into building blocks that the viewer can then associate and reassemble in an infinite number of ways. In the projection environment, three hundred

video clips are simultaneously distributed around the huge circular screen. Using a special interface, the viewer can select, sort, rearrange, and link these video clips, creating new sequences that then play in the all-encompassing viewing space. Thus the viewer is provided with an engrossing density and intensity of ever-changing recombinant narrative formations.

The EVE (Shaw 1993) interactive cinema system in many ways is an apotheosis of this research trajectory. First developed at the ZKM Karlsruhe in 1993, this "expanded virtual environment" is a large inflatable dome, in the optical center of which a video projector is mounted on a motorized pan-and-tilt device that can move the projected image anywhere on the dome surface. A head-mounted device worn by one of the visitors tracks the position and angle of his or her head and controls the position of video projector such that the projected image follows the direction of the viewer's gaze. This allows the viewer to move the picture frame over the entire dome surface and interactively explore the virtual computer-generated or filmic spherical image that is presented there. In this way, EVE constitutes a space of representation that almost entirely surrounds the viewer; its head-tracking user interface embodies the notion of a fully immersive world of multivarious images and events that reveal themselves to the inquiring gaze of the viewer.

RC. One thing that is changing is how one works with "images." German cultural critic Florian Rotzer writes, "Today looking has come to mean calculating rather than depicting external appearance. . . . We build machines . . . not just to connect perception and process, but more importantly to internalize these and connect them with the millions of rhythms and cycles in our body." Practically speaking, what have been the significant limits to how images still function (and are made) in developing projects like these. Which changes in computer software and hardware have most changed your way of using (and thinking about) the computer in art production?

JS. Concerning Florian's positions on new media I have a more skeptical attitude: everything is different and yet everything is the same. I recognize (and embrace) the new qualities of our machine culture, and yet I question how deep-going this newness is existentially. In other words I feel myself more of an avant-gardist than a new-ager.

On the other hand, I affirm the prospect and necessity that art has to reinvent itself continuously, and that in our time this constitutes a new identity that in many respects fundamentally differentiates it from its past forms and purposes. Here are some of its "new" features:

- Its interactivity, enabling tangible cocreative input from the user.
- The notion of an open, "unfinished" artwork that always (and forever) reveals itself in different ways in response to different (and unrepeatable) user input.
- The notion of the artwork that is not a space of representation per se, but more a space of exploration and (self-)discovery. Interestingly, the digital capability to construct a user-navigable virtual space of almost infinite dimensions aligns well with this purpose. *Legible City* (Amsterdam) has a virtual area of over ten square kilometers, and each of the **PLACE** installations presents a modular space that repeats itself indefinitely in all directions.
- The creative action of the artist now largely having to take place in the immaterial domain of algorithmic design. Such an artwork is essentially a software construct, whose visible (and other sensory) properties are simply the manifestation of code operating in a computational environment. This shifts the creative practice of art very much away from being a manual craft into one of conceptual engineering.
- The social operation of the digital artwork becoming essentially performative. Even a single-user interactive art installation (as mine usually are) offers itself to the general public as a sharable performed experience. And in works like *Televirtual Chit Chat* (Shaw 1993b) and *Distributed Legible City*, the virtual space created by the artwork becomes itself a shared social environment for its visitors. The recent massive popularity of social-media sites on the Internet confirms this essential aspect of new media.

A radical feature of an artwork whose forms derive from its algorithmic architecture is the possibility of designing algorithms that are subject to change due to user or environmental input, or that change independently of any external input due to the ability of the computational system to modify itself— that is, as a consequence of software instructions that imbue the system with some form of "artificial intelligence." The idea of auto-creativity in a man-made machine is an age-old fascination (linked of course to the machine's potential to replicate itself)—as if the making of such a "device" would exemplify the peak of human creativity. Many contemporary artists are not at all embarrassed by this idea and see the digital realm as offering a unique opportunity to experiment with auto-creative processes as the next logical step in art's cultural trajectory.

FIGURE 23. Overview of the installation *T_Visionarium* (Brown et al. 2008) at the Alhambra in Granada, Spain, Biennale of Seville 2008. Three hundred video clips are distributed in three dimensions over the AVIE cylindrical projection screen. Photo: Jeffrey Shaw.

RC. This seems to engender new kinds of creative relationships between artist and engineer. Could you give an example of how this played out in actuality? I imagine it can cause one to rethink the artist's role and the relationship of the artist to audience (when the audience is looking at a work that might be as much "made" by a machine as the artist-engineers who created the machine).

JS. There are only a few new-media artists with the all-round capability to conceptualize, design, and build such typically complex works. More usually, they require a working relationship between artists and technicians with various skills such as programming and electromechanical engineering. This is not a historically new situation—many artists in the past ran studios where persons with various skills contributed to the work. And, multiple agency in the theater and cinema is almost axiomatic. What is new, perhaps, is the uniquely creative role that such engineers can have in the construction of a digital media artwork. In my own practice, there are numerous instances where programmers have become identified as coauthors because of this level of contribution. Furthermore, media artworks are (usually) not dependant on idiosyncratic individual artistic skills, as are needed, for example, in painting, so they can open themselves to a more cooperative process of creation where

the outcome is constituted by the conceptual, aesthetic, and critical interaction of individuals who have a closely shared enthusiasm and vision. In my own practice such cooperations have been a hallmark and are integral to the vitality of its (and each contributor's) development.

A project that fascinates me would be an exhibition titled "Artists Make Machines to Make Art"—focusing on machines that are creative facilitative devices rather than art objects per se. The camera obscura is, of course, a paradigmatic historical example, followed by the multivarious apparatuses built—often invented—by painters, sculptors, filmmakers, writers, musicians, and so on to enable them to undertake their specific creative objectives. Contemporary media-art practice is very much about artists building machines—especially interface devices and software engines—to engender specific forms of artistic expression and particular modes of user interaction. Such software architectures can be highly complex machines, with levels of autonomous behavior that extend the definition of the creative process whereby artists become the conceptual engineers of systems of aesthetic capability rather than of circumscribed objects.

Embodying Place: *Place—a user's manual* and *Place-Hampi*

In *Place—a user's manual,* a rotating platform with three video projectors allows the viewer to interactively rotate his window of view around a large, circular screen, and so to explore a virtual three-dimensional world constituted as a constellation of eleven photographic landscapes. These images, cylindrical panoramas recorded with a special camera in locations including Australia, Japan, the Canary Islands, Bali, France, and Germany, are simple landscapes of ground and sky that repeat themselves in all directions. The ground on which they are positioned is marked by a diagram of the kabbalists' sephirotic tree; the position of each panorama reflects a relationship between the landscape's scenery and the signification of that location on the diagram. The viewfinder on the interface camera offers an aerial view of the diagram and allows the viewer to see the exact position of the eleven panoramas. Moving texts are generated by the voice of the viewer and leave traces of their presence in this virtual world.

Place-Hampi builds on the interactive cinema paradigm launched in *Place—a user's manual.* Its central feature is a motorized platform that allows the viewer to rotate a projected image within a cylindrical screen nine meters in diameter and to navigate a three-dimensional environment of panora-

FIGURE 24. Interior view of *PLACE-Hampi* (2008) showing the motorized platform, cylindrical projection screen, stereoscopic panorama of Hemakuta Hill, Hampi, and composited animation of the elephant deity Ganesha. The installation was coauthored by Sarah Kenderdine and Jeffrey Shaw, with John Gollings and Paul Doornbusch. Photo: Jeffrey Shaw.

mas photographed at the UNESCO World Heritage site Vijayanagara Hampi, in southern India. These stereoscopic images are linked through narratives and enlivened by animations of Hindu gods and mythological events. These events reveal the folkloric imagination of contemporary pilgrims active at the temple complex. The single-user interface allows viewers to control their forward, backward, and rotational movements through the virtual scene as well as the rotation of the image. In walking around the viewing space, they also synesthetically engage their bodily movements with the stereoscopically perceived world, creating a heightened sense of presence.

RC. Physically, can you explain the technology of these works and how they compare to CAVEs or other immersive environments? What specific advantages do immersive environments provide, and this technical approach in particular?

JS. All of the *Place* installations embody the same visualization and interaction paradigm—one that I invented for *Place—a user's manual* in 1995 and that derives from the EVE installation first presented at the ZKM in 1993. In this paradigm, the user moves a projection window so as to explore a surround-

ing virtual scene. The *Place* installation has a nine-meter-diameter projection screen, with a motorized platform at it center from which a portion of that screen is projected upon. Rotation of the platform by the user controls the rotation of the projection window and the user's exploration of the panoramic scene. In this respect the *Place* installation has a greater affinity with a head-mounted display than with the CAVE. A head-mounted display also presents a restricted viewpoint, and the viewer has to turn and tilt his or her head to discover the complete scene, whereas a CAVE would simply project the scene in its entirety. Paradoxically, it is the human manipulation of a constrained projection window that offers a more kinesthetic experience than in a CAVE, simply because it demands a more concerted bodily effort on the part of the user, and furthermore, what appears on the screen is more closely linked to choices made by the viewer—that is, an active seeking out of information. Other perceptual and kinesthetic factors also come into play: the dynamic process by which a personal mental picture of the complete 360-degree scene is constructed in the viewer's mind as he or she explores its features; the user's experience of physical rotation on the platform that aligns his or her body with the virtual point of view, thereby making more tangible (even somewhat hallucinatory) the sense of tangible presence in that space; and the obligation of other viewers in the installation to walk around and follow the rotation of that platform and the projected image, thereby causing a psychophysical conjunction of real and virtual movement that amplifies every viewer's sense of the actuality of the scenes presented and the immediacy of their visit.

One distinction between *Place-Hampi* and the earlier *Place* works is the later work's use of stereoscopic 3-D projection. Stereoscopy is a feature of most immersive display systems because of its ability to give a more tangible experience of the three-dimensional properties of situations and objects. Every monoscopic display from PDA to Omnimax forces the viewers to focus their eyes on the two-dimensional surface of the screen, thereby belying the third (depth) dimension of the image being presented. A stereoscopic display, on the other hand, allows viewers to focus their eyes both in front of and beyond the screen surface (to infinity in fact) so that the depth of the projection can be experienced as an immersive reality. In works like *Place-Hampi* and *Web of Life*, the projection screen becomes a transparent window that reveals a space of representation that effectively conjoins with the viewer's space of being (and action).

RC. In terms of how the works are made, *Place—a user's manual* and *Place-Hampi* employ video compositing and layering, with realtime CG characters

and pre-animated ones reacting to the movements and actions of audience members via tracking systems. How has this changed the way in which narrative elements function? And, I imagine transparency of the technology must be a problem . . .

JS. *Place-Hampi* in its present form presents animated three-dimensional Hindu gods that have been composited into the three-dimensional panoramic photographs that were shot at Hampi. During the viewer's exploration of those scenes, these figures can be "discovered" at certain locations. But the animations themselves are pre-rendered and simply play over and over again in a seamless loop.

The next version of the *Hampi* project, which is currently in production, will be implemented in iCinema's AVIE environment. This is a 360-degree fully projected stereoscopic display. In AVIE each viewer's physical location and bodily gestures can be detected by infrared video cameras and used as input to influence the projected imagery. Our intention is to populate two of the *Hampi* panoramas with computer-generated autonomous narrative agents who will react in real time to the physical disposition of the viewers with respect to the scene. In one instance, a group of temple monkeys will be these reactive agents. In another scene, a group of virtual tourists will autonomously respond to the viewers' proximity, identifying them also as tourists, who they proceed to photograph. In each of these "experiments," the viewer experiences the shock of a virtual world that is dynamically aware of his or her presence and behavior, and continuously and autonomously modifies itself accordingly. This modicum of machine intelligence is enough to create a so-called co-space—a merging of the physical and the virtual, enabling simultaneous interactions between the real and virtual worlds. Irrespective of its obvious technological contrivances (and constraints), such a co-space promises to introduce a whole new dimension into the narratives of immersive virtuality—one where autonomous machine agents are socially copresent and coactive with human agents.

RC. Walking in your multimedia environments suggests the integration of time-based media like film and spatially represented arts like panorama. As with bicycling in *Legible City*, the walking articulates a changing relationship (similarities, differences) between humans and machines in relation to information processing and meaning. Is that right?

JS. Yes.

RC. Walking, then, seems to be one of the ways you construct conditions for exploring both the human experience of "presence" and what presence means

in a world of machines. . . . Perhaps this had practical implications in making works that explore presence or even impacted your understanding of what it might mean to construct (or articulate) presence in artwork?

JS. The success of the Nintendo Wii is largely due to the way it extends the range of physical interaction offered to its players. The effectiveness of such a device was prefigured by the earliest examples of media art, such as my *Legible City* and David Rockeby's *Very Nervous System* (1986; see Cooper 1995). But already in the nineteenth century, the attraction (and commercial success) of panoramic painting, as Errki Huhtamo has rightly pointed out, was that one could stroll around it as a flaneur—an attraction that was lost once seating was set up in the cinema, to be replaced by a more modern fascination, that of the voyeur (Huhtamo 2004).

A denominator in so much media art is the intention (once again) to reengage the body of the viewers, to affirm their bodily presence in the mediated space, and conjoin them in an extroceptive, proprioceptive, and kinesthetic relationship with the artwork. There are at least two drivers for this ambition: to revitalize the sociocultural operation of art in general because of its dysfunctional state, and to adhere this revitalization to a technological imaginary that has become the central ideology of our time. Samuel Beckett said, "To find a form that accommodates the mess, that is the task of the artist now" (Bair 1978, 21). Because the technological imaginary is a domain of digital immateriality, the existential success of this project necessitates its embodiment as a cultural prosthesis where we can critically register and enact our presence. When machines increasingly determine the spatial formations of this world (and the world of art) and can even inhabit it as autonomous agents, the core challenge on every level is to articulate and give meaning to these new modalities of "being" in this world. To address this challenge, the artworks we are making operate as laboratories of confrontation, interaction, and self-reflection around this issue, using technological and aesthetic constructs that delve deeply to elucidate its properties, problems, and potentialities.

References

Bair, Deirdre. 1978. *Samuel Beckett: A biography*. New York: Harcourt Brace Jovanovich.

Brown, Neil, Dennis del Favero, Matt Mcginity, Jeffrey Shaw, and Peter Weibel. 2008. T_ *Visionarium*. Produced by the UNSW iCinema Research Centre Sydney. Supported under the Australian Research Council's Discovery funding scheme.

Calvino, Italo. 1974. *Invisible cities*. Trans. William Weaver. New York: Harcourt Brace & Company.

Cooper, Douglas. 1995. Very nervous system. *Wired* 3, no. 3.

Debord. Guy. 1959. *Internationale Situationniste* 3 (December).

Gleich, Michael, Jeffrey Shaw, Torsten Belschner, Bernd Linterman, Manfred Wolff-Plottegg, and Lawrence Wallen. 2002. *Web of life.* Application software: Berd Linterman. Produced by the ZKM Karlsruhe. Sponsored by the Aventis Foundation.

Hegedus, Agnes, Bernd Linterman, Jeffrey Shaw, and Leslie Stuck (sound). 1996. *conFiguring the CAVE.* Application software: Bernd Linterman. Collection of ICC Intercommunication Centre Tokyo.

Huhtamo, Erkki. 2004. "Peristrephic pleasures": The origins of the moving panorama. In *Allegories of communication: Intermedial concerns from cinema to the digital*, ed. John Fullerton and Jan Olsson, 215–48. Rome: John Libbey Publishing.

Perec, Georges. 1994. *A void.* Trans. Gilbert Adair. London: Harvill Press.

Scudéry, Madeleine de. 1979. *Clélie.* Paris: A.-G. Nizet.

Shaw, Jeffrey. 1984. *Points of view III.* Application software: Larry Abel. Engineering: Tat van Vark and Charly Jungbauer.

———. 1988. "Un musée imaginaire de la Revolution." *Mediamatic* 2 (4).

———. 1993a. EVE (Extended Virtual Environment). Application software: Gideon May. Engineering: Ralph Gruber. Produced by the ZKM Karlsruhe.

———. 1993b. *Televirtual chit chat.* Application software: Gideon May. Produced by the ZKM Karlsruhe.

Shaw, Jeffrey, and Dirk Groeneveld. 1989–1991. *The legible city.* Application software: Gideon May. Engineering: Huib Nelissen. Collection of ZKM Karlsruhe.

———. 1998. *The distributed legible city.* Application software: Gideon May and Adrian West. Produced by ZKM Karlsruhe. An eSCAPE European ESPRIT i3 project.

———. 1999. Création et diffusion des arts numériques. *EdNM/Ciren*, http://www.ciren. org/ciren/conferences/220199/index_E.html (accessed July 1, 2010).

Smith, Terry. 2009. *What is contemporary art?* Chicago: University of Chicago Press.

Rewiring Culture, the Brain, and Digital Media

Vibeke Sorensen

Jeffrey Shaw's interview and Roderick Coover's article bring to light a number of important issues, most especially the crucial role that independent artists play in providing a critical social point of view in regard to the development of technology. An artist's critical distance is more important today than ever before given the world-wide proliferation of electronic and digital media. As the late video artist Nam Jun Paik stated in the 1960s, the question is not whether or not to use technology but rather how to humanize it (Paik and Rosebush 1974).

The history of technology development has almost always involved cultural producers and artists, but until recently (the past twenty-five years in the West) it was not typically recorded this way. Artists produced or presented their artworks publicly but did not normally publish technical papers about how the work was made (even if the scientific method was employed within experimental art practice).

An artist's understanding of spatial and temporal phenomena, their expression, and representation (such as perspective) has always been valuable in rendering an image of the world that is understood as accurate. Indeed, mapmaking has provided a dominant spatial conception of the world. Those who understand how to translate navigation in the three-dimensional natural world (an immersive space) into two-dimensional movable images have had an advantage. Maps allow people to contemplate and plan their actions in their immediate world, whether for agriculture, exploration, or the building of empires. In fact, the definition of imperialism is the "remote" control of people and their lands, a practice clearly facilitated by cartographic images. During colonial expansion, all evidence of "other" cultural memories was violently attacked and as much as possible destroyed. This was especially true in visual cultures, where images, sculptures, and architecture—all modes of thinking about space—had an impact on preexisting cultural narratives that reached back thousands of years. Colonists typically retained only useful and utilitarian knowledge, separating methods and techniques from content, retaining the former and destroying the latter. The ability to insert meaning into the visual domain, and to control the

production, distribution, and consumption of visual culture, became the realm of the rich and powerful, as they sought to redefine vanquished cultures.

We can detect this when we look at art-historical archives in most university museums and libraries. Artifacts from past civilizations are typically organized chronologically, geographically, and by technique (e.g., cast bronze). It is difficult to find information about specific artists or cultures, much less why the artist made the work, what it means, and how it was used. Certainly during colonial times this knowledge would not have been welcome and would not have been recorded and disseminated.

In the past fifty years, there have been countless artists directly involved with the development of computer graphics. Their work, however, has been marginalized if not forgotten despite the fact that their technical innovations are being unconsciously quoted today by everyone who makes a 3-D image. These artists were much less generously compensated than their peers in the engineering and computer science communities, even though the technology developed was motivated by the desire to create artwork. The privileging of the utilitarian over that which has cultural content and value is a continuation of the same colonial attitudes that led to earlier destructive practices.

For generations, artists and entire populations had to develop clever strategies for survival, since open practice of their otherwise long and continuous traditions could mean death to themselves and to their cultures. Strategies included syncretism, the juxtaposition of images and ideas within those of the colonizing cultures. The original meanings of images and artifacts, including narrative, visual art, music, poetry, and oral history, would be retained as disconnected elements and dissociated fragments through metaphor and memory. To rescue these elements and fragments from total annihilation and erasure, they made use of the brain's capacity to fill in discontinuities with personal memory and thus construct local and alternative narratives independent of and resistant to repressive power structures. While all cultures experience some form of discontinuity, the larger discontinuities in cultural narratives and world art caused by colonization mirrored increasingly destructive cultural traumas, culminating in at least two world wars in the twentieth century, and a third, the "war on terror," in the twenty-first century.

The Dadaists of the early twentieth century responded to World War I by stating that a culture that creates war does not deserve art, and so made what they called "anti-art." They used similar techniques of fragmentation to attack and transform the status quo, building into the Surrealist movement that succeeded them (some of whose members were Dadaists), developing the "cut-up" and related techniques of montage and collage, as well as chance processes. The "ready-made," or "found art," presented common and often banal objects of everyday life as art (e.g., Duchamp's urinal, entitled *Fountain*). By making the common seem alien, a critical distance was established. But

the ruling class at the time thought the Dadaists were criticizing older forms of art and the role of the church, and so ironically embraced them. What was meant to be critical art was thus adopted as mainstream, and these techniques became a reference for all Western visual art that followed. The ruptures they produced provided opportunities for resistance, the insertion of alternative points of view, and a wider range of interpretation.

We are now in an even more extreme state of global cultural fragmentation, de-contextualization, and destruction. This is due to the widespread availability of vastly more devastating ways of waging both physical and psychological warfare. Both make use of sophisticated media and techniques. The proliferation of digital cameras, computers, and software, along with the Internet, makes it easier than ever to record events and produce content, but it is also easier to edit, to remove important contextual information and to insert false or contentious materials. This is a sophisticated, high-tech "culture war" conducted through media language, a "cool war" that most people are not even fully aware is taking place. Disinformation and censorship by omission are difficult for the public to detect. (The production of software to do this is a growing area of digital media research today.) So while there has been fragmentation in the past of spoken languages and visual cultures, today it affects more people simultaneously, in more complex and "invisible" ways. Each person in the world who is connected to the Internet is a potential target. In this way, digital culture wars can be waged against anyone, anywhere, and at any time.

There is again an urgent need for resistance and alternative reconstruction. This, the larger context and subtext for contemporary digital art and cultural practice, is in dialogue with a larger Western cultural romance with digital media. There is a kind of utopian digital ideology: that it will bring us closer to other people, solve poverty, reduce class differences and inequalities, and even help reverse the environmental crisis. But there is a huge disconnect between the dream and reality, between the impulse and the effect. None of these problems have been solved as a result of technology, and in fact they are becoming worse. While it *is* possible to address them, perhaps our approach is insufficient. Technology may be teaching us how to sense, but not to *feel* or to contemplate deeply enough, the problems in the real world. We are, indeed, less engaged with the natural world where these problems are manifest and where we should look for positive effects.

As Coover says about photographic panoramas, the spectator is looking into a world that does not look back. The promise of digital panoramas—or as he calls them, "cinemascapes"—is that the opportunity they provide to disrupt the illusion of verisimilitude and wholeness begins a process of looking back from a perspective that has long been rendered invisible. In this instance, the incorporation of a perspective that looks back undermines the wholeness produced by colonial narratives. But

what else is needed to translate this breakdown into an experience that motivates users to understand the complicity of technology with dominant power structures? What else is needed to create equally powerful alternatives that resist it? Do we need more smells and views from people walking in the street in the city?

The presentation of a fragment—be it the juxtaposition of a seemingly unrelated image or sound, the layering of unusual montage elements, the insertion of temporal discontinuities, or the creation of unexpected visual and aural transformations and "morphs" in a panorama—allows for a different kind of meaning and experience to take place. Yet access to these practices is still limited and exclusionary. Use of the requisite technology is limited to those with sufficient money, energy, and time, that is, those in an elite socioeconomic position. Indigenous people around the world—the very people whose cultures were attacked by colonial forces—are typically not included. So it may be the goal of panoramas to see and know everything, to be omniscient, but this overarching view does not include everyone. The ability to rewire the mind with new digital experiences is powerful, but it requires a greater connection to the natural world and to living beings, and the presence of even more imaginative rewirings of those connections than currently exists. As Umberto Eco (1999) has observed, spoken languages are expanded through a combination of individual invention and the borrowing of words from other languages. The same is true of digital media. In this regard, Coover and Shaw are working to create valuable alternative paradigms for interaction that are in greater dialogue with the natural and human worlds.

From a global point of view, the discontinuities and fragmentation of world cultures is vast, made all the more visible and accessible in networked, immersive, nonlinear digital environments (including the World Wide Web). There is a huge contradiction or paradox here: much of the content online, accessed through "links," creates the impression that many cultures are included and connected. It is a powerful fantasy. But statistically, 75 to 90 percent of the world population remains *not* connected. The scale of our online, virtual migrations and diasporas mirror the scale of migrations taking place in the physical world. The scale of suffering and dystopia in the physical world is in direct opposition to the utopian romance with the virtual world. While specific uses of media in the digital community —like Jeffrey Shaw's and Roderick Coover's work—show the possibilities and potentialities of interruptions and frictions, there are far more lost opportunities and disconnections than solutions or connections in this environment. The illusion of continuity today is laid bare by this increasing exposition of discontinuity and exclusion.

The human mind reacts by filling in gaps and making bridges, attempting to fit fragmentary memories into some kind of cohesive narrative. The natural desire is to make things whole, and the mind is agile in its use of stored memories. Digital media

can assist by interpolating between scattered bits of data to make seemingly continuous and contiguous spaces (visual or otherwise). If all of the cultures on the planet participated in digital culture, providing their stored memories, the result might be a complex, plural, global narrative that reinforces the goal of digitally enabled cross-cultural understanding, and a site for reflection and contemplation of the past, current, and future global condition. Artists who work with digital media are catalyzing this sort of bridge building. They are in a sense "digital civil engineers" or, from a social point of view, "digital social workers." Yet this too is illusory because there are still many experiences left out. Greater multicultural participation in digital media art practice can introduce new approaches to the interpretation of space, time, and even verisimilitude within what Coover describes as contiguous spaces that are not disruptive of boundaries. Digital media can assist in this through expanded and integrated forms of physical-digital computing, social and creative networks, and large-scale dynamic and complex systems with distributed databases and archives, pioneered by individual artists and groups working with a widening and ever more inclusive array of the world's people.

The tendency to fragment and deconstruct cultures is still progressing, not least because the challenge of digitizing the world and its cultures is so daunting and the process far from complete. It is also reinforced by strong and persistent neocolonial tendencies. Just as in earlier periods, when image technologies developed in tandem with industrial and territorial expansion (panoramas, CinemaScope, the railroad in the West), computer graphics and the Internet, which have evolved into important and valuable alternative social networks, are also being used to conduct war. Culture, as in previous eras, is still a site of warfare, and our media technologies actively participate in its production.

In popular culture today many artists are making "mash-ups." Are these new juxtapositions works that disrespect and erase the meaning of the works they recombine, or are they positive creations that celebrate commonality within diversity by making new kinds of visual metaphors? In general, global cultural fragmentation and deconstruction outpaces reconstruction: there are far more dissociated and disconnected fragments than bridges. This situation reflects the larger political sphere, where there is a huge if unstated conflict between those who would use technology to dominate and "clean" the world and those who would use it to do the opposite. Totalitarian uses of technology, such as the films and mass media produced and controlled by Joseph Goebbels, propaganda minister in Nazi Germany from 1933 to 1945, often appear clean, orderly, and unified because they idealize limited points of view. In this environment, when ruptures *do* take place they are usually carefully controlled and frequently anti-intellectual, dehumanizing, humiliating, or intimidating toward those who disagree or may simply have another point of view. Plurality

and democratic uses of technology can look messy precisely because many more points of view are discussed and tolerated. As J. Rami Mroz (2008) observes, extremist websites frequently use visual and verbal language in a hostile, disrespectful, and dehumanizing way to attack those with whom they disagree, silence dissent and discussion, and use the Internet to build a group of dispersed, like-minded "believers" who also present themselves as victims, thus rationalizing violence. Pluralist, non-extremist websites not only present far more respectful discussion of a greater variety of viewpoints but regard this activity as fundamental, a primary measure of the strength of their democratic structures, of a piece with their support of human rights, nonviolence, and physical, intellectual, and emotional security for all people.

But art can be a kind of cultural camouflage. Appropriation of the arts by authoritarian regimes is a tried and true technique, and this tendency is apparent in the struggles for dominance of the Internet and new media community. Authoritarian control is growing in online news, where popular cultural forms, including those that are cutting edge and contemporary (such as electronic poetry and multimedia performance art) are increasingly being combined with extremist points of view, disinformation, and false news.

Artists working across borders of all kinds, respecting cultural, human, and biological diversity, fostering ethics, justice, peace, truth, tolerance, inclusion, and human rights, especially of women and children, do so with courage. Those who critically and creatively engage the intersection of technology with world cultures, the environment, and ecology employ cooperative and lateral rather than competitive and hierarchical structures. They present important alternative paths that impact the field of digital media, all of the arts, and world cultures by providing new forms of entry to technology and media for people around the world.

In order to open new doors between the physical and virtual worlds for more of the world's cultures, much of the physical world has been dematerialized through analog-to-digital conversion, turned into numbers and symbols ripe for endless transformation. Free from physical constraints, as in a dream, the same technology turns our thoughts, numbers, and languages into expanded forms of conceiving and contemplation for output into the physical or virtual domain or both. Digital cinema, moving images, sculpture, and music can arise from geological and atmospheric data—or any kind of data for that matter. Anything that can be digitized is transformable and can be shared across a network in a giant feedback loop. The dream of this new artistic production, therefore, is to be shared, real-time, and real. And just as the function of dreams is to imagine and the purpose of dreaming is to solve problems and propose alternatives to be used when in a conscious state, our collective lucid dream can do the same.

Ultimately, the value of technology is measured by its ability to improve and

affirm life and promote well-being and vitality. By looking at the weakest members of the human community one can see just how effective it really is. Women, children, and the elderly; people displaced by human and natural catastrophes, including war, environmental destruction, and the effects of global warming (such as extreme weather, desertification, and species extinction); and those from cultures historically suppressed by violent forces of colonization may have the most to contribute to our collective digital database and thus to shaping our understanding of the world today. But they have the fewest opportunities to do so. If media technology had realized its utopian promise, we would see a much wider leveraging of ethnic experience as "cultural capital" in the expanding virtual environment, and with it improvements in education, health, and welfare. There would be an overall improvement in living conditions for many more of the world's peoples, especially those who are least privileged. This remains a promise and a goal.

The role of artists and the community of users is as cocreators of high-tech experiences, but their interventionist activity is fostering the creation of alternative histories and chronologies. They are seeing the world through new glasses, revealing our human failures and successes, our nightmares and our dreams. In this way, we can better reflect and criticize, see our limits, and see also our real possibilities.

Artists are a window to the future. Coover and Shaw are working with the immersive and interactive worlds growing in the space between cinema and computing. Their activities and those of other artists in this field attempt to redefine the contours of human experience. They are creators and thinkers, exploring the intersection of temporalities and knowledge systems that ultimately can help liberate the expanding media world from past colonial entanglements that normalized singular worldviews.

Finally, the driving force in digital culture may still be the desire for omniscience, omnipotence, and immortality. But omniscience will come only from collective intelligence, omnipotence from collective imagination, and immortality from collective memory. We will discover continuity and contiguity by living, thinking, and working together, by prioritizing conscience and compassion, and forging closer links to one another in the natural world.

References

Eco, Umberto. *Serendipities: On language and lunacy.* 1999. San Diego/New York: Harvest Books/Harcourt Brace & Company.

Mroz, J. Rami. 2008. Countering violent extremism, videopower and cyberspace. Policy paper. New York: East West Institute. http://www.ewi.info/pdf/Videopower.pdf.

Paik, Nam June, and Judson Rosebush, eds. 1974. *Nam June Paik: Videa 'n' videology (1959–1973).* Syracuse, NY: Everson Museum of Art.

Re/presentations: Language and Facsimile

poets

QUASHA AND HILL

are looking
for trouble

LATOUR AND LOWE

Electronic Linguistics

GEORGE QUASHA
IN DIALOGUE WITH GARY HILL

My art has steadily moved from
a perceptual priority of imaging
toward a more conceptual method
for developing idea constructs.
Remaining throughout my work has
been the necessity to dialogue with
the technology. The earlier image
works, primarily concerned with color
and image density, were engaged
in the invention of new and more
complex images within compositional
and rhythmic structures. The current
work involves image-text syntax,
a kind of electronic linguistic,
utilizing the dialogue to manipulate
a conceptual space that locates
mental points of intersection, where
text forms and feeds-back into the
imaging of those intersects.
Gary Hill (1980)

This is an essay about things that may not quite exist. The interest in thinking
about them is due to their also not *not* existing, indeed their apparent persis-
tence and persistent appearance. The line here between these two conditions,
existence and nonexistence in electronic timespace, is scarcely a line at all.

Rather it's a *limen*, a threshold to a zone of liminality that is also a high intensity site of discovery. That makes it less like a binary system's demarcation, on/off or here/there, than a condition of access to—what to call it?—a certain state of being? Of experience? We can think of these terms as provisional and in brackets: A [state] that shows up in specific contexts. These contexts themselves are ontologically indeterminate and "exist" only by virtue of the distinction "art." What is not provisional in the same sense, but a distinction that has persisted for thirty years, is the fact that we—Gary Hill and I—have all along referred to this state/experience as *language*. Obviously "language" is a distinction of notorious complexity and inevitable controversy, and we do not mean for it to resolve difficulties in art definition (does it ever?); rather, we use it, first of all, to indicate an art phenomenon that, without it, loses dimension and in fact may be misapprehended, if not trivialized. And we view it as the right name for the phenomenon that we are bringing into view.

Speaking of particular works that he had made over the previous few years, Gary Hill said, in the 1980 statement above, that they involved "a kind of electronic linguistic." He did not say that this notion applied to his entire oeuvre or constituted his main focus in making art, but he has said and continues to say that it has played a critically important role in the composition of certain works, both then and now. My approach is to take him at his word and go where that leads.

The point of foregrounding liminality here is twofold. First, it gives us refuge from the presumption of science in our discussion of the distinction *language/ linguistics*. Things that cannot be said to have positive existence cannot be fruitfully discussed on narrow positivistic premises; the "science" of linguistics, while not of course irrelevant, does not provide a standard or a necessary perspective. A *liminalist* perspective, as we think of it, issues first from the domain in which the appearance originates: art. That is, art itself, not critical theory or art history. Accordingly, the second point, which is prior to the first, is the fact that *language*—indeed *electronic linguistic(s)*—emerged as a dynamic within a specific modality of electronic art and its inherent cybernetic features. Such an "inside" term must have a very different status from one invented on the "outside," for example, a term with a clear consensus. The term is therefore liminal to the very discourse that presents it *outside art process*—and that means here! In a sense, the term is an instance, at another level, of its own principle as declarative act: it is a limen (not a line and not a point) at which a critical phenomenon, key to the work of a certain artist, or arguably a species of art, comes into appearance. Language in this sense arises in a state of *between*.

Speaking here, therefore, without allegiance to a system or consensus (academic, artistic, or otherwise) is for us an essential part of the inquiry into the possible meaning of our thematic matrix: language—understood through the terminological lens *electronic linguistics*—and its partner in discovering its further nature, liminality. Our approach, which is hardly methodological, is to see by way of the works themselves how the distinction *language* helps us understand an actual practice of (often nonverbal) art.

To put this in a larger context, Gary Hill, who primarily works with video and media installation, is sometimes considered also as an artist of language.[1] This has meant for the most part that he uses written and spoken text in video, but, as important as that can be, it is not what is meant here; rather, I am saying that, irrespective of whether a particular piece uses text, in particular instances his work inquires into the nature of language as intrinsic to electronic/digital technology.

Hill began making metal sculpture, and eventually, due in part to the rich tonalities of sounds that happened to emerge from taut wire components, he gravitated toward electronic tools that allowed immediate playback and dialogue with the created sounds, as well as other electronic options that showed up in the (local Woodstock) circumstances—video and the phenomenon of feedback. Somewhere here begins the practice that he characterizes thus: "Remaining throughout my work has been the necessity to dialogue with the technology." (That was said nearly three decades ago and, while now there is considerably more conceptual underpinning, the desire basically hasn't changed.) Going to a root sense of his word *dialogue* as a "speaking between," we find the feedback/playback phenomenon giving rise to a sense of engagement of self and other, where the "other" may be a machine.

What follows is a partial journey through the works where the notion of language first showed up, so that we can track how it developed and consider the implications.

Electronic Linguistic

In retrospect *Electronic Linguistic*, a 1977 single-channel work of under four minutes[2] was a turning point in Gary Hill's orientation toward language, although that fact would hardly have been obvious even to a viewer familiar with his work. Despite the title, there is no apparent sense of language in the work. What one finds is something that might be more readily associated

FIGURE 25. Stills from Gary Hill, *Electronic Linguistic* (1977).

with music, especially electronic music; indeed, abstract (nonfigurative) visual *events*—alternatively, *image matter*—appear as manifestations of electronically generated sounds. The basic visual occurrence could be described in this way: small pulsating pixel structures grow into ever more intense full-screen monadic pulsations. The accompanying high-frequency sounds descend in tone when a bright still image fills the screen, only to return to the high tones heard at the onset once the small pixel structures become semicircular. Such a particular performative event bears the quality of a specific instrumentation, much as a given musical performance is married to a certain instrument, even a very specific instrument played by one individual at a given time and place.

The special tools in the case of *Electronic Linguistic* were some Dave Jones prototype modules combined with Serge audio modules.[3] This array of digital/analog hybrid instruments produces a very particular visual and auditory vocabulary, reflected in the final piece and its image-sound events. These events have a certain "between the cracks" feel as opposed to a "visual music," or perhaps each use has an idiolect with its own accent. An artist working in this electronic milieu over time becomes sensitive to subtle variations in these abstract yet highly configurative events.

A difficulty here is that unless one has experience with a specific electronic instrument, it can be hard to imagine the exact terms of generating art events, especially those we are thinking of as language. It may be rather tricky getting a real sense of the *linguistic* pressure, somewhat as if one hears certain vocal events in an unfamiliar (say, a tribal) context and cannot be sure whether one is hearing "language" or "music."[4] The practitioner of the art becomes an initiate into specific technological "mysteries," which is to say, one feels the frictive engagement thresholds between meaningful and not.

There are a number of sound/image events—audio frequencies corresponding to electronically generated images—that suggested to Hill a kind

GEORGE QUASHA IN DIALOGUE WITH GARY HILL

of language, yet in *Electronic Linguistic* they do not reach beyond a preverbal level. The fact that to him they came across as language indirectly opens the possibility of a full verbal realization of some kind, but it's not clear to what extent this notion entered his mind at the time. In retrospect he speaks of it as

> an impulse situation (I probably made it in a day) arising out of the sense that the material I was working with—hybrid digital/analog signals in a feedback environment—was throwing back to me something very primal, almost ritualistic. The same control voltages that I used to manipulate the video were being used to control simultaneously generated electronic sound. However, I wasn't really interested in a sound/image object. The attraction was rather the sudden emergence of other sounds that seemed close to human voices, crowds of people, screams, perhaps even unidentified animals. It was as though entities of some kind were harnessing an unexplored aspect of this electronic signal, and I was tuning in. There seemed to be a curious connection between these "voices" and something *behind* the image.[5]

The piece is an on-screen performance that seems to speak and manifest an immediate presence of active mind—yet not so much an *authorial* mind as a willing *participant* mind. It feels alive in its own right. It seems to be something like a self-(re)generating mindscape arising within electronic timespace.[6]

Certain sounds "seemed close to human voices," although most of the soundscape did not, and in fact, listening now, the artist doesn't much care for the sounds that seem too close to the vocabulary of electronic music. It's the atypical, suddenly emerging sounds that seemed to cry out from behind the work that cut through to his sense of a previously unheard language and took him across a line to the distinction *linguistic*. It charged the territory as a site of speaking, and years later this would continue to resonate in titles like *Site Recite (a prologue)* (1989) and *Site Cite* (1993). It was the sound that reframed the image matter, and the spontaneous conception of language that reframed both.

Why language? Abstractions generated through synthesized video and audio, of which there are potentially an infinite number, take on a self-limiting and self-organizing quality of "identity" manifestation; that is, they come to seem somehow entitative, even though the boundaries of a given emergent entity are relatively fluid. There comes a point where the emergent entity assumes a sort of *responsive intelligence* with which one feels oneself in dialogue,

even to the degree that it appears to embody a condition of request, as if it wants to be a certain way. It is at this point that one feels oneself to be in a state of language.

In the works that followed the "nonverbal" *Electronic Linguistic*, such as *Processual Video* (1980), *Videograms* (1980–1981), and *Happenstance (part one of many parts)* (1982–1983), there comes another stage of realizing the dialogue with technology as a language site where machines talk back—call it the unanticipated lingo of spontaneous electronica. Now the relationship of verbal language/spoken text to electronic visual events becomes richer and more complex.

Processual Video

Image matter worked from special tools can have extraordinary visual power, but just as Hill noted in the case of *Electronic Linguistic* that he "wasn't really interested in a sound/image object," his focus was not on image power as such. (And this despite the fact that his early work in video synthesis, like his camera work, shows a clear gift for imagist composition.) The image as core focus in art is seductive, and for Hill the incursion of language opens a path of conscious process. Some of the most powerful image-making instruments in electronic art turn out to open *internally* to that incursion, which paradoxically shows a way out of the primacy of image, often thought to be central to digital culture. For Gary Hill, certainly, undercutting the cultural dominance of the image as a species of cognitive passivity has been of foundational importance.

Processual Video, a single-channel work of under twelve minutes,[7] is hardly an image-centered work; rather, it strikes one as conceptual, even minimalist. A solitary, screen-width white line revolves clockwise around an invisible axis in the center of the monitor, its movement synchronized to a text read by the artist in a slow, rather stylized monotone voice. The visual field and the emerging text seem at once independent of each other and related only obliquely. One can't be sure if the visual field is reflecting the text or somehow re-creating it; or perhaps the visual event is an effort to align with a text that increasingly gets carried away. Figuration and abstraction seem two sides of the same configurative event.[8]

The mechanically rotating line is, nevertheless, a pure geometric abstraction, which could be *framed* by any number of implicit or explicit narratives: for example, it's a clock or some other spatializing time marker. The spoken

FIGURE 26. Stills from Gary Hill, *Processual Video* (1980).

text pulls the visual experience toward connection with story elements that come up moment by moment. This has the effect of *nearly* narrativizing any given instant of the rotating line's position—but not quite. This liminal state of connection causes a liminalizing feedback onto any given moment of language, further ambiguating it by appearing to literalize figures of speech as if they referred to movements of a geometric line. This reflexive axiality—a referential freewheeling between visual and verbal figures—seems to physicalize both.[9] It does this by foregrounding the *material* aspect of the visual field—an object created by patterning light—as well as the verbal entry into that field—words of indefinite reference suddenly appearing to relate immediately and physically to geometric shape. Then the connection evaporates as quickly as it appeared—also in a rather physical way, like receding waves—or seems perhaps prestidigitated—now you see it, now you don't. Sudden visionary emergents quite *invisibly* reside in the material electronic field/screen.

The "insubstantial" text turns the event as much as does the "physical" white line. It begins with what seems a normal description of a relation to place—personal history, landscape, habits:

> He knew the ocean well. He grew up there and observed the waves; the water always returning, informing the shoreline, feeding the waves back into themselves.

Pretty straightforward, but there is an immediate "perspective by incongruity" (to borrow Kenneth Burke's term) in the cold geometric appearance of the rotating white line against the black background. This narrative incongruity is steadily enhanced by the extreme regularity of the electronic event, especially as the narrativity is further axialized by the layering of incongruous meanings and referential splintering in the text. Indirectly the words seem almost to be tracked by the thickening and thinning line as it turns clockwise on its axis;

the line, like the water, is "always returning," defining the screen much as the waves return, "informing the shoreline." It's also the first indication that this is a reflexive site, "feeding the waves back into themselves," which is also one way of describing the way images are formed by feedback on the Rutt/Etra scan processor, discussed below.[10]

The continuing description of ordinary events (skiing, cold weather, the bright sun) migrates into double meanings that also point to the gradation of screen events:

> The outline separating the pristine blue sky and distant peaks never seemed to stabilize. His perception reflected what he conceptualized to be true, that there was really no line at all.

Here not only the language is axialized, but so is the status of the "line," the core visual idea; that is, the outline/horizon is not a line but a limen of the distinction sky/peaks. (Outline/horizon in landscape is a threshold of appearance itself.) So, the visible white line is a phenomenon of *light* thickening at the apogee and thinning and breaking up (the very threshold of disappearance) at the horizontal (horizon) position.

Appearance and disappearance, then, are not neatly binary, but axial—somehow interdependent, con-fusing, "consubstantial"—in the way that the (electronic) line comprises the light by which it appears and upon arriving at the horizon (of appearance) disappears. Perception is created (outlined, framed) by conception. And our perception of the appearance that embodies the conception is now itself *further created* by shifting perception, reframed here by the enhanced conception in the recited text. Frames of reference overlap. This is a self-axializing situation that conceptualizes all perception and perceptualizes all conception. Certainly it's based on "truth" phenomena of fundamental perceptions, such as the insubstantial horizon line that orients our daily life as if outline *existed*, but it's also a reality created by this specific electronic situation/event and the language we hear unfolding.

To backtrack a bit to the artist's mode of composing and conceptual frame of reference: Hill first created the rotating video "line" in an earlier minute-and-a-half silent piece called *Resolution* (1979).[11] Beginning with the line in vertical position (in contrast to the later horizontal beginning), it does a 180-degree rotation, thickening and thinning as we have described, and at its most horizontal begins to break up "between the (scan) lines" of the video signal. Hill recollects:

The idea was to focus on the moment that the line passed through the horizontal position—coming to and going from, literally, a space between the lines. Given that the video signal consists of 525 lines per frame, the line (white on black) passes through a kind of liminal moment in which it is "deciding" which line will be scanning it and thus ambivalently creates an intermittent line, a momentary unruly dotted line, as it passes through the horizontal position. This was telling me in some way that there was a kind of hidden space that might be an *ingress* for language. This was the opposite of what I might naturally think about an electronic signal and language. In other words, the electronic signal always seemed like a subparticle in relation to language, which by comparison is rather bulky and time-consuming to think, speak, receive, and comprehend. So the only way to get between the lines and deal with this liminality seemed to be some kind of textuality.

So the work, by seeming to scan (it roughly resembles the familiar radar scanner), is at one level *performing* the scanner, and the "line" is scanning itself as part of the processing. It is equilibrating in the middle. It axializes. This generates the idea of the *processual*, which, in the context of video, draws both on the technology and on the view of open process in composition.[12] And the conceptual focus—what constitutes the self-scanning event on the screen— quickly enters into a perspective by reflection, which then generates a self-aware poetics.

Thus, the next phase in this compositional frame is indicated by the artist's having given the "same" work a new name reflecting a further level of the language process: *Processual Video*. He now composed by "performing" the piece at the level of text-based language; that is, he made a text in *dialogue* with the rotating line, then later recited the text in sync with video, first as actual performance and then as single-channel video.[13] He recalls:

I "generated" a text reflecting nuances that the line itself was "generating" as it negotiated the limits of the architectonics of the signal generating it! (A line is not a line is not a line.) Immersed in the real time of being with the line and writing the lines, I found myself in the viewer's shoes as well. To reflect this I embedded repeating phased phrases, slightly reconfigured with each cycle, concerning the viewer's position, the line's position, and time's position in the event, an event that had

the quality of enfolding my language into the line. (The approach to embedding was probably influenced by the phase music of Terry Riley, which I listened to a lot.)

"Line" is now a site of many turning meanings that reflect in, on, and from the unfolding/enfolding text and radiate through the whole text, axializing not just the notion of line but practically anything that is said—and this is *processual text with its electronic linguistic.*

The recited text continues:

> The forecast was the same for time to come. He thought to himself and not for a moment too long. He imagined he was there observing distance; the space always returning, informing time, feeding memory back into itself. He stood in the sediment of the text banking on and off its reverberances, sentencing himself to a temporal disparity.

"Sentencing himself"—syntacticizing self-reflection in the electronic incongruities of the emerging linguistic—he is experiencing his reality as a radical surrender to this *created time* (his "sentence" that captures, defines, contains), "informing time" by way of a feedback process that is both the electronic event itself and either a reflection of neurological process or a generative incursion into that process—or both! One implication is that the discovery of an electronic linguistic is a singular event of reflexive speaking that marries mind and machine beyond any notion of reference as such. There is no stable signifier or signified. There is an unexplained asymmetrical mirroring that, as it were, moves syntax into the zone of synapse. There is a further sense that neither mind nor machine will ever be the same, at least for the artist, whatever "same" would be in a world of time-based singularities.

When we enter the language event in this and subsequent work by this artist we realize that we are in the world of poetics, and the openness, complexity, and subtlety of his language puts him in a category of his own. His connection with the work of poets during the period of this work has been often noted, and his language ontology—to use the concept that awkwardly straddles information technology and ontological philosophy—is rooted in poetics, accommodating what the poet Robert Duncan called an "open universe." It's this path of sensitivity to language that serves the transition from the preverbal experience of language in *Electronic Linguistic* to the branching levels of intricate reference, meaning, and syntax in the subsequent pieces. *Processual Video* continues its curious narrative:

GEORGE QUASHA IN DIALOGUE WITH GARY HILL

The voice of presentation was awkward for him, as were slide rules and what they represented to equilibrium and certain geometric art, respectively ascending their horizontal and vertical cultures. From here he could survey the slopes, the graph and the patterns of a predictable randomness. He was at or nearing the apex of deliverance. Answering was acutely secondary, nevertheless close to begging the question. The discourse was what to expect by the time he got there. The outline separating the blue chroma and white data never seemed to stabilize. His conception reflected what he perceived to be true, that the line was an iconic abrasion enabling him to follow the negative going edge of the clock. He lost track of where he was; a dancer forgetting to throw his head ahead of himself before pirouetting. He recovered his concentration from a panoramic smear drawing a slightly different perspective: A passenger in a chair, suspended, waiting at a constant rate, moving the platform towards the landing, in all probability to loop again. . . . He suggested the last horizons would lead to states of blanking increasing with time.

The forward-moving narrative increasingly crosscuts to a three-dimensional plane, "moving the platform towards the landing," where words become liminal to "geometric art": "slide rules," for example, awkwardly connect to the "voice of presentation" narrating visual objects as words and words as material objects. The slide rule tool glosses the angle of the white line. It also shows us that, in the poetics of electronic emergence, rules slide with "predictable randomness." Syntax becomes a journey over a trans-bounding Klein bottle–like surface: "The discourse was what to expect by the time he got there." The fourth dimension is always bending nearby; word-objects reappear ("outline," "horizons") in newly phased incarnations: "the line was an iconic abrasion." While *he* "lost track of where he was," *we*—viewer, audience, reader—are kept tracking "a slightly different perspective" (phasing as rephrasing): "A passenger in a chair, suspended, waiting at a constant rate . . . in all probability to loop again . . ." That's us, and our "states of blanking"—or what might be called *spacing in* to this particular electronic linguistic.

This ontology of open discourse speaks poetics, as it were, in that its main work is to track itself through what it finds itself saying.[14] Instead of flowing from a concept, the event of language itself generates a conceptual flow. It's an adventure in reflection as self-discovery in an asymmetrical mirror, the me I've always never seen by the time I get there.

So what is it that *happens* in the experience of engaging language at the level of electronic space? One thing is clear: language follows an unknown path and does things unlikely to happen elsewhere. Yet exactly the same may be said about the apparent self-generation of image matter in electronic composition. With the advent of video synthesis and a vast array of electronic image-making devices, both hardware and software, a core problematic of art in some sense reverses. Where the artist traditionally has sought ways, often laboriously, to achieve new effects in support of a vision, now a digitally engaged artist may be more concerned to *limit* image proliferation, which is technically infinite—and fast!

How to get traction on shifting ground, be grounded at high velocity, get in meaningful sync with the developing image as it moves through undreamt-of formations at electronic speed? The body is for many artists a perhaps unconscious but powerful factor in how art achieves a state of meaningful formation. The physical act of inscription or actual movement of vocal cords in the poet's vocalizing during composition can mediate body and language *meaningfully*. The mind tunes in, gets toned. And so it seems that the intervention of language into the experience of electronic media has a special function: to ride the vehicle *at human speed*. By physicalizing the word in its attention to image matter in formation, the wild serpentine power of image-flow in its torsional emergence falls under the attraction of vocalizing text. Reflexive attraction in the intensifying dialogue causes image and language matter to share each other's nature in co-traction.

The artist's engagement with technology can bring forward a magnified instance of the raw configurative force of language, called out by sheer unlimited formativity; yet it retains its nature as language, however that may be further characterized, with its seemingly unknowable intuitive resources. The text, as in the case of *Processual Video*, can become quite wild in its own right, yet (perhaps due here to the tamed force of the minimalist image matter) retain a certain precarious balance with the flow of the whole.[15] ("His processual continuum with the object forced this to the true state. . . . His mind rested within a suspension system of equal probable beauty.")

In *Videograms* and *Happenstance (part one of many parts)* the dynamic between image matter and text is somewhat reversed. This may or may not have to do with the primary instrument used for their creation: the Rutt/Etra scan processor.[16] Their image world is quite different from that in Hill's previous work, the product now of a unique instrument, which, like the Dave Jones prototype mentioned above, is associated in broad historical terms with video

synthesis. This tool from the 1970s is essentially an analog computer for video raster manipulation (that is, it controls the deviation signal that generates the scanning of the raster in a cathode ray tube). The special quality of the generated images and the way they could be *modulated on-screen in real time* (then videotaped by pointing the camera at the monitor) opened exciting compositional possibilities, and the works Hill produced—especially *Videograms* and *Happenstance (part one of many parts)*—are often listed, along with works by Steina and Woody Vasulka, as the preeminent creations on the Rutt/Etra scan processor. They showed an impressive range of possibilities for this kind of processual imaging, and beyond that they opened a quite new path for art itself.

Videograms

Digital technology has seemed to take one deeply into mental space that leaves the body behind, which may be a factor behind the dearth of resistance to jargonlike terminologies and one-to-one referentiality dominating the language of technology. Artistic engagement with the same technology paradoxically can function quite differently, perhaps due to the effect of feedback on neurological and transneurological (field) processing. (Certainly this possibility was a motivating view of early experimental video, which Gary Hill shared.) A rather surferlike entry into electronic space triggers awareness of the *energetics* of languaging, grasping the connection between electronic wave phenomena and physical waves—in the ocean as in the body as in the mind—linking the process-thinking/languaging of electronics and the body-mind.[17]

The nineteen short, vignettelike texts of *Videograms* (1980–1981) unfold slowly and deliberately during some twelve and a half minutes of total time.[18] Each videogram embodies the physical force of an often strangely beautiful black-and-white image configuration, even as it seems to be converting itself into words, as if neither image nor text were prior to the other. Clearly they're related, even interdependent, rather like beings in parallel dimensions, a subliminal dialogue through overhearing each other. As prose poems they obliquely narrate their own genesis by standing at the threshold of virtual incarnation:

83
Thought travels at one speed. Like oxygen released underwater, surfacing to mingle with its kind. Any change in this universal velocity is

FIGURE 27. Stills from Gary Hill, *Videograms 83* (1980–1981).

noticed and without delay seized. It no longer fades, merges or continues as it has. Mouth. Leg. Stomach. Hand. Testicle. Something will dispose of it producing physicality. Physicality.

It appears that each named thing nearly sees or images its other half-self or half-realizes its centaurlike nature—strange and alluring fruit of sheer possibility—"surfacing to mingle with its kind," *like* attracting almost unrecognizable *like*. Intimations of a further nature. And a stream of keys to its electronic linguistic, the primal urge of a singularity to *say itself*, which, being heard for what it is, shows intrinsic completeness, sudden flare/vanishing figuration. Spoken as it goes:

50

The conversationalist pressed for the facts. Catastrophe was inevitable. A primal sound hermetically sealed in its skull was masked by choreographies at play between brain and tongue. The linguist experienced a separation of present tense and lost all motor skills, lapsing

FIGURE 28. Stills from Gary Hill, *Videograms 50* (1980–1981).

into nonsense. The sound rushing from its mouth duplicated that of a stream nearing a large body of water.

It's all about an unexampled speaking at the limen between the human and the techno-energetic, which for perhaps unknowable reasons brings the artist near to a primal truth that he senses he shares. Here Hill recollects how it was:

> With *Videograms* I had consciously decided to work with narrative, or at least prose, and abstract electronic video signals: to get inside the time of these transmogrifying signals and generate stories, syntax, verbiage, things, objecthood via the control, manipulation, and sequencing of events using the blank raster and the supporting signals of a scan processor (Rutt/Etra). For the most part I wrote the language events first, yet, almost without exception, I shifted them around to reflect where I was with the image, which was considerably more difficult to control than the syntax of a phrase or sentence. The scan processor is very controllable, but at the same time it produces an enormous amount of variation on the expected output. There is, too, a lot of play whereby one releases control and receives "moments" from the machine due to confluences of simultaneous signals in just such and such a way. What is that way? Who knows. Sometimes you just take what comes because it works right then and there, and if you pause too long you find yourself out of the loop. How can the image and

language at times seem/feel as if they could not have been generated separately, and in another instance one thinks they are in a quagmire of nonsensical relationships? I don't know that either.

Happenstance (part one of many parts)

> Vanishing points. Things. Things are going to happen. Happenstance. . . . The words are coming, listen to them. Nothing surrounds them. They are open, they speak of nothing but themselves with perfect reason. I am talking, I am talking them out into the open. They sit like deer in a field, if I approach them too quickly they fade into the quick of things. Silence is always there—there is silence when I stop to take a breath, when I see breathtaking things.
> *Happenstance (part one of many parts)*, spoken text

Not knowing as a value?—how curious, nothing in mind? Electronic space is a *zero point* compositional opening, and just as in the case of what is now called "zero point physics," the vacuum—contrary to physics since Newton—is theorized to be a source of infinite energy. Likewise the great paradox of electronic compositional space is that its essential emptiness—the "states of blanking increasing with time" (*Processual Video*), the "blank raster" of the Rutt/Etra—is non-separate from infinite emergence, appearance, variability—unlimited configuration. The work *Happenstance (part one of many parts)* is something like a nonnarrative drama of *unfolding configuration, narrating* its own event as it goes.[19] In what could almost be a genre unto itself within art that works midway between figurative and abstract—let's call it *configurative art*—*Happenstance* is, in one sense, the culmination in 1982–1983 of a process beginning in 1977 with *Electronic Linguistic* and, in a quite different sense, the beginning of a new possibility in art conception; that is, it's "part one of many parts" whether or not the stated series actually continued or might yet resume. As an event in liminalist poetics, it straddles figuration and abstraction as well as image materialization and textual objectification. And, in

FIGURE 29. Stills from Gary Hill, *Happenstance (part one of many parts)* (1982–1983).

FIGURE 30. Stills from Gary Hill, *Happenstance (part one of many parts)* (1982–1983).

a kind of *metapoetics*, it theorizes itself inside the compositional process as it manifests its own constitutive principle.

Carrying forward *Videograms'* brief abstract *image events*—little happenings rather than things—*Happenstance* also extends their quality of poetic integrity. This has to do with the way that discrete image events seem to speak for themselves without ever fully settling into representation or illustrative connection with the texts. Processual glyphs rather than emblems or sym-

bols, they hold back from ordinary signification, yet cut through to language in unexampled ways. I see them as unfolding *hyperglyphs,* pointing to multiple locations of meaning both all at once and developmentally, yet without exclusive attachment to any particular site of reference. If we consider the image event itself as embodying a unique syntax, we could say, with some neologistic help, that the grammatical mood is the *performative indicative*—a mood of *responsive indication of an object that is only virtually there,* or there in the sense that its performance (as it were, its saying) is under way in a real-time now.[20] And to see "it" at all is to engage co-performatively what is *changing within the viewing itself.* This sort of seeing involves a spontaneous emergence affecting the very meaning of *object.* And it equally affects our sense of *language* that is co-performative with these "liminal objects."[21]

In Hill's accounts, cited all along here, of his discovery and compositional practice of electronic linguistics, he is sympathetically reentering a state of attention operative three decades earlier, yet his excitement about the question of the nature of this special sense of language persists. I think this is due to its being incomplete in the sense of remaining an open possibility still active in his work. His descriptions are precise yet inconclusive; not knowing *how* it actually manifested extends a creative unknowing intrinsic to the process. And as he responds further, at my request, to account for at least the first generative gestures of *Happenstance* (certainly his most highly realized work in this modality, and one that seems to call him back to a certain *projected* unfinished business expressed in "part one of many parts"), his very description takes on properties of the "original" language process itself, its singular thinking as if *still inside* the *initiating* creative process:[22]

Following *Processual Video, Black/White/Text,* and *Videograms,* I was getting to the point of wanting to break this "intermedia" (electronic linguistic) down further and further, which I ended up complicating further by throwing sound (other than my voice) into the equation. Quite literally I began at square one and proceeded. It was difficult to get started, to begin with something (anything) that could immediately establish a particular, thus setting a direction (and eliminating all the other possibilities). So "square one" was an electronically generated square, and I called it "this" (as "voice over"). . . . And if the first is a square and a "this," then "that" shall be a circle, and so I proceeded like "this" and like "that"—and then what's next?—and 1 + 1 is three(-) sided anyway—a triangle; and so if a square is "this" and a circle "that,"

well then, a triangle had to be some other thing, and so: "the other thing." And so the logos goes. . . . There I was with "this," "that," and "the other thing," entangled in a scribble of connecting wires.

"*Things.*" Things were beginning "*to happen.*" The three elemental forms of geometry delineated by proximity and difference called for *sound*—I wanted to *sound out* the forms. If the square was first, the beginning, the cornerstone, so to speak—the box that I'm either thinking in or out of—then what is its *sound* (the *voice of the thing* itself)? It's gotta be the gut, some deep thud, the base—the bass, subsonic and unmovable. And if I go with that, then the circle as "that" over there—over there being at a distance from my base, my belly point; something that I have a distance from and can point to as symbol of symbol, in fact the quintessential generic symbol par excellence like the sun, then might it be a *cymbal*—a crashing cymbal of sorts? I mean I suppose it could be a glockenspiel—one strike upon the "play of bells," and at some point it could be *any singular sound,* so I go with the play of words—the *cymbolic.* And then there is this "other thing," a *triangle,* and what its sound could be in relation to the base/bass thud and symbol/cymbal, and so maybe to play with the somewhat onomatopoeic word itself, "*thhiiinnnggggg,*" sounding like an electric string, a twang, an *otherworldly* kind of sound when following the others. The linkages become stretched like the reverberating string itself, bearing something akin to linguistic transducers.

We leave him here—"in the middle of the journey of"—thinking back as if it's all still beginning—at the origin. And, so to speak, it is. The artist returning to the state of electronic linguistics is facing forward into a work of which it can be said: the original is yet to come.

The Principle of Electronic Linguistics in Principle Art

> "Processual" might be considered a space between the perceptual and conceptual. The processual space serves neither as a composite nor as a balancing of these two modes; it relies on the continual transition or synapse between them.
> Gary Hill (1980)

Gary Hill's conceptualist stance, or the part of his stance that seems conceptual, notably in the period of the works discussed here, is quite strong, yet its conceptualism emerges primarily in terms of what he has called "the necessity to dialogue with the technology." Here the concept itself is an artifact of a technology/situation–specific inquiry within the space of work: that is, a concept of the work emerges in terms of the operative technological principle—what makes the thing tick, so to speak, and how can I get it to show me *the other thing?*—the yet-to-be-known event-thing just now emerging in the process of the work. This sense of *principle*[23] as something like the *law of its occasion* is prior to concept and preempts any kind of authority in a self-governing work. I think of this as *principle art,* distinct from conceptual (or concept) art (or for that matter minimalist art).[24] This is art where, in its process, concept and method surrender to, or derive from, an operative principle, because *the work is performative of its principle.* Accordingly the process is continuously emergent, open, and everywhere tending to return to its own zero point.[25] Electronic linguistics is a particular instance of this species of art and in any given case bears the marks of its specific technology and whatever comprises its situation. Just as the original is always still to come, its reality is coemergent with its discovery. Gary Hill is the discoverer and his work is the discovery site of a principle that in principle has no owner.

It would be an unnecessary limitation of view to expect other instances (past or present) not to show up.[26] Are there consistent features that would aid in locating other instances of electronic linguistics in the sense used here? In an effort to vividly call attention to an elusive dynamic we have focused on certain factors:

- the sheer speed of configuration within image matter emerging in electronic free space;
- the free flow of self-generating/self-limiting languaging that conceptualizes its own emergence without referential fixation;
- the oscillation between contraries at specific thresholds—the limen or "space between the perceptual and conceptual" where work "relies on the continual transition or synapse between them";
- body/physicality/materiality as *grounding* factors in the reflexive modulation of electronic imaging and languaging;
- the released energetics of image-language configuration;
- the surrender to axial ordering where the work has no fixed center but

only an instantly apparent present grip within a continuously moving/evolving center.

And yet the most important factor always remains unsaid: how it is that what emerges in electronic space takes on life and speaks for itself.

That speaking is radically other to languaging by convention and the pressures of consensus. The trend of language use in information technology toward narrowing reference is at the furthest pole from the implicit view in electronic linguistics as conceived here. Language itself, in this view, aspires to be the threshold where the tension of opposition is *retained*. Language in this register does not expend energy so much as attract it and carry it toward a further, indeed singular, expression. This view suggests that the art/excitatory aim of language is not so much communication as it is *communion*—a meeting place of energies. And that "place" is hyperlocal, subject to spontaneous emergence and nonlinear/radial dynamics. Electronic linguistics may be said to track life-emergence in Klein bottle space, where boundaries/limits/horizons are perspectival events. Its ally is a certain Hermes factor, named after the trickster daemon: the unpredictable contrary force that feeds back from "language reality" to disrupt artificial or narrowly constructed language (as opposed to "natural language") whenever it is "applied" to actual life situations. It stands as a placeholder for the unaccountable appearance that language is alive and has a mind of its own, or that there is a chaotic factor in language behavior that could as well be called the "trickster function." Its work is to preserve singularity. In simple terms, it can't stand being pinned down.

Notes

1. Charles Stein and I, in active dialogue with Gary Hill, have for years written about his work from a perspective of poetics in pieces now collected with new essays in *An Art of Limina: Gary Hill* (Hill, Quasha, and Stein 2008).

2. *Electronic Linguistic*, 3:45 minutes, single-channel video, black and white, sound. All single-channel video works discussed here may be viewed online in links provided at http://www.garyhill.com.

3. In the 1970s Hill worked with various image-manipulating devices generally referred to as "video synthesizers." A brief history and technical description of the video synthesizer can be found in Wikipedia, which begins with: "A video synthesizer is able to generate a variety of visual material without camera input through the use of internal video pattern generators. . . . The synthesizer creates a wide range of imagery through purely electronic manipulations. This imagery is visible within the output video signal when this signal is displayed." For more on Dave Jones and his influential creations,

see http://www.djdesign.com/history.html. Jones's technical collaboration with Hill over several decades is of great importance in the latter's work. Specifically, the tools referred to here are a Dave Jones prototype real-time analog to digital to analog converter, generic 64 × 64 frame buffer, digital matrix bit switcher, and audio synthesizer modules designed by Serge Tcherepnin.

4. An issue in ethnopoetics has been the early anthropological tendency, countered in more recent studies, to view untranslatable verbal units as nonsense syllables rather than as richly meaningful in context (Rothenberg 1968; Quasha and Rothenberg 1973). A similar problem arises in the interpretation of the cries and songs of animals, particularly whales and dolphins but also birds, where increasingly scientists are willing to understand specific sounds in context as having (sometimes complex) linguistic functions (Narby 2005).

5. Unless otherwise attributed, all statements of Gary Hill's views are from recent written or oral comments in our dialogue for this piece.

6. Fascination with the idea of *self-generating life* connected to creative process reaches for biological, neurological, and systems metaphor, probably because the idea carries a charge rather like art itself. Some biological scientists concerned with intelligence in nature now consider the almost canonical scientific avoidance of anthropomorphism to have been counterproductive, limiting the investigative frame and, especially, *motivation*. The art-sympathetic "like attracts like" principle, or the rather Goethean notion that *like perceives like*, may also drive the sense of language as self-generating system. Consider the attractive notion of autocatalysis, which biologist Stuart Kaufman theorizes as life-originating and which, along with self-organization and far-from-equilibrium dynamics, many now relate to other domains (cybernetics, cultural evolution, cognition, economics, business, systems analysis of the web, etc.). Perhaps the *nature* of such theory is that it embodies its principle and *generates itself*, implicitly asking to be followed according to a law of attraction! Gary Hill's interest in electronic linguistics vis-à-vis technology and the processual has a related focus. This interest can also be viewed variously in relation to traditions of mysterious or artificial life, from Pygmalion and Golem to Frankenstein, the "ghost in the machine," artificial intelligence, and synthetic life.

7. *Processual Video*, 11:30 min., single-channel video, black and white, sound.

8. A distant precedent for these works in diverging text/image might be Blake's illuminations to the "prophetic books," such as *Visions of the Daughters of Albion* (1793) or *Jerusalem: The Emanation of the Giant Albion* (1804), where even the visual figures that seem at first to "illustrate" the poem turn out to comprise a separate stream of transforming and self-interfering narrative, a sort of parallel life that reflects obliquely, often ironically, upon the apparent narrative. For Blake each moment, each page, each book is a singularity, obscured by repetition, illustration, and representation, which is why after *The Songs of Innocence & Experience* (1789–1794) he refused to allow his poems to be printed on a printing press; everything had to be done by hand, and each edition unique. Thus he broke with the tradition of illustration and the classical notion of image/text equivalence expressed in Horace's "authoritative" *ut pictura poesis*.

9. I use "axial," "axialize," and "axiality" to refer to a principle of variability due to some kind of free or open movement around a nonapparent center or axis, and applicable to many frames of distinction, including biological morphology, physical movement, language ambiguation, and artistic process. (See Hill, Quasha, and Stein 2008; Quasha 2006.)

10. This feedback image-process applies more to another quasi-geometrical single-

channel work of this period, *Black/White/Text* (1980; 7:00 min., black and white, stereo sound). There an approximate rectangle proliferates internally in precise rhythmic relation to an optimally equivalent language process (a chantlike embedding of longer phrases within the space of the sounded word), reaching an extreme state of vibrant, indeed psychedelic, transformation. Appearance itself is in question when a rectangular geometric form moves toward the condition of sound and, through sheer intensification according to its conceptual procedure, ceases to be identifiable as rectangle. The text of this piece was used again in the installation *Glass Onion* (1981), which involves a spatially and temporally complex electronic linguistic. For a further textual embodiment (or structural "equivalent") of *Glass Onion*, see Quasha (1980) and Hill, Quasha, and Stein (2008).

11. On technical matters, Hill recalls: "I used the same circuit to produce both *Resolution* and *Processual Video*. I drew a graphite line on a piece of paper and put it on a turntable that I could maneuver manually. I placed a camera directly overhead, and the signal from this camera was then passed through a comparator or outline/border generator, turning the image to a digital signal in black and white. Due to the peculiarities of the circuit, it produced additional attributes beyond generating borders, whereby the 'outline' would grow/expand as the line approached verticality. So, even though the concept began with a *line* and its approaching disappearance at the horizontal position, there now was a sort of subtext involving expansion at the vertical position and subsequent contraction. This added a whole other complexity to the text in *Processual Video*."

12. At the time Hill lived in Barrytown, New York, in the late 1970s and early 1980s, his early interest in "process" and the "processual" was influenced by a then-current usage in poetics, which stood antithetically to overvaluation of the "perfected" or "closed" art object or poetic form. This emphasis was strongest among poets (the present author included) who were aligned with various lineages of practice associated with Black Mountain College of the late 1940s and early 1950s, represented by, among others, poets Charles Olson, Robert Duncan, and Robert Creeley, composer/writer John Cage, artist Robert Rauschenberg, and architect/poet Buckminster Fuller. This sense of the word "processual" was itself introduced to us (including Charles Stein and Franz Kamin) by Robert Kelly (his usage traceable, apparently, to the 1960s) and characterized a realized poetic practice especially related to Charles Olson's "Projective Verse" (circa 1950) (see Olson 1997, 239).

13. In an early interview Hill speaks of the generation of *Processual Video* as a performance piece: "Actually, I did a performance out of *Processual Video* for the Video Viewpoints series at the Museum of Modern Art. In fact, the piece was written as my lecture for the series. . . . There was a large monitor facing the audience, and the text was scored on paper. I watched a small monitor so I knew approximately where the bar was in relation to what I was reading. In different readings, there would be slight variations, but it all remained pretty close to the score. In that tape, there are references to me, references to the audience sitting in chairs . . ." Lucinda Furlong, "A Manner of Speaking," in Morgan (2000, 195).

14. Among the poets Hill met in Barrytown was Robert Duncan, whose poetics emerged inside his work at every level and who wrote in a poem: "I ask the unyielding Sentence that shows Itself forth in language as I make it, / Speak! For I name myself your master, who come to serve. / Writing is first a search in obedience" (Duncan 1973, 12). Gary Hill has said: "My working methodology is not one of theorizing and then applying

that to making art. In each work I find myself committed to a process that of course may involve material where . . . philosophical issues may seem to be relevant. But I'm committed to the idea that the art event takes place within the process. One has to be open to that event and be able to kind of wander in it and feel it open up; to see it through until some kind of release feels inevitable."

15. The 1,183-word text perhaps carries out the implications of "Being a surfer . . .," invoked near the beginning of *Processual Video*, as a release into electronic space *surfs* the language waves: "The speaker threw his head ahead of himself before prewetting his tongue. The outline separating the mouth and words was prerecorded. He needed a signal to retrigger the trace. The control of immediacy was movement. His arms outstretched and dialed a space resetting the methodology. Direction was open-ended. Transmission lines could carry his message anywhere provided it began with the rise time of the form. His position was refractive. Scale was not a part of the trajectory. The pulse width of interim was widening and time was sinking through the window containing the vacuum. His distance was referenced by the frame. He was at arms length with it. The outline separating the left and/or right and right and/or left sides of the brain never seemed to stabilize. . . . He imagined measuring the abstract. His eye floated in a green illuminated substance between the lines (the pendulum always returning, performing entropy, feeding stasis back to the object revolving in his head). He wasn't accustomed to metrodemonic devices as they wrought a certain slant on linear statements such as: when binary operations and the art of origami are considered the two equal sides of an isosceles triangle with the third being a satellite of sorts, a contextual shift begins to cycle causing the polarization of all axes within a proximity determined by a violet code. He was one to one with himself. The space was wired with discrete tensions adding to the torque when nearing the perpendiculars. Old pilings once the support of a platform had been outmoded and replaced by a bridge. His mind rested within a suspension system of equal probable beauty. He watched the last length of cable trying to 'get' its tensile strength as the double line broke allowing him to pass. The rearview mirror was slightly ajar. He adjusted it. Within limits, he enjoyed long distance driving and traveling light." For the full text of this and other video works mentioned see Hill (2002).

16. This scan processor (often called, more broadly, a video synthesizer) was coinvented by Steve Rutt and Bill Etra (prototype, 1972). See http://www.audiovisualizers. com for examples of what this particular instrument can do. Note that since 1978 Hill had used the Rutt/Etra already in making three other pieces interesting in relation to the emergence of language: *Elements* (1978), the first piece in which he speaks and incorporates actual words; *Picture Story* (1979); and *Equal Time* (1979). For reasons of space they are not presented here, but see our full treatment of the latter in *An Art of Limina*, chapter 1, "*Equal Time* and the strangeness of sameness" (Hill, Quasha, and Stein 2008).

17. Hill's passion for surfing has shown up pervasively in his work, an instance of which is mentioned in the note above. The persistence of the metaphor "surfing the web" suggests nearly archetypal force to the root notion.

18. *Videograms*, 13:25 min., single-channel video, black and white, sound. The work consists of nineteen short vignettelike works combining image configurations with texts spoken by the artist (varying from eleven to a hundred words). The texts are concise, suggestive, quirky, and indeed singular in ways that give them the feel of unconventional prose poems. The series is numbered nonconsecutively between 0 and 99, with no apparent significant design in the order of succession (6, 27, 33, 83, 24, 41, 70, 39, 0, 7, 18, 82, 12, 99, 2, 9, 64, 50, 3). (See Hill, Quasha, and Stein 2008, chap. 1.)

19. *Happenstance (part one of many parts)*, 6:30 min., single-channel video, black and white, stereo sound. *Happenstance* (as we will call it) is a short and intense nonnarrative work, rich in image matter that takes place more or less simultaneously in multiple sensory and cognitive dimensions. These include geometric forms (square, circle, triangle, point, line), spoken and written text, configurative imaging, and rather abstract sounds (electronic sounds sometimes suggestive of musical instruments). As in *Videograms*, black-and-white electronic, intuitively generated, steadily changing configurations suggest mostly identifiable, yet quite ambiguous, forms. These are keyed to briskly spoken and written statements, running in counterpoint, often straining attention.

20. We note a connection with Maurice Blanchot, whose writing (published by Station Hill Press in Barrytown and Rhinebeck, New York, at the time Gary Hill lived and worked there) profoundly affected the artist, beginning around the time of the later works discussed here. Particularly relevant to electronic linguistics is the radical narrativity of Blanchot's distinction "*récit*" (tale, story, telling, recital), as against a "*roman* (novel)," in "The Song of the Sirens: Encountering the Imaginary": "If we regard the *récit* as the true telling of an exceptional event which has taken place and which someone is trying to report, then we have not even come close to sensing the true nature of the *récit*. The *récit* is not the narration of an event, but that event itself, the approach to that event, the place where that event is made to happen—an event which is yet to come and through whose power of attraction the tale can hope to come into being, too. . . . The secret law of the *récit* . . . is a movement toward a point, a point which is not only unknown, obscure, foreign, but such that apart from this movement it does not seem to have any real prior existence, and yet it is so imperious that the *récit* derives its power of attraction only from this point, so that it cannot 'begin' before reaching it—and yet only the *récit* and the unpredictable movement of the *récit* create the space where the point becomes real, powerful, and alluring" (1981, 109). Note that we have restored Blanchot's word *récit* for "tale" to emphasize its special usage.

21. This term originates with Gary Hill's later computer animation work, called *Liminal Objects*, beginning in 1995, which creates another level of electronic linguistics that is beyond our scope here. There the term also raises the question of "object" from two sides: (1) that the object as content—the thing/event unfolding on the video screen— is only liminally what it seems to be (e.g., hands moving together, yet passing through each other); and (2) that the art work itself is at the edge of the distinction "object," a limen or threshold-object-event with no intrinsic stability, but remains the site of continuous possible distinctions. What is interesting here is how the later approach to "object" fits these early works, *Videograms* and *Happenstance*. The term "liminal objects" was created by George Quasha and proposed as title in 1995 (see Hill et al 2008, Chapter Seven).

22. Since it's well beyond our scope to treat this rich, intricate, and quite magical work here, we can only recommend experiencing it in light of this discussion.

23. "Principle" is difficult to define but provisionally I say: the basic or essential element determining the *evident functioning* of particular natural phenomena, mechanical processes, or art emergence.

24. *Processual Video*, and especially its predecessor *Resolution*, is "perceptually" a minimalist work; however, the language is performative of a principle that liberates it from that conceptual orientation, as we have seen.

25. The zero point would be in principle the energetic source-point of the work, the point where, for one thing, it does nothing to interfere with the performance of

its principle. This "efficiency principle" is often part of conceptual art (no extras). But one difference is that a conceptual work is often the unique realization of the concept and therefore exhausts the concept. Unlike a concept, a principle is never defined by the work, of which there can be an unlimited number; there is no definitive instance. Thus any given electronic linguistic is in theory inexhaustible. For example, the video "line" in *Processual Video* is conceptually "complete," but the language has no principle of completion and in formal terms stops arbitrarily (or organically); therefore *Processual Video*'s principle involves an oscillation between concept and process. I discuss principle art (and the principle complex "axiality/liminality/configuration") at length in *Axial Stones* (Quasha 2006)

26. It is beyond both the scope and the mode of inquiry here to suggest instances of electronic linguistics (or principle art) outside of Hill's work. In "applying" this notion to an artist's work one should take care not to turn a principle into an art-historical concept, thus violating the principle of principle art. That said, we hope to inspire further inquiry as a way of discovering the rather mysterious workings of singular electronic linguistics in certain artists.

References

Blanchot, Maurice. 1981. *The gaze of Orpheus and other literary essays*. Trans. Lydia Davis. Barrytown, NY: Station Hill Press.

Duncan, Robert. 1973. *The opening of the field*. New York: New Directions.

Hill, Gary. 1980. Processual video. Program notes for a performance in the series Video Viewpoints, Museum of Modern Art, New York. February.

———. 2002. *Selected works and catalogue raisonné*. Köln: Dumont/Kunstmuseum Wolfsburg.

Hill, Gary, George Quasha, and Charles Stein. 2008. *An art of limina: Gary Hill*. Barcelona: Ediciones Poligrafa.

Morgan, Robert C., ed. 2000. *Gary Hill*. Baltimore: Johns Hopkins University Press.

Narby, Jeremy. 2005. *Intelligence in nature: An inquiry into knowledge*. New York: Jeremy P. Tarcher.

Olson, Charles. 1997. *Collected prose*. Berkeley: University of California Press.

Quasha, George. 1980. *Talking rectangles: Notes on the feedback horizon*. Barrytown, NY: Station Hill Press.

———. 2006. *Axial stones: An art of precarious balance*. Berkeley, CA: North Atlantic Books.

Quasha, George, and Jerome Rothenberg, eds. 1973. *America a prophecy: A new reading of American poetry from Pre-Columbian times to the present*. New York: Random House.

Rothenberg, Jerome, ed. 1968. *Technicians of the sacred: A range of poetries from Africa, America, Asia and Oceania*. Garden City, NY: Doubleday.

The Migration of the Aura, or How to Explore the Original through Its Facsimiles

**BRUNO LATOUR AND
ADAM LOWE**

To Pasquale Gagliardi

Something odd has happened to Holbein's *Ambassadors* at the National Gallery in London. The visitor does not immediately know how to describe her malaise. The painting is completely flat, its colors bright but somewhat garish; the shape of every object is still there but slightly exaggerated. She wonders what has happened to this favorite painting of hers. "That's it," she mutters. "The painting has lost its depth; the fluid dynamics of the paint has gone. It is just a surface now." But what does this surface look like? The visitor looks around, puzzled, and then the answer dawns on her: it resembles almost exactly the poster she bought several years ago at the gallery bookshop, the poster that still hangs in her study at home. Only the dimension differs.

Could it be true? She wonders. Could they have *replaced* the *Ambassadors* with a facsimile? Maybe it's on loan to some other museum, and so as to not disappoint the visitors, they put up this copy. Or maybe it is a projection. It's so flat and bright it could almost be a slide projected on a screen. . . .

Fortunately, she composes herself and does not ask the stern guard whether this most famous painting is the original or not. What a shock it would have been. Unfortunately, she knows enough about the strange customs of restorers and curators to bow to the fact that this is, indeed, the origi-

nal, although only in name, that the real original has been irreversibly lost, replaced by what most people like in a copy: bright colors, a shining surface, and above all a perfect *resemblance* to the slides sold at the bookshop, the slices shown in art classes all over the world by art teachers most often interested only in the shape and theme of a painting, not in any other marks registered in the thick surface of a work. She leaves the room suppressing a tear: the original has been turned into a *copy of itself that looks like a cheap copy*, and no one seems to complain, or even to notice, the substitution. They seem happy to have visited in London the original poster of Holbein's *Ambassadors*!

Something even stranger happens to her, some time later, in the Salle de la Joconde in the Louvre. To get to this cult icon of the Da Vinci code, hundreds of thousands of visitors enter through two doors that are separated by a huge framed painting, Veronese's *Nozze di Cana*, a dark giant of a piece that directly faces the tiny *Mona Lisa*, barely visible through her thick antifanatic glass. Now the visitor is really stunned. In the Hollywood machinery of the miraculous wedding, she no longer recognizes the *facsimile* that she had the good fortune of seeing at the end of 2007 when she was invited by the Fondazione Cini to the island of San Giorgio, in Venice. There it was, she remembers vividly, a painting on canvas, so thick and deep that you could still see the brush marks of Veronese and feel the cuts that Napoleon's orderlies had to make in order to tear the painting from the wall, strip by strip, before rolling it like a carpet and sending it as a war booty to Paris in 1797—a cultural rape very much in the mind of all Venetians, up to this day. But there, in Palladio's refectory, the painting (yes, it was a painting, albeit produced through the intermediary of digital techniques) had an altogether different meaning: it was mounted at a different height, one that makes sense in a dining room; it was delicately lit by the natural light of huge east and west windows so that at about 5 p.m. on a summer afternoon the light in the room exactly coincides with the light in the painting; it had, of course, no frame; and, more importantly, Palladio's architecture merged with admirable continuity within Veronese's painted architecture, giving this refectory of the Benedictine monks such a *trompe l'oeil* depth of vision that you could not stop yourself from walking slowly back and forth and up and down the room to enter deeper and deeper into the mystery of the miracle.

But here, in the *Mona Lisa* room, although every part of the painting looks just the same (as far as she can remember), the meaning of the painting seems entirely lost. Why does it have such a huge gilt frame? Why are there doors on both sides? Why is it hanging so low, making a mockery of the Venetian balcony on which the guests are crowded? The bride and groom, squashed into

the left-hand corner, seem peripheral here, while in Venice, they were of great importance, articulating a scene of sexual intrigue that felt like a still from a film. In Paris, the composition makes less sense. Why this ugly zenithal light? Why this air-conditioned room with its dung brown polished plaster walls? In Venice, there was no air conditioning; the painting was allowed to breathe as if Veronese had just left it to dry. Anyway, here she cannot move around the painting to ponder those questions without bumping into others momentarily glued to the *Joconde*, their backs turned to the Veronese.

A terrible cognitive dissonance. And yet there is no doubt that this one, in Paris, is the original; no substitution has occurred, no cheating of any sort—with all its restoration, Veronese would certainly be surprised to see the painting looking as it does, but that's different from cheating. The painting in San Giorgio, she remembers, was clearly labeled: "A facsimile." There was even a small exhibition that explained in some detail the complex digital processes that Factum Arte, a workshop in Madrid, had used to de- then re-materialize the gigantic Parisian painting: laser-scanning it, A4 by A4, photographing it in similarly sized sections, scanning it again with white light to record the relief surface, and then somehow stitching together the digital files before instructing a purpose-built printer to deposit pigments onto a canvas carefully coated with a gesso almost identical to that used by Veronese. (Adam Lowe describes the process in an appendix to this essay.) Is it possible that the Venice version, undeniably a facsimile, is actually *more original* than the Paris original, she wonders? She now remembers that on the phone with a French art historian friend, she had been castigated for spending so much time in San Giorgio with the copy of the *Nozze*: "Why waste your time with a fake Veronese, when there are so many true ones in Venice?!" her friend had said, to which she replied, without realizing what she was saying, "But come here and *see it for yourself*. No description can replace seeing this original . . . oops, I mean, is this not the very definition of 'aura'?" Without question, for her, the aura of the original had *migrated* from Paris to Venice: the best proof was that you had to come to the original and see it. What a dramatic contrast, she thought, between the San Giorgio Veronese and the London *Ambassadors*, which claims to be the original in order to hide the fact that it is now just an expensive copy of one of its cheap copies!

"But it's just a facsimile!" How often have we heard such a retort when confronted with an otherwise perfect reproduction of a painting? No question about it, the obsession of the age is with the original. Only the original possesses an aura, this mysterious and mystical quality that no secondhand version can hope to attain. And the obsession, paradoxically, only increases as more and bet-

ter copies become available and accessible. If so much energy is devoted to the search for the original—for archeological and marketing reasons—it is because the possibility of making copies has never been so open-ended. If no copies of the *Mona Lisa* existed, would we pursue it with such energy? Would we devise so many conspiracy theories concerned with whether or not the version held under glass and protected by sophisticated alarms is the actual surface painted by Leonardo's hand? The intensity of the search for the original, it would seem, depends on the amount of passion triggered by its copies. No copies, no original. To stamp a piece with the mark of originality requires the huge pressure that only a great number of reproductions can provide.

So, in spite of the knee-jerk reaction—"But this is just a facsimile"—we should refuse to decide too quickly the value of either the original or its reproduction. The real phenomenon to be accounted for is not the delineation of one version from all others but the whole assemblage of one—or several—original(s) *together with* its continually rewritten biography. Is it not because the Nile ends in such a huge delta that the century-long search for its sources was so thrilling? To pursue the metaphor, we want, in this essay, to attend to the whole hydrological complex of a river, not just its elusive origin. A given work of art should be compared not to any isolated spring but to a catchment area, a river along with its estuaries, its tributaries, its rapids, its meanders, and, of course, its hidden sources.

To give a name to this watershed, we will use the word *trajectory*. A work of art—no matter the material of which it is made—has a trajectory or, to use another expression popularized by anthropologists, a career (Appadurai 1986; Tamen 2001). What we will attempt to do in this essay is to specify the trajectory or career of a work of art and to move from one question that we find moot (Is it an original or merely a copy?) to another that we take to be decisive, especially in a time of digital reproduction: Is it *well* or *badly* reproduced? This second question is important because the quality, conservation, continuation, sustenance, and appropriation of the original depend entirely on the distinction between good and bad reproduction. A badly reproduced original, we will argue, risks disappearing, while a well-copied original may enhance its originality and continue to trigger new copies. Facsimiles, especially those relying on complex (digital) techniques, are thus the most fruitful way to explore the original and even to redefine what originality is.

To help shift the attention of the reader from the detection of the original to the quality of its reproduction, let us remember that the word "copy" need

not be derogatory; indeed, it comes from the same root as "copious," and thus designates a source of abundance. A copy, then, is simply a proof of fecundity. So much so that, to give a first shape to the abstract notion of the trajectory, we will call upon the antique emblem of the cornucopia, a twisted goat horn with a sharp end—the origin—and a wide mouth disgorging an endless flow of riches (all thanks to Zeus). This association should come as no surprise: to be original means necessarily to be the *origin* of a lineage. That which has no progeny, no heirs, is called, not original, but sterile, barren. Rather than ask, Is this isolated piece an original or a facsimile? we might, then, inquire, Is this segment in the trajectory of the work of art barren or fertile?

To say that a work of art grows in originality in proportion to the quality and abundance of its copies is nothing odd: this is true of the trajectory of any set of interpretations. If the songs of the *Iliad* had remained stuck in one little village of Asia Minor, Homer would not be considered a (collective) author of such great originality. It is *because*—and not in spite—of the thousands and thousands of repetitions and variations of the songs that, when considering any copy of the *Iliad*, we are moved so much by the *unlimited* fecundity of the original. We attribute to the author (although his very existence cannot be specified) the power of each of the successive reinterpretations by saying that "potentially" all of them "were already" there in the *Ur-text*—which we simultaneously know to be wrong (my reading could not possibly already have been there in ancient Greece) and perfectly right, since I willingly add my little extension to the "unlimited" fecundity of this collective phenomenon called "the" *Iliad*. If it is indeed unlimited, it is because I and others continue to push the limit. To penetrate the poem's "inherent" greatness, you need to bring with you all of the successive versions, adaptations, and accommodations. Nothing is more ordinary than this mechanism: Abraham is the father of a people "as numerous as the grains of sand" (and of three religions) only because he had a lineage. Before the birth of Isaac, he was a despised, barren old man. Such is the "awesome responsibility" of the reader, as Charles Péguy so eloquently said, because this process is entirely reversible: "If we stop interpreting, if we stop rehearsing, if we stop reproducing, the very existence of the original is at stake. It might stop having abundant copies and slowly disappear."[1]

We have no difficulty raising questions about the quality of the entire trajectory when dealing with dance, music, theater—the *performing* arts. Why is it so difficult when faced with the reproduction of a painting, a piece of furniture, a building, or a sculpture? This is the first question we want to clarify.

No one will complain on seeing a performance of *King Lear*, "But this is not the original!" The whole idea of "playing" *Lear* is to *replay* it. Everyone is ready to take into account the work's trajectory, from the first presentations through the latest "revival." There is nothing extraordinary in considering any given staging as a moment, a segment, in the career of the work of art called *King Lear*. No one has ever seen and no one can ever circumscribe the absolute Platonic ideal of the play. One will never see *the* original, as presented by Shakespeare himself, nor even *the* original text, but only several premieres and several dozen written versions with endless glosses and variations. As with a river, we seem perfectly happy with the anticlimactic discovery of the source of a major river in a humble spring, barely visible under the mossy grass. Even more important, spectators have no qualm whatsoever at judging a new production of the play, and the standard is clear: Is it well or badly (re) played? People may differ wildly in their opinions, some scandalized by novelties (Why does Lear disappear in a submarine?), some bored by clichéd repetition, but they have no difficulty in considering that this moment in the career of all the successive *King Lears*—plural—should be judged *on its merit* and not by its mimetic comparison with the first (now inaccessible) presentation. It is what we see now, with our own eyes, on stage that counts in making our judgment, and not its resemblance to some distant, hidden *Ur*-event (though what we take to be the "real" *King Lear* remains in the background of every one of our judgments). So clearly, in the case of the performing arts at least, every new version runs the risk of losing the original—or of regaining it.

So unconstrained are we by the notion of an original that it is perfectly acceptable to evaluate a performance by saying, "I would never have anticipated this. It is totally *different* from the way it has been played before, utterly *distinct* from the way Shakespeare played it, *and yet* I now understand better what the play has always been about!" Some revivals—the good ones—seem to extract from the original latent traits that can now (or again) be made vivid in the minds of the spectators. The genius of Shakespeare, his originality, is thus magnified by this *faithful* (but not mimetic) reproduction. The origin is there anew, even if vastly different from what it was. And the same phenomenon would occur for any piece of music or dance. The exclamation "It's so original," attributed to a new performance, does not describe one section of its trajectory (and especially not the first *Ur*-version) but the *degree of fecundity of the whole cornucopia*. In the performing arts, the aura keeps migrating and might very well come back suddenly—or disappear altogether. Too many bad repetitions may so decrease the fecundity of a work that the original itself will

be abandoned; there will be no further succession. Such a work of art dies out like a family line without offspring. Like a river deprived of its tributaries, one by one until it has shrunk to a tiny rivulet, the work is reduced to its "original" size, that is, to very little. It has then lost its aura for good.

Why is it so difficult to apply the same type of judgment to a painting or a sculpture or a building? Why not say, for instance, that Veronese's *Nozze di Cana* has been *revived* thanks to a new interpretation in Venice in 2007 by Factum Arte, much as Hector Berlioz's *Les Troyens* had been presented at last for the first time by Colin Davis in 1969 in Covent Garden in London (poor Berlioz had never had the money or the orchestra to play his original work in full). And yet, to claim that the *Nozze di Cana* has been "given again" in San Giorgio seems far-fetched. "That's *just* a facsimile," someone will immediately object. "The original is in Paris!" The intimation of fakery, counterfeiting, or betrayal would seem absurd for a piece of theater (though one might term a very bad production a sham or a travesty). Still, it seems almost impossible to say that the facsimile of Veronese's *Nozze di Cana* is not about falsification but instead a stage in the verification of Veronese's achievement, a part of the painting's ongoing biography.

One reason for this unequal treatment is what could be called the *differential of resistance* among the segments of the trajectory of a visual artwork. In his much too famous essay, amid a deep fog of art-historical mysticism, it is this differential that Walter Benjamin (1968) pointed out under the name "mechanical reproduction." In the case of the performing arts, each version is just as difficult to produce, and at least as costly, as the first. It is not because there have been zillions of presentations of *King Lear* that the one you are about to give will be easier to fund. The marginal cost will be exactly the same—except that the public already knows what "a *King Lear*" is and comes fully equipped with endless presuppositions and critical tests concerning how it should be played (a double-edged sword, as any director knows). This is why, in the performing arts, we don't distinguish between an original and a copy but rather between successive versions of the same play: version *n*, version *n* + 1, and so on. It is also why the "real" *King Lear* cannot be localized (not even at the very beginning); rather, the name is given to the whole cornucopia (though each spectator may cherish special moments in his or her personal history when, thanks to exceptionally good "revivals," the genius of *Lear* was "instantiated" more fully than at any time before or later). The trajectory of a performance, then, is composed of segments that are made, more or less, of the same stuff or require a similar mobilization of resources.

The situation appears to be entirely different when considering, for instance, a painting. Because it remains in the same frame, encoded in the same pigments, entrusted to the same institution, one cannot resist the impression that a reproduction is much *easier* to make and thus there can be no comparison, in terms of quality, between the various segments of its trajectory. The aura seems firmly attached to one version only: the autograph one. And certainly this is superficially true. No one in his right mind would deem your digital snapshot of the *Nozze di Cana*, palely rendered on the screen of a computer, commensurable with the sixty-seven square meters of canvas in the Louvre. If you claimed that your picture was "just as good as the original," people would shrug their shoulders in pity, and rightly so.

But it is not because of some inherent quality of painting that we tend to create such a yawning gap between originals and copies, nor because paintings are more "material" (an opera or a play is just as "material" as pigments on canvas). The distance between version n ("the original") and version n + 1 ("a mere copy") depends just as much on the differential of efforts, costs, and techniques as on any such substantial distinction. While in performance art, the resources required are grossly homogeneous (each replay relying on the same gamut of techniques), the career of a painting or a sculpture consists of segments that are vastly heterogeneous, varying greatly in the intensity of the efforts entailed. It is this asymmetry, we wish to argue, that precludes one from saying that the *Nozze di Cana* in Paris has been "reprinted" or "given again" in Venice. And it is certainly this presupposition that so angered the French art historian who castigated her friend for wasting her time in San Giorgio. Hidden behind the commonsense distinction between original and copy lies a totally different process that has to do with the technical equipment, the amount of care, and the intensity of the search for the originality that goes from one version to the next. Before it can defend the quality of its reenactment, a facsimile is already discredited because of a perceived gap associated with the techniques of reproduction, a gap based on a misunderstanding of photography as an index of reality.

The proof of this claim can be obtained by showing what happens to our search for originality when we *modify* this differential—something that becomes easier and easier in the new digital age. Consider, by way of comparison, the copying of manuscripts. Before printing, the marginal cost of producing one more copy was identical to that of producing the penultimate one (a situation to which we are actually returning now with digital copies). Inside the scriptorium of a monastery, all exemplars were facsimiles. No copy-

ist would have said, this is the original, that a mere copy; distinctions were instead based on quality. Here again, the aura was able to travel and might very well have migrated to the newest and latest copy, excellently done on the best of parchments and double-checked against the best earlier sources. Following the invention of the printing press, however, the marginal cost of one extra copy became negligible compared to the time and techniques necessary to write the manuscript. An enormous distance was introduced, and rightly so, between segments of the trajectory: the autograph manuscript became *the original*, while the print run, from that moment on, consisted of mere copies (until of course the great art of bibliophily revealed endless subtle differences among successive printings and forensic digital analysis allowed us to date and order those copies).

There is no better proof that the ability of the aura to be retrieved from the flow of copies (or to remain stuck in one segment of the trajectory) crucially depends on the heterogeneity of the techniques used in the successive segments, than to consider what happens to *the original* now that we are all inside that worldwide cut-and-paste scriptorium called the web. Because there is no longer any huge difference between the techniques used for each successive instantiation of some segment of a hypertext, we accept quite easily that no great distinction can be made between one version and those that follow. We happily label successive renderings of the "same" argument version 1, version 2, version *n*, while the notion of the author has become just as fuzzy as that of the aura—not to mention what happens to copyright royalties. Hence the popularity of collective scriptoria like Wikipedia. In effect, Benjamin confused the notion of "mechanical reproduction" with the inequality in the techniques employed along a trajectory. No matter how mechanical a reproduction is, once there is no huge gap in the process of production between version *n* and version *n* + 1, the clear-cut distinction between the original and its reproduction becomes less crucial—and the aura begins to hesitate and is uncertain where it should land.

All of that might be very well, but is it possible to imagine the migration of the aura in the reproduction or reinterpretation of, say, a painting? After all, it is the contrast between the *Nozze* and the *Ambassadors* that triggered our inquiry, which would have proceeded very differently had it been limited to the performing arts. One cannot help suspecting that there is in painting, in architecture, in sculpture, in objects in general, a sort of stubborn persistence that makes the association of a place, an original, and some aura impossible to shed.

Let us first notice, however, that the difference between performing arts and the others is not as radical as it seems: a painting *has always to be reproduced,* that is, it is always a re-production of itself, even when it appears to stay exactly the same in the same place. That is to say, no painting remains the same in the same place without some reproduction. For paintings, too, existence precedes essence. To have a continuing substance they need to be able to subsist. This requirement is well known by curators all over the world: a painting has to be reframed, dusted, relit, sometimes restored, and it has to be re-presented, in different rooms, with different accompanying pictures, on different walls, inserted in different narratives, with different catalogs, and with changes in its insurance value and price. Even a painting that is never loaned, that survives within the same institutional setting without undergoing any heavy restoration, has a career; to subsist and be visible again, it needs to be taken care of. If it is not cared for, it will soon be accumulating dust in a basement, be sold for nothing, or be cut into pieces and irremediably lost. Such is the justification for all restorations: if you don't do something, time will eat up that painting, as certainly as the building in which it is housed will decay and the institution charged with its care will decline. If you doubt this, imagine your precious works of art housed in the National Museum in Kabul. For a work of art to survive, it requires an ecology just as complex as that needed to maintain the natural character of a park (Western 1997).

If the necessity of reproduction is accepted, then we might be able to convince the reader that the interesting question is not so much how to differentiate the original from the facsimiles as how to tell the good reproductions from the bad. If the *Ambassadors* has been irreversibly erased, it is not out of negligence but, on the contrary, because of an excess of zeal in "reproducing" it. What the curators did was to confuse the obvious general feature of all works of art—to survive they have to be somehow reproduced—with the *narrow notion of reproduction provided by photographic posters* while ignoring many other ways for a painting to be reproduced. For instance, they could have had a perfect facsimile made, registering all the painting's surface effects in three dimensions, then restored the copy instead of the work itself. If they had done this, they could have invited several art historians with different views to suggest different ways of restoring the copy and produced an exhibition of the results. Their crime is not to have offered a reproduction of the Holbein *instead of* the Holbein itself to the visitors of the National Gallery—"the *Ambassadors*" remains behind all successive restorations much as "*King Lear*" does over each of its replays, granting or withdrawing its auratic dimension depending on the

merit of each instance—but to have so limited the range of reproduction techniques that they chose one of the most barren: the photograph—as if a painting were not a thick material but some ethereal design that could be lifted out of its materiality and downloaded into any reproduction without any loss of substance. In fact, a terribly revealing documentary shows the culprits restoring the Holbein, using as *their* model photographs, subjectively deciding what was original, what had decayed, what had been added, and imagining the painting as a series of discrete layers that could be added or removed at will—a process that resembles plastic surgery more than an open forensic investigation.

What is so extraordinary in comparing the fate of the *Ambassadors* with that of the *Nozze di Cana* is not that both rely on reproduction—this is a necessity of existence—but that the first relies on a notion of reproduction that makes the original disappear forever while the second *adds* originality *without* jeopardizing the earlier version—without ever even touching it, thanks to the delicate processes used to record it.

But, one might ask, how can originality be added? One obvious answer is: by bringing the new version back to the original location. The cognitive dissonance experienced by the visitor in the *Mona Lisa* room comes in part from the fact that in Palladio's refectory every detail of the *Nozze* has a meaning that is entirely lost and wasted in the awkward situation provided for the version *n* - 1 in Paris. In other words, originality does not come to a work of art in bulk; it is made of different components, each of which can be interrelated to produce a complex whole. New processes of reproduction allow us to see these elements and their interrelationship in new ways. To be at the place for which it had been conceived in each and every detail is certainly to observe one aspect—one element—in what we mean by an original. On that ground, there is no question that the facsimile of the *Nozze* is now the original, while the version in the Louvre has lost at least this comparative advantage.

We should not, however, wax too mystical about the notion of an "original location" in the case of the Veronese, since the very refectory in which the facsimile has been housed is itself a reconstruction. If you look at photographs taken in 1950, you will notice that the original floor was gone and another had been installed at the height of the windows. The top was a theater and the basement a wood workshop—the whole space had been altered. It was rebuilt in the 1950s, but the plaster and floor were wrong and the boiserie that surrounded the room and added the finishing touches to the proportion of the room was missing. In its stripped-down state, it looked more like a high

Protestant space that seemed almost to laugh at the absence of Veronese's Counter-Reformation flourish. But now there are rumors that the return of the painting—the facsimile, that is—has triggered a plan for a new restoration that will retrospectively return the space to its former glory. A facsimile of a heavily restored original, now in a new location, may cause new elements to be added to an original in its original location that is, in part, a facsimile of itself. Originality once seemed so simple . . .

The same is certainly true of *availability*. What angered the visitor to the Louvre so much was that she could not visually scan the *Nozze* without bumping into *Mona Lisa* addicts. The Veronese is so full of incident and detail that it cannot be seen without time to contemplate its meaning, its implications, and the reasons for its continued importance. What does it mean to enshrine an original, if the contemplation of its auratic quality is impossible? This, too, is an element that can be prized away and distinguished from all the others. This component of originality need not be bound to the originality of the location; the best proof of this may lie in the facsimile of the burial chamber from the tomb of Thutmosis III in the Valley of the Kings.[2] It contains the first complete text of the Amduat to be used in a pharaonic tomb. The Amduat is a complex narrative mixing art, poetry, science, and religion to provide a coherent account of life in the afterworld. The tomb was never made to be visited, and the physical and climatic conditions inside it are incompatible with mass tourism. As a result, the tomb is deteriorating rapidly and glass panels have had to be installed to protect the walls from accidental damage and wear and tear. These interventions, however, change the nature of the space and inhibit both detailed study of the text and an appreciation of the specific character of the place. Exhibitions that present the facsimile and contextualize the text have now been visited by millions of people in North America and Europe. The delocalized facsimile has thus established the reasons for its continued importance, turned its visitors into a proactive force in the conservation of the tomb, and possibly become part of a long-term policy that will keep the version $n-1$ safe but accessible to the small number of specialists who require access for continued study and monitoring. See? Each of the components that together comprise what we mean by a true original begins traveling at a different speed along the trajectory and begins to map out what we have called the catchment area of a work of art.

A third element of originality has to do with the *surface features* of a work. Too often, restorers make a mockery of the materiality of the original they claim to be protecting by attending only to two-dimensional shape. If there is one

aspect of reproduction that digital techniques have entirely modified, it is cer-
tainly the ability to register the most minute three-dimensional aspect of a work
without putting the work at risk. It is often forgotten that in its early years the
British Museum used to take plaster casts of its objects; indeed, the first British
Museum catalog contained a list of copies that were available and for sale. It
is often forgotten because the plaster-cast collection was discarded at the end
of the twentieth century, and valuable information about the surfaces of the
works when they entered the museum was lost. Subsequent restorations have
dramatically altered the surface and appearance of many of the objects. But
beyond evidence of their earlier forms, many of the molds still contained paint
that had been removed during the casting process. So, even for a work of art to
be material is a question of complex trajectories. Many Venetians, when they
first heard of the *Nozze* facsimile, conjured up images of a glossy flat surface, like
that of a poster, and were horrified at the idea of this being given in reparation
for Napoleon's cultural rape of San Giorgio. They could scarcely have anticipated
that the facsimile would consist of pigment on a canvas coated with gesso, "just
like" Veronese had used. When it was unveiled, there was a moment of silence,
then ecstatic applause and many tears. Many Venetians had to ask themselves
a very difficult question: How is it possible to have an aesthetic and emotional
response in front of a copy? This question is followed by another: how do we stop
Venice from being flooded with bad copies without the criteria to distinguish
between good and bad transformations?

Once again, digital techniques allow us to distinguish features that are
being regrouped much too quickly under the generic term "reproduction." As
we have seen, exactly the same intellectual oversimplifications and category
mistakes happened when Benjamin wrote about "mechanical reproduction."
Surely the issue is about accuracy, understanding, and respect—the absence
of which results in "slavish" replication. The same digital techniques may be
used either slavishly or originally. It depends again on which features one
chooses to bring into focus and which one leaves out. The use of tiny painted
dots based on photographs rather than the broader brush marks used to make
the original may give the restorer more control and hide the interventions, but
surely it proves that a *manual* reproduction might be infinitely more disput-
able and subjective than a "mechanical" one. The road to hell is paved with
good intentions.

No doubt, it is an uphill battle: facsimiles have a bad reputation—people as-
similate them with a photographic rendering of the original—and "digital" is

associated with an increase in virtuality. So, when we speak of digital facsimiles, we are looking for trouble. And yet we claim that, contrary to common presuppositions, digital facsimiles are introducing many new twists into the centuries-old trajectory of works of art. There is nothing inherently "virtual" in digital techniques—and for that matter, there is nothing entirely digital in digital computers![3] The association of the digital with the virtual is entirely due to the bad habits associated with just one of its possible displays: the pretty bad screens of our computers. Things are entirely different when digital techniques are only one *moment* in the move from one material entity—Veronese's *Nozze* version $n - 1$ in the Louvre—to another equally material entity—version $n + 1$ in San Giorgio. During this time of mass tourism and increasingly vocal campaigns for the repatriation of the spoils of wars or commerce, when so many restorations are akin to iconoclasm, when the sheer number of amateurs threatens to destroy even the sturdier pieces in the best institutions, it does not require excessive foresight to maintain that digital facsimiles offer a remarkable new handle to give to the notion of originality what is required by the new time. Since all originals have to be reproduced anyway, simply to survive, it is crucial to be able to discriminate between good and bad reproductions.

Appendix. The process used to create an accurate facsimile of *Le Nozze di Cana* by Paolo Caliari (called Veronese)

Adam Lowe

In the autumn of 2006, the Musée du Louvre reached an agreement with Fondazione Giorgio Cini and granted Factum Arte[4] access to record Veronese's vast painting *Le Nozze di Cana*. The conditions were carefully specified: the recording must entail no physical contact with the painting, all equipment must meet the highest conservation standards and be approved prior to use in the museum, no external lighting or scaffolding could be used, work could only happen when the museum was closed, and no equipment could be left in the room when the public was present. In defining each condition the safety of the painting (and the other paintings in the room) was always the decisive factor.

To record this 67.29-square-meter painting at actual size and at the highest possible resolution, Factum Arte built a non-contact color scanning sys-

FIGURE 31. Time-lapse photgraph of Factum Arte's team recording the original but heavily restored painting in the Louvre. A telescopic mast and flatbed scanning system was used to record the entire surface of the painting. A 3-D scanning system was used to record the surface of the lower part of the painting. Photo: Grégoire Dupond.

tem that uses a large format CCD and integrated LED lights. The system records at a scale of 1:1 at a maximum resolution of 1,200 dots per inch (dpi). The scanning unit is mounted on a telescopic mast, which is operated by an air pump and can accurately position the scanning unit on the vertical axis. The mast has a maximum reach of 8 meters from the ground, has an ultrasonic distance sensor to ensure that the scanning head is parallel to and a uniform distance (8 centimeters) from the picture surface, and is fitted with a linear guide to position the scanning head laterally in front of the painting. This is essential to ensure that the numerous scan files can be fitted together without scale, focus, or perspective distortion.

The scanning head moves over the surface illuminating the area that is being recorded (figure 31). The LED light used contains no ultraviolet rays and generates minimum heat. The painting was scanned in thirty-seven columns and forty-three rows. Each capture was 22 by 30.5 centimeters with an overlap of 4 centimeters on the horizontal dimension and 7 centimeters on the vertical dimension. Each file was saved in two formats, TIFF (the working file) and JPEG (a reference file). The recording was done at 600 dpi with 16-bit color

FIGURE 32. Naoko Fukumaru, Factum Arte's chief conservator, working in the Louvre with a selection of pre-prepared color sticks that are matched to the surface of the painting. Equal attention was paid to the color and the reflectivity of the surface. Photo: Grégoire Dupond.

depth. During the recording of *Le Nozze di Cana*, 1,591 individual files were saved in TIFF format, resulting in an archive of 400 gigabytes.

The telescopic mast was also used for conventional photography using a Phase One H25 digital back fitted to a medium-format Hasselblad body. The Phase One records 5,488 by 4,145 pixels (22 megapixels) with a pixel size of 9 by 9 microns and 48-bit color (16 bits per channel). The photography was done in 450 sections (18 columns and 25 rows) using the ambient light in the room. For reference, a photograph of the complete painting was taken with the camera positioned on a tripod at the other end of the room, in front of the *Mona Lisa*, to ensure minimum distortion. The archive of photographic data consists of 593 different files totaling 41 gigabytes of data.

The lower part of the painting was recorded using a noncontact 3-D scanning system made by NUB 3D (Spain). No markers, spheres, or registration systems are fixed to the object. The average working distance is about a meter away from the surface being recorded. The NUB 3D Triple White Light Scanning System uses a mix of optical technology, 3-D topometry, and digital image processing to extract three-dimensional coordinates from the surface of an object. This technique, known as structured white-light triangulation, produces accurate measurements of the surface by analyzing the deformation in lines and pat-

terns of light that are projected onto the surface of an object. Multiple images are captured by an integrated camera in the measuring head, and using these the system's integrated technology calculates a coordinated x, y, z point cloud relating to the surface of the object. About 10 square meters of the painting were recorded in 3-D at a resolution of between 400 and 700 microns. The scanning was done in sections of one meter square, generating an archive of about 1 gigabyte. Due to the tonal difference of the painted surface and the varying reflectivity of the varnish a multiexposure option was used. For the alignment and post-processing Invometric Polyworks software was used.

During the recording extensive color notes were made using a series of color sticks made on site and matched to specific points on the surface of the painting (figure 32). Bits of the color sticks were cut off and fixed into a book containing a 1:1 scale line drawing of the painting at locations corresponding to these points on the painting.

The first step in assembling and aligning the data, carried out while still working in the Musée du Louvre, was to preassemble all the columns using Photoshop Scripting. This resulted in a roughly assembled image of the entire painting. The final assembly, carried out in Madrid, reduced the 1,591 individual files into 185 larger units (again with overlaps). The vertical columns were used as the basic unit. Strips comprising eight or nine scans each were accurately assembled; each full column was made of five of these files. The file size of each strips is about 1 gigabyte.

The edges of the painting were accurately assembled in order to give an absolute reference. Three horizontal lines were established across the painting to ensure that no distortion was taking place. Four vertical lines were then stitched to these horizontals and the resulting blocks were filled in the same way, subdividing each one into horizontal and vertical areas. This avoided any compound distortion and ensured an accurate master file. The master file was broken down into manageable units (file size under 12 gigabytes) with an accurate reference to each adjoining unit. Once these units were finalized the individual scans were flattened. The painting was then divided into 1-by-2-meter blocks, which served as the printing units. There are forty-four printing units.

The scanner data and the color photographic data had to be treated independently but aligned in perfect registration. The photographic data (recorded in RGB, with a color depth of 16 bits per channel) had to be mapped onto the 1-by-2-meter scanner data units. The scanner data contains no distortion, but camera data always contains some lens and perspective distortion. To join these two types of information, each photograph had to be generally distorted

FIGURE 33. During the production of the facsimile the color references recorded in the museum were essential to ensuring the accuracy of the final print. Photo: Alicia Guirao.

and then locally transformed, using transparency in different blending modes depending on the nature of the data. This was mainly done using features in the picture such as brush marks or "noise" within the canvas.

When more then one data set is used, the usual difficulties of color printing increase exponentially. The aim of the color adjustments was to make Factum Arte's flatbed printer match the color sticks recorded in the Louvre (figure 33). The monitors were all calibrated to the colors that were to be printed onto the gesso-coated canvas. The color of the gesso is not a pure white so it was important to create a range from the lightest white to the darkest black. The exact matching of all the colors was then a question of trial and error, involving changes to both the digital files and the gesso mix. Printing began with the panel at the bottom left of the painting, and further changes were made until both the tone and the color of the two layers (scanner and photographic data) printed together matched the color sticks after the print had been varnished. Every change was archived and then simplified gradually resulting in a series of Photoshop "actions." One set of actions was applied to the Phase One data and another to the Cana Scanner data. Once finalized, these actions were applied to all forty-four printing files, and small versions of each file were printed. During the recording the lighting conditions for both photography and scanning had

BRUNO LATOUR AND ADAM LOWE

FIGURE 34. The flatbed printer specially designed by Factum Arte's engineer Dwight Perry. Each section of the painting was printed several times in perfect registration in order to ensure correct tone and color. Photo: Alicia Guirao.

been kept constant so these universal actions, in theory, would result in accurate color matching across all parts of the 67-square-meter canvas.

After printing the tests and comparing them with the color sticks, further local corrections were made to specific colors, mainly in areas with a lot of whites or with complex grays and blacks. These changes were made using locally applied masks to isolate specific areas of the painting.

The facsimile was printed on Factum Arte's purpose-built flatbed printer (figure 34). This is based on an Epson Pro 9600 digital printer. The printer uses pigment inks in seven colors (cyan, light cyan, magenta, light magenta, yellow, black and light black). The bed is fixed, and the print heads move up and down the bed on linear guides. The movement of the heads is accurate to a few microns, and their height can be adjusted during printing. This made it possible to print the image in pigment onto gesso-coated canvas. The gesso coating, a mixture of animal glue, calcium carbonate, and precipitated chalk, used no metal oxides. The texture on the surface of the 16-ounce Irish flax was made from flax fibers and threads mixed with gesso. Due to its history *Le Nozze di Cana* has a complex and unusual surface. To reproduce this appearance, each piece of canvas was coated with a layer of animal glue, a layer of gesso and fibers, and then two layers of gesso. Acetate sheets printed with the Phase One photographic data were used, with a pin registration system, to ensure accurate placement of the texture on the prepared canvas. Each panel was then printed twice in perfect register. The first layer to be printed was the information recorded on the Phase One

FIGURE 35. The printed sections of the facsimile were laid out on the floor of the workshop, carefully spliced together, and glued to Alucore panels. Photo: Alicia Guirao.

FIGURE 36. A detail of the finished surface after joining but before retouching. The painting was printed onto prepared canvas in sections that were spliced together and retouched. The white line in this image is a filled join that has not yet been retouched. The horizontal join is the result of heavy restoration to repair the painting after it was cut from the wall by Napoleon's troops. Photo: Alicia Guirao.

FIGURE 37. After retouching the spliced join is no longer visible. The retouching was carried out by Factum Arte's conservation team in Madrid, and the finishing touches were done on-site in Venice when the painting was installed. Photo: Alicia Guirao.

FIGURE 38. Naoko Fukumaru retouching a section of the painting in Factum Arte's workshop in Madrid. Photo: Grégoire Dupond.

FIGURE 39. The completed facsimile installed in Palladio's refectory at the Fondazione Giorgio Cini, Venice. Photo: Grégoire Dupond.

photographs. The second layer was the scanner data. The overprinting resulted in accurate color matching and a control of the tonal values of the painting. The entire image was divided into 110-by-220-centimeter printing files, with 10 centimetres of overlap. The printed panels were varnished with a satin Golden acrylic varnish with UVLS (an ultraviolet filter).

Ten 20-millimeter-thick Alucore panels were made, each 340 by 205.2 centimeters. When perfectly aligned in two rows of five panels they make up the whole painting. Each of the large aluminum panels was assembled from six printed canvas panels, with some of the panel overlapping the edges (figure 35). First the printed panels were laid out on the surface and perfectly aligned. They were then spliced together with irregular cuts that followed features in the painting. Straight lines were always avoided. The canvas was then fixed to the aluminum with PVA. The joins resulting from the stitching of the printed panels were then retouched by hand by a team of trained conservators. The joins were first filled with a mixture of Golden acrylic molding paste and glass microspheres, then tinted, and finally retouched using Golden acrylic paint (figures

├─── BRUNO LATOUR AND ADAM LOWE

36–38). During this process a gloss Golden varnish was used. A Golden gel was then used for the final texture and to enhance selected brushmarks and areas of impasto paint. A final coat of satin Golden varnish with UVLS was applied.

The honeycomb aluminum panels with the retouched printing were sent to Venice, where they were fixed on-site to an aluminum frame. This was done in two parts, which were then lifted into place and fitted onto the wall. The final filling, retouching, and control of the surface was done when the facsimile was in its final position and with the lighting that exists in the refectory (figure 39).

Acknowledgments

We thank the participants at the dialogue held in Venice in San Giorgio on "Inheriting the Past" for many useful conversations and especially the director of the Cini Foundation, Pasquale Gagliardi.

Notes

1. See the commentaries of Péguy in Deleuze (2005).

2. The facsimile of the tomb (in its current condition but without the elements that turn the environment into a museum) has resulted in detailed publications, in both film and book form, by the Egyptologist Erik Hornung and the psychologist Theodor Abt (Hornung and Abt 2005; Hornung et al. 2006).

3. See Lowe and Schaffer (2000); Smith (2003).

4. See http://www.factum-arte.com.

Works Cited

Appadurai, Arjun, ed. 1986. *The social life of things: Commodities in cultural perspective.* Cambridge: Cambridge University Press.

Benjamin, Walter. 1968. The work of art in the age of mechanical reproduction. In *Illuminations*, 217–51. New York: Schocken Books.

Deleuze, Gilles. 2005. *Difference and repetition.* Trans. Paul Patton. New York: Continuum International.

Hornung, Erik, and Theodor Abt. 2005. *The dark hours of the sun: The Amduat in the tomb of Thutmose III.* DVD. Madrid: Factum Arte.

Hornung, Erik, et al. 2006. *Immortal pharaoh: The tomb of Thutmose III.* Madrid: Factum Arte.

Lowe, Adam, and Simon Schaffer. 2000. *Noise, 2000.* Catalog for exhibition held simultaneously at Kettle's Yard, the Whipple Museum of the History of Science, and the Museum of Archaeology and Anthropology, all in Cambridge, and the Wellcome Institute, London. Cambridge: Kettle's Yard.

Smith, Brian Cantwell. 2003. Digital abstraction and concrete reality. In *Impressiones.* Madrid: Calcografía Nacional.

Tamen, Miguel. 2001. *Friends of interpretable objects.* Cambridge, MA: Harvard University Press.

Western, David. 1997. *In the dust of Kilimanjaro.* New York: Shearwater/Island Press.

The Truth in Versions

Charles Bernstein

I love originality so much that I keep copying it.

I am the derivative product of an originality that spawns me as it spurns me.

The focus on the original that is addressed by Bruno Latour and Adam Lowe is not limited to the plastic arts. In poetry, the assumption is always that the uncorrupted alphabetic text is the original and that performances (including those by the author) or versions (including those with which the author was complicit) are secondary.

Sound recordings (and live performance) offer a much thicker, much richer, sound texture than alphabetic presentations of poems. Key elements not found in the written text include timbre, tempo, accent, and pitch. Each of these feature is, for my way of "close listening," a crucial feature of the poem.

The work of art "itself" does not exist, only incommensurable social contexts through which it emerges and into which it vanishes.

The author dies, the author's work is born.

Poems are networked texts.

Existence needs essence the way a walking tour needs local color.

A work of art is the overlay of a set of incommensurable possibilities, linked together around an anoriginal vanishing point.

Which reminds me of the story of the man who reports a wife-beating to a neighbor. "Then stop beating her," the neighbor replies. "But it's not my wife!" replies the good Samaritan, becoming agitated. "That's even worse!" says his neighbor.

In the world of the imagination, impossible just means the next opportunity to get real.

Yet the Dark, untouched by light, injures it all the same.

Authority is never abolished but constantly reinscribes itself in new places.

Digital space is not so much disembodied as differently bodied. And those different bodies can be as scary as the demons that haunt our dreams for human freedom.

There is a pleasure, also, in delusions: not of grandeur but of agency.

Gary Hill: In the viscosity of process, the end never arrives.

Connect the knots.

The time is not far off, or maybe it has already come to pass, when computers will be able to write better poems than we can. So we must now add to logopoeia, phanopoeia, and melopoeia: *algorhythmia*.

But computers will never replace poets because computers won't take that much abuse.

Poetry is metadata without code, free-base tagging, cascading style sheets with undefined markers.

Is the diachronic robustness more valuable than synchronic flickering?

". . . we attain to but brief and indeterminate glimpses." [E. A. Poe, *The Poetic Principle*]

"It is a puzzle. I am not puzzled but it is a puzzle. . . . I am not puzzled but it is very puzzling." [Gertrude Stein, *The Mother of Us All*]

A hole in an argument is not the same as a point of light.

Good poets make analogies, great poets make analogies between analogies.

"The ladder urges us beyond ourselves. Hence its importance. But in a void, where do we place it?" [Edmond Jabes, tr. by Rosmarie Waldrop]

Rabbi Eliza would always say, *Which comes first, the egg or the idea?* as a way to stop a conversation she felt was coming too soon to a conclusion. One very hot afternoon, Rabbi Omar asked Rabbi Eliza to trace the origins of her favorite maxim. "In a roundabout way," Rabbi Eliza began, looking up from the passage she was studying, "it's related, to Rabbi Yukel's so-called Rule of the Index Finger: *Don't put all your chickens in one egg,* which itself is a variant of the saying, attributed to Rabbi Raj, and which we chant on the first half moon of Winter, *One egg is not the world.* On hearing this, Rabbi Omar loudly protested, noting that several centuries before Rabbi Raj, Rabbi Not-Enough-Sand-in-Desert-not-Enough-Water-in-the-Sea had insisted that the central question to ponder on nights-without-visible-rainbows is *Which comes first the basket or the idea of the basket?*. "Exactly," Rabbi Eliza said with a triumphant laugh, "without baskets or eggs we would only have words and without words only mouths."

Think digitally, act analogically.

Pamphlets, Paintings, and Programs: Faithful Reproduction and Untidy Generativity in the Physical and Digital Domains

Judith Donath

Several years ago I was writing a paper about the plagues of the thirteenth and six-teenth centuries. My research brought me to the Beinecke Rare Book Library, where I was able (once I'd handed over all my possessions other than a pencil and notepad, and under a guard's watchful glare) to read—and hold—actual pamphlets.

The crumbling yellowed pamphlet in my hands had existed during the plague of which it spoke. It had been carried through the same streets that the corpses of plague victims passed. It may have accompanied its owner on visits to the houses of sick and dying plague victims. Perhaps the owner himself had fallen victim.

> Moreover receyve not into your house any stuffe, that commeth out of a house, wherin any person hath ben infected. For it hath bene sene, that such stuffe lyenge in a cofer shutte by the space of two yeres, after that the coffer hath bene opened, they whiche have stande nygh to it, have ben infected, and sone after have died. (Sir Thomas Elyot *Castel of helthe*, 1539)[1]

On the one hand, I knew the pamphlet was quite safe. Yet it was itself "stuffe," car-rying with it, while not *Yersinia pestis* itself, some ineluctable essence of its passage through the plague years.

A physical object's passage through history gives it a biography (Kopytoff 1986). This is not just an ephemeral narrative; it is as if it has picked up some traces, some rubbings, from the people and events it has encountered. We see this in the high value given to an object that has been worn or touched by a famous person, from the Shroud of Turin to the ruby slippers worn by Judy Garland.[2] Even mundane objects can thus acquire talismanic power.

Time creates identity. The acquisition of history turns mass-produced objects into

individuals. But, as Latour and Lowe point out, this creates tension when the object, for example, a beautiful artwork, has great intrinsic value. The two identities can be at odds. For the restorer, the key question is which is real or significant: the painter's initial creation, in which case all later marks should be eradicated, or the worn, torn, historical, biographical object, in which case the marks are themselves significant and valuable.

Not all historical interventions are of equal value. The Gatorade-stained shirt worn by coach Doc Rivers when the Boston Celtics won the 2008 NBA championship was sold for $35,000. Those stains added value, but any subsequent stains will detract. The economics of relics is a complex interplay between intrinsic value and historical significance.

This tension, between process and product and between the physical and the visible, can exist in the very creation of an object. This was made explicit in the 1950s with the emergence of action painting. The critic Harold Rosenberg said:

> At a certain moment the canvas began to appear to one American painter after another as an arena in which to act—rather than as a space in which to reproduce, re-design, analyze or "express" an object, actual or imagined. What was to go on the canvas was not a picture but an event.
>
> The painter no longer approached his easel with an image in his mind; he went up to it with material in his hand to do something to that other piece of material in front of him. The image would be the result of this encounter. (Rosenberg 1952)

The action painting, as described by Rosenberg, is a side-effect of activity. Thus it is absurd to copy its appearance, its surface properties, by some accurate but different process. To copy traditional painting, as posited at the other end of the spectrum, with the finished work as the primary objective, makes more sense. Yet in reality there is not a clear dichotomy between traditional and action painting. We value the works of the Renaissance not only for their surface appearance, but also for the person and the process that produced them.

These issues are of interest far beyond the rather rarefied realm of art conservation. We are entering an era in which increasing amounts of our information, entertainment, and everyday communication come to us in digital form, a form that can be impervious to wear and use, a form that allows for endless, seamless reproduction. It is acutely important that we deepen our understanding of the meaning of physicality and attempt to untangle our ambivalent relationship with the marks, scars, stains, and reminders of history.

In the digital realm, the easiest form of copying is perfectly accurate, bit by bit, pixel by pixel. We can make infinite numbers of identical documents. And these digital artifacts show no signs of wear. The web page that has been viewed a million times remains pristine.

Yet the digital world is fabulously malleable. Perfection in copying is a design decision, as is the invisibility of history. And thus, the opposite can be made: I can design a system in which copying causes minute transformations, one in which viewing leaves traces (Hill et al. 1992; Wexelblat and Maes 1999), one that changes, mutates, evolves, or decays with time or with each glance or passing event.

There is certainly value in doing this. Seeing the paths that others have followed in reading a book or making subsequent generations of an object different than the initial ones can bring an organic complexity to the often sterile digital space. It engenders objects that create their own context, that exist in a continuum of becoming through use.

These traces need not, and should not, slavishly follow the metaphor of wear and tear, of footprints and paths. While the ninth generation of a photocopy is faded and smudged, the ninth generation of a digital object can be made to have picked up interesting data from the time and place of each act of copying. Synthesized imperfection can be made to suit your needs perfectly.

And that is perhaps its fundamental flaw. There is a certain antiseptic feeling to these vetted interventions. They are approved imperfections, nothing like the faint yet vivid (and by now, imaginary) traces of germs in the plague pamphlets, the oils and dirt and bits of shed skin that go with passing through the hands of another. What is the essence of that physical aura? Is it the tiny bits of stuff left behind? Or is it the uncontrollability that gives it value?

Some of the physical world's unpredictability can be replicated in the digital. We can make objects that are generated from complex, unrepeatable inputs, that grow and change in response to the outside world. But would we choose to do this? Today, I think many would say no. The sterile cleanness of the digital is refreshing, simple. Those who feel that this is in some way a loss need to find ways to articulate the value of accumulating history, of choosing the chaotic and accumulative. It is with such changes and permutations that objects acquire their significance.

Latour and Lowe also emphasize the importance of how a work shapes the future, whether its trajectory is "fertile" or "barren." They start by discussing the creative fertility of performance, where a play written centuries ago can still generate new interpretations. They then argue that copies of paintings and other static artworks are analogously "fecund." The flaw in this argument is that the interpretations of plays bring new creative material to the production; they are not unchanging repetitions of the exact same actions, or faithful reproductions of the exact same surface. A better analogy in

the world of painting would be to the influence one artist has on another; it is Picasso's influence on artists such as de Kooning, Pollock, and Lichtenstein (FitzGerald 2006) that is important, not the reproductions, no matter how nicely crafted, of his work (though those may be an important channel for enabling that influence).

In the digital realm, this distinction between clonelike copying and creative regeneration can be reified in the design of new media. It is the ability to modify, as well as to copy, that has brought about much of the richness of the digital world today, what the legal scholar Jonathan Zittrain (2006) calls "the generative internet." Modification, a.k.a. mutation, is essential to evolutionary progress. A medium (and a legal environment) that makes it easy to make and modify copies encourages a cumulative creativity.

Mutations are not, of course, always beneficial. Most are not. Yet the richness of life comes from a myriad of accidental yet advantageous mutations—at the cost of the many that failed. As we enter the digital era, we are able to program the level of risk we are willing to take with unexpected changes. We can create a sterile, synthetic world, safe, but somewhat barren. Or we can create worlds that are much more open, messier, and more "organic"—how far we want to go in this direction remains an open question. The richness of the physical world encompasses both its great beauty and its plagues.

Notes

1. Quoted in Healy (1993).

2. A pair of ruby slippers worn by Judy Garland in *The Wizard of Oz* (1939) are in the collection of the National Museum of American History, Smithsonian Institution, Washington, DC (http://www.smithsonianlegacies.si.edu/objectdescription.cfm?ID=18; accessed July 17, 2008).

References

FitzGerald, M. C. 2006. *Picasso and American art*. New Haven: Yale University Press.

Healy, Margaret. 1993. Discourses of the plague in early modern London. Working paper. Centre for Metropolitan History, University of London.

Hill, William C., James D. Hollan, Dave Wroblewski, and Tim McCandless. 1992. Edit wear and read wear. *Proceedings of SIGCHI conference on Human factors in computing systems*, Monterey, CA.

Kopytoff, Igor. 1986. The cultural biography of things: Commoditization as process. In *The social life of things*, ed. Arjun Appadurai. Cambridge: Cambridge University Press.

Rosenberg, H. 1952. The American action painters. *Art News* 51 (8): 49.

Wexelblat, A., and P. Maes. 1999. Footprints: History-rich tools for information foraging. *Proceedings of the SIGCHI conference on human factors in computing systems*, Pittsburgh, PA.

Zittrain, J. 2006. The generative internet. *Harvard Law Review* 119: 1974.

EPILOGUE

Enquire Within upon Everything

RICHARD POWERS

Whether You Wish to Model a
 Flower in Wax;
to Study the Rules of Etiquette;
to Serve a Relish for Breakfast or Supper;
to Plan a Dinner for a Large Party
 or a Small One;
to Cure a Headache;
to Make a Will;
to Get Married;
to Bury a Relative;
Whatever You May Wish to Do, Make,
 or to Enjoy,
Provided Your Desire has Relation to the
 Necessities of Domestic Life,
I Hope You will not Fail to
 'Enquire Within.'
Editor's introduction, *Enquire Within upon Everything* (London: Houlston and Sons, 1856)

Say a boy is born in a northern middle class suburb of the large Midwestern metropolis of C.

Say he is born in the year 1989.

This is the last of years. This is the first of years.

This is the year the walls come down and the webs come up.

The boy learns to point and click right around the time he learns how to talk.

From the earliest age, he is always able to cut, paste, or undo.

By eight, the boy will type with two thumbs much better than he can write with either whole hand.

Card catalogs become obsolete by the time he reads his first book.

The first graphical web browser is outmoded before he starts second grade.

By the age of eleven, the boy has difficulty doing fewer than four things at once.

He never once needs to use a print reference, except as an exercise in historical nostalgia.

His favorite childhood pet, a virtual Jack Russell terrier that he breeds and trains and romps around with online, dies when the boy goes on a summer vacation with his family and is away from the web for two weeks.

The boy builds an online mausoleum for the deceased digital dog, which he forgets all about and never dismantles. The site ends up drawing condolences, tearful empathy, and mocking abuse from all over the world, even after the boy himself dies, nine decades later.

In junior high, the boy discovers music. He grows obsessed with acquiring copies of the world's fifty million musical titles. In time, he comes to carry with him access to enough music that he could listen to a thousand pieces a day for a century without repeating.

After puberty, the boy falls hard for information science. Between high school and his graduation from college, the world's information doubles. It will double again several times before he dies, until just the indexes themselves outstrip the total data of his childhood.

In high school, the boy joins a club of everyone on earth who shares his name and birthday. The club has hundreds of members and adds dozens more a year. Soon, new members are located and added to the mailing list immediately upon birth.

The boy doesn't really remember his college years. But he does remember vividly the details of those years that he spends the rest of his life retrieving from various social networking sites.

While in college, the boy makes a nice income by adding helpful tags to other people's travel photos. His tags make it possible for anyone to spend Sunny Afternoons/By Large Bodies of Water/With Friendly People/Cooking Chicken/On the Grill for /People/Playing/Volleyball, anytime the desire strikes.

After graduation, the boy makes a living teaching software how to tag pictures automatically.

Later, the boy makes a living helping to create a system that can match any person's browsing history with exactly the product they don't yet know they need.

People who buy the things that the boy buys often buy the very next thing that they are told that people like them often buy.

The boy receives an out of the blue e-mail from his wife-to-be explaining that, while she may appear to be a perfect stranger, the data in fact prove their lives have been following a weird synchrony that more or less dooms them to marriage.

The boy checks the links that his wife-to-be sends. The data are indeed incontrovertible.

Eight out of ten partner-matching sites declare the boy and his wife-to-be to be "highly compatible." Another site analyzes their backgrounds and reassures them they can expect to remain married for at least seventeen and a half years—almost twice the median.

The boy and his inevitable fiancée comb through thirteen million starter homes by four hundred criteria and come up with three that fit them. They can't agree on which one to buy. They consult a site that generates random numbers.

The boy has a boy of his own, whose life the proud father documents in a variety of folksonomies. The boy's folks and his folks' folks and the state and private sectors combine to index the boy's boy's life at the scale of about one to five.

One day when he is thirty-eight, the boy passes on the street without knowing it another boy who—all the data miners agree—he should have met and become fast friends with. One century later, two biographers will independently determine the fact of this near-meeting. Neither biographer will be aware of the other's existence.

In early middle age, the boy makes a fortune developing a program that can determine the percentage of factual accuracy of any web page. Many such programs already exist, but his is the first that graphs truth along the axis of time.

Using this program, the boy discovers that the entire web is tending toward an accuracy of about 55 percent. His estimate itself turns out to be about 70 percent correct.

The boy appears in the frame of tens of thousands of amateur videos on

the web, only the smallest fraction of which he'll ever know about. The boy's family's various pets will star in many dozens of web videos of their own. Most of these will involve bathroom fixtures and treadmills.

When he no longer needs to work, the boy spends much of his time creating a three-dimensional panoramic immersion of the large Midwestern metropolis of C., the city of his birth. He assembles the place as a mash-up out of bits and pieces of mementos in the public domain.

In the model of his boyhood's city, he can control the weather by sighing.

The boy's own boy is bored by the model city, when the boy tries to take his own boy there.

The boy hangs around a site that matches people up with other people who they would have stayed in touch with from high school, had they gone to high school together.

At his most popular, the boy has about three hundred thousand networked friends and friends of networked friends. This is roughly a hundredth of the lives that the boy's personal information manager can handle, or roughly one thousand times more people than the boy's brain evolved to keep track of.

The boy communicates with many of these friends by automatic greeting cards. His calendar-driven greetings will continue to be sent for years after his death. A number of the friends who continue to receive these cards are themselves bots. These bot friends will nevertheless be deeply bewildered when the cards finally stop.

Whenever he meets someone he likes, the boy sets a semantic crawler loose to learn how many degrees of personal connection separate them. It's never more than two and a half, but for some reason, people keep talking about six.

When the boy's own boy turns twenty, he decides to drop off the face of the grid. The boy spends much of the next two decades searching for his boy, posting increasingly large rewards to all the appropriate virtual communities for any useful leads.

The boy's wife dies prematurely of accidental information poisoning.

The boy launches a massive genotyping-genealogy search, in an attempt to contact his every living blood relative. He loses interest when no one can tell him how far out "blood relative" actually goes.

A full scan of his genome tells him his alleles are nearly identical to a man in Croatia sixteen years his junior. The boy flies to Zagreb to spend an afternoon with his genetic semblance. The boy and the near-boy talk for hours

through a hand-held translator. Unfortunately, a software error generates a misunderstanding resulting in fisticuffs.

The boy takes to finding all the pictures in creation with ochre or azure in their pallet that involve four or more human figures in the act of Morris dancing. When the boy finds them all, he beams them to a life-size frame in his living room. The frame selects and displays the pictures in response the boy's own body movements. In this way, the boy dances with thousands of people, 95 percent of them long dead.

Sometime in his middle forties, the boy discovers by accident a mysterious site that has been tracking his every significant movement since childhood. Three years later, the boy tries to use the site to find where he left his car keys. But he can no longer find the site.

Over the course of his lifetime, the boy is told 47 times by humans and 231 times by bots to read the stories of Borges, but somehow fails ever to do so in the life he actually leads.

Something is missing in the boy's life. He conducts various searches and metasearches to find out what. The boy gets numerous answers, none of them entirely satisfying.

When the boy turns fifty, he spends a year restoring the year 1989. He does this through the more or less complete repository, *Today in History*. The boy passes once more through the year of his birth, taking each day a day at a time.

From March of that repeated year onwards, the boy watches the Web get born, from out of the germ of an ingenious coding project called *Enquire*.

Using a primitive Trajectomizer, the boy traces *Enquire* all the way back to its inspirational source: a handbook of universal Victorian knowledge called *Enquire Within upon Everything,* a book whose 113th edition the inventor of the Web once flipped through as a boy.

The boy mods up a camera that can see, analyze, and interpret nineteenth-century paintings better than can most twenty-first-century humans. With the help of this machine, the boy achieves some renown in automated art circles for his skilled, digitally assisted re-creations of Monet's second painting of the portal of Rouen Cathedral from 1893. The boy re-creates the painting twice a year for two decades, preserving a remarkable document of the subtly changing pigments of the original over that time.

With another group-modified, open-source program, the boy composes reasonable probabilistic re-creations of all the symphonies that Mozart would

have composed, had Mozart lived to be the boy's age. The boy performs these symphonies with scores of acquaintances around the globe. None of these players ever meet one another, and few of them can play a real musical instrument.

The boy's life itself, from about the age of sixty onward, will be tagged and taxonomied by an automated program capable of trawling the boy's every recorded experience and determining its dominant narrative, from out of the few hundred narratives that have been determined to exist. The story underwriting the boy's entire life will turn out to be: *The hero goes on a journey* . . .

When he reaches seventy, the boy becomes convinced that his entire life is another person's statistical speculation. But he's never able to prove this definitively.

The boy's life can, in fact, be accidentally generated from the random page hits produced when a real semantic ontology builder roughly the boy's age initiates a search while researching his own autobiography.

The boy's life is, in fiction, just a series of data structures postulated for a book of essays that will kick around in print for a few years before finally being digitized on its way to the oblivion of immortality.

The sum of all the tags and metatags and subclasses of metatags used to digitize the book that the boy's life appears in will be seven percent greater than the total word count of the book.

In older age, he likes to watch films spliced together out of favorite shots from all the films he's ever watched. The shots are selected on the fly based on the boy's current emotional state.

The boy is haunted his entire life by a book he read in childhood. But nothing the boy remembers about the book will ever match anything produced by any search engine.

A year before his death, the boy is alerted by the archives that someone 140 years before him on the other side of the globe lived a life more or less equivalent to his, albeit, of course, at a much more brutal level of technology.

The boy's last hospital bed is fitted out with a visual browser that will allow him to travel anywhere, anytime, at any speed and resolution, in the guise and temperament of anyone, with all the appropriate memories invoked and re-experienced.

The boy dies at the age of ninety-eight, in a world of endless free creativity, insight, and gratification that has largely gotten away from him.

On his death, a handful of social networks will dynamically generate sev-

eral thousand obituaries for the boy, customized to fit the individual retriev-
ers. These obituaries will be, on average, about 55 percent accurate.

Some years later, another boy will run the boy's entire life over again, *in silico*, based on extrapolations from the semi-accurate data.

In this digitally restored life, the simulated boy will experience three scattered moments when he feels the infinite odds against any existence at all.

CONTRIBUTORS

Michele Barbera
Director of research and development, Net7, Pisa
Barbera is a founder and chief scientist of Net7, an IT company known for its collabora-
tion with major European research institutions on projects within the human sciences.
He is also a lead researcher with the multinational consortium Digital Semantic Cor-
pora for Virtual Research in Philosophy, a three-year project funded by a major grant
from the European Commission to develop a research infrastructure for the humanities.

Thomas Bartscherer
*Director, Language and Thinking Program, and assistant professor of humanities, Bard
College; research associate, Institut des Textes et Manuscrits Modernes, CNRS (ENS), Paris*
Bartscherer has since 2001 worked with the Institut des Textes et Manuscrits Modernes
in Paris to research and develop digital infrastructures for the support of humanities
scholarship. He has published and lectured on these projects in both European and
American venues. He also works and publishes on topics in literature, philosophy, and
contemporary performance and art. With Shadi Bartsch, he coedited *Erotikon: Essays on
Eros, Ancient and Modern* (University of Chicago Press).

Charles Bernstein
Poet, Donald T. Regan Professor of English, University of Pennsylvania
Bernstein is the author of over thirty books of poetry and libretti, including *All the Whis-
key in Heaven: Selected Poems* (FSG), *Girly Man* (University of Chicago Press), and *Shad-
owtime* (Green Integer), as well as two books of essays and one essay/poem collection:
My Way: Speeches and Poems (University of Chicago Press), *A Poetics* (Harvard University
Press), and *Content's Dream: Essays 1975–1984* (Sun and Moon Press; reprinted by North-
western University Press). More information is at epc.buffalo.edu.

Albert Borgmann
Regents Professor of Philosophy, University of Montana
Borgmann is a philosopher whose works include *Technology and the Character of Contem-
porary Life*, *Crossing the Postmodern Divide*, and *Holding on to Reality: The Nature of Informa-
tion at the Turn of the Millennium*, and *Real American Ethics*, all published by the University
of Chicago Press.

Werner Ceusters
*Professor of Psychiatry, School of Medicine and Biomedical Sciences, SUNY
at Buffalo NY and Co-Director of the Ontology Research Group of the New
York State Center of Excellence in Bioinformatics and Life Science*
Ceusters has published scores of scientific articles and coedited two volumes on topics
concerning the intersection of information technology and medicine, including *Syn-*

tactic-Semantic Tagging of Medical Texts: The Multi-TALE Project. *Studies in Health Technologies and Informatics* (IOS). Since 1993 he has been involved in numerous national and European research projects in the area of electronic health records, natural language understanding, and ontology.

William J. Clancey

Chief Scientist, Human-Centered Computing, Intelligent Systems Division, NASA
Ames Research Center and Florida Institute for Human and Machine Cognition
Clancey is a computer scientist specializing in cognitive science and work systems design. He has published numerous essays and scientific reports. His books include *Situated Cognition: On Human Knowledge and Computer Representations* (Cambridge University Press) and *Contemplating Minds: A Forum for Artificial Intelligence* (MIT Press), which he coedited with Steven W. Smoliar and Mark J. Stefik.

Roderick Coover

Associate professor of film and media arts, Temple University
Coover's works include interactive humanities projects such as *Cultures In Webs: Working in Hypermedia with the Documentary Image* (CD-ROM, Eastgate), *From Vérité to Virtual* (DVD, Documentary Educational Resources), and *Unknown Territories* (www.unknownterritories.org) as well as interactive arts installations such as *Something That Happened Only Once* (EKG Science Center), *The Theory of Time Here* (DVD, Video Data Bank), and *Outside/Inside* (Museum of the American Philosophical Society).

Judith Donath

Harvard Berkman Faculty Fellow, Harvard University
Donath synthesizes knowledge from fields such as urban design, evolutionary biology, and cognitive science to build innovative interfaces for online communities and virtual identities. Formerly director of the Sociable Media Group at MIT Media Lab, she is known internationally for her writing on identity, interface design, and social communication. She created several of the earliest social applications for the web, including the original postcard service and the first interactive juried art show. Her work with the Sociable Media Group has been shown in museums and galleries worldwide, and was recently the subject of a major exhibition at the MIT Museum.

Ian Foster

Director, Computation Institute, Argonne National Laboratory; Arthur Holly Compton
Distinguished Service Professor of Computer Science, University of Chicago
Foster leads computer science projects developing advanced distributed-computing ("Grid") technologies, computational science efforts applying these tools to problems in areas ranging from the analysis of data from physics experiments to remote access to earthquake engineering facilities, and the Globus open-source Grid software project. His publications include *The Grid: Blueprint for a New Computing Infrastructure* (Morgan-Kaufmann), *Designing and Building Parallel Programs* (Addison-Wesley), and, with S. Taylor, *Strand: New Concepts in Parallel Programming* (Prentice Hall).

Jean-Gabriel Ganascia

Professor of computer science, Université Pierre et Marie Curie, Paris
Ganascia is the author of over 350 articles and several books, including *Voir et pouvoir: Qui nous surveille?* (Pommier), *Communication et connaissance: Supports et médiations à l'âge de l'information* (CNRS), *L'Odyssée de l'esprit* (Flammarion), and *Gédéon ou les aventures ex-*

travagantes d'un expérimentateur en chambre (Pommier). His works examine issues related to data mining, scientific discovery, and creativity, as well as machine learning and its relation to human knowledge acquisition. He has also worked on the use of computer technology for the study of music and creativity in the making of music and on computer modeling of inductive reasoning.

James Hendler
Tetherless World Senior Constellation Professor of Computer Science and Cognitive Science, Rensselaer Polytechnic Institute
Hendler has authored some two hundred technical papers in the areas of artificial intelligence, semantic web, agent-based computing, and high-performance processing. He is president of the Semantic Web Science Association and is editor in chief emeritus of *IEEE Intelligent Systems*. Hendler is the first computer scientist to serve on the board of reviewing editors for *Science*.

Gary Hill
Artist
Hill's installations and tapes have been the subject of retrospectives and solo shows around the world, at venues including the American Center, Paris; Whitney Museum of American Art, New York; 2nd International Video Week, St. Gervais, Geneva; Musée d'Art Moderne, Villeneuve d'Ascq, France; and the Museum of Modern Art, New York. His awards include grants and fellowships from the McArthur Foundation, the New York State Council on the Arts, the National Endowment for the Arts, the Rockefeller Foundation, and the Guggenheim Foundation.

Paolo D'Iorio
Chargé de recherche habilité, CNRS, affiliated to the Institut des Textes et Manuscrits Modernes (École normale supérieure), Paris.
Other affiliations: Maison Française d'Oxford, Oxford eResearch Centre
D'Iorio has authored and edited numerous books and published many articles on philosophical topics and on the impact of digital technology on research and education in the humanities. He directed several national and European projects whose common goal was to develop a research infrastructure for the human sciences. He is general editor of Nietzsche Source

Sarah Kenderdine
Visiting associate professor, City University, Hong Kong; director of research, Applied Laboratory of Interactive Visualization and Embodiment (ALiVE), Hong Kong Science Park; curator, Special Projects, Museum Victoria, Melbourne
Kenderdine researches at the forefront of interactive and immersive experiences for museums across media arts and digital humanities. Her books include *Theorizing Digital Cultural Heritage: A Critical Discourse* (MIT Press) and *Place-Hampi: Inhabiting the Panoramic Imaginary of Vijayanagara* (Kehrer Verlag). Her installations include *YER-Turkiye* (2010), *UNMAKEABLELOVE* (2008), *PLACE-Hampi* (2006), and *Ancient Hampi: The Hindu Kingdom Brought to Life* (2008–2010).

Bruno Latour
Professor, Sciences Po Paris
Latour's books include *Reassembling the Social* (Oxford University Press), *Laboratory Life*

(Princeton University Press), and *Science in Action* (Harvard University Press). Together with Peter Weibel, Latour has curated two international exhibitions: *Iconoclash: Beyond the Image Wars in Religion, Science and Art* and *Making Things Public* (both catalogs published by MIT Press). All the references and most of the articles can be found at http://www.bruno-latour.fr.

Alan Liu
Professor and chair, Department of English, University of California, Santa Barbara
Liu teaches in the fields of digital humanities, British Romantic literature and art, and literary theory. He has published three books: *Wordsworth: The Sense of History* (Stanford University Press), *The Laws of Cool: Knowledge Work and the Culture of Information* (University of Chicago Press), and *Local Transcendence: Essays on Postmodern Historicism and the Database* (University of Chicago Press). Liu is principal investigator in the University of California's multicampus research group Transliteracies: Research in the Technological, Social, and Cultural Practices of Online Reading. He is the editor of *The Voice of the Shuttle*, a website for humanities research.

Adam Lowe
Artist and founding director, Factum Arte
Lowe's artistic work has been extensively exhibited and he has had large-scale survey exhibitions in St. Petersburg (Marble Palace, Russian State) and Mexico City (Museo National de Arte Grafica). He is currently working with Egypt's Supreme Council of Antiquities to record and make exact facsimiles of the tombs of Seti I, Nefertari, and Tutankhamun. He is also working with the Fondazione Giorgio Cini to establish a research center in the town of Caravaggio built around high-resolution recordings in two and three dimensions of Michelangelo Merisi's paintings.

Richard Powers
Novelist; Swanlund Professor of English, University of Illinois at Urbana-Champaign
Powers's novels include *The Echo Maker*, which won the National Book Award for Fiction in 2006, *The Time of Our Singing*, *Galatea 2.2*, *The Gold Bug Variations*, *Prisoner's Dilemma*, and, most recently, *Generosity*. In addition to the National Book Award, he received a MacArthur Fellowship in 1989 and the Lannan Literary Award in 1999.

George Quasha
Artist and poet
Venues for Quasha's solo exhibitions include the Baumgartner Gallery, New York (Chelsea), the Slought Foundation, Philadelphia, and the Samuel Dorsky Museum of Art at SUNY New Paltz. He has authored and edited numerous books, including *Somapoetics, Ainu Dreams, Verbal Paradise: Preverbs, America a Prophecy* (with Jerome Rothenberg), *Axial Stones: An Art of Precarious Balance*, and *An Art of Limina: Gary Hill's Works & Writings* (with Charles Stein). Awards include fellowships from the Guggenheim Foundation and the National Endowment for the Arts. He has taught at Stony Brook University (SUNY), Bard College, the New School University, and Naropa University.

Jeffrey Shaw
Artist; dean of the School of Creative Media, City University, Hong Kong
A leading figure in new media art since the 1960s, Jeffrey Shaw was cofounder of the Eventstructure Research Group, Amsterdam, and founding director of the ZKM Institute for Visual Media, Karlsrue, and the UNSW iCinema Research Centre, Sydney. Shaw has

pioneered and set benchmarks in the fields of virtual and augmented reality, interactive art, and immersive cinematic systems. His best known works include *The Corpocinema* (1969), *The Legible City* (1989), *The Golden Calf* (1995), *conFiguring the CAVE* (1997), *Future Cinema* (MIT Press), and *T_Visionarium* (2008).

Barry Smith
Julian Park Distinguished Professor of Philosophy, State University of New York at Buffalo;
director, Institute for Formal Ontology and Medical Information Science, Saarbrücken
Smith is the author of some 450 scientific publications, including 15 authored or edited books, and is editor of *The Monist: An International Quarterly Journal of General Philosophical Inquiry*. His research has been funded by the National Institutes of Health, the US, Swiss, and Austrian National Science Foundations, the Volkswagen Foundation, and the European Union. He is collaborating with Hernando de Soto, director of the Institute for Liberty and Democracy in Lima, Peru, on the ontology of property rights and social development.

Vibeke Sorensen
Professor and chair, School of Art, Design and Media,
Nanyang Technological University, Singapore
Sorensen is an artist and professor working in digital multimedia and animation, interactive architectural installation, and networked visual-music performance. She was professor and founding chair of the Division of Animation and Digital Arts in the School of Cinematic Arts at the University of Southern California from 1994 to 2005. She is a Rockefeller Foundation Fellow and has exhibited and published her work in many venues.

Mark Stefik
Research fellow, Xerox Palo Alto Research Center; manager, Human-Document
Interaction Area, Information Sciences and Technology Laboratory
Stefik directs the Information Sciences and Technologies Laboratory at PARC. His books include *Breakthrough: Stories and Strategies of Radical Innovation*, *The Internet Edge: Social, Technical, and Legal Challenges for a Networked World*, and *Internet Dreams: Archetypes, Myths, and Metaphors*, all published by MIT Press. He is also a fellow of the American Association for Artificial Intelligence and the American Association for the Advancement of Science.

Graham White
Lecturer of computer science, Queen Mary, University of London.
White has published widely on topics in computer science, philosophy, and mathematics. He is the author of *Luther as Nominalist* and is coeditor of several collections, including *Philosophy and the Cognitive Sciences* and *Modern European Philosophy*.

Eric Zimmerman
Independent game designer; visiting arts professor, NYU Game Center
Zimmerman is a game designer and theorist of game design. He has created award-winning games on and off the computer for entertainment, education, and art contexts. He is the coauthor of the textbooks *Rules of Play* and *The Game Design Reader*, both from MIT Press, and has taught at MIT, School of Visual Arts, and Parsons at the New School University. He is a founding faculty member at the NYU Game Center.

INDEX

Babbage, Charles, 140
Bacon, Francis, 148
Bair, Deirdre, 236
Baker, Robert, works of (*Ballte of Abonlair; London from the Roof of Albion Mills; The Panorama of Edinburgh; View of the Fleet at Spithead*), 200
Bal, Mieke, notion of traveling concepts, 2
Barabási, A.-L., 20
Barbera, Michele, 5–6, 89, 91–93, 95, 98, 99
Barbrook, Richard, 91
Baricco, Alessandro, 84, 85, 92
Barlow, John Perry, 91
Barrett, Edward, 10n3
Becker, H. S., 180
Beckett, Samuel, 236
being, modalities of, 4, 222. *See also* embodiment; presence
Benchley, Robert, 161, 166; Benchley's Law of Distinction, 161
Benesh, Joan, 115
Benesh, Rudolf, 115
Benjamin, Walter, on "mechanical reproduction," 281, 283, 287
Bergson, Henri, 224
Berlioz, Hector, *Les Troyens*, 281
Berners-Lee, Tim 29, 30, 79, 81, 87n16, 129
Bertenthal, Bennett, 19
bibliographies, 72–83 passim; bibliographic reference and quotation, necessity for, 64
Bier, Eric, 58
Billmann, Dorrit, 58
biology: intelligence in nature and anthropomorphism, 270n6; use of databases, 20
Birke, Julia, 20
Black Mountain College, 271n12
Blake, William, illuminations to "prophetic books" of (*Jerusalem: The Emanation of the Giant Albion, The Songs of Innocence and Experience, Visions of the Daughters of Albion*), 270n8
Blanchot, Maurice, *récit* versus *roman* distinction, 273n20
blogs and blogosphere, 40, 66, 80, 83, 90, 93, 94, 131; and expertise, 27, 129
Bobrow, Dan, 58
Boden, Margaret A., 141, 147
Bohr, Niels, 181
Bolles, B., 117
Bolter, Jay David, 10n3
bookmarking, 26, 129
books, electronic versus traditional codex, 5, 79. *See also* indexes
Booth, David, 21, 28
Borges, Jorge Luis, 310
Borghoff, U. M., 86n7
Borgman, Christine, 10n2
Borgmann, Albert, 5, 187

Boulez, Pierre, 141
Bowker, Geoffrey, 10n2
Brachman, Ronald J., 127
Brahe, Tycho, cataloging stars, 16–17
Bremond, François, 118
Brin, Sergey, 20, 27
Brown, Neil, *T_Visionarium*, 228, 231
Buchanan, B. G., 141
Buckland, Michael K., 19
Buffon, Comte de (Georges-Louis Leclerc), 152
Buntine, W., 156
Burke, Kenneth, 255
Burt, Ronald, on social structures, 41, 52
Bush, Vannevar, 2, 18
BUSMAN system, 117
Byron, Lord, 140
Byron-Lovelace, Ada, 140

caBIG (Cancer Biomedical Informatics Grid), 22, 31
Cage, John, 271n12
"Californian ideology," 91
Calvino, Italo, 72, 86n11; *Invisible Cities*, 226
camera: digital, 17, 23, 108, 241; film, 216; surveillance video, 105, 117
camera obscura, as example of creative facilitative device-machine, 232
Cameron, Andy, 91
Cape, Douglas, 208, 209; *What we will have of what we are: something past . . .* (online artwork by Cayley, Perring, and Cape), 208–9
Card, Stuart, 58
Carl, Kim, 19
Carnap, Rudolf, 148, 152
Carnig, Jennifer, 20
Cartes et Figures de la Terre, exhibition at Centre Pompidou (Paris), 226
Castronova, Edward, 25
Catlett, Charlie, 31, 32
CAVEs (Cave Automatic Virtual Environments), 215, 218, 219, 222, 224, 233, 234
Cayley, John, 208–10; *What we will have of what we are: something past . . .* (online artwork by Cayley, Perring, and Cape), 208–9
CD-ROMs, 83
censorship, 241
Certeau, Michel de, 202, "wandering of the semantic," 204–5
Cetin, E., 108
Ceusters, Werner, 8, 104, 107, 112, 161–64, 167–71 passim, 179, 180, 181, 185
checksum, 65
Chemero, A., 177
Chi, Ed, 58
Christiansen, John H., 22
CIDOC ontology, 104
cinema, interactive, 2, 4, 199, 205, 211–16, 218–29, 232, 245; long take and cinematic pan, 199, 203, 205, 211–12, 216n2 (see

also montage); time and, 203, 211; and
traditional cinema, 200, 202–4
"cinemascapes," 199, 211, 214, 241; defined, 205
CinemaScope, 243
Cini Foundation (Fondazione Giorgio Cini), 276, 288, 296, 297
citation, 51, 63, 66, 71, 73, 79–82, 83, 92; and "dynamic contextualization," 80
citeulike (website), 66
cityscape: virtual, 225; city as text, 202, 204–5
Clancey, William J., 7, 164, 168, 169, 173, 174, 175, 176, 177, 179, 180, 181, 182n3
classification. *See* data and databases; indexes; ontology
climate change research, 15, 22, 33
"code," 3, 162; as "mode of thought," 181–82n1
cognition, embodied notion of, 171; social character of, 171
cognitivist psychology, 182n3
Cohen, Harold, 141, 173–74. *See also* Aaron (computer program)
Cohen, I., 117
Cokol, Murat, 21
collaboration and collective modes: collaborative bookmarking, 26; "communion" and collective participation, 8, 269; in data analysis, 26, 59n12; interdisciplinary, 32; massive colllaboration enabled by computing, 16; in scholarship and research, 4, 16, 34, 68, 72, 89, 92, 169–70; shared terminology in, 7. *See also* interactivity in interactive artworks; social networks
"collective intelligence," 91, 92, 245; versus collective unintelligence, 91
Collodi, Carlo, *Pinocchio*, 63–64
colonialism, 239–45 passim; and the "other," 239
Comment, Bernard, 201, 203
communication technologies, 24, 27, 64, 66, 132; speed of, 15, 119
compositing, 7, 199, 200, 205, 210, 233, 234, 235
computation, 15–34; automated analysis of data and complex systems, 16, 20–21, 30–31; effect on productivity in intellectual activity, 16; modeling and simulation, 16, 21–22; as part of social networks, 58; problems and benefits of, 33; role in research today, 17
computational assistants, 26–27
computational linguistics, lexical anaylsis, 73, 83
computer-aided visualization systems, 224
computer graphics (CG), 226, 234, 243
computer science, 185, 28; challenges for research, 28–30
computer systems architecture, 30–31
concepts, 7, 9, 75, 167, 180; conceptual maps and mapping, 142, 144, 146–47,

154–58 passim, 169, 171, 175–77; essentially contested, 97–99 (*see also* ontology); human conceptualization versus machine, 174, 177–79; traveling, 2–3
concordances, 44, 90
connotea (website), 66
content-based image retrieval (CBIR), 109, 118
content-provider industry, 119
continuity: attempt to destabilize, 210, 242; idealization of, 243; narrative, 200, 209; spatiotemporal, 201, 203. *See also* verisimilitude, experience of
Cooper, Douglas, 236
Cooper, Jeffrey, 58
cooperation. *See* collaboration and collaborative modes
Coover, Roderick, 8, 212, 213, 216n2, 218, 220, 239–45 passim; *Something That Happened Only Once*, 211–13, 216n4; *The Unknown Territories*, 211, 213–14, 216n4
Cope, D., 141
copying. *See* facsimile; manuscripts, copying of; reproduction
copyleft, 67, 75, 83
copyright, 67, 71, 72, 73, 92, 104, 283; and DRMS, 66–67
COST action 32 (organization), 86, 87n20
Cousin, Victor, 150
creative machines. *See* creativity in computers
creative writing, 8
creativity, human, 140–58 passim, 171–77; conceptual mapping and, 142; "cumulative creativity," 4, 304; memory and, 146–47, 175; problem solving and, 143; transactional view of, 167, 171–72
creativity in computers, 2, 5, 140–58 passim, 172–76, 185, 230–32; compositional model of, 143, 146–47; entropy-based (compression) model of, 142, 145–46, 175; exploratory model of, 142, 143; mathematical model of, 142, 143–45. *See also* artificial intelligence (AI)
Creeley, Robert, 271n12
cross-disciplinary exchange, 2–3, 7–9, 32, 41, 120, 181
culture, 1–9 passim, 93–94, 98, 111, 239–45, 254; and AI research, 170, 172; and computational analysis, 19, 33–34, 104–16 passim, 162–64; cross-cultural exchange, digital culture's facilitation of, 181, 216, 243; "cultural capital," 245; cultural diversity, 111, 163; cultural fragmentation, 240–43; cultural heritage, 66, 110, 112, 120, 121n2; cultural memory, 239–40; cultural oppression, 206; machine culture, contemporary, 227; popular and contemporary, 186, 243; cultural transformation and art, 220–23; "two cultures" problem, 2; culture war, 243

opinion and multitudes, 27, 90; expert
status and "harbingers" in indexing, 42,
51–52, 56, 59n10, 91–93; expert systems in
AI, 131, 162, 168; modular writing versus
expert judgment, 90–91; as professional
common knowledge, 93; in scholarship,
80, 83
extremism, 244–45

facial expression recognition, 109
facsimile, 7, 275–97 passim; and fakery,
counterfeiting, 281; quality of digital
facsimile, 284, 287
Factum Arte, 277, 288–97
Feuillet, Raoul Auger, 115
Figment (game), 3. 5; instructions for, 191–96
film. *See* cinema, interactive
Fink, Monika, 116
Fischetti, Mark, 29, 87
FitzGerald, M. C., 304
flaneur, 236
Flickr, 129
Floridi, Luciano, 10n3
FOAF (friend of a friend) person ontology, 131,
135–38 passim
folksonomies, 309; proliferation of, in web,
104, 309
Foster, Ian,1, 5, 22, 27, 31, 89–93, 96–98
Foundational Model of Anatomy (FMA), 104
fragmentation: as aesthetic strategy, 240; in
culture, 220, 240–43
frame, notion of, in traditional cinema, 224
Frankenstein, 270n6
Fromherz, Markus, 58
frontiers, information. *See* information
Fukumaru, Naoko, 290, 295
Fuller, Buckminster, 271n12
functionalism and functional equivalence,
185–86
functional magnetic resonance imaging (fMRI),
24
Furlong, Lucinda, 271n13

Gagliardi, Pasquale, 297
Galaxy Zoo project, 27
Galileo Galilei,184
Gallie, W. B., 97
game design and gaming, 3, 8, 24–25, 49, 62–63,
99, 143, 200, 215, 216n1
games: chess, 135, 185; ESP, 27; Figment, 3, 5,
191–96; poker, 167; soccer, 108; tennis, 108;
World of Warcraft, 24
Ganascia, Jean-Gabriel, 5, 8, 10n2, 146, 154,
161–62, 180, 185; logical approach to
creativity, criticisms of, 171–77
Gardner, H., 171
Garfield, Eugene, 73
Garland, Judy, *Wizard of Oz* slippers as artifacts,
301, 304n2

gay culture. *See* Rechy, John
Gedigian, Matt, 20
Gelernter, David, "mirror world," 24
genetics, 15, 24
genres, artistic, 20, 172, 179
geographically organized information services,
59n11
geographic information systems (GIS), 19
geography, 214
Georis, B., 117
gesammtkunstwerk, 221
Ghemawat, S., 30
Gibson, William, *Neuromancer*, on "cyberspace,"
25, 89–90
Gleich, Michael, *Web of Life*, 219
globalization, 3, 93–94, 163, 221, 241–45
Gobbel, Randy, 58
Goebbels, Joseph, 243
Golbeck, Jennifer, 139n7
Gold, E. M., 148
Goldberg, Louis, 112
Golem, 270n6
Gombrich, E. H., 213
Good, Lance, 58
Goodman, Nelson, 148, 213
Google, 31, 79, 119, 129; gateway role of, 28;
Google Books, 74; Google Hell and page
ranking, 96; Google Maps, 59n11; Google
PageRank algorithm and linking, 27;
mentioned, 25, 61, 63, 86, 135, 186; image
searches on, 107. *See also* search engines
Gori, Marco, 28
GRDDL, 131
Greenbaum, J., 168, 171, 180
Greenberg, Andy, 96
Gregory, Ian, 19
grid technologies, 30
Groeneveld, Dirk: *Distributed Legible City*, 219,
225; *Legible City*, 218–19
Grusin, Richard, 10n3
Guédon, J. C., 86n12
Guilcher, Jean-Michel, 116
Gurney, K., 117

Hakeem, Asaad, 112
Hall, Wendy, 30
Hampden-Turner, C., 177
Hatol, J., 119
Hayes, Patrick J., 126
Hayles, Katherine, 10n1
Heal, Jane, on cognitive penetrability, 96
Healy, Margaret, 304n1
Hegedus, Agnes, *ConFiguring the CAVE*, 219, 222
Heidegger, Martin, 72
Hempel, Carl Gustav, 148, 152
Hendler, James A., 8, 30, 135, 139n3, 161–62,
164–71, 180, 185
Heraclitus, 66
hidden Markov models (HMMs), 116

International Electrotechnical Commission (IEC), 119
International Society of Visual Sociology, 216n5
International Standards Organisation (ISO), 119
International Virtual Observatory Alliance, 19
Internet, 4, 94, 121,181; challenges posed to scholars by, 61, 65; culture wars on, 241; extremism and, 244; "generative internet," 304; as multiuser emergent behavior model, 220; and scholarly publishing, 73–75, 78, 82, 85; and war, 243. *See also* web
Izquierdo, Ebroul, 108, 118

Jabes, Edmond, 300
Jain, Ramesh, 109
Jansen, Bill, 58
Johnson, Steven Berlin, 19
Johnson, W. Lewis, 25
Jones, Dave, 252, 260, 269
Jordan, T. H., 21
journals, scholarly, 25, 72–73, 80–81; humanities versus scientific, 72–73; online, 66; open-access, 32
Judd, Kenneth L., 22

Kalukin, Andrew, 117
Kamin, Franz, 271n12
Kant, Immanuel, 62, 70, 72, 93; "conditions of possibility," 62; *Critique of Pure Reason*, 72
Karl, Brian, *Counterface* (with Tirtza Even), 210
Karmiloff-Smith, Annette, 142
Kaufman, Stuart, 270n6
Kelly, Robert, 271n12
Kemp, Karen, 19
Kenderdine, Sarah, 218; *PLACE-Hampi* (with Jeffrey Shaw), 218
Kepler, Johannes, heliocentric theory of solar system, 16
Kesselman, Carl, 22
Kessler, Brett, 20
Kiesler, Friedrich, 220–21
kinematic classification, 105
kinesthetic experience, 115, 219, 234, 236
King, Elspeth, 111
Kiranyaz, S. K., 117
KL-ONE, early KR system, 127
Knoche, M., 86n15
knowledge, 7, 21, 25, 27, 31, 58, 161–71 passim; barbaric (Baricco), 92; collective, 39; expert, 93; human versus artificial, 125–39 passim; versus information, 74; knowledge base, or A-box, 127, 135–37; machine learning and, 147–58 passim; manifested in action, 165; pagan (Lyotard), 92; public, 93; scholarly, 68–85 passim; universal, Enlightenment belief in, 93; utilitarian, 239–40; viewed as linguistic expressions, 169. *See also* data and databases; indexes; information; knowledge representation (KR)

knowledge representation (KR), 125–39, 147, 152–53, 164–71; assumption of quality of knowledge, 136, 138; early assumption of single point of view, 127; and first-order logics, 137; logicist approach to, 126; machine readable KR language versus natural language, 126; next-generation KR systems, 137; and the "real world," 132, 136; and the web, 125–31. *See also* artificial intelligence (AI)
knowledge representation and reasoning (KR&R), 125–39 passim, 166. *See also* knowledge representation (KR)
Koch, Ed, 225
Kodratoff, Y., 154
Kolmogorov complexity, 146
Kompatsiaris, I., 117
Kopytoff, Igor, 301
Koru system, 27
Korzybski, Alfred, 182n6
Krishnakumaran, SaiSuresh, 20
Kyng, M., 168, 171, 180

Laban Movement Analysis (LMA), 115
Labanotation, 119
Labyrinth Project, Annenberg Center, 205–6
Lachelier, Jules, 148, 150
Lachmann, Karl, 68, 75
Landow, George, 10n3
Langley, Pat, 143
language: computing and programming languages, 82, 119, 131, 135, 155; different languages, 19, 25, 80, 83, 98, 107, 181, 241; kinetic language, 115, 163; language evolution, 22, 33, 242; "language of mathematics," 184; "pattern language," 45; representational language and ontologies, 113, 117, 118, 126, 129–31, 163; utopian unification in Semantic Web, 166; "visual language," 215; words versus images in art, 227; word use and, 97; in the work of Gary Hill, 8, 250–74 passim
Lanier, Jaron, 91
Large Scale Concept Ontology for Multimedia (LSCOM), 118
Large Synoptic Survey Telescope, 17
Lassila, Ora, 30
Latour, Bruno, 5, 8, 299, 302, 303
learning, 8, 161–81 passim; and algorithms, 117; and culture, 120; learning paradigms, 148; modern curricula, 32; in virtual worlds, 25. *See also* education; machine learning; sensemaking
Lederberg, Joshua, 38, 58
Lee, Lawrence, 58
Lenat, Douglas, 143
Leonardo da Vinci, *Mona Lisa*, 276, 278
Lester, James C., 25
Lettrism, 226

Li, Yanhong, 20, 27
libraries, 22, 25, 61, 73, 76–79, 104–5, 106, 240; difficulties in access to, 17–18, 31–32, 98; digitization and digital libraries, 62, 77–80; "open-shelf" libraries, 77; preservation and, 66–67; purpose of research libraries, 77; scanning of, 16, 98; "virtual" library, 25
Lichtenstein, Roy, 304
Licklider, J. C. R., 26
Liehm, Anthony J., 111
Lilienthal, O., 139
linguistics, 97; linguistics and animal sounds, 270n4; "science" of linguistics versus Hill's "electronic linguistics," 250. See also Hill, Gary
"links," 242
Liu, Alan, 3, 5–6
livejournal.com, 131
LOCKSS (lots of copies keep stuff safe), 66
logic, 140–58 passim, 171–72; first-order logics, 137; first order predicate logic (see induction, logical); "logical modularity," 5, 90–91; logical versus ecological modes of thought (chart), 178; propositional logic, 153;
logicist-technologists, 126–27, 162, 165, 168–69, 171, 179–80, 181–82n1
long tail distribution of information, 39, 50, 58n1, 71, 132; versus normal distribution (bell curve), 97
Lorenz, Konrad, 181
Louvre (Paris), 276, 282, 285, 286, 288–92
Lowe, Adam, 5, 8, 277, 297, 299, 302, 303
Lucas, George, Star Wars, 226
Lucretius on nature of writing, 72
Lumiere brothers, 203
Lyotard, Jean-François, 92

machine learning, 47, 142, 145, 152–54, 176, 177; algorithms to create topic models, 51–52; conceptual mapping, structural matching, and, 142, 147, 156–58; numeric versus symbolic, 152–53. See also artificial intelligence (AI)
Macromedia Director, 205
Maechling, P., 21
Maes, P., 303
Magritte, René, 224
Maniatis, Petros, 28
manipulation resistant recommender systems, 32
Manning, Christopher G., 97
Manovich, Lev, 10n2, 215
manuscripts, copying of, 66–67, 82, 98, 282–83
mapmaking, 226, 239; and cartography, 214
Margolis, Eric, 216n5
"mash-ups," 131, 166, 310; in artworks, 243
"massively human processing," 27, 90
mathematics, field of, 184

McCarthy, John, 126, 144, 145
McCorduck, P., 174
McCowan, Iain, 116
McKeon, Richard, 6
MediaArchive system, 117
medicine, 104, 182n2
Menabrea, L. F., 140
metadata, 7, 68, 71, 78, 89, 119; tagging, 80, 228, 300
Michalski, R. S., 154
Mill, John Stuart, 148; on induction, 149–51
Milne, D., 27
Minsky, Marvin, 145
Mittal, Priti, 58
Mittal, Sanjay, 58
Möbius strip, 212
Mondrian, Piet, 172
Monet, Claude, 172
montage, 200, 202, 204–5, 210, 211, 216n2, 240, 242; and "cut-up" technique, 240
Montfort, Nick, 10n2
Moore, Gordon, 23
Moore's Law, 23
Moretti, Franco, 20
Morgan, Robert C., 271n13
Morris, Adalaide, 10n3
Mostern, Ruth, 19
motion, ontology of, 105–6, 109; and movement theorists, 114–15
Mozart, Wolfgang Amadeus, 311
Mozer, M. C., 117
Mroz, J. Rami, 244
MUD bot, 187
Muggleton, S., 154, 156
multimedia, 9, 107–9, 119, 164; artworks, 200, 212, 216, 235, 244
Murray, James, 27
museums, 18, 104, 240; display of artwork in context in, 275–77, 281–88
Museum Victoria (Australia), 218
music: automated musical composition, 141; jazz music playing and music composition, 146–47, 186; revival through performance, 281
mutilated checkerboard problem, 144–45, 176
Myspace, 68, 92

Narby, Jeremy, 270n4
narrative, 239–43, 301, 312; in interactive artwork, 200, 207–9, 211–12, 214, 225–35 passim, 254–74 passim; choice in interactive work, 215, 227
NASA EOSDIS system, difficulty in accessing data of, 18
National Cancer Institute's Oncology Ontology (NCI), 135
National Gallery (London), 275, 284
National Institute of Health, 182n2
Nelson, Theodore H., 2

Schmolze, James G., 127
Schneiderman, B., 96
"scholarly navigation system," 79
scholarship, in the humanities, 4, 7, 16,
 33, 62–86, 92, 95–99; "conditions of
 possibility" or norms of (quoting,
 consensus, preservation), 62–63, 95; "digital
 scholarship," 33, 68, 85, 94; institutional
 backing and financial support for, 70–72;
 scholarship ontology, 75–78 (see also
 research, scholarly, in the humanities)
Scholarsource project, idea for, 85–86, 92
Schön, D. A., 166, 176, 179
Schreibman, Susan, 10n3
Schütze, Hinrich, 20, 97
science, 2–3, 9n1, 15, 17, 21, 24, 26, 67, 72, 83,
 92, 177, 180, 184–85; art and science, 220;
 computational assistants and, 26–27, 143;
 conditions of falsification, 76; consensus
 and, 21; journals and publications in hard
 science, 17, 18, 72–73, 90; and positivism,
 250; research, 24; science academies,
 68; "scientific discoveries," 143, 176–77;
 scientific theories or laws, 179, 184;
 scientific thinking, 180; standard of truth
 and, 165, 180
Science Citation Index (SCI), 73
scriptorium, monastic, 282; web as present
 day, 283
Scudery, Madeleine de, Carte de Tendre, Clélie,
 226
sculpture, 283
Seah, C., 168
search engines, 26, 38, 74, 83, 125; difficulties
 for with multimedia, 107; keyword-based,
 129; limitations of, 40, 135–36; queries on,
 45. See also data and databases: Google
Second Life, 24, 228
self-generation, idea of, 270n6
self-organizing system, 220
semantic crawler, 310
semantic gap in multimedia classification,
 107–8, 112, 164
semantics, 29–30, 125–31. See also Semantic
 Web
Semantic Web, 7, 74–78, 89, 93, 182n1; data
 and content of, 135–37; ideal of, 29–30,
 164–65; and knowledge representation in
 AI, 125–39 passim, 161–71 passim; ontology
 language, 131
Semmens, Richard, 116
sensemaking: challenges for, 42, 58; digital,
 38–42 passim, 53, 56, 58, 59n9, 89; human,
 19, 38–42 passim; social, defined, 39
Shadbolt, Nigel, 30
Shah, Mubarak, 112
Shakespeare, William: Macbeth, 145; King Lear,
 280, 281, 284
Shaw, Clifford, 143

Shaw, Jeffrey, 5, 8, 218–36 (discussion with), 239,
 242, 245; expanded cinema installations
 of 1960s, 224; influences on, 226; text and
 image relationship in, 227
Shaw, Jeffrey, works by: conFiguring the CAVE,
 218, 219, 222, 224; Distributed Legible City,
 219, 230; Heavens Gate, 227; Legible City, 218,
 219, 224–27, 230, 235; different versions
 of, 225–26; The Narrative Landscape, 227;
 Place—a user's manual, 224, 227, 230, 232–34;
 PLACE-Hampi, or Place-Hampi, 218, 232–35;
 Points of View III, 228; T_Visionarium, 228,
 231; Televirtual Chit Chat, 230; Web of Life,
 218–20, 224, 227, 234
Shawn, Ted, 115
Shirky, Clay, on Semantic Web, 129
Siemens, Ray, 10n3
Sierhuis, M., 168
Simon, Herbert, 39, 143–44, 181
Situationists, notion of dérive, 226
Skype, 6, 61, 62
Slezak , P., 181
Sloan Digital Sky Survey, catalog of stars, 16,
 18, 32
Smeulders, Arnold, 108
Smith, Adam, 103
Smith, Barry, 8, 104, 107, 112, 161–64, 167–71
 passim, 179, 180, 181, 185
Smith, Brian Cantwell, 297n3
Smith, John R., 118
Smith, Terry, 221
Snow, C. P., 2
Snow, John, mapping of cholera cases, 19
social index. See indexes
social informatics data grid (SIDGrid), 19–20
social media and social-media sites, 48, 52, 58,
 228, 230; social indexing as form of, 58
social networks: 4, 48, 52–54, 68, 94, 167, 243;
 and humanities research, 83; and indexing,
 53; social network friends, 310; websites,
 48, 59n9, 68, 92, 129, 131, 167
social sciences, 17, 18, 22, 25, 180, 216n5; social
 sciences research and virtual worlds, 25;
 survey data online, 18
software: 24, 32, 34, 76, 109, 121, 166; design
 paradigm of direct manipulation, 96; for
 digital arts, 199, 215, 219, 229–30, 232; error,
 311; first engineer of, 140; software agents,
 82, 108, 112
Sorensen, Vibeke, 8
Sparck-Jones, Karen, 134
SPARQL query language, 131
spectatorship, 218; passive versus active
 viewing, 200–202, 223. See also cinema,
 interactive
spreadsheets, 26
Station Hill Press, 273n20
Stefik, Barbara, 58
Stefik, Mark, 5, 41, 43, 44, 89–93, 97, 98;